THE STUDY OF
THE BAYEUX TAPESTRY

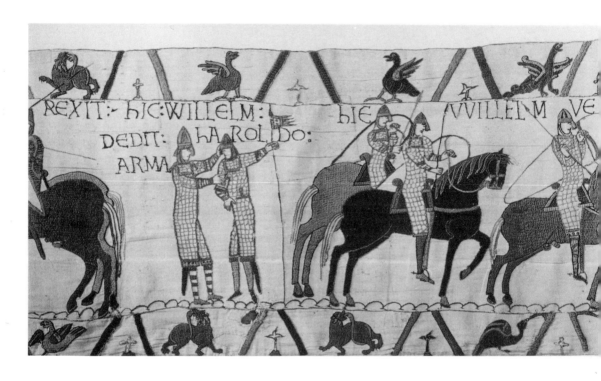

THE STUDY OF
THE BAYEUX TAPESTRY

edited by

RICHARD GAMESON

THE BOYDELL PRESS

First published 1997
The Boydell Press, Woodbridge

ISBN 0 85115 664 9

The Boydell Press is an imprint of Boydell & Brewer Ltd
PO Box 9, Woodbridge, Suffolk IP12 3DF, UK
and of Boydell & Brewer Inc.
PO Box 41026, Rochester, NY 14604–4126, USA

A catalogue record for this book is available
from the British Library

Library of Congress Cataloging-in-Publication Data

The study of the Bayeaux Tapestry / edited by Richard Gameson
 p. cm.
 Includes bibliographical references and index.
 ISBN 0-85115-664-9 (alk. paper)
 1. Bayeux Tapestry. 2. Embroidery, Medieval–France.
3. Hastings, Battle of, 1066, in art. I. Gameson, Richard.
NK3049.B3S78 1997
746.44'20433'0942–dc21 96-46931

This publication is printed on acid-free paper

Printed in Great Britain by
St Edmundsbury Press Ltd, Bury St Edmunds, Suffolk

CONTENTS

PREFACE AND ACKNOWLEDGEMENTS

This book is a collection of 'classic' literature on the Bayeux Tapestry. Notwithstanding several useful monographs and one excellent one, much of the most important work on the artefact has been published as articles in periodicals. The writings in question are now mostly out-of-print, and difficult to obtain. The function of *The Study of the Bayeux Tapestry* is to make available a number of key articles within a single volume of convenient size.

The principles that guided me in the selection of works were as follows. (1) That each paper make a seminal contribution to the study or interpretation of the Bayeux Tapestry in its historical context. (2) That it should be of enduring worth – both to scholars and students. (3) That there should be a fair chronological spread of writings to give the reader a sense of the development of scholarship in the field. (4) That as a collection, the resulting volume should be varied and well balanced: although certain issues inevitably recur, the studies are largely complementary in focus and approach. And (5) that the volume itself should complement the existing monographs on the Tapestry. Despite their undoubted excellence, there seemed little sense in reprinting the pieces by Stenton and Wormald from *The Bayeux Tapestry: a comprehensive survey*, ed. F. M. Stenton 2nd ed. (London, 1965), when that book is still widely available, and Wormald's study was reprinted in his *Collected Writings I* (London, 1984). The reader may be interested to know that, given these fairly stringent criteria, it was not, in fact, very difficult to reduce the hundreds of articles on the Bayeux Tapestry to the eleven reprinted here.

The original publication details of each essay are provided below. The three that were published in French appear here in an English translation for the first time. My own contribution, which has not been published before, is based on lectures given in Oxford, London, and Canterbury during the last five years, and on a paper read to the British Archaeological Association in February 1995. Whether it is hubris to present it in such venerable company, readers must judge for themselves.

Needless to say, articles written over a period of nearly two centuries and originally published in a variety of contexts follow different conventions of presentation and citation, and some of this diversity is necessarily carried over into the present volume. Although reset, the texts are reproduced exactly as first published, apart from the silent correction of a few minor errors. A modicum of standardisation has, however, been introduced into the notes, without of course altering their content.

Some of these studies were illustrated when first published, others were not. The present volume is equipped with a selection of plates reproducing more than half of the Tapestry, and references to these have been inserted throughout. The individual contributions are generally, therefore, more fully illustrated here than

they were in their original form. It was not possible to illustrate the whole Tapestry; however several complete reproductions are readily available, undoubtedly the most useful (not to mention economical) being the 1/7th scale fold-out version published by Bayeux. This gives a much better sense of the original than do its codex equivalents, which inevitably dismember the work into small sections. Ultimately there is no substitute for viewing the Tapestry itself at Bayeux.

It remains to tender my thanks to those who have aided in the realisation of this project – namely all the authors and publishers who graciously granted permission for the republication of the works in question; and, on a more personal level, Christine Gameson, Fiona Gameson, Mary Jane Connell, Julie Wilks, Richard Eales, and Hélène Barbier. The photographs of the Tapestry are reproduced by special permission of the Town of Bayeux.

The articles in this volume were first published as follows.

1 C. A. Stothard, 'Some Observations on the Bayeux Tapestry', *Archaeologia* 19 (1821), 184–91.
2 E. A. Freeman, 'The Authority of the Bayeux Tapestry' and 'The Ælfgyva of the Bayeux Tapestry', both in his *The Norman Conquest of England: its causes and results*, vol. III 2nd ed. (Oxford, 1875), 563–75 and 708–11.
3 W. R. Lethaby, 'The Perjury at Bayeux', *Archaeological Journal* 74 (1917), 136–8.
4 H. Prentout, 'Essai d'identification des personnages inconnus de la Tapisserie de Bayeux', *Revue Historique* 176 (1935), 14–23.
5 S. Bertrand, 'Etude sur la Tapisserie de Bayeux', *Annales de Normandie* 10 (1960), 197–206.
6 R. Lepelley, 'Contribution à l'étude des inscriptions de la Tapisserie de Bayeux', *Annales de Normandie* 14 (1964), 313–21.
7 C. R. Dodwell, 'The Bayeux Tapestry and the French Secular Epic', *Burlington Magazine* 108 (1966), 549–60.
8 N. P. Brooks and H. E. Walker, 'The Authority and Interpretation of the Bayeux Tapestry', *Proceedings of the Battle Conference on Anglo-Norman Studies* 1 (1979), 1–34 and 191–9.
9 H. E. J. Cowdrey, 'Towards an Interpretation of the Bayeux Tapestry', *Anglo-Norman Studies* 10 (1988), 49–65.
10 R. Brilliant, 'The Bayeux Tapestry: a stripped narrative for their eyes and ears', *Word and Image* 7 (1991), 93–125.
11 S. A. Brown and M. W. Herren, 'The *Adelae Comitissae* of Baudri de Bourgueil and the Bayeux Tapestry', *Anglo-Norman Studies* 16 (1994), 55–73.

Studying the Bayeux Tapestry

RICHARD GAMESON

The Bayeux Tapestry is one of the most famous works of art to survive from the Middle Ages; it is also one of the most celebrated documents of English and Norman history. By virtue of this dual status, as well as its exceptional attractiveness, it has been the subject of prolonged scrutiny from historians and art historians for more than two centuries.

The Bayeux Tapestry has spawned a vast literature – of very uneven quality. While major monographs – above all the magisterial volume edited by Sir Frank Stenton in 1957 – have inevitably been key points of reference, some of the best work has been published in the form of articles. (The great strength of Stenton's volume, incidentally, lies in the fact that it comprises a collection of closely focused studies, written by a team of specialists.) The function of *The Study of the Bayeux Tapestry* is to make readily available in a convenient format some of the most interesting, important, and influential writings of this nature.

The chronological span of material here included covers the best part of two centuries, though there is, appropriately, a weighting towards work done in the second half of the twentieth century. The older pieces are inevitably dated in various respects, including views and debates that have been superseded, but nevertheless they retain material of value and remain worthy of attention. Stothard's article, for instance, with which this collection begins, has almost the status of a primary source for the fabric of the Tapestry by virtue of the author's close and attentive examination of it, during the lengthy preparation of his handmade facsimile in the early years of the nineteenth century (1816–18). He provides a guide to his famous and much-cited reproduction (issued as hand-coloured engravings in 1820, and republished in *Vetusta Monumenta* VI sixty-five years later), as well as offering many acute observations on the work as a whole. The contributions by Freeman, Lethaby, and Prentout likewise represent important landmarks in the evolution of Bayeux Tapestry scholarship with thoughts and material of enduring value: much subsequent work ultimately echoes views and facts here propounded. In addition to their inherent interest, the opportunity to re-read such works will, it is hoped, have a sobering effect on current scholarship, deterring yet more writers from returning to insoluble problems, and making them aware that beliefs which are sometimes seen as originating in Stenton's volume have very much deeper roots. In point of fact, far from each generation bringing new approaches and new material to the

interpretation of the work, the questions asked of it and the data deployed to answer them have remained remarkably stable for well over a hundred years.

Within these broad parameters, the pieces included here show the development of Bayeux Tapestry studies, and exemplify the different approaches that have been taken to the work. Thus on the one hand we find a close focus on particular figures (Prentout), inscriptions (Lepelley) or problems, such as the relationship of the work to Baudri of Bourgueil's *Adelae Comitissae* (Brown and Herren); while on the other hand, there are broad-ranging, interpretative accounts (Dodwell, Brooks and Walker, and Cowdrey). Collectively these articles provide a comprehensive 'companion' to the study of the Bayeux Tapestry, addressing the main issues that are central to a balanced understanding of it. What, then, are these issues?

Of fundamental importance for interpreting the work is a detailed knowledge of its fabric and manufacture. Unfortunately, however, this is a very difficult field to explore. Because of the nature of the artefact and the way it is necessarily displayed, scholars do not, in general, have access to its fabric in the way that they do to that of coeval manuscripts, for example. Very few people have inspected the work out of its display case, there is no detailed account of the various restorations it has undergone, and it is even difficult to find published photographs of the reverse side of the fabric. In the absence of fully annotated restoration diagrams, the student is dependent on visual inspection (through glass), and on the use of older reproductions, especially those of Montfaucon and Stothard, to ascertain the authenticity of particular motifs. The results of the examination undertaken in the early 1980s prior to the re-hanging of the work, when they are finally published, will bring new and much-needed precision to this crucial field. In the meantime Bertrand's discussion, based on long, close association with the work and, in particular, on scientific study done in the 1950s, represents a reasonable, provisional account. Nevertheless, although examination of the fabric with modern techniques may resolve some problems, key issues such as how the work was designed, how many hands were involved in its manufacture, and how long it took to make, are likely always to remain obscure.

No less important for understanding and interpreting the Tapestry and evaluating its authority are establishing its likely date and place of origin. These questions have rightly preoccupied countless writers since the very beginning of serious scholarship. Both the connection of the work with Odo of Bayeux and the probability of English workmanship were realised long ago, although manufacture in Normandy has intermittently been proposed as an alternative, most recently in 1994. Comments on the origin and date of the work are offered in most of the essays in this collection, the fullest discussions being in Freeman, Brooks and Walker, and Gameson.

A germane theme is the content of the story and its relation to other early written sources. What does the Tapestry relate about the events of 1064–6? (Convenient summaries of its narrative are provided by Brooks and Walker, and Cowdrey.) How does its version compare with the accounts of the *Anglo-Saxon Chronicle*, William of Jumièges and William of Poitiers? What do discrepancies between these sources tell us? Detailed scene by scene commentaries have been

published in several of the monographs on the Tapestry, and the extent to which they differ in their interpretations of scenes and motifs underlines the degree of ambiguity inherent in the visual imagery. Analyses of the Tapestry in the light of the written accounts of the events of the Conquest are found in Freeman, Brooks and Walker, Cowdrey, and Gameson; while comparisons between the Tapestry and written texts of other genres are presented in Dodwell, and Brown and Herren. A key point here, of course, is that one has to understand the visual language of the work in order to be able to read it. Many of the divergent interpretations that have been propounded over the years arise ultimately from the writers' differing assumptions about how to read the imagery. The dispute over which figure or figures represent the slain Harold is probably the most famous case in point. This question is treated magisterially by Brooks and Walker.

Attention has inevitably focused on the figures in the Tapestry who are not immediately identifiable from other sources. Who are they, what are they doing there, and what do they tell us about the work in general? The probable relevance of Wadard and Vital (and perhaps also Turold) in this respect had been established in the nineteenth century (see Freeman), although alternative 'readings' of Turold continue to be propounded (cf. Prentout). Ælfgyva, on the other hand, remains a mystery. Because she has proved so elusive, the search for her identity seems to have taken on the attraction of the Quest for the Holy Grail. In the view of the present writer, it has just about as much chance of success. The contributions to the debate that are included here (Freeman and Prentout) are both fairly elderly, and they are all the more valuable for that. Both contain a sufficiency of improbabilities and speculations to satisfy what appear to be the demands of current scholarship on the question. Moreover, both should remind the modern reader of how many 'knights' have already perished in this 'quest'. Freeman's formulation of the issues is one of the clearest: 'We may put aside Matilda and all other women who never were, or could have been, called Ælfgyva. We may put aside all those women who were named Ælfgyva but who were dead and buried at the time. But of all the women named Ælfgyva who were living at the time, which could have been in William's palace at that particular moment?' He also had the good sense, not shared by some more recent writers on the question, to acknowledge that his solutions 'are mere guesses, of no more value than the guesses of other writers. They are all, I acknowledge, improbable guesses, but I think that they have the advantage over some other guesses of not being absolutely impossible.'

As was noted above, the interpretation of the Tapestry depends upon understanding its visual language. The main dangers here are, on the one hand, underestimating the skill of the designer; but, on the other hand, over-reading what he did. The artist in question undoubtedly enriched his work with countless subtleties. But was every 'detail' of crucial importance for the narrative (or meta-narrative); or were some of them essentially incidental ways of setting scenes and evoking generalised moods? One must be attentive to every detail for its possible narrative or polemical import, whilst simultaneously being aware that even the most engaging and intriguing touches may have had neither. And what contribution, beyond pure

decoration, did the borders make to the message of the work? This last question is addressed by Dodwell and Cowdrey. The details of the Tapestry have been scrutinised for their witness to the conditions of eleventh-century everyday life, and ransacked for subtle points of narrative meaning (including, in recent years subversive, nationalistic messages). The touchstone for a just interpretation of the work in either respect must be a knowledge of the visual resources that an eleventh-century artist had at his disposal in general, and a clear understanding of the way the designer of the Tapestry in particular tended to deploy them. These issues are addressed in the fullest detail here by Brooks and Walker, Cowdrey, Brilliant, and Gameson.

Writing was clearly one of these devices, and the inscriptions are of central importance to the art and message of the Tapestry. Scholars have been surprisingly reluctant to allow a visual narrative its own, independent authority, and the 'Search for the Text underlying the Tapestry' has been pursued with a zeal approaching that of the search for the real Ælfgyva. In the opinion of the present writer it has even less chance of success. The inscriptions have been an important factor in encouraging people to take this approach, and they have sometimes been regarded as reflections of a pre-existing verbal narrative (Bertrand alludes to such a view). Without denying that the designer may have drawn upon one or more written sources, this seems to me to represent a fundamental misunderstanding of the nature of the inscriptions: they are an integral part of the art of the Tapestry. Judicious comments on the form and function of the inscriptions are found in Brilliant and Gameson; while the implications of the information provided by a couple of the spellings are explored by Lepelley.

If the Tapestry does not reflect a Chanson de Geste, it may nevertheless be fruitfully compared with that genre, as Dodwell's exposition eloquently demonstrates. Correspondingly, the Tapestry itself may have inspired a poetic evocation of a comparable narrative hanging, as is argued by Brown and Herren. More generally, such explorations remind us once again of the degree to which overarching narrative and artistic conventions and considerations influenced the presentation of 'historical' matter. And it is worth reiterating that it is impossible properly to interpret the latter without understanding the former. We should also be aware of the distinction between the words and images that are objectively encoded on the long, linen strip, and the subjective responses that they evoked (and evoke) in beholders. One cannot invariably deduce the latter from the former, particularly given that we do not know exactly how people experienced the Tapestry in the eleventh century.

While there has been much speculation over the years concerning how the Tapestry was originally displayed, the implications of this question for its impact on the beholder had not been fully explored. These issues receive detailed treatment by Brilliant, who rightly stresses the extent to which the context and arrangement of the Tapestry, as well as the presence of human guides, will have influenced the beholder's perception of its story and message.

Ultimately the key point – one whose importance and interest is reflected in the many studies that have addressed it – is establishing the meaning and purpose of

the work: what was it designed to convey – and to whom? Approaches and answers to this thorny question will be found in Lethaby, Bertrand, Dodwell, Brooks and Walker, Cowdrey, and Gameson. Needless to say there is no one view – a situation that may well, in fact, reflect eleventh-century reality.

Although there have been many disagreements about the Tapestry and the issues surrounding it – some of which appear in this collection – no one would doubt that this is a work of exceptional interest and superlative quality. It invariably excites admiration from specialist, student, and general viewer alike, and this surely provides us with a valuable insight into its original function. The Tapestry tells a gripping contemporary story in an attractive way, which is at one and the same time easily legible and wholly compelling, yet enriched with countless subtleties which reward careful scrutiny. As such it is an awesome memorial to the visual sophistication of eleventh-century society. For the historian, the Tapestry is thus a potent reminder of the central importance of visual representations in medieval culture; while for the art historian, it is an unequivocal demonstration of the fact that the medieval artist could be fundamentally creative. If *The Study of the Bayeux Tapestry* contributes to a fuller understanding of the work and its implications for eleventh-century society, and encourages further judicious and fruitful study, it will have achieved its purpose.

1

Some Observations on the Bayeux Tapestry

CHARLES STOTHARD

On finishing and delivering to the Society of Antiquaries the Drawings which complete the series from the Bayeux Tapestry, I think it necessary to address you on the subject for the purpose of stating what licences I may have thought proper to take in the discharge of my commission, and at the same time to point out such circumstances as have presented themselves to my notice during the minute investigation in which I have been necessarily engaged. I shall beg leave to offer with the latter such comments as I have made, hoping if I have produced nothing that will lead to just conclusions on the age of the Tapestry, I shall at least have furnished some useful materials for others. I believe in a former paper I observed that the work in some parts of the Tapestry was destroyed, but more particularly where the subject draws towards a conclusion, the traces of the design only existing by means of the holes where the needle had passed. On attentively examining the traces thus left, I found that in many places minute particles of the different coloured threads were still retained; a circumstance which suggested to me the possibility of making extensive restorations. I accordingly commenced on a small portion, and found it attended with so much practicability as well as *certainty*, that I believed I should be fully justified in attempting to restore the whole; more especially when I reflected that in the course of a few years the means of accomplishing it would no longer exist. I have succeeded in restoring nearly all of what was defaced. Such parts as I have left as traced by the needle, either afforded no vestiges of what the colours were, or such as were too vague in their situation to be depended on. On a comparison with the print in Montfaucon's work (if that be correct) it appears that this part of the Tapestry has suffered much injury even since his time. The restorations that I have made commence on the lower border with the first of the archers (pl. 25). Of these figures I found scarcely one whose colours of any kind remained perfect. In the upper border and historical part, the restorations begin a little after, with the Saxons, under the word "*ceciderunt.*" From the circumstances of the border being worked down the side at the commencement of the Tapestry, it is evident that no part of the subject is wanting; but the work in many places is defaced, and these parts have been restored in the same manner as at the end; but the last horsemen attendant on Harold in his route to Bosham have been partly torn away so as to divide them (pl. 1). The two fragments were ignorantly sewed together. This in the

1

drawing has been rectified, and shews the portion wanting. In that part of the battle between William and Harold, where the former is pulling off his helmet to shew himself to his soldiers, under the words "*Hic est Dux Wilelm,*" there is on his left hand a figure with outstretched arms, bearing a standard; above which a part of the Tapestry has been torn away, and only the two last letters VS of an inscription apparently remaining (pl. 25). On carefully examining the torn and ragged edges which had been doubled under and sewed down, I discovered three other letters, the first of the inscription an E, and T I, preceding V S, a space remaining in the middle but for *four* letters, the number being confirmed by the alternations of green and buff in the colours of the letters remaining. I therefore conjecture that the letters as they now stand may be read *Eustatius,* and that the person bearing the standard beneath is intended for Eustace, earl of Boulogne, who I believe was a principal commander in the army of William. By a similar examination of the end of the Tapestry, which was a mass of rags, I was fortunate in discovering a figure on horseback, with some objects in the lower border. These are additional discoveries not to be found in Montfaucon's print. The figure of the horseman certainly decides the question, that the pursuit of the flying Saxons is not ended where the Tapestry so unfortunately breaks off.

Before I proceed to state my remarks, I must urge a point which cannot sufficiently be insisted upon, that it was the invariable practice with artists in every country, excepting Italy, during the middle ages, whatever subject they took in hand, to represent it according to the manners and customs of their own time. Thus we may see Alexander the Great, like a good Catholic, interred with all the rites and ceremonies of the Romish Church. All the illuminated transcripts of Froissart, although executed not more than fifty years after the original work was finished, are less valuable on account of the illuminations they contain not being accordant with the text, but representing the customs of the fifteenth century instead of the fourteenth. It is not likely that, in an age far less refined, this practice should be departed from. The Tapestry, therefore, must be regarded as a true picture of the time when it was executed.

In the commencement of the Tapestry it is necessary to observe, that the Saxons appear with long mustachios extending on each side the upper lip, which continues with some exceptions (the result perhaps rather of neglect than intention) throughout the whole work. But in no instance but one, I believe, is this distinction to be found on the side of the Normans. This exception occurs in the face of one of the cooks, preparing the dinner for the Norman army after their landing in England. It may be also remarked in various places, that the beard is another peculiarity common to the Saxons; it may be seen in the person of Edward the Confessor (pls 1, 11, 12), and, several times represented amongst the Saxon warriors. It is rarely to be observed among the Normans, and is then chiefly confined to the lower orders. It does not appear probable that the above noticed distinctions existed after the Conquest among the Saxons.

On coming to that part of the Tapestry where Harold is prisoner in the hands of Guy, earl of Ponthieu, a most singular custom first presents itself in the persons of

Duke William, Guy, and their people: not only are their upper lips shaven, but nearly the whole of their heads, excepting a portion of hair left in front (pl. 4). It is from the striking contrast which these figures form with the messenger who is crouching before William, that it is evident he is a Saxon, and probably dispatched from Harold.

It is a curious circumstance in favour of the great antiquity of the Tapestry, that time has, I believe, handed down to us no other representation of this most singular fashion, and it appears to throw a new light on a fact which has perhaps been misunderstood: the report made by Harold's spies that the Normans were an army of priests is well known. I should conjecture, from what appears in the Tapestry, that their resemblance to priests did not so much arise from the upper lip being shaven, as from the circumstance of the complete tonsure of the back part of the head.

The following passage seems to confirm this conjecture, and at the same time to prove the truth of the Tapestry.

> Un des Engles qui ot veus,
> Tos les Normans res et tondus
> Cuida que tot provoire feussent
> Et que messes canter peussent.
>
> *Le Roman du Rou,* fol. 232.

How are we to reconcile these facts with a conjecture that the Tapestry might have been executed in the time of Henry the First, when we are well assured that during the reign of that king the hair was worn so long that it excited the anathemas of the church? There are many examples of sculpture on the continent which exhibit the extravagant fashions of that time. The men are represented with long hair falling below their shoulders; the women with two locks plaited or bound with ribbands, and falling over each shoulder in front, frequently reaching below their knees. The only examples, I believe, of this kind that can be cited in England are the figures of Henry the First and his queen on a portal of Rochester cathedral [now regarded as Solomon and the Queen of Sheba]. It may be asked at what period these fashions arose. From the violent censures which teemed throughout England and France in reprobation of them at the beginning of the twelfth century, it is not probable they had been then long established with the people. A passage in William of Malmsbury indicates that these fashions sprang up with some others during the reign of William Rufus: "Tunc fluxus crinium, tunc luxus vestium, tunc usus calceorum cum Arcuatis aculeis inventus. Mollitie corporis, certare cum foeminis, gressum frangere gestu soluto, et latere nudo incedere, Adolescentium specimen erat."

The figures on horseback where Harold is seized on his landing in the territory of Wido, bear on their shields various devices, but none which may properly be termed heraldic (pl. 3). Neither here nor in any other part of the Tapestry is a lion, fess, chevron, or other heraldic figure to be found; they are almost entirely confined to dragons, crosses, and spots. Nor do we find any particular or distinguished person twice bearing the same device. The pennons attached to the lances of the Normans are similarly ornamented, with this exception, that they bear no animals.

It is not easy to fix the time when heraldic bearings assumed a more decided character than in the Tapestry, but there appears to exist some proof that heraldic bearings were used in the time of Henry the First. John, a monk of Marmoustier in Touraine, who was living in the time of Geoffrey Plantagenet, on that prince's marriage with Matilda the daughter of Henry the First, at Mans, describes him previous to his being knighted as having put on him a hauberk and stockings wrought with double mailles, golden spurs fastened to his feet, *a shield emblazoned with little golden lions* hung about his neck, and a helmet glittering with precious stones on his head. The only representation of Geoffrey Plantagenet, I believe, known to exist, is upon a beautifully enamelled tablet of copper, which depicts him bearing an immense shield emblazoned with *golden lions* on a field azure. The number of the lions is not certain, as but one half the shield is seen, yet is seems probably there were six, 3, 2, and 1, as we find his bastard grandson William Longespee, on his tomb in Salisbury cathedral, bearing on his shield in a field *azure* six lions *or*, or 3, 2, and 1.

The beautiful memorial of Geoffrey Plantagenet here alluded to, (a drawing of which is now exhibited) formerly hung in the church of St. Julien at Mans, but disappeared during the revolution. It has, however, been lately saved from the melting pot to which the unsparing hands of the revolutionists had consigned it, and is now preserved in the public museum of that town. Geoffrey Plantagenet died in 1159, and there can be little doubt from the style in which it is executed that this memorial is of that date. A similar enamelled tablet representing Ulger, bishop of Angers, who died in 1149, formerly hung over his tomb in the church of St. Maurice at Angers, but was destroyed during the revolution.

Under the words *Ubi Harold et Wido parabolant*, the figure holding by the column on the left of Wido from his antic action, and the singularity of his costume, I imagine is intended to represent a fool or jester, attendant on Guy, Earl of Ponthieu (pl. 4).

There are only three female figures represented in the whole of the Tapestry, Ælfgiva (pl. 7), Edith, the queen of Edward the Confessor who is weeping by the death bed of the king (pl. 12), and a female flying from a house which is on fire (pl. 19). These females, by the manner in which their hair is invariably concealed, bear a strong resemblance to the delineations of women to be found in our Saxon MSS.

The armour represented is entirely different in its form from all other examples: instead of the hauberk being like a shirt, open at the bottom, it is continued as breeches, reaching to the knees; the sleeves are short. Formed thus, it does not appear how it is to be put on, but it seems probable from some contrivance of rings and straps which are represented on the breast in many instances, that there was an opening at the collar sufficiently large for the legs to enter previously to the arms being put into the sleeves. There is an apparent confirmation of this conjecture in that part where William is giving armour to Harold: the former is represented with his left hand putting the helmet on the head of the latter, and with his right hand apparently fastening a strap, which is drawn through the rings on the breast of Harold. The armour of William is fastened in the same manner. In general the legs are bound with bands of different colours, but in some instances they appear

covered with mail, and when this is the case it is only found to be so on the legs of the most distinguished characters, such as William, Odo, Eustatius, &c.

It is remarkable that a principal weapon used in the Norman as well as the Saxon army resembles a lance in its length, but is thrown as a javelin or dart (pls 21, 23). This is the only manner in which it is used by the Saxon soldiers, and there are two instances of Saxons being armed with three or four of these weapons. The Normans not only appear to use them in this manner, but also as lances, and always so when the pennon or small flag is attached. I believe examples of this sort of weapon are very rarely, if at all, to be seen long after the Conquest.

The Saxons are invariably represented as fighting on foot, and when not using missiles are generally armed with axes (pl. 22); their shields are many of them round, with a boss in the centre, as in the Saxon MSS., and in no instance do we find a Norman bearing a shield of this form. These three last mentioned circumstances are, I think, strong arguments in favour of the opinion that the Tapestry is of the time of the Conquest.

A single character in some parts of the Tapestry is so often repeated, almost in the same place, and within so small a space, that the subject becomes confused; there is an example of this in the deaths of Leofwine and Gyrth, the brothers of Harold (pl. 22); and another instance, better defined, in the death of Harold, who appears first fighting by his standard-bearer, afterwards where he is struck by the arrow in his eye, and lastly where he has fallen, and the solder is represented wounding him in the thigh (pl. 26).

The supposition that Taillefer is depicted throwing up his sword is a mistake so evident that the slightest observation of the Tapestry must correct it. The weapon in the air is clearly a mace: this may be proved by comparing it with the weapons in the hands of the three last figures at the end of the Tapestry.

In the Tapestry there is no attempt at light and shade, or perspective, the want of which is substituted by the use of different coloured worsteds. We observe this in the off legs of the horses which are distinguished alone from the near legs by being of different colours. The horses, the hair, and mustachios, as well as the eyes and features of the characters, are depicted with all the various colours of green, blue, red, &c. according to the taste or caprice of the artist. This may be easily accounted for, when we consider how few colours composed their materials.

That whoever designed this historical record was intimately acquainted with what was passing on the Norman side, is evidently provided by that minute attention to familiar and local circumstances evinced in introducing, solely in the Norman party, characters certainly not essential to the great events connected with the story of the work; a circumstance we do not find on the Saxon side. But with the Normans we are informed that Turold, an individual of no historical note, held the horses of William's messengers, by the bare mention of his name. And again, the words, "*Here is Wadard,*" are simply written without more explanation. Who Wadard might have been, history does not record; we must therefore conclude he was a character too well known to those persons acquainted with what was passing in the army of William to need any amplification to point out his rank, but not of

sufficient importance to be recorded in history. The same application may be made in regard to Vital, whom William interrogates concerning the army of Harold.

The interesting subject of these remarks has induced me to extend them beyond my first intention. I trust this will plead my excuse for having so long trespassed upon your time. I have the honour to be,

Dear Sir, very respectfully yours,
CHARLES A. STOTHARD

The Authority of the Bayeux Tapestry

EDWARD FREEMAN

It will be seen that, throughout this volume, I accept the witness of the Bayeux Tapestry as one of my highest authorities. I do not hesitate to say that I look on it as holding the first place among the authorities on the Norman side. That it is a contemporary work I have no doubt whatever, and I have just as little doubt as to its being a work fully entitled to our general confidence. I believe that the Tapestry was made for Bishop Odo, and that it was most likely designed by him as an ornament for his newly rebuilt cathedral church of Bayeux. In coming to these conclusions I have been mainly guided by what seems to me the unanswerable internal evidence of the Tapestry itself. Of that internal evidence I shall presently state the more important points, but, as the age and antiquity of the Tapestry have been made the subjects of a good deal of controversy, I think it right to begin by giving a summary of the literature of that controversy.

The earliest notice of the Tapestry is to be found in a communication made by M. Lancelot in 1724 to the French Academy, which was printed in the sixth volume of their Memoirs, p. 739 (Paris, 1729), and which, in some sort, entitles him to the honour of being looked on as its discoverer. Among the papers of M. Foucault, who had been Intendant in Normandy, was found what Lancelot calls "un Monument de Guillaume le Conquérant." This was no other than a copy of the earlier scenes of the Tapestry, as far down as the coming of William's messengers to Guy. The real nature of the monument was quite unknown; that it might be tapestry was simply one conjecture out of many which Lancelot made before the truth was found out. And he not unnaturally connected his discovery with Caen rather than with Bayeux. But the description which he gave of that part of the Tapestry which he had then seen, and the historical disquisition which he added, showed a very creditable knowledge of the original writers both English and Norman. His conclusion was as follows: "Plus j'ay examiné le monument qui a servi de sujet à ces remarques, et plus je me suis persuadé qu'il estoit du temps à peu près où s'est passé l'évenement qu'il represente; habits, armes, caractères de lettres, ornements, goût dans les figures representées, tout sent le siècle de Guillaume le Conquérant, ou celuy de ses enfants." (p. 755).

Lancelot then was the first to call attention to the Tapestry, but without knowing that it was tapestry or where it was to be seen. This discovery was owing to the

diligence of Montfaucon, who first guessed, and afterwards found his guess to be right, that the fragment published by Lancelot was a copy of part of a roll of tapestry which used to be shown on certain feast-days in the church of Bayeux. Montfaucon gave two accounts of it in his "Monumens de la Monarchie Francoise" at vol. i. p. 371, and at the beginning of vol. ii. He decides (ii. 2), on the evidence of the style of the work, the form of the armour, &c., that the work is a contemporary one, and he accepts as probable, what he says was the common opinion at Bayeux, that it was wrought by Queen Matilda. He thought that the Tapestry was designed to go on to the coronation of William, and that its imperfect state was owing to the Queen's death in 1083.

The first volume of Montfaucon was published in 1729, the second in 1730. In the latter year Lancelot communicated to the Academy a second paper which appeared in the eighth volume of the Memoirs (Paris, 1733), p. 602. He had by that time found out another fact with regard to the monument. The Tapestry, known locally as "la Toilette du Duc Guillaume," was thus mentioned in an inventory of the goods of the Church of Bayeux of the date of 1476: "Item. Une tente tres longue et etroite de telle à broderie de ymages et eserpteaulx [escripteaulx] faisans representation du Conquest d'Angleterre, laquelle est tendue environ la nef de l'Eglise le jour et par les octaves des Reliques."

A short notice of the Tapestry in Beziers' History of Bayeux (Caen, 1773) is wholly founded on Lancelot and Montfaucon.

The first English mention of the Tapestry, as far as I can make out, is to be found in Stukeley's Palaeographia Britannica, ii. 2. An abridgement of Montfaucon's account, by Smart Lethicullier, F.R.S. and F.S.A., is added as an Appendix to Ducarel's Anglo-Norman Antiquities, No. I. But the earliest actual writers of English history who dealt with the age and authority of the Tapestry were two authors who hold such different places in the estimation of the scholar as Lord Lyttelton and David Hume. Lyttelton (Hist. Henry II. i. 353, ed. 1769) came to a conclusion unfavourable to the authority of the Tapestry; but he did not come to it without really reading and thinking about the matter. His main point of objection was the supposed discrepancy between the Tapestry and the narrative of William of Poitiers with regard to the details of the Breton war, an objection perfectly reasonable as far as it goes, and the grounds of which I shall examine elsewhere (see Note X). Assuming, I suppose, that the tradition which ascribed the work to a Matilda must have some groundwork, Lyttelton "judged" that it was made by the orders, not of William's Queen Matilda, but of her granddaughter the Empress.

This "judgement," it should be noticed, was simply Lyttelton's own guess, thrown out on his own responsibility. It is curious to mark the fate of this guess in the hands of Hume. It is due to Hume to say that he seems to have had a clearer notion of the real value of the Tapestry than Lyttelton. Yet in 1762, when he published the first edition of his early history, he knew the Tapestry only as "a very curious and authentic monument *lately discovered*. It is a tapestry, *preserved in the ducal palace at Rouen*, and supposed to have been wrought by orders of *Matilda, wife to the Emperor*. At least it is of very great antiquity." (i, 128).

When this was written, the first discovery of the Tapestry, at least of that part of it of which Hume was speaking, was thirty-eight years old. Still it was in Hume's eyes "lately discovered," because he had never before heard of it. The cathedral at Bayeux and the ducal palace at Rouen were all one to him, just as Milan and Pavia, Guelf and Ghibelin, were all one to him, when (p. 183) he turned Lanfranc into "a Milanese monk." The tradition of Bayeux and the conjecture of Lyttelton are seemingly rolled together in the word "supposed," and one might almost guess that Hume, while writing the reign of Eadward, had not yet learned to distinguish one Matilda from another; it clearly was quite indifferent to him which Emperor it was that either of them married.

But the beginning of any really serious and critical inquiry into the age and author- ity of the Tapestry was reserved for the present century. Attention began to be called to it during the time of the first French Republic. Some curious letters on the subject are printed in Pluquet's "Essai Historique sur la ville de Bayeux", pp. 76–81. It ap- pears that the Tapestry at one time narrowly escaped being cut into shreds to adorn a civic car. It afterwards actually underwent a fate almost as degrading. The elder Buonaparte, then "First Consul," carried it off to Paris, and showed it at the Louvre to stir up his subjects – "citizens" they are still called in the official letters – to another conquest of England. But this kind of folly had at least the advantage of fixing the thoughts of learned men on the Tapestry itself. The first fruits of their studies ap- peared in 1812, in the form of a paper by the Abbé de la Rue, Professor at Caen and Canon of Bayeux, of which an English translation by Mr. Douce is printed in *Archaeo- logia* 17, p. 85. M. de la Rue followed Lyttelton in attributing the Tapestry to the time and the orders of the Empress Matilda. Against the tradition which attributed it to the wife of the Conqueror he brings several arguments. It is nowhere mentioned in the will of Queen Matilda or in any other wills or charters of her age or that of her sons. If it had been placed in the church of Bayeux in Queen Matilda's time, it must have perished in the fire by which that church was destroyed in 1106. Some relics were saved, but no one would have taken the trouble to save the Tapestry. Some points of non-agreement between the accounts in the Tapestry and the *Roman de Rou* show that Wace had never seen the Tapestry. But, as a canon of Bayeux, he could not fail to have seen it, if it had been there in his time. The work again must be later than Queen Matilda's time because the border contains references to the fables of Aesop, which were not known in the West till the time of the Crusades. It is shown moreover to be of English work from the occurrence of the mysterious Ælfgyva. This name he takes to be an English way of describing the Duchess, afterwards Queen, Matilda. Wadard again, whose name he takes to be English, and the word "ceastra" are brought as proofs of English workmanship. Another point on which he strongly insists is that the Normans are called Franci in the Tapestry, which he argues would not have been done by Norman artists. He concludes therefore that the Tapestry was made in England by order of the Empress, at some time between 1162, about which time Wace wrote, and 1167, the year of her own death.

This communication led to several other papers on the subject in *Archaeologia*, and to what was more valuable than all, to the publication of the beautiful and accurate

representation of the Tapestry itself, made for the Society of Antiquaries by Stothard. At vol. 18, p. 359 of *Archaeologia* is a letter written in 1816 by Mr. Hudson Gurney who had seen the Tapestry for himself. He argues in favour of the antiquity attributed to the work by the local tradition. He insists on various points of costume, and on the evident attempt at preserving a likeness in the figures, especially in that of William. He concludes that it was made for Queen Matilda by English work-women. The nineteenth volume of *Archaeologia* contains three papers on the Tapestry or on subjects connected with it. The first by Mr. Amyot, at p. 88, does not deal with the question of the age of the Tapestry itself, but only with the evidence which it gives as to the cause of Harold's voyage to Normandy. The second, at p. 184, is a powerful argument by Stothard in favour of the antiquity of the Tapestry, but in which he does not commit himself to any connexion with Queen Matilda. Stothard was the first to see that the one proposition did not involve the other. He enlarges on the costumes as belonging to the eleventh century and not to the twelfth, and on the utter improbability that any mediaeval artist of a later age should attend to anti-quarian accuracy in these matters. He remarks also on the obscure persons repre-sented on the Norman side, Turold, Vital, and Wadard, as distinct proof that the Tapesty was a contemporary Norman work [see Ch. 1 above].

In the hands of Stothard the subject had for the first time fallen into hands really capable of dealing with it as it deserved. But Stothard is well followed up in a second paper by Mr. Amyot at p. 192 of the same volume, in which he disposes of most of the arguments of M. de la Rue against the antiquity of the Tapestry. He still however seems to think that, if it were a contemporary monument, it must have been the work of Queen Matilda, or wrought by her order. Mr. Amyot also points out that Wadard is not only, as Stothard had seen, a proper name, but that it is the name of a real man who appears in Domesday, and also that Wadard, Turold, and Vital were all tenants of Odo. Mr. Amyot very truly says that "Franci" was the only name which could rightly express the whole of William's mingled army, and that "Franci" and "Francigenae" are the words constantly opposed to "Angli" in docu-ments of the age of the Conqueror and much later.

In 1824 M. de la Rue republished at Caen his essay from *Archaeologia* with an Appendix containing at attempt at a refutation of Stothard and Amyot. He was again briefly answered by another Norman antiquary, M. Pluquet, in his *Essai historique sur la ville de Bayeux* (Caen, 1829). Pluquet was the first distinctly to assert that the work had nothing to do with either Matilda, but that it was made by order of Bishop Odo (p. 82). In 1840 Mr. Bolton Corney put forth a tract, in which he attempted to show that the Tapestry was made by the Chapter of Bayeux after the French conquest of Normandy. He argues that, during the union of England and Normandy, the *conquest* of England, which William took such pains to disguise under the semblance of legal right, would not be thus ostentatiously set forth in Normandy. Some learned person, he holds, was employed to keep the costume right, a degree of antiquarian care for which it would be hard to find a parallel in the middle ages.

Thierry reprinted Lancelot's account as a note at the end of his first volume (p. 353, ed. 1840), adding two notes of his own. In the first he accepts the Tapestry

as a contemporary work, designed for the ornament of the church of Bayeux, and quotes M. de la Rue as attributing the work to the Empress Matilda. In the second he quotes him as attributing it, neither to William's Queen Matilda nor to Matilda the Empress, but to Eadgyth-Matilda, the wife of Henry the First. I do not know whether this was a confusion of Thierry's, or whether De la Rue ever came to change his opinion. At any rate Thierry successively accepts these two distinct theories as highly probable, and sees in one or other of them the explanation of the alleged English words and forms which are found in several places of the Tapestry.

Dr. Lingard (Hist. of England, i. 547, ed. 1849) gives a note to the subject, for the substance of which he professes to be indebted to Mr. Bolton Corney. But he does not commit himself to the more grotesque parts of Mr. Corney's theory. He altogether rejects the supposed connexion between the Tapestry and any of the Matildas. He holds that it was made as a decoration for the church of Bayeux, and that it was designed to commemorate the share which the men of Bayeux bore in the Conquest of England. This he infers from the prominence given to Odo, and from the appearance of his retainers, Turold, Vital, and Wadard. Rather than attribute the work to Matilda, he inclines to believe that the Tapestry was due to the personal vanity of some of these men, or of their descendants.

I can hardly be expected to take any serious notice of some amusing remarks on the Tapestry made by Miss Agnes Strickland (*Queens of England*, i. 65, 66), who recommends "the lords of the creation" "to leave the question of the Bayeux Tapestry to the decision of the ladies, to whose province it belongs". According to Miss Strickland, the Tapestry was "in part at least designed for Matilda by Turold, a dwarf artist." Miss Strickland speaks of a Norman tradition to that effect, but perhaps even a "lord of the creation" may venture to ask where that Norman tradition is to be found.

I come back into the every-day world in company with Dr. Collingwood Bruce, who read a paper on the Tapestry before the Archaeological Institute at Chichester in 1853, which afterwards grew into a volume called *The Bayeux Tapestry Elucidated* (London, 1856). Dr. Bruce follows Stothard in the argument for the early date of the Tapestry, drawn from the correctness of the costume. He argues further on the same side from the manifest object of the Tapestry, namely to set forth the right of William to the English Crown. He cleaves in a somewhat unreasoning way to the tradition which attributes the work to the first Matilda, but he fully grasps the manifest connexion of the Tapestry with Bayeux and its church. He even goes so far as to attribute the two or three seemingly English forms which are found in the legends of the Tapestry to the common use of the Teutonic language in the Bessin, which he supposes, without any authority that I know of, to have lasted as late as the reign of William. Dr. Bruce however thinks that the designer of the Tapestry, as distinguished from those who wrought it in the stitch-work, was an Italian.

Sir Francis Palgrave, in the posthumous part of his work (iii. 254), has an incidental reference to the Tapestry, in which he takes for granted that it is the work of Queen Matilda, without any hint that any question has ever been raised about the matter.

Lastly, Mr. Planché published a paper "On the Bayeux Tapestry" in the *Journal of the British Archaeological Association* for June, 1867 (p. 134). Mr Planché follows M. Pluquet, and gives a good summary of his arguments; he then goes minutely through the Tapestry, giving his views at each stage, to some of which I shall have to refer again. "The report," he says, "mentioned by Montfaucon that it was the work of Queen Matilda and her handmaids, originated probably in the suggestion of some antiquary of the sixteenth or seventeenth century repeated till it assumed the consistency of fact."

I now go on to give my own reasons for accepting the early date of the Tapestry. The arguments of Stothard drawn from the accurate representation of the costume of the eleventh century seem to me unanswerable. Dr. Bruce adds a good instance of his own in a comparison of the Tapestry with a passage in the *Roman de Rou*. Wace (v. 12628) speaks of the horse of William Fitz-Osbern as "all covered with iron" (see below, Note NN, and Taylor's note, p. 162), whereas in the Tapestry "not a single horse is equipped in steel armour; and if we refer to the authors who lived at that period we shall find that not one of them mentions any defensive covering for the horse."

Mr. Amyot's arguments with regard to Wadard, Vital, and Turold seem to me distinctly to prove that the work was a contemporary one, and one made for Bishop Odo and the church of Bayeux. As Dr. Lingard says, it is quite inconceivable that these persons, who are of no importance in the general history, whose reputation must have been purely local, should have received such prominence in any but a purely local work. The only persons on the Norman side who appear by name in the representation of the landing and of the battle are the Duke and his two brothers, Count Eustace of Boulogne, and these three obscure retainers of Bishop Odo. We see them here in the Tapestry, and the industry of Mr. Amyot and Dr. Lingard traced them out in Domesday, but no other mention survives of them. Ralph, the son of Turold, Vital, Wadard "homo episcopi," are all to be seen in Domesday, 1, 6, 7, 8, 8a, 9, 10, 32, 77, 155b, 238b, 342b, and in every case their land is held of Bishop Odo. It is plain that, in the mind of the designer of the Tapestry, the Bishop of Bayeux and his favourite followers came next after Duke William himself. This fact seems to me to be equally decisive in favour of its being a contemporary work and against it being a work of Matilda.

Here, I think, is abundant evidence both to establish the contemporary date, and to show the object of the work. It was plainly a gift from Odo to his own newly-built church. But it is quite possible that the work was done in England. The evidence is certainly very slight. I believe it is wholly contained in the words "at Hastinga-ceastra". I cannot think that "at" for "ad" proves anything, but the form "ceastra" goes a good way to prove that the work was English. The notion of Dr. Bruce and Mr. Planché that these forms are not English but Saxon of Bayeux seems very fanciful. Besides, the form "ceaster" is one which is not Nether-Dutch in a wide sense, but distinctly and locally English. I know of no instance where it is to be found in the Bessin, or indeed anywhere out of England.

Most of the objections made to the early date of the Tapestry are well disposed

of by M. Pluquet and Mr. Planché; but to one of their arguments I must demur. M. de la Rue objected that the borders contain scenes from Aesop's Fables, which he says were not known in the West till afterwards. Mr. Planché, oddly enough, quotes (p. 136) Freculf, Bishop of Lisieux, who, he tells us, "lived in the eleventh century," as saying that Eadward caused the Fables of Aesop to be translated into English. He goes on with a reference to the false Ingulf, which I need not discuss. As for Freculf, who died somewhere about the year 853, if he said anything at all about our Eadward, he must have enjoyed a prophetic power rivalling that of the saint himself. But it is well known that Mary of France, the poetess of the [twelfth] century, professes to have made her French version of the Fables from an English version made by an English King. For the author of that version we have, strangely enough, to choose between Alfred and Henry the First. (See this matter discussed in the Appendix to vol. iv.) If Alfred be the right reading, there is no doubt of the early knowledge of the Fables in England. If Henry be the right reading, we may be sure that whatever Henry translated was done into English early in life, and Henry was born about the time when the Tapestry must have been making.

For my own part I should reverse the argument. I have that confidence in the Tapestry that I accept the figures wrought in its border as proof that the Fables were known in Normandy and England in the eleventh century.

The external evidence then seems to be complete. The work must be a contemporary one; there is no reason to connect it with Matilda; there is every reason to connect it with Odo. It was probably, but I cannot say certainly, made in England. I now turn to that branch of the question which to me is yet more interesting, the internal evidence for looking on the Tapestry as I look on it, as a primary authority for the subject of the present volume, as in fact the highest authority on the Norman side.

I ground this belief on the way in which the story is told. It is told from the Norman point of view, but it is told with hardly any of the inventions, exaggerations, and insinuations of the other Norman authorities. In fact the material has a certain advantage. Stitch-work must tell its tale simply and straightforwardly; it cannot lose itself in the rhetoric of Eadward's Biographer or in the invective of William of Poitiers. And the tale which the Tapestry tells us comes infinitely nearer to the genuine English story than it does even to the narrative of the Conqueror's laureate. To the later romances, the tales for instance of Eadward's French Biographer, it gives no countenance whatsoever. With regard to the great controversial points, those which I shall go through in detail in future Notes, the Tapestry nearly always agrees with the authentic account. There is not a word or a stitch which at all countenances any of the calumnious tales which were afterwards current. In the Tapestry the bequest of Eadward to Harold, his orderly acceptance of the Crown, his ecclesiastical coronation, all appear as plainly as they do in the narrative of Florence. The only point of diversity is that the Tapestry seems to represent Stigand, and not Ealdred, as the consecrator. Now there was no absolute necessity for a partizan of William to deny the facts of the case. William's argument was rather to assert the invalidity of the bequest, the election, and the coronation, than to deny that the acts themselves

had taken place. And accordingly, in the earlier Norman writers, most of the facts are admitted in a kind of way. It is not till long afterwards that we find the full development of those strange fables which, in so many modern histories, have supplanted the truth. Had the Tapestry been a work of late date, it is hardly possible that it could have given the simple and truthful account of these matters which it does give. A work of the twelfth or thirteenth century would have brought in, as even honest Wace does in some degree, the notions of the twelfth or the thirteenth century. One cannot conceive an artist of the time of Henry the Second, still less an artist later than the French conquest of Normandy, agreeing so remarkably with the authentic writings of the eleventh century. The truth was in those days almost wholly forgotten, and no one would have been likely to represent the story with any accuracy.

But though the Tapestry perverts the story less than any other Norman account, it is still essentially a Norman account. The main object of the work is plainly to set forth the right of William to the English Crown. This was of course the great object of William himself and of his contemporary partizans. But it was not an object which greatly occupied men's minds in the days of Henry the Second or later. The writers of that time, as I shall presently show, are as bitter, perhaps more bitter, against Harold than the Norman writers of his own time; but their bitterness comes from a different source. Under the Angevin dynasty, sprung, as it was, in a roundabout way from Old-English royalty, men were beginning to look on Harold and William as alike usurpers. We now begin to hear of strict hereditary right and of the exclusion of the lawful heir. Henry the Second encouraged his panegyrists to set forth his lawful descent from ancient English Kings, without any reference whatever to his descent from the Norman invader. It was only in the female line that Henry was either Norman or English; in his real ancestry, in his real feelings and character, he was as little of one as of the other. It is most unlikely that any one should have wrought, in the days of Henry or for Henry's mother, a work which throughout breathes the spirit of the earliest days of the Conquest.

In like manner, the representation of William's landing and of the great battle could have come only from the hand of a contemporary. The mere fulness of detail, the evident delight with which the artist dwells on all the little incidents of the campaign, point it out as the work of one in whose memory they all still lived. The notices of insignificant people, like Turold, Wadard, and Vital, while they point to the place for which the Tapestry was designed, point also to a time when these retainers of Bishop Odo were still living. In the days of the Empress Matilda their fame is not likely to have been great, even at Bayeux. So again every antiquarian detail is accurate; the nose-pieces, the lack of armour on the horses, the care taken to represent every man bearded, moustached, or close-shaven, according to his age and nation (see vol. ii, p. 27) all bespeak the work of a contemporary artist. The idea of Mr. Corney that the Chapter of Bayeux in the thirteenth century would specially orders its artists to attend to such points is ludicrous beyond measure, and it had been disposed of beforehand in the masterly argument of Stothard. But the Tapestry is equally accurate in greater matters. The English army is an English army of

the eleventh century and nothing else. The two classes of warriors, the here and fyrd, the housecarls in their coats of mail with their great axes, the peasantry armed almost anyhow, are nowhere more clearly marked. The utter absence of horses, except as a means, as in the days of Brihtnoth (see vol. i. pp. 269, 272), for reaching or leaving the field – the King himself fighting on foot – the ensign of the West-Saxon Dragon – all these are touches from a contemporary hand, which it is utterly inconceivable that any artist working a hundred and fifty years later could have thought of. It is worth while to mark the remarkable contrast between the Battle of Senlac [Hastings] as represented in the Tapestry, and the Battle of Stamfordbridge as described by Snorro. The contemporary artist represented things as he saw them. The writer of the thirteenth century described as he saw them also; but then they did not see the same things. The Bayeux Tapestry shows Harold's army at Senlac as Harold's army really was. The narrative in the Heimskringla describes Harold's army at Stamfordbridge after the pattern of an army of the thirteenth century.

This precious monument is now well preserved and cared for. After its ridiculous journey to Paris, it came back safe to its Norman home, but it was kept for a while in a way which did not tend much to its preservation. It was wound round a sort of windlass, and was unwound and handled whenever anybody looked at it. It is now in much better keeping. It is kept under glass in the public library at Bayeux, where it is stretched out round the room at a convenient height, where it may be studied with the greatest ease. I have there examined it three times, once in 1861, and twice in 1867, and I may say that, fully to take in its value and importance, it should be seen. Stothard's reduction is admirable in every way, and serves for every ordinary purpose of study, but I doubt whether any one thoroughly knows what the Tapestry is till he has seen it with his own eyes. I had myself learned to value the Tapestry long before I saw it, but my examination of it certainly made my confidence in it far stronger and clearer. It is no small matter to spell over the details of the story in the picture itself, and the process reaches its height at the last stage. I think that no one can see the end of the battle, the housecarls every one lying dead in his harness, while the light-armed are taking to flight, some of them on the horses of the fallen, and not feel that he is in the presence of a work traced out by one who had himself seen the scenes which he thus handed down to later ages.

The Ælfgyva of the Bayeux Tapestry

There is no representation in the whole of the Tapestry which is more thoroughly puzzling than the one referred to in the text, with its legend "Ubi unus clericus et Ælfgyva" (pl. 7). Who is the lady, bearing a purely English name, who is thus suddenly brought in, seemingly at the gate of William's palace, with no apparent reference to anything before or after? One would naturally look for the figure of

William's wife or daughter in such a position, rather than for that of any other woman. Harold's promise to marry William's daughter, which is so prominently dwelt upon in every other version of the story, is not once alluded to in the Tapestry, unless this place has reference to it. But how could William's wife or William's daughter be described by the familiar English proper name Ælfgifu? On the other hand, what chance is there that any Englishwoman really bearing the name of Ælfgifu could be present in Duke William's palace at such a moment? And, if any such Ælfgifu really was there, what bearing had her presence on the general course of the story, so as to account for the prominent position thus given to her?

Some of these difficulties naturally struck the very earliest commentators on the Tapestry, and from their days to ours a series of the wildest conjectures have been poured forth with regard to the Ælfgyva in question. The matter is treated by Lancelot (*Mémoires de l'Académie*, viii, 612), by De La Rue and his translator Mr. Douce (*Archaeologia* 17, 100), by Mr. Amyot (*Archaeologia* 191, 199), by De La Rue again in his Appendix of 1824 (*Recherches sur la Tapisserie*, p. 53), by Mr. Bolton Corney (p. 19), by Dr. Bruce (p. 53), and lastly by Mr. Planché (*Journal of the Archaeological Association* 1867, p. 142). The strange thing is that several of these writers seem not to have understood that Ælfgifu is simply a very common English name, but to have fancied that it was a sort of title, meaning queen or princess. Their stumbling-block was the double name of Eadward's mother, "Ælfgifu-Emma," in which formula Lancelot argued that Ælfgifu was equivalent to Hloefdige. Any one who turns to the passages which I have referred to will find a great number of guesses, some of which refute themselves, while others are refuted by other writers in the dispute. "Ælfgyva" has been identified with the Duchess Matilda, with her daughter Adeliza, with Harold's sister Eadgyth and his wife Ealdgyth, while some have taken the trouble to show that she cannot be either Ælfgifu-Emma or "the other Ælfgifu" (see vol. i. p. 714) of Cnut's time. What it is that Ælfgyva and the clerk are doing no one seems to know for certain, neither can I throw any light on the matter. Out of all this mass I will only, by way of relaxation, quote Mr. Bolton Corney's remarks, as at once the most curious and the least generally accessible. "William promised to bestow one of his daughters on Harold. She is represented beneath the inscription AELFGYVA – but Elfgiva was not her name. Emma, daughter of Richard I of Normandy, and mother of Edward the Confessor, is sometimes called by the Saxon annalists *Elfgiva* Emma. *Elfgiva therefore, whatever we read in Florence of Worcester, seems to have been an appellation of honour*, and may have been understood as such by the *Saxons Bayeusains*. If so, why was the name of the betrothed omitted? Could it not be ascertained, or was it deemed superfluous? I apprehend the latter to have been the case; she was the DAME par excellence – she was buried and was annually commemorated at Bayeux."

We may infer then, first, that the Saxon language was spoken at Bayeux in the thirteenth century, the date to which Mr. Corney assigns the Tapestry; secondly, that in the Saxon language of Bayeux *Ælfgyva* meant "Lady"; thirdly, that one particular daughter of William was known, distinctively and familiarly, as "*the* Ælfgyva"; fourthly, that Mr. Bolton Corney understood Old English better than Florence of Worcester.

Now leaving all wild conjectures, let us try and see what really suggests itself about this obscure matter. The Tapestry represents a woman named Ælfgifu as being in Duke William's palace at the moment of Harold's coming thither. Who was she? We may put aside Matilda and all other women who never were, or could have been, called Ælfgifu. We may put aside all those women who were named Ælfgifu, but who were dead and buried at the time. But of all the women named Ælfgifu who were living at the time, which could have been in William's palace at that particular moment? Several guesses have occurred to me at different times. They are mere guesses, of no more value than the guesses of other writers. They are all, I allow, improbable guesses, but I think that they have the advantage over some other guesses of not being absolutely impossible.

1. In my second volume (p. 658) I threw out, half in jest, the suggestion that Ælfgifu, the name assumed by Emma on her marriage with Æthelred, was the name usually assumed by foreign women who married English husbands. Is it possible that there is really something in this? Is it possible that William's daughter, if she had married Harold, would have had to change her name to Ælfgifu? Is it possible that she is here called Ælfgifu proleptically, perhaps sarcastically? This is, I grant, very far-fetched and unlikely, but it is perhaps not absolutely impossible. We should certainly expect the Tapestry to contain some reference to the intended marriage between Harold and William's daughter. We should certainly expect to find William's daughter, rather than any other girl or woman, represented where we find Ælfgifu represented. And here is a way, however far-fetched, in which it is just possible she might be called Ælfgifu.

2. Ælfgifu was (see vol. ii. p. 658) the name of the widow of Ælfgar, the mother of Harold's wife Ealdgyth. According to some accounts, she was of Norman birth. Could she have been living or visiting in Normandy at this time? And can her introduction have any reference to Harold's marriage with her daughter?

3. I have mentioned in my second volume (p. 554) the probability that Harold had a sister of the name of Ælfgifu, and that she must have been the sister whom Harold (Eadmer, p. 5; Sim[eon] Dun[elmensis] 1066) promised, as part of his oath, to give in marriage to one of William's nobles. Is it possible that she was in Normandy at this time? If Harold's voyage really was, as I believe it to have been, a mere yachting excursion, he may very well have been accompanied by his sister as well as by his brother and his nephew. If it should be asked how Ælfgifu came to be in William's palace while her brother was still a captive at Beaurain, it may be answered that even Guy may not have pressed his right of wreck so far as to imprison a woman, and that it is certain that one or more of Harold's party escaped Guy's clutches, if only to carry the news of his imprisonment to William (see above, p. 224). If therefore Harold was accompanied by his sister, it is quite possible she might find her way to Rouen before he did. I throw this out as a mere conjecture, and it certainly has its difficulties about it, but every explanation of this puzzling group must be mere conjecture, and it certainly strikes me that this conjecture has less of difficulty about it than some of the others.

Whomever we fix upon as the Ælfgifu of the Tapestry, it is still by no means clear what is happening between her and the clerk, or why the incident should receive so prominent a place in the pictured story. Like the introduction of Turold, Vital, and Wadard, there is evidently an allusion to some fact which was perfectly well known at the time, but of which no other record has been preserved. As such, it is another witness to the contemporary date, and thereby to the authority, of the Tapestry.

3

The Perjury at Bayeux

W. R. LETHABY

The famous embroidery at Bayeux, besides being an historical document of importance, is also a work of art, and in this aspect I have long studied it. I was lately reminded of it in reading the Itinerary of Henry I, given in recent numbers of the *English Historical Review*, and I venture to put some slight suggestions on record, although I am writing away from books, and even without my notes. From the Itinerary it appears that about 1100 the kings crossed to Normandy from either Portsmouth or Southampton, and stayed at some neighbouring manor before embarking. Now Bosham, which Harold visited immediately before his adventures in Normandy (pl. 2), would have been a perfectly suitable starting point if he had intended to visit Duke William at Rouen, a purpose which has been denied by English chroniclers. Such an intention, however, agrees perfectly with the story as presented on the Tapestry. The drama there begins with Harold and his party riding away after an audience with the feeble old king, Edward (pl. 1). It is the suggestion of the Tapestry in the language of art that Harold departed from King Edward on a mission of state.

The prominence of Bishop Odo in the events depicted on the Tapestry has often been noticed, but all the implications of this and kindred facts have never been drawn out. A principal scene on the Tapestry is that where Harold takes the oath over the shrine of relics in Bayeux Cathedral (pl. 10). A series of subjects well in the centre of the work deals with Harold's part in the Breton campaign, which was the occasion of his presence at Bayeux (pls 8–9). The object of depicting this subject was to amplify the Bayeux episode, to show how well Harold was treated by Duke William, and to make his guilt the plainer. This is the centre of interest in the pictured drama, and the crucial incident is the oath on the relics of Bayeux. Harold's false swearing and what came of it is really the subject matter of the story-design.

It has been a matter for comment that a subject like the Conquest of England should have been selected for the adornment of Bayeux Cathedral, but this great historical event was seen clerically. As treated here it became God's judgement on the oath at Bayeux; and thus it was a sacred subject. The Pope had blessed the punitive expedition: it was a crusade. The prominence of Odo need occasion no surprise, for in this other aspect he was almost the protagonist and Duke William

was but the lay instrument of the judgement of God. Again it has been supposed that the Tapestry is incomplete and that the pictured story would have gone on to show William seated on Edward's throne. Such a completion, however, belonged rather to the other story. It would not have been exactly out of place here, perhaps; but it would be anti-climax to Harold's terrible doom and those stark corpses. The drama falls into two great divisions, the crime and the punishment, and these into minor parts such as: Harold's embassy from King Edward (pl. 1); the visit to Bayeux and the oath on the Relics (pl. 10); the sign of God's anger by the comet (pl. 14) and William's preparations (pls 15–16); the battle (pls 20–5), the pope's banner and Harold's dreadful end (pl. 26). The banner with the cross seems to have remained the standard of the Norman kings until the lions were assumed.

The embroidery was a hanging brought out for the cathedral festivals, especially the feast of Relics. It showed how their sanctity had been vindicated by speedy judgement, and was a warning against any perjury like in kind, however different in degree. The psychological background from which the treatment of the story was projected thus becomes plain. The scheme of subjects was doubtless suggested by Odo himself or under his immediate directions.

The artistic design and workmanship are English, and, I have no doubt, Winchester work. Winchester at the time of the Conquest was the centre of a great school of art which had been fostered and indeed re-founded by one who should be our national hero – the strong and wise Englishman Alfred. It was famous for painted books, goldsmiths' work and embroidery. It is said that Queen Matilda, in her will, bequeathed certain vestments, the work of an embroiderer of Winchester. Possibly he was the chief artist concerned in the working of the Bayeux embroidery.

4

An Attempt to Identify Some Unknown Characters in the Bayeux Tapestry

CHARLES PRENTOUT

After two hundred years during which historians and archaeologists have been commenting on the work, one might be tempted to apply to the Bayeux Tapestry (which, as is well known, it would be more accurate to term an embroidery) the words of La Bruyère: that everything on the subject has already been said. I have previously reiterated, in the *Revue des cours et conférences*, all the arguments mounted by Messrs Prou, Muntz, Lanore and Paris against M. Marignan's attempt to redate the work, and I have added a few arguments of my own. Subsequently, in a paper to the Académie des arts, sciences et belles-lettres of Caen in July 1924 (which has come out in vol. IV of the new series of its *Mémoires*) I have tried to solve one of the riddles posed by the scene in the Tapestry entitled 'Ælfgiva and a cleric' (pl. 7). I have also related everything that my visits to Scandinavian museums revealed, particularly in the field of maritime archaeology. These visits (undertaken in the course of a lecture tour on the subject of the Tapestry to all three countries) brought to light points of comparison between William's fleet and Viking ships (in so far as the latter are known from the boats exhibited at Oslo and the objects gathered in the museums of Copenhagen, Viborg and Stockholm).

I, for my part, believe that the general archaeological discussion can be closed, though one might still be able to glean new facts, and possibly draw new conclusions from detailed examination of the material. To use the well-chosen words of Stothard, an English copyist of the Tapestry (words which the French commentator Delauney employed as an epigram),[1] 'painters of old painted what they saw'. Now, as has been shown, the draughtsmen of the Tapestry have laid before our eyes the civil and military costume, the horse trappings, the knights' weaponry, and the military and religious architecture of the eleventh century. Consequently, the Tapestry presents an incontestible archaeological reality, a reality which dates from the eleventh century itself. Yet if archaeological examination leads us to believe that the Tapestry is a contemporary memorial of the Conquest, we have yet to evaluate its historical value as a pictorial narrative of the events of 1066. This issue raises

1 *Origine de la Tapisserie de Bayeux prouvée par elle-même* (Caen, 1824) (cf. Ch. 1 above).

another, namely the problem of its author – or, to be more precise, whether the inspiration behind the work was English or Norman.

With the problem of its date resolved and the Tapestry once again accepted as a document of the eleventh century and contemporary with the Conquest, let us tackle the problem of its origin. This falls into two parts: the workmanship, and the patronage. With regard to the question of the workmanship, we have summarised all the evidence which indicates that it was Anglo-Saxon in the *Revue des cours et conférences*, for the 15th April, and the 15th and 31st May. The evidence has already led us (like many other commentators before us) to the wholly plausible hypothesis that the person who commissioned the Tapestry was the Bishop of Bayeux, Odo, the half-brother of William the Conqueror. Given that Odo was the Earl of Kent after the Conquest, he could easily have had a workshop of Anglo-Saxon craftsmen or embroiderers at his disposal. Furthermore, does not the fact that Odo was represented five [*sic (recte:* four)] times in the Tapestry point to him as its patron? On three of these occasions he is named 'Odo'; in the others – namely at the meal he blesses (pl. 18), and in the council that precedes the Battle of Hastings – he is designated by the abbreviation *EPS* (*episcopus*), i.e. bishop. This is highly significant. At Bayeux, where the Tapestry was to have been exhibited, everyone would have known that it was their bishop who was thus designated. There is more. In the course of that battle, Odo is shown in action, rallying his troops: he has not forgotten his knights – *Odo confortat pueros* (pl. 24).

For a while now attention has been directed to the presence in the Tapestry of figures of secondary rank, unmentioned in contemporary Latin, Anglo-Saxon and Norman sources, who appear alongside the principal figures of the three kings (Edward, Harold and William) and the counts (Eustace of Boulogne, William's lieutenant (pl. 25), and Gyrth and Leofwine, Harold's brothers (pl. 22)). Their presence, it has been said,[2] also provides strong grounds for dating the Tapestry to the generation of the Conquest itself, since who in the twelfth century would have cared about four obscure figures, Ælfgiva, Turold, Vital and Wadard, who are unattested even in eleventh-century sources? Identifying such figures ought also to reveal the milieu from which the Tapestry came and in which it was conceived.

Ælfgiva

The difficulty of establishing the identity of the first two figures, Ælfgiva and Turold, arises from the circumstance that there are a number of possible candidates. In the case of Ælfgiva, the following suggestions have been made.

1 Ælfgiva-Emma, the sister of Richard II of Normandy, who was the wife of Ethelred, king of England *c*.1000, and subsequently married his conqueror, the Danish king Cnut. Some scholars have wanted to see in the scene entitled *Ælfgiva et unus clericus* (pl. 7) an allusion to the affair which the lady had late in life with the

2 Steenstrup, *Die Bayeux Tapestry* (Copenhagen), and other commentators.

Bishop of Worcester. However she died in 1051,[3] some fifteen years before the creation of the Bayeux Tapestry.

2 Ælfgiva of Northampton, Cnut's concubine.[4]

3 One commentator on the Tapestry, Fowke, imagined that Ælfgiva was Harold's sister who was abducted by a Breton prince. The sole aim of the Brittany campaign was to recapture her, and that is why Harold accompanied William on it.[5] Fowke bases this identification upon its parallels with a suggestive scene in the border below Ælfgiva. This hypothesis, which is accepted and repeated by an American scholar, Loomis,[6] is pure fantasy. William of Poitiers, the only source besides the Tapestry to relate the expedition to Brittany, gives a range of other reasons for it and makes no allusion to Harold's sister. As for the scene shown in the lower border, I have given an explanation for it elsewhere: it represents an Anglo-Saxon wardance of the sort described by the *De gestis Herewardi comitis*,[7] a contemporary Anglo-Saxon source [compiled in the twelfth century]. With regard to the meaning of the cleric's gesture towards Ælfgiva, contemporary Norman charters enable us to explain it. The image we have before our eyes is not the Bishop of Worcester caressing the cheek of Ælfgiva-Emma, but rather one of the bishop of Bayeux's clerics striking the Abbess Ælfgiva. Why? Contemporary charters, and in particular those of the abbeys of Préaux and La Trinité-du-Mont at Rouen, provide an explanation by analogy. In Normandy at this time one struck someone to encourage them to commit a momentous occurrence to memory. After placing a donation charter on the altar of an abbey, one struck a young child so that he would commit the event to memory.[8] So, at the moment of William's departure for his Breton campaign, which culminated

3 *The Anglo-Saxon Chronicle*, ed. Thorpe (Rolls Series), I, p. 317; II, p. 150.

4 On whom see also *Anglo-Saxon Chronicle*, I, p. 292, 293; II, 129. She was Harthacnut's mother. She was expelled from England in 1037 and took refuge in Bruges, where she received a warm reception from Count Baldwin of Flanders. It is not impossible that from there, like other Anglo-Saxon refugees such as Tostig, Harold's brother, she reached Normandy in the retinue of Matilda, Baldwin's daughter, who became Duchess of Normandy *c.* 1050, or even with Tostig himself on the eve of the Conquest.

5 *The Bayeux Tapestry* (London, 1913), p. 56.

6 It is, he says, a scandal ('The origin and Date of the Bayeux Embroidery', *Art Bulletin* 6/1, p. 5).

7 As I said in the *Revue des cours et conférences* 31 May 1922, p. 306, n. 1: 'Certain of the risqué scenes in the lower border of the Tapestry seem to represent soldiers dancing, imitating a kind of Pyrrhic dance. They are beating their axes on their shields. This could be a copy of an Antique model since the Ancients were familiar with such dances; however one reads about such a thing in the *De Gestis Herewardi Saxonis*, a legendary work written in the twelfth century at the Abbey of Crowland to celebrate Hereward, the Anglo-Saxon leader. Here one sees the hero happening upon an orgy where the Norman warriors and their companions are drunk. A jongleur walks around singing and mocking the English and *incompositos quasi angligeros fingens saltus*. The Normans evidently attributed dances of this sort to the Anglo-Saxons, hence their inclusion in the Tapestry. I do not believe that anyone has hitherto given an explanation for these dances, these orgiastic scenes. Indeed Lambert, a local archaeologist, was even accused of having devised them during a restoration of the Tapestry!

8 At the beginning of the Cartulary of Préaux, in the foundation charter printed in volume 11 of *Gallia Christiana* there are two examples in succession. We note here the presence of three sons of Onfroy de Vieilles, the founder of the abbey. One of them, William, *qui etiam a patre ob causam memoriae colaphuo suscepit. Suscepit etiam colaphun Ricardus de Lillebona*. He asked why. He was told: so that

in Harold's oath on the relics of Bayeux – the central scene of the Tapestry, and the justification for the Conquest of England – a cleric invites Ælfgiva to note all the details of the events which she was to reproduce on the linen.

4 Other identifications have also been proposed. Ælfgiva (who is actually meant to be Matilda), whom a cleric approaches in order to inform her of the marriage agreement which William has just concluded with Harold for one of his daughters.[9] But it is difficult to understand why the Tapestry should have substituted the name Ælfgiva for that of Matilda!

Other writers have said that Ælfgiva could be one of William and Matilda's daughters – the one who was to have been betrothed to Harold. (All the contemporary Norman sources allude to this planned marriage.) Orderic Vitalis has given us the name of the woman who was to be betrothed to the handsome Englishman: it was Agatha. Agatha was supposedly so deeply in love with Harold that after the Conquest and his death, she died of a broken heart rather than marry the King of Spain (to whom her father had subsequently promised her).[10] One of William's daughters did undoubtedly marry a king of Spain.[11] However – and this is a weighty argument against the proposed identification – none of the Duke of Normandy's daughters was called Ælfgiva. Orderic Vitalis has given us their names: Agatha, Adelize, Constance, Adela and Cecile.[12] As the girls were born between 1053[13] and ?1066, they could only have been the subject of promises of marriage in 1064 or 1065, the probable dates of Harold's stay in Normandy. The commentators who favoured this hypothesis (one, incidentally, which is not founded on any text) were obliged to suppose that the daughter in question had had to adopt the name Ælfgiva when going to be queen of England, as had previously been the case with her great aunt Emma when she had married King Ethelred.[14] But Orderic Vitalis's text, which talks of the engagement of Agatha and Harold, makes no allusion to the Tapestry. Finally and most important, this whole story of an intended marriage between Harold and one of William's daughters runs up against a practical difficulty: at the time of his arrival in Normandy, Harold was married! He was married to Edith, daughter of Count Ælfgar, the sister of the Anglo-Saxon Counts Edwin and Morcar, and the widow of Griffith, king of the Welsh.[15]

you remember. I advanced this conjecture in 1922. Since then I have had the pleasure of noting that it had been suggested by Paulin Paris in a lecture delivered to the formal session of the Antiquaries of Normandy on 21 December, 1869.

9 Smart Le Thieullier, *Description de la Tapisserie conservée à la cathédrale de Bayeux*, trans. Léchuadé d'Anisy (Caen, 1824), p. 29.

10 *Porro Agatha regis filia, quae prius fuerat Heraldo desponsata, postmodum Amfurnis regi Galliciae, per preces petenti, missa est desponsanda.*

11 *Ibid.*, II, p. 391.

12 *Ibid.*, III, p. 159.

13 On the marriage of William and Matilda see H. Prentout, 'Le mariage de Guillaume' in *Études sur quelques points de l'histoire de Guillaume le Conquérant*, Mémoires de l'Académie des sciences, arts et belles-lettres de Caen, n.s. 6 (1931), 28–57.

14 Freeman, *Norman Conquest*, III, p. 698.

15 Orderic Vitalis, II, p. 119 with n. 3.

Now, could this Edith, who Orderic Vitalis calls Edgiva, be Ælfgiva? Might not Edgiva, Harold's widow, have rallied to William's side during the course of his march on London,[16] at the same time as her brother and Archbishop Stigand did? And might not the Duke of Normandy, who worked to create his own Anglo-Saxon faction in England, have given her an abbey, and commissioned her to make the Tapestry which was to tell the story of Harold's oath and the Norman Conquest?

This hypothesis would not contradict, and could possibly even reinforce, another theory on the subject of Ælfgiva which I advanced several years ago. Ælfgiva might be the Abbess of Barking whom William appointed when he was in that hamlet, hunting for relaxation, after the disrupted festivities of his coronation on 25 December 1066:[17] *Willelmus Dei gratia rex omnibus ubique fidelibus salutem. Hiis literis omnibus notum facio quod ego A. abbattissa, pacem et amorem meum concedo, et omnes leges suas in ciuitate et extra ciuitatem, sicut unquam eas melius habuit in alia abbatissa in isto monasterio Sancte Marie in tempore Edwardi regis…*[18] [William, king by the grace of God, sends greetings to all his faithful followers everywhere. I hereby make it known to all that I grant my peace and my love to Abbess A., and I grant her all her rights within and without the town to the full extent that the previous abbess of that monastery of St Mary had them in the time of Edward the Confessor…].

'A' could be Ælfgiva. She might have received the abbey of Barking in recompense for her support; and she might have offered proof of her pro-Norman sentiments by undertaking to make the Tapestry. We know, moreover, that the Anglo-Saxons were famous embroiderers.[19]

Turold

Ælfgiva is drawn to our attention in the Tapestry by an inscription and by the portico which frames her. Another figure is highlighted in the work in the same way – an inscription and a cartouche – namely Turold (*Turoldus*: pl. 5).[20] Needless to say, various identifications have been proposed for this Turold.

1 Turold of Brémoy who was the bishop of Bayeux in the twelfth century. A German scholar, Tavernier, proposed that he was the author both of the Bayeux Tapestry and of the *Chanson de Roland*.[21]

16 *Idem.*, p. 155.
17 *Mémoires de l'Académie de Caen* n.s. 4, p. 68.
18 Davis, *Regesta regum Anglo-Normannorum 1066–1154* I: *Regesta Willelmi conquestoris* (Oxford, 1913), p. 129, appendix XXXIX, calendar no. 240.
19 William of Poitiers, *Gesta Willelmi ducis Normannorum*, ed. Giles (London, 1845), p. 155: *Anglicae nationis feminae multum acu et auri textura egregie viri in omni valent artificio.* This text makes the hypothesis of Anglo-Saxon workmanship all the more plausible. It also provides a rejoinder to the objection which can be made in the name of modesty against it having been made by women in a convent. There were in England two kinds of Anglo-Saxon religious houses, male and female. It was perhaps an atelier of men who rendered the suggestive scenes in the border.
20 Ed. Fowke, pl. XI.
21 Wilhelm Tavernier, *Zur Vorgeschichte des altfranzösischen Rolandsliedes*, Romanische Studien V (Berlin, 1903).

2 Another possibility is the Turold who became abbot of Peterborough after the Conquest. The *Anglo-Saxon Chronicle* shows this man as a tough warrior who was extremely harsh on his Anglo-Saxon monks: he brought Norman knights into the abbey to deal with the monastic clergy who formed the core of the native resistance.[22]

I have already noted another identification which is quite compelling. A charter of the abbey of La Trinité-du-Mont, dating from 1053, is signed by a certain *Turoldus hostarius*.[23] Now it is in precisely this role, as a porter, that Turold is depicted in the Tapestry. He is shown at the palace gate holding the horses of Guy of Ponthieu's envoys (and this clearly implies that he could have known every detail of Harold's journey after his landing in France). Whoever this Turold might have been, there is a noticeable parallel between his circumstances and Ælfgiva's. She received the abbey of Barking at the end of William's march around London; he had received lands from Odo, bishop of Bayeux.[24]

I am now going to introduce another Turold, thanks to a document which has hitherto escaped the notice of commentators. I am going to show the man in association with two characters who no one has previously tried to identify, namely Vital and Wadard. I extracted the document in question from the cartulary of Préaux. This has never been edited, though Auguste Le Prévost has presented interesting excerpts from it in his *Notes et documents pour servir au département de l'Eure*.[25] The passages on which my work is based remain unpublished. They concern Vital, Wadard and, above all, Turold.

Vital, Wadard

If there have been errors and hesitations over the various identifications that are possible for Ælfgiva and Turold (the two people who the Tapestry itself strives to pinpoint as its authors) the same cannot be said of Vital and Wadard. Both men play their part in the work before the Battle of Hastings: Wadard seems to be supervising the requisitioning of supplies, while Vital is the first person to alert William to Harold's army in the distance.

One of the earliest commentators on the Tapestry, Ducarel, limited his comments on Wadard to the following: 'One sees a man on horseback, clad in a mail coat, bearing a long pointed shield on his left arm, with a baton or lance in his right hand.' The mounted warrior must have been well known to the army since the

22 I have offered some cautious reflections on this identification in *Revue des cours et conférences* (as in n. 7 above), noting that the name Turold (which is still represented in Normandy today in the form Thouroude) is very common in the texts of this period. I abandon it here for another Turold, as will become apparent in due course.

23 The cartulary is published following that of St Bertin.

24 Domesday Book shows that in 1086 a certain Turold was the vassal of Odo, earl of Kent for some places in Norfolk. It is notable that the Abbey of Barking, like Turold of Rochester, had some lands in Essex. Both were tenants of the Bishop of Bayeux.

25 3 vols (Évreux, 1862–78).

Tapestry refers to him alone by name (*Hic est Wadardus*).[26] His demeanour seems to indicate that he had overall responsibility for the provisions, and he perhaps held the office of chief steward or quartermaster of the army.

As for Vital, Ducarel had this to say: 'Next we see William going to meet a knight who gallops towards him, and whom he had perhaps dispatched to reconnoitre the countryside, to get news of Harold's army. With a gesture, this knight shows William that Harold is only a short distance away. The inscription names the man as Vital, a fact which encourages us to believe that he was a distinguished figure who was well known, despite the fact that no historical source mentions him.' The inscription runs: *Hic Willelmus dux interrogat Vital si vidisset exercitum Haroldi.*

Another commentator, Delauney, is even more laconic. On the subject of Wadard he restricts himself to the statement: 'History does not speak of this person';[27] while on Vital he is silent.

The abbé de la Rue who has expatiated at such great length about Ælfgiva (which he has interpreted as a title equivalent to Duchess) adds, 'A second title used in the inscriptions is that of "Wadard"'. It designates a man armed from head to toe and stationed as a sentry beside three structures which may be houses or warehouses erected next to the place where Duke William had his first meal after disembarkation. The word is neither Latin, nor French. Lancelot presumes that it is the name of the seneschal or steward; however at that time William FitzOsbern was Duke William's seneschal. Wadard seems to me, therefore, to be the sentry appointed to guard the possessions of the army which had just disembarked. Moreover this is a Saxon name, and it provides further proof that the authors of the Tapestry were Anglo-Saxons.'[28] The learned scholar has, it must be added, been inconsistent about the identification of Wadard: sometimes he is keen to regard it as a proper name; at other times he sees it as the title of an office – it is the equivalent of *warder*, i.e. the man who looks after the baggage.[29]

Lancelot and Hudson Gurney saw Wadard as Duke William's seneschal.[30] In the Bayeux Tapestry he does indeed seem to be occupied with the provisions and supplies. However, in 1066 the Duke's seneschal was William FitzOsbern, as all the sources including charter subscriptions attest. Freeman suggested that Wadard was the envoy of Robert Wimare, a Norman who was established in England before the Conquest and is named by William of Poitiers.[31] Another commentator, interpreting the scene in the Tapestry in a different way, sees Wadard himself as a Norman established in England before the Conquest who is here coming to help his countrymen.[32]

26 *Antiquités anglo-normandes*, trans. Léchaudé d'Anisy (Caen, 1824), p. 378.
27 *Origine de la Tapisserie de Bayeux*, p. 78.
28 *Sur la Tapisserie de Bayeux*, Nouveau essais historique sur Caen, 2 vols (Caen, 1842), II, pp. 185–292.
29 *Ibid.*
30 Freeman, *Norman Conquest*, III, p. 413.
31 *Gesta Willelmi ducis*, ed. Giles, p. 128.
32 *Journal of the British Archaeological Association* 23, p. 149.

What has been certain for a long time is that Vital and Wadard were established in England after the Conquest and that there, like the abbess of Barking, they were vassals of the Bishop of Bayeux who was also the Earl of Kent.[33] We may also note that a son of Turold appears in Domesday Book (and therefore around 1086) holding an estate at Berdestaple from the Bishop of Bayeux, and another at Wicford.[34]

Thus after the Conquest the four unknown figures in the Tapestry are all vassals of Odo, bishop of Bayeux, who is universally credited with having been its patron.[35] What I want to do now is to demonstrate that Turold, Vital and Wadard were already connected with the bishop of Bayeux before the Conquest.

The geographical centre of Normandy has always been the valley of the River Risle. This was William's power base before the Conquest. William remained in the Risle Valley for three years while besieging Guy of Bourgogne in his town of Brionne. It was also in the Risle Valley that Herluin had recently established the abbey of Bec, where Lanfranc taught. Lanfranc met William during the siege of Brionne and went on to become his advisor in the great religious affair of the time (the trial of his adversary the heresiarch Berengar), subsequently serving as the Duke's adviser in a matter which affected William more intimately, namely his marriage to Matilda. The abbey of Grestain was also founded in this valley during the same period by another Herluin, known as Herluin de Conteville, who married Arlette, the mother of William the Conqueror. Grestain was the neighbour of Saint-Pierre de Préaux, a foundation of greater antiquity. It was while studying the cartulary of this latter abbey (obligingly put at my disposal in the University Library by the kindness of the archivist of l'Eure) that I found three *acta* which are of supreme interest for identifying Wadard and Vital.

At some point in Duke William's reign between 1035 and 1066 (in the cartulary of Préaux as in many others, the transcribed acts are not dated – except on the occasions when they coincided with a known event and this was noted) Roger de Beaumont, son of Onfroy de Vieilles, the founder of the abbey, gave to Préaux the forest of Hespaignes and all that he possessed there, except his knights. Vital and Wadard appear side by side among the witnesses.[36] In another act Gulbert, son of Guimond, gave the abbey the tithe of all the goods he possessed in the village of Marboué; while William, the abbot, granted Gulbert the fellowship of the place

33 Domesday Book, vol. II, p. 25.
34 *Ibid.*, II, pp. 24 and 25.
35 I have already pointed out that Vital held houses in Caen in the eleventh century from the Bishop of Bayeux (Bourrienne, *Antiquus cartularius Ecclesiae Baiocensis* 2 vols (Rouen-Paris, 1903)).
36 *Regnante eodem principe Willelmo dedit Rogerius Bellemontis Sancto Petro Pratelli silvam Hispanie et quicquid in ea villa in dominio suo habebat, exceptis militibus suis, ex quibus tamen alioquos postea concessit Sancto Petro... Et ex utraque parte affuerunt testes Hugo Putefosse, Goscelinus filius, Vitalis, Wadardus...* (arch. de l'Eure, H. 711, fol. CII). Thus at a date we cannot specify, though during William's reign and before the Conquest (since he is described as *Princeps* not *Rex*), Vital and Wadard subscribed one after the other in a charter of one of the principal lords of Normandy, Roger de Beaumont. They are presumably tenants of the abbey of Préaux (to which this donation was made) and not Roger Beaumont's witnesses, since Wadard reappears in a later *acta* as the abbot's witness.

(*societatem loci*). It was thus a contract. The witnesses for the two parties are listed, and Wadard appears again among the abbot's witnesses.[37]

And now we come to the most important act. A child named Turold, the son of the Vicomte de Montfort, was brought to Préaux to be trained as a monk – which indeed happened. His mother Anfrée, his grandfather Osmond (a characteristically Norman name, derived from the Scandinavian Asnundr), and his uncle Bauduin[38] (Balduinus) brought him. Abbot Anfred, the monks and some of the abbey's vassals (among whom Vital appears this time) were present at the ceremony.[39] This child, Turold, who was offered to the abbey, was an oblate, and it is possible therefore that he was a cripple. He became a monk. Now, the figure who appears in the Tapestry below the legend *Turold*, whom the Abbé de la Rue has seen as dwarf wearing the garb of a monk, is in reality a cripple.

Thus just as we discovered four of the Bayeux Tapestry's unknown figures in Domesday Book after the Conquest, all connected in some way with the Bishop of Bayeux, so we re-encounter three of them, namely Turold, Vital and Wadard, in the cartulary of Préaux before the Conquest – the one as an oblate, the other two as vassals of the abbey. Moreover, Préaux, near to Pont-Audemar, is close to the abbey of Grestain, which was founded by Herluin de Conteville and Arlette, the father and mother of Odo, the future bishop of Bayeux. Furthermore, Herluin himself features in the cartulary of Préaux: he came to ratify a donation made by his son Robert, the future Robert de Mortain who appears in the Bayeux Tapestry at the meal (blessed by Bishop Odo, his brother) before the Battle of Hastings.[40] On another occasion Viscount Herluin came to the abbey with his wife Arlette.[41] This is, to the best of my knowledge, the only document which mentions her – the woman made famous by her son, and who has so exercised the imagination of novelists from the twelfth to the twentieth century.

Odo's brother, father, and mother all, therefore, had connections with the abbey of Préaux, the abbey where Turold was a monk, and of which Vital and Wadard were vassals. So, with the exception of Ælfgiva (who, we now know, was the widow of a Welsh king), all the unknown figures in the Tapestry, namely Turold, Vital and Wadard, the figures whose presence could formerly not be explained (but of whom Freeman and Steenstrup had rightly said that they had to be contemporaries of the Conquest, otherwise their presence in this pictorial drama was inexplicable) were

37 *Ibid.*, fol. 132v: *Ex parte vero abbatis maledoctus Erchembaldus Wadardus.*
38 This name still survived 100 years ago in the Risle Valley in the form Baudoin (not Beaudoin).
39 *Praescripto principe Willelmo regnante dilatus est quidam puer nomine Turoldus, filius vicecomitis Montisfortis* (Montfort-sur-Risle), *Pratellum ut ibi fieret monachus, quod est factum. Detulit autem illum mater sua Ausfrida nomine, avusque suus Osmundus cognomento Malhurulus, patruusque Boldinus... Astantibus vero ex parte abbatis Pratelli nomine Auffridi monachisque et nonnullis hominibus suis videlicet Maledocto Vitale* (arch. de l'Eure, H. 77, fol. 133).
40 *Regnante Willelmo, Roberti marchionis filio atque jubente, venit frater ejus ad Pratellos Robertus nomine, faciens mihi donationem de quadam terra Sanctus Clerus nomine... Huic donationi interfuerunt testes Herluinus pater supradicti Roberti...* (arch. de l'Eure, H. 711, fol. CIv).
41 *Regnante Willelmo Roberti marchionis filio venit Herluinus vicecomes cum uxore sua ad Sanctam Pettrum Pratellensem... (Ibid.*, fol. CXIX).

natives of the Risle Valley; they were connected with the abbey of Préaux, not far from the abbey of Grestain, which was founded by the parents of Odo of Conteville; they were subsequently rewarded for their services by grants of land in the east of England, where the Bishop of Bayeux, the Earl of Kent, was a great landowner; and they were also rewarded by their inclusion in the Tapestry, a monument raised to the glory of Bishop Odo, and of William the Bastard his brother. Can it now be doubted that, although the workmanship of the Tapestry was Anglo-Saxon (executed, doubtless, by Ælfgiva's Anglo-Saxon embroiderers), the inspiration was Norman. The Bayeux Tapestry is thus the first monument to reveal the fusion of the Anglo-Saxon and Norman races that William had wanted from the beginning of his reign.

A Norman work, composed to the greater glory of the Duke, his brother and their soldiers, the Tapestry (or, more accurately, the embroidery) was exhibited during the consecration on 14 July 1077 of the new cathedral of Bayeux which was built by Odo. It was exhibited again during the octave of the Feast of St John in 1476, at which point it was recorded in the inventory of the cathedral treasury. The view that it was a work conceived by an Anglo-Saxon cleric trying to rehabilitate Harold is untenable. The Tapestry bears within itself for those who know how to examine it with care and to compare it with contemporary documents, pictorial or written, published or unpublished (like the cartulary of Préaux) the proof of its true origin.[42]

42 It is desirable that a major academic body, such as the Académie des inscriptions, should publish under its aegis a definitive edition of the Tapestry to replace the inadequate work of Levé and the English edition by Fowke, whose reproductions are excellent but whose text is equally unsatisfactory.

5

A Study of the Bayeux Tapestry

SIMONE BERTRAND

We must start with a few preliminary remarks to provide a context for our study of the embroidery of Bayeux which is commonly called the Tapestry of Queen Matilda. Thereafter, our observations on the work comprise attempts to answer the following fundamental questions. What are the basic materials that were used in the manufacture of the work, and how were they employed? What was the original form of the work? What do we know about the workers, and where was the Tapestry made? At the wish of what powerful and creative person was the Tapestry conceived, and why?

Like all works of art, the Tapestry has a message to convey, and it was made especially to convey it. The key point was: how might the Norman Conquest be explained in a fashion which conformed to the intentions of those who wished to make known their own particular version of events? A narrative account in the form of a text could only have reached a very restricted public; however William the Conqueror and Odo of Conteville doubtless wanted the story, and above all the justification of the Conquest (as we will discover in due course) to reach the illiterate masses. Anticipating by some nine centuries the use of images for mass communication, the designer had the visionary genius to present a contemporary event both as a form of text for the literate public, and also – and perhaps above all – via a vast illustration of this text designed for a mass audience. The place he intended his work to adorn was the cathedral at Bayeux. The Tapestry lent itself admirably to display in such a vast space both because of its dimensions, and because of the number of spectators who could have been assembled to gaze at it there. To the objection that a sacred building would not have been a suitable place for profane subject matter, one can answer that the subject of the hanging was not exactly a profane one: it is a type of tract about an oath. Moreover, had not the Council of Arras (1025) authorised – recommended indeed – that ecclesiastical authorities should use hangings for the edification of the faithful?

The embroidery, therefore, sets out to recount the Conquest of England. With painstaking concern for detail, the well-known central scenes, which are realistic and blatantly historical, relate the facts; while the upper and lower borders provide an additional dimension by offering a continuous symbolic commentary. The Tapestry aims to exalt the exploits of the man who was not only the Duke of Normandy, but also the King of England, and to glorify his dynasty. Into this glorification it weaves

31

the theme of the sacrality of a sworn oath, thus apotheosising William the warrior and Odo the bishop together. The Tapestry is, in consequence, a work of propaganda and preaching at one and the same time.

Does this narrative hanging reflect a *chanson de geste*? In support of this thesis it will suffice in this context to cite the occasions where the designs are seemingly reversed – William's messengers, and the death of Edward the Confessor. The inscriptions accompanying the first of these sets of scenes read as follows.

10 'Ubi nuntii Willelmi ducis venerunt ad Widonem'.
11 'Nuntii Willelmi'.
12 'Hic venit nuntius ad Wilgelmum normanorum ducem'.

Those around the death of Edward the Confessor read (pl. 12):

26 'Hic portatur corpus Edwardi regis ad ecclesiam sci Petri apostoli'.
27 'Hic Eadwardus rex in lecto alloquit[ur] fideles'.
28 'Et hic defunctus est'.

Do these 'inversions' reflect errors or absent-mindedness on the part of the workers? All the rest of the work runs counter to such an explanation. If we replace this theory with the hypothesis that a magisterial *chanson de geste* lies behind the work, everything by contrast now makes sense. The order is logical – it has the logic of a recitation. The first sequence could run as follows:

'And the messengers of Duke William came to Guy (to contest Harold's ransom). The messengers of William (are coming at full gallop), one messenger having come to Duke William (to inform him of Harold's captivity).'

The second sequence could be:

'They carry to the church of St Peter the Apostle the body of King Edward, Edward (who) had conversed with his fideles in his bed and who was dead.'

The Support and the Technique of Execution

Let us begin with a few words which will evoke at once the physical impressiveness of this work. The dimensions which are generally attributed to the Tapestry are: 70.35m in length by 50cm high. The word 'generally' was employed on purpose here. During the German occupation, the staff officers were very keen to examine the work prior to the invasion of England that they themselves envisaged mounting, and they sponsored a detailed examination of it by eminent specialists from Germany. These scholars, having measured the Tapestry several times, assured their contemporaries that it was only 65.45m long. Obviously it is impossible to pronounce categorically in favour of one length as opposed to the other since, as with all textiles, the manner in which the Tapestry is displayed affects how much it is stretched and can result in a degree of lengthening. Let us assume, therefore, that

the work measures approximately the traditional 70m x 50cm. [Editor's note: measurements taken after the rehanging of the Tapestry in 1983 were 68.38m long by 45.7–53.6cm high.]

Another point which helps us to appreciate the work for what it is, is to recollect the incorrect term by which it has been described since the eighteenth century: 'The Tapestry of Queen Matilda'. This immediately brings to mind some magnificent hanging of great smoothness, one of those sumptuous works created from coloured threads that the artist weaves onto the warp held in front of him, bringing to life under his shuttle harmonies of tones and lines in one wholly homogenous, single fabric – if one may use such an image. The role that the designer of the Tapestry had in mind for his creation to play, namely that of a narrative church hanging, was probably at the root of the error which transformed the 'Telle del Conquest' into the 'Tapestry of Queen Matilda'. Telle (i.e. 'toile' [linen]) undoubtedly was its real name in that context. An inventory of the treasures of the Cathedral of Bayeux described it thus in 1476: 'une tente très longue et estroite de telle à broderies de ymages et escrilpteaux faisans représentation du Conquest d'Angleterre'. It was an embroidered cloth. In such a work the figures are not (as in a tapestry) an integral part of the whole: rather they are superimposed upon the base fabric which in fact forms the ground – a ground which always remains visible and bare. It is appropriate, therefore, to study the base fabric first of all, and then to look at the embroidery itself.

The base fabric is linen. Thanks to the enthusiasm that M. de Micheaux, conservator of the Musée des Tissus at Lyon and M. Laulier, professor at the Ecole de Tissage of Lyon readily brought to the study, it has been carefully analysed for the first time – a point which is worth underlining. This analysis has formally established something which hitherto had only been based on tradition and was nothing more than a hypothesis, namely that the base material of the Bayeux embroidery is indeed a linen fabric.

Base material: linen. Torsion: the torsion is determined by the diameter of the thread and the angle at which it turns. In order to obtain this information, two measurements were done on the warp and weft threads of the fabric. Warp: torsion 400–650 twists per metre. Weft: torsion 430–650 twists per metre. The variations in torsion are explained by the irregularities in the thickness of the threads which result from hand manufacture. The thickness of the threads has not been established. All that has been noted is their apparent variations in diameter – something which is more pronounced for the warp thread than for the weft thread.

The finished state was obtained by joining together eight separate pieces of linen of unequal length. The first piece (which includes the start of the Tapestry) measures 13.65m; the second measure 13.75; the third 8.3; the fourth 7.7; the fifth 6.55; the sixth 7.05; the seventh 7.15; and the eighth (the end of which is particularly badly damaged) 5.2m. These measurements, which were taken with the Tapestry suspended and not laid out flat, are accurate to within a few centimetres. The sections are joined together by seams of extreme fineness. Indeed the joins were made with such skill that until 1874 the work was believed to be entirely without seams.

Were the seams joined before or after the embroidery was done? The seam joining the first and second sections was undoubtedly executed after the embroidery. This contention rests on two facts. The first is that there is no embroidery over this seam. The second relates to the two parallel lines (made in stem stitch) which delimit the upper decorative border. Now, the bottom line of the upper border of the first section is *c.* 2cm lower than the corresponding line of the second section. If the sections had been joined before the embroidery was done, one would expect this line simply to continue straight along. The clear break in continuity permits us to assert that in this case the join was made after sections 1 and 2 had been embroidered. Such a procedure did not, however, seem felicitous or practical to the embroiderers, and the other six junctures were effected before the embroidery. The fact that embroidery was executed on the very join itself (without any observable touching up) leaves no room for doubt on the matter. The only instance where doubt could possibly linger is in relation to the join between the third and fourth sections (that is towards the middle of the Tapestry as a whole). Here the join is almost entirely bare of embroidery: scarcely 1 cm^2 is covered with it. It would seem, however, that this was simply because the juncture happened to coincide with an almost empty space in the design.

The height of the linen does not remain exactly constant: it varies at times between 48 and 51 cm.

The work is not edged by a formal hem: all that can actually be observed are two simple folds. The fold at the top is defined by a sort of hem made with large stitches. This allowed the 'Tapestry' itself to be cast over a narrower band of coarser linen, which facilitated hanging and strengthened it. The fold towards the bottom must have been more significant, a circumstance to which the numerous stem stitch restorations of the lower line attest. The work was not hemmed but was cast over a braid which looks rather like *ruban croisé*, that is to say it is woven in a chevron pattern. The relatively well-preserved state of the work is explained by the fact that the Tapestry is backed throughout and is fixed to its lining at regular intervals by support stitches.

Turning now to the embroidery: we find that it was entirely executed using two basic stitches, namely stem stitch and 'laid and couch' work. Mention should also be made of chain stitch; however this was not one of the primary stitches, as will be explained in due course.

Stem stitch was employed for what one might describe as the basic work – namely for all the lines of the faces, for hands, and for all bare flesh. Thus in the scene where the vessels are dragged through the breakers, the bare legs of the men (who have tucked up their breeches into their belts) are indicated by a simple line in stem stitch. Bare flesh is universally rendered by this simple stitch. This is even the case for the corpses that have been stripped of their clothes, and for those figures in the Tapestry which are traditionally referred to as the 'obscenities' (pl. 7). Moreover, the designer was evidently of an imaginative turn of mind and used the same technique for insubstantial, otherworldly concepts: the representation of the symbolic, ghostly ships which appear directly under the scene of Harold's coronation, evoking

the impending misfortunes (pl. 14). Such stark conceptions are rendered in exactly the same way as the nakedness of real people.

Stem stitch was also used to reinforce all the outlines of the areas of design that were made in relief in laid and couch work. This was, in effect, the application of a decorative principle which was very popular in the Middle Ages, namely defining designs with a heavily accentuated outline. The outline was the finishing touch. One can see that the wool was sometimes angled towards the right and at other times towards the left. The direction depended upon the position of the Tapestry itself when the work was being done: sometimes the position gave the stitch an upward direction, other times a downward one.

The second type of stitch that was used was laid and couch work – what modern embroiderers call 'Boulogne stitch'. This was executed in three stages. The first stage consisted in covering the appropriate area of the design with numerous tightly packed threads, one virtually overlapping the next. The appropriateness of saying 'covering the design' is underlined by the back of the work, where all one can see is a simple track of thread following the outline of the design. Only the surface of the design is covered, while the back of the fabric remains virtually untouched. The second stage comprised running a second row of the same threads over the first set, alligned at right angles to them and spaced at roughly 3mm intervals. Finally, a light, almost invisible stitching was applied at regular intervals along these last threads, generally in staggered rows, to fix the whole ensemble onto the fabric ground, giving it solidity and stability.

The laid and couch work gives a convincing impression of mass and homogeneity – one is almost tempted to say of relief. Indeed, viewed by the naked eye, elements of the Tapestry, such as the figures and horses, seem remarkably three-dimensional. In our concern for accuracy we have ascertained that in its completed state this stitch could result in a depth of up to 3mm. The stem stitch, which re-inforces the outlines of all these masses, also helps to bring out their thickness, contributing to the illusion of relief.

Towards the end of the work some of the shafts of the lances and some of the bowmen's arrows are entirely executed in chain stitch. This, however, is not one of the original stitches; rather it is a stitch that was employed during the restorations that were carried out on the work. It seems likely that the same is true of those occasions where chain stitch occurs in the inscriptions (it rarely appears elsewhere). The inscription for the scene of Harold's coronation, for instance, ('Hic dederunt Haroldo coronam regis') is for the most part defined in chain stitch. The 'Hic' of the upper line, however, and the C and O which appear just below it are in stem stitch, as is the final S of 'regis'. These stem stitch areas are, in effect, the outer edges of the inscription and they delimit a central zone which had worn out and within which a restorer used chain stitch.

What are the materials from which these embroideries are made? They comprise simple wools of eight colours. These are: brick red, a fairly intense yellow, a fawn yellow, a light green, a dark green, and three tones of blue, one of which is almost black. The detailed analysis drew attention to the fact that under a microscope

numerous opaque brown fibres can be seen in the dark blue threads. In point of fact, these fibres are visible with a weak magnifying glass. (The torsion of this wool, incidentally, is approximately 350 turns per metre.)

Dyes provided the primary colours, red, yellow and blue. And it had been known since Antiquity how to obtain secondary tones, notably green, which was derived from blue and yellow mixed together in varying proportions. The reader may recall that in his *Historia naturalis* Pliny drew attention to the fact that the inhabitants of Cisalpine Gaul had discovered the means of manufacturing Tyrian purple, scarlet, and 'every other colour imaginable' from the juice of plants. Discussing 'places where trees grow', he noted that 'broom, a plant which is very good for dyeing wool, grew in the mountains'. He also drew attention to 'two other well-known plants' 'notably madder, of which dyers of woollen fabrics make great use for giving them colour ... and which is widespread', 'and the *muscari comosum* (tassled hyacinth) ... which, when it does not have scarlet seeds, has a bulbous onion-like root'. 'As for a fourth species of plant, domestic woad (*glastum*) is habitually used by wool-dyers'.

Rather than producing a proper purple, red yarns were obtained in the following ways.

From *fucus* (seaweed). Several seaweeds which are commonly called dyer's seaweed give a fairly good red tone. Red seaweeds have always been abundant on the coasts and they are easy to collect.

From *kermes* or *coccus*. The exact process that was used to obtain kermes scarlet is unknown. All we do know is that the colour obtained was much less expensive than 'classical' purple; it was, however, less attractive.

From *madder* – which was probably the very same plant that dyers cultivate today. Although used as a red pigment, it was fairly impermanent. Moreover, in the Middle Ages they did not know how to lighten its tone and the red obtained was, in consequence, fairly drab. Might this perhaps be the reason why the creators of the Tapestry opted instead for the brick red which is quite a pretty shade and so distinctive?

We have seen that broom (*genesta tinctoria*) was used for the colour yellow. It could also be obtained from a plant called the lotus (*lotus medicago arborea*), the roots of which furnished 'a yellow which held well in wool'. One could engineer variations in the colour by using walnut tree bark and walnut stain.

The blue wools owed their tint to *glastrum* or woad. Its common name in Normandy is vouède, and A. Hugo has demonstrated that it was formerly cultivated on a large scale in Calvados. The dark shades were obtained via the admixture of a decoction of gall nut.

Whatever the shade, these wools had to be dyed in the fleece. Wool fibres were far more absorbent while they were still separate one from another than when they had been spun together. The colour of wool which is dyed in the fleece remains richer, the dye is more durable, and there are only minor variations in shade between the right side and the underside of the work. This is all true in the case of the Tapestry. Such a procedure would also explain why there are only slight differences between the tones of individual fibres of the same colour, and why this holds good

in the interior as well as on the surface of the work. Moreover, in the case of the Tapestry the wool was dyed twice, being carded between the two operations.

In addition, the wool had to undergo degreasing, an exercise which was essential before dyeing. Perhaps because this degreasing was done with particular care, or possibly because the dye products contained a rudimentary moth repellent – either as an integral part of their nature, or as some sort of addition of which we are ignorant – the original work has not been ravaged by moths. It is quite extraordinary that in the course of nine centuries moths have not eaten this work, while the wool of the nineteenth-century restorations, which was dyed by chemical processes, has in fact suffered their attacks.

The Tapestry was, therefore, made with the following materials. 1. Natural wools. One can offer an approximate guide to their price on the grounds that around that time a fleece cost 2/5 the price of a ewe (Wilkins, *Leges saxonicae*, p. 23). 2. Needles. These were presumably bronze. The very obvious traces left by the eyes of the needles lead one to suppose so. But in evaluating these traces it is also necessary to take account of the thickness of the wool, which also played a part in determining the size of the holes in question (and also of the fact that two strands of it went through the cloth together). 3. A frame. It seems impossible that such a work could have been accomplished 'free hand'. Moreover, laid and couch work requires the use of both hands and it could not, therefore, have been done without the fabric being supported on a frame.

Were the designs that were embroidered drawn directly onto the cloth to facilitate the work; alternatively was it done following separate cartoons? When photographs were taken in 1955, the first suggestion appeared to be the correct one. In strong illumination some reddish traces appeared, notably under the dark blue inscriptions. Could these be traces of pigment which was decomposing – as a result, for instance, of damp? With further examination, the same red traces were found elsewhere, such as under some of the green inscriptions. Evidently they were not a discharge of the blue dye, but were rather traces of crayon strokes. Once recognized, these crayon strokes were even visible to the naked eye. Had the Tapestry, therefore, been drawn out on the cloth? The answer is: probably not. These traces are only visible in the areas which have undergone restoration. They were, therefore, made to facilitate the work of the restorers, helping to enhance its accuracy.

One last issue deserves our attention here: has the work come down to us in a pristine condition? Certainly not. Everyone is unanimous on this point. The end is undoubtedly lost: the restorations to that area are so numerous that it is now virtually impossible to discern the original work. The ragged nature of the linen leaves no room for doubting that this is the case. But how much of the work has disappeared? The length of the final section in its present state (5.2m) is clearly much less than that of the other sections, which permits us to assume that we have lost a minimum of 1–1.5m of embroidery. There is an alternative possibility however: namely that we have lost an entire extra sequence which might have extended right up to William's coronation. The first hypothesis tallies better with the fact that the famous inventory of 1476 specifies that the work was hung in the nave of the

cathedral and its length (making allowance for the loss of only a small part) cor-
responds with such an arrangement, hanging from pier to pier. A tradition which,
although only oral was however passed on by many people who had themselves
talked to the individual in question, maintains that Professor Jankun discerned
vertical marks on the Tapestry which looked like areas of rubbing and which cor-
responded exactly to the spacing of the piers of the nave (i.e. occurring roughly
every 6m). The first hypothesis conforms equally well with the supposition that the
Tapestry is a work of a religious character which was designed to be exhibited be-
fore the eyes of the faithful for their edification. The Tapestry underlined the
importance of an oath sworn on relics, and it recounted the drama of the perjury, a
drama which ended with the tragic death of Harold who had reneged on his sworn
pledge. If the work had indeed been conceived simply to present Odo as the judge
and William as the lawman, it did not have to continue much beyond Harold's
death. The punishment of Harold's perjury was its conclusion.

There is another question which ought also to be raised in this context: have we
got the start of the work in its original state? Although it would seem that this
question has never been raised before, nothing allows us to answer 'yes'. People
have constantly argued that the final scenes have gone on the grounds that there is
no vertical border at the end corresponding to the one at the beginning. However,
although there is indeed a border at the beginning, it is entirely the work of re-
storers. The only authentic piece in this border is wholly separate from the fabric of
the first scene proper, 'Edward rex'. As to the linen ground of this border, the
original work comprises less than a third (22cm) of what is an arbitrary reconstruc-
tion. The remarkable decorative motif which appears there, namely the 'scrolls', is
entirely the fantasy of the restorers. The original work here is very limited in scope;
some parts date from the time of the first restorations (1482 perhaps) as they are
shown in Montfaucon's illustration. The other scrolls in stem stitch or laid and couch
work date, by contrast, from restorations done after 1730 and are part of the 'mod-
ern' reworkings which are easy to discern because they were done over preliminary
sketches in red. Could one advance the hypothesis that another fragment is miss-
ing? If so, what was the original work like?

6

A Contribution to the Study of the Inscriptions in the Bayeux Tapestry: *Bagias* and *Wilgelm*

RENÉ LEPELLEY

The inscriptions in the Bayeux Tapestry include the names of certain towns from both sides of the English Channel. It is no surprise to encounter among them that of the very city which was the episcopal see of Odo of Conteville, and which has given its name to the Tapestry itself.

Scene 22* comprises, in essence, three horsemen riding towards a castle. Among them appears William of Normandy. He leads Harold, 'Duke of the English' to the town where the latter will swear an oath to the effect that he will recognise William as Edward the Confessor's successor. At this point we read the brief commentary: *Hic VVillelm venit : Bagias*, that is: 'Here [i.e. in the image that you have before your eyes] William went to Bayeux'. We may note in passing that in these inscriptions, the verb *venire* often has the sense of the French *aller* [to go], while the verb *ire* was not employed, apart from in the composite forms *transire* (scenes 17 and 13: pl. 8) and *exire* (scene 48: pl. 19).

What are we to make of the word *Bagias*? From a semantic point of view, there is no doubt that it designates Bayeux. It is true that the early historians of the Norman Conquest do not agree in locating the place where Harold swore his oath on relics in this town. However, all that concerns us here is to ascertain beyond reasonable doubt that the author of the inscription did indeed wish to designate Bayeux via the word *Bagias*. Now, the presence of two affronted birds below the symbolic representation of the town in question would seem to prove that this was indeed the case. For historians who specialise in the study of the Tapestry interpret these birds as two eagles, and regard them as the prototype of what was subsequently to become the arms of the Chapter of the Cathedral of Bayeux – namely a two-headed eagle.

Looking at the syntax of this inscription, we note the rigorous observance of the rules of classical Latin grammar. *Bagias* is in the accusative as an adverbial phrase of place, responding to the interrogative *Quo* (where); and it lacks a preposition since it happens to be the name of a town. In an era when the preposition *Ad* would frequently be deployed in such circumstances, this latter usage is worthy of note. In the

*The scene numbers are those marked on the support fabric above the Tapestry itself.

inscriptions to scenes 18 and 38 (pl. 17), where the names of the places appear in non-inflected forms, we read *Et venerunt ad Dol* and *Et venit ad Pevenesae*.

The most important problem here, however, is that of the morphology of *Bagias*. In order to resolve it, it is necessary to explore the etymology, the phonetic evolution, and the pronunciation of the word.

Bagias

Given that the commentary which accompanies the Tapestry is written in Latin, it is reasonable to start by examining *Bagias* to see whether it is a Latin word. What, then, was the origin of the name of the town Bayeux? It goes back to the Celtic word *Bodiócasses*. When the Romans adopted this word, they preserved the stress on its antepenultimate syllable, despite the fact that the penultimate syllable was a long one. This explains why the long *a* has completely disappeared today; whereas if it had been a pure Latin word the *a* would have left traces in modern French. The inscription in the Tapestry does not, therefore, present the primitive form of the word. This is not, incidentally, very surprising, since an evolved form of the word, which was mid-way between the Romano-Celtic form and the French one, was current in scholarly Latin in the Middle Ages. The spelling used in medieval Latin texts to designate the town of Bayeux is *Baiocae*. Given the intellectual activity in this town in the eleventh century, we can reasonably assume that the word *Baiocae* would have been frequently used in the Latin of the time. In the accusative case it would be *Baiocas*. This is not, however, the form used in the Tapestry. We have, therefore, reached our first conclusion, namely that *Bagias* is not derived from the Latin of the Gallo-Roman period, nor from medieval Latin.

Consequently, given that the construction of the word is incontestably latinate, it can only be the latinised form of a non-Latin word. The person who embroidered this section of the inscription wished to give a Latin veneer to a word, of whose actual Latin version he was ignorant. This veneer was essentially conveyed by the ending. *Bagias* is not, incidentally, the only case of artificial latinisation to be found in these inscriptions. It is, in fact, very unlikely that the forms *Cosnonis* (for the river Cousenon: pl. 8) and *Pevenesae* (for Pevensey: pl. 17) are genuine Latin words. As for *Rednes*, it is simply a thinly disguised version of the French Rennes (its true Latin form being *Redones*). But what, then, was the word that the embroideror wanted to 'clothe' in Latin in this way?

The majority of modern historians and students of the Bayeux Tapestry (sometimes called the Tapestry of Queen Matilda) consider that it is likely to have been made in England. And a number of words in the inscriptions do in fact reveal an Anglo-Saxon hand at work. It will suffice to cite the deployment of *Eadwardus* for *Edwardus*, and of *Ceastra* for *Castra*. It might seem reasonable, therefore, to hypothesise that *Bagias* conceals an Anglo-Saxon word. There are, however, two objections to this. First of all, it would be necessary for the English to have had a word which was typically Anglo-Saxon to designate the town of Bayeux, before the

Norman Conquest. If the views held by certain nineteenth-century historians were credible, this would not have been impossible, since they maintained that in the Fifth Century certain Saxons had given their name to the shore of Calvados which is called the *Litus Saxonicum*. However, the true sense of the Latin expression *Litus Saxonicum* is, as modern scholars have shown, 'The Coast which must be protected against the Saxons', and not 'The Coast of the Saxons'. In any case, if the supposition that the Saxons had imported into England a special term to designate the city of the Bajocasses *were* valid, one would expect the English to have employed it whenever they mentioned that town. Now, there exists at least one text written in Anglo-Saxon (Old English) in which the town is indeed mentioned, namely the *Peterborough Chronicle*. This source provides a near-contemporary account of William the Conqueror, and it includes the following words about Odo of Bayeux: *He wæs swiðe rice biscop on Normandy, on Baius wæs his biscopstol* ('He was a very powerful bishop in Normandy; his bishopric was at Bayeux'). The documented form is not, therefore, *Bagias* but rather *Baius*. This is an Anglo-Saxon writer's normalisation of the French form Bayeux (or *Baieus*). The point is that, because the sound [oe][1] (written 'eu' in French) did not exist in Old English, it was necessary to substitute the sound in that language that was closest to it, namely [u]. This is written as 'ou' in French; but in Old English (as in Latin) it is written 'u'. The form *Baius* (= Bayous) therefore represents the most accurate pronunciation of Bayeux possible for the Anglo-Saxon tongue. Now, given that the Anglo-Saxon chronicler deployed what is effectively the French word, it would appear that he did not have a specifically English word at his disposal. This leads us to our second conclusion, namely that the form *Bagias* is not based on an Anglo-Saxon word.

Bagias, then, can only reflect a French word – the word Bayeux itself. Two problems now remain to be resolved: the final *a*, and the presence of the *g*. In the French word Bayeux, the terminal 'eu' is derived from the stressed *o* of *Badiócasses*, or, if one prefers, from *Baiocas*. It would therefore be logical for an embroiderer who wanted to give the word 'Bayeux' a Latin veneer, to supply it with the ending *o* (which would become *os* in the accusative case). One would then have the phonetically more accurate **Bagios*. But such a reconstruction presupposes that the embroiderer had at least some grasp of phonetics, and knew that French endings in 'eu' derived from Latin endings in 'o'. (The derivation of 'meule' from 'mola' and 'fleur' from 'flora' are examples of the phenomenon.) With this knowledge, starting from *Bayeux* he could have worked back to *Bagios*. However, not only was the embroiderer doubtless ignorant of these concepts, it is quite possible that he did not even know French. It is out of the question, therefore, that he could have made the connection between 'fleur' and 'flore', for example.

The next question to address is why the ending 'as' was used rather than some other form. An examination of all the proper names in the Tapestry reveals that the author of these inscriptions had something of a predilection for the first declension in Latin, which is the simplest (e.g. *Hestinga* and *Hestenga* for Hastings). It also reveals a

1 The forms in square brackets are phonetic: e.g. [wi] = oui. NB: [oe] = eu; [u] = ou.

degree of inconsistency in the latinisation of proper names, some being declined and others not. Thus we find *Edward* alongside *Edwardus*, and *Willelm* as well as *Willelmus*.

Alternatively, one could hypothesise that the cleric who composed the inscription which interests us placed the principal stress on the first syllable of the word rather than on the second. That is he said Báyeux rather than Bayéux. In point of fact, as F. Mossé says, 'Old English tended to stress the root syllable of simple words. This is known as the accent of initial stress ... The root syllable is forcibly detached, and the end of the word tends to be more feebly articulated'. Applying this theory to 'Bayeux', the sound 'eu' being unaccentuated would become weaker, and would end up as an almost silent 'e' (e): 'Bayes'. Phonetically the ending 'as' would, therefore, represent 'es', following the usage which was then customary (e.g. 'rosas' – 'roses').

All that remains to be explained now is the presence of a 'g' in the middle of *Bagias*. This problem, which at first sight seems the most difficult, is in fact the simplest to resolve. We have acknowledged the likelihood that the Tapestry was executed in England – or at least that English hands were involved in its production. For an historian, of course, this is not the same thing; for a philologist, however, the difference is not of great significance. We should, therefore, ask how an Englishman who had perhaps never seen the word 'Bayeux' but heard it pronounced, would himself have written it down. Accustomed to the graphic system of his own language, he would have used conventional Anglo-Saxon orthography to render the sounds he heard. How, then, did Old English write 'yod' – that is 'y' or 'ill' in modern French, 'y' or 'i' in Old French? The symbol that was most frequently employed was yogh, which for convenience we now write as 'g'. This letter was unknown in France. (After the Norman Conquest, the letter in question was gradually superseded in England – either by 'g', which was introduced [for this sound] by the French; or by 'y'.) Dæ**g** (= dey; modern English 'day') and we**g** (= wey; modern English 'way') are examples of it in use. Before a vowel '**g**e' or '**g**i' were often used rather than just '**g**': **g**ea (= ye; modern English 'yes'), **g**ear (= yer; modern English 'year'), **g**ielp (modern English 'yelp'), **g**iestran dæg (modern English 'yesterday'), and **g**iet (modern English 'yet') are cases in point. Now, the majuscule letter which corresponds to the minuscule yogh is **G** – exactly the same as the French majuscule 'g' – and the inscriptions in the Bayeux Tapestry are, of course, written in majuscules. If *Bagias* had been written in minuscules, incidentally, it would have been *ba**z**ias* [the 'z' standing for yogh], but it would still have been pronounced 'Bayas', that is without a guttural at the centre. Consequently, we can assert that the only difference between *Bagias* and the French *Bayeues* (attested in Wace's *Roman de Rou*) is the graphic system (and the ending).

At this point we can usefully raise a tangential issue. Can we confidently attribute this representation of 'yod' by 'gi' to an English embroiderer? It seems that we cannot answer the question with an unqualified, 'Yes'. The use of the letter **g** to express 'yod' was not, in point of fact, unknown in France before the Norman Conquest. Miss M. K. Pope (*From Latin to Modern French*) unearthed some examples in Latin texts which date back to the Romanesque period: *agebat* for *aiebat* occurs in a manuscript of Gregory of Tours. The eighth-century Glosses of Reichenau include an entry

where the written form *gi* is used to distinguish the consonant **i** (or 'yod') from the vowel **i**: *iurgiis* for *ivorjis*. The same written device also appears in the oldest known text of northern French – the late ninth-century *Sequence of St Eulalia* – where *pagiens* occurs for [payens]. Although these facts in no way invalidate the proposition that *Bagias* was pronounced [Bayas], they do provide cause for hesitating over the racial origin of the copyist of this inscription. Nevertheless, it appears that the use of **g** and, particularly, **gi**, for 'yod' was not widespread in France before the eleventh century, whereas it enjoyed general currency in England in the period of the Norman Conquest.

We can thus conclude that *Bagias* is neither a purely Latin form, nor an Anglo-Saxon one. On the contrary, it is an Anglo-Saxon spelling of a fairly arbitrarily latinised version of a word which was certainly French, namely Bayeux.

Wilgelm

Our investigation of the word *Bagias* involved us in considering the value of the graphic symbol **g** [yogh] in Old English. To complete our study of this character, let us examine what it represents in *Wilgelm*, a word which is regularly used in the Bayeux Tapestry.

William is, naturally, the proper name that one encounters most frequently in the inscriptions of the Tapestry. It appears no less than nineteen times. If we discount variations in the rendering of the initial **W** (**VV**, **W**) and also the inflected endings, these nineteen examples can be classified into four basic types: *Willelm* (which occurs eleven times); *Wilelm* (which occurs twice – including *Wilel-*, where the abbreviation mark undoubtedly corresponds to an **m**); *Willem* (three times) and *Wilgelm* (three times).

The form that occurs most frequently in old Norman texts is *Wilhelm*. However the subsequent evolution of the word – in English (William) as much as in French (Guillaume, which was for a long time pronounced [Gilyom] or [Guilyom] and is now pronounced [Giyom] or [Guiyom] – would seem to prove that at the time of the Norman Conquest it was pronounced [Wilyelm].

Restricting ourselves to the inscriptions, the key question is whether the four different spellings represent essentially the same word. We can affirm that *Willelm*, *Wilelm* and *Wilgelm* were pronounced in exactly the same way: namely [Wilyelm] with a palatal **l**, or if one prefers, **ly**.[2] In Old French this palatal **l** was in theory represented by a double **l** or by **ill**; however scribes sometimes contented themselves with writing just a single **l**. Thus *fille* and *file* were both said as [filye]; similarly, *bataille*, *batalle* and *batale* were all pronounced [batalye]. Only in the mid-seventeenth century did the pronunciation [fiye] appear, becoming dominant a century and a half later. The spellings *Willelm* and *Wilelm* are, therefore, nothing other than the normal way of representing [Wilyelm].

2 As a typographical convention, I am using *ly* for palatal *l*.

The spelling *Wilgelm*, on the other hand, seems surprising; nevertheless there is no doubt that it too represents [Wilyelm]. The fact that this spelling appears three times – in scenes 12 (*Ad Wilgelmum ducem*), 13 (*Ad VVilgelmum normannorum ducem*: pl. 6), and 14 (*Dux VVilgelm*: pl. 7) – show that it was not simply a careless slip on the part of the embroiderer. Consequently, it is logical to interpret the juxtaposed **l** and **g** as a way of spelling the palatal **l**.

The problem we faced in connection with *Bagias* must then be readdressed: is the origin of this spelling Anglo-Saxon or Continental? On the one hand, the juxtaposed **lg** (or, more accurately, **l** and yogh – **LG** in majuscules), pronounced [ly], certainly appears in Old English texts. At Luke 15, 15 in the West Saxon version of the Gospels, for example, we read, 'Ða ferde and folgode anum burgsittendum menn ðæs rices' ('Then he went and followed an inhabitant of that kingdom). *Folgode* is pronounced [folyode]. The same is true in Mercian dialect: in Matthew 4 we read, 'in ða halgan cæstre' ('in the holy town'), *halgan* being pronounced [halyan]. On the other hand, Miss M. K. Pope has noted at least one convincing example of the spelling **lg** for the palatal **l** in a tenth-century text from north east France, namely the Sermon on Jonah. It occurs in the word *cilg*, which originated from the Latin *cilium* and was pronounced [sily] in Old French. A little hesitation is, therefore, in order. Nevertheless, given that the spelling **lg** was current in England, but seems to have been extremely rare in France before the eleventh century, we can conclude that the form *Wilgelm*, like that of *Bagias*, has an Insular character. It is, moreover, worth stating that this way of writing palatal **l** became more common in French texts written in England after the Norman Conquest. Pope discovered ten different spellings of palatal **l** in Domesday Book (1086); and we note that five of the ten contain a palatalised **g** – **lg**, **ilg**, **illg**, **ilgi** and **llg** (*Talgebosc, Tailgebosc, Taillgebosc* and *Tallgebosc*, all pronounced [Talyebosc], just like *Taillebosc, Tailebosc*, and *Tallebosc*.

To resume: our study of the inscriptions in the Bayeux Tapestry leads us to the conclusion that a number of the words they include were apparently written by Englishmen. Does it necessarily follow that the entirety of the inscribed text was the work of Englishmen and that it was composed in England? Only historians can answer this, since from a linguistic point of view phrases such as *Hic Willelm dedit Haroldo arma* and *Hic trahunt naves ad mare* could equally well have been conceived and written by a Frenchman as by an Englishman. What is, however, certain is that words like *Bagias* and *Wilgelm* were, in all likelihood, embroidered by people whose natural mode of writing was an Anglo-Saxon one.

We should add that what we are seeing here is almost certainly the Anglo-Saxon of England itself. Certain historians have advanced the opinion that the authors of the inscriptions could have been the descendants of the *Saxones Bajocassini*, that is the Saxons who settled on the Norman coast near to Bayeux in the fifth century. This was the opinion of Canon Laffetay, a former conservator of Bayeux Bibliothèque municipale, who in 1885 [*recte* 1873] endeavoured to prove that the Tapestry had a Bayeux origin. Nowadays, however, specialists unconditionally reject the hypothesis that Saxon stock survived in the Bayeux region into the eleventh century; indeed they consider the very existence of the *Saxones Bajocassini* to be contestable. Yet even

if one *were* prepared to allow Canon Laffetay's view about the survival of a Saxon element at Bayeux, one would still be forced to acknowledge that, after a separation of several centuries, they would not have been speaking the same language as the Anglo-Saxons themselves. In any case, their system of spelling would certainly have been different. English writing of the early medieval period had, in point of fact, been strongly influenced by the Irish; but there is no real reason to believe that the continental Saxons had sought lessons from the same Irishmen! Thus, while forms such as the **EA** in *Eadwardus* (scenes 26 and 27) and *ceastra* (45), and the crossed letters such as the eth in Gyrð (52: pl. 22) were current among the Anglo-Saxons themselves, there is little doubt that they would have been unfamiliar to Saxons of the Bayeux region.

The English also borrowed from Irish script an abbreviation mark which appears in the Bayeux Tapestry and which the continental Saxons will certainly not have known. The symbol in question is '⁊' (called the Tironian 'et'), which was substituted both for the Latin *et* and for the English *and*. In the ninth-century psalter glosses, for example, the interlinear Old English translation of the Latin text *ego servus et filius ancillae tuae* is *ic ðiow ⁊ sunu menenes ðines*. Correspondingly, in the ninth scene of the Tapestry (pl. 4), we find *Ubi Harold ⁊ VVido parabolant* (i.e. '[The scene] where Harold and Guy are in discussion'). It is my opinion that the presence of this Tironian *nota* provides additional proof of the fact that English hands at least participated in creating the Bayeux Tapestry. This symbol would seem to have been virtually unknown in France before the Norman Conquest – the equivalent continental abbreviation being the symbol '&', which one can find as early as the *Oaths of Strasbourg*: *savir & podir* (savoir et pouvoir). On the other hand, the use of '⁊' became more widespread in France at a later date. One finds it, for example, in the French manuscripts of Wace's *Vie de Sainte Marguerite* dating from the thirteenth and fourteenth centuries, which doubtless reflect the original orthography of this Anglo-Norman author.

Let us in conclusion return to our initial focus, namely the word *Bagias*. It is not just the spelling that reveals the Insular connections of our inscription: the very choice of this word does so as well. If the text had actually been written by a clerk from the Bayeux region, he would in all probability have referred to the town as *Civitas Baiocensis* or *Baiocae*, the two forms of Bayeux which were current in the medieval Latin that he knew. The more common of the two, *Civitas Baiocensis*, is admittedly a little too lengthy to be suitable for an embroidered inscription; but the second – which is attested from the early fifth century, when it appeared in the *Notitia Dignitatum*, being employed five centuries later in Flodoard's chronicle – had a form that would have been easy to use. A clerk of Bayeux, whatever his origin, could hardly have been ignorant of it; and this is surely the word that he would naturally have employed in an inscription of the sort that we have just examined.

Be that as it may, the inscriptions of the Bayeux Tapestry remain a uniquely valuable document. Although written in Latin, they do, in effect, permit us to discern the first fruits of the interpenetration of two other languages, French and English. In addition, we can assert that they represent the first written monument of Anglo-Norman or – to be more accurate – of Anglo-French civilisation.

7

The Bayeux Tapestry and the French Secular Epic

C. R. DODWELL

Technically speaking, the Bayeux Tapestry is, of course, not a tapestry but an embroidery. This is well known but we may further ask whether it was, in fact, intended for Bayeux – or, at least, for the cathedral there.

The traditional view is that the Tapestry was made for Odo, bishop of Bayeux. This itself carried conviction for Odo is given a prominence in it that is not accorded to him in literary sources, among the lesser figures are two who can perhaps be identified as his vassals[1] and the Tapestry is alone among contemporary sources in setting the famous oath scene at Bayeux. It does not necessarily follow, however, that the Tapestry was commissioned for Bayeux Cathedral. The earliest record of its presence there does not occur until 1476 – some 400 years after its production – and, though the association may well go back to a very early date, there is no evidence that it was actually made for the cathedral. Though it extends more than 200 feet in length, it is only 20 inches high and would, in fact, have looked somewhat incongruous as a permanent decorative feature of any large cathedral. And the supposition that it was intended to serve in a religious setting itself confronts us with some difficulties.

To begin with, one or two of the border scenes have an obscenity and lewdness that are difficult to reconcile with a cathedral setting (pl. 7). When all allowances have been made for different attitudes of mind of different periods, it is hard to believe that they were actually intended to decorate a centre of worship where the divine office was regularly held.

Then the narrative itself is obstinately unreligious and secular in interpretation. In fact, William the Conqueror, who in accounts like that of William of Poitiers and William of Jumièges, tends to emerge as the fount of virtue and religious morality, is in the Tapestry never seeen at church or at prayer or in any posture of piety. Much has been made of the famous oath scene at Bayeux (pl. 10) but this takes place outside the cathedral, it is to ratify an entirely feudal and secular engagement and William himself appears as the straightforward lay-ruler depicted (as on seals of secular rulers) with his sword over his shoulder. As we shall see later, these oaths on relics were a familiar ingredient of French secular poetry.

1 W. Urry, *The Normans in Canterbury*, Occasional Paper, No. 2 of the Canterbury Archaeological Society, pp. 11–12.

In the account of William of Poitiers, William the Conqueror wore round his neck at Hastings the relics on which Harold was said to have sworn his oath in order to emphasize the perjury of Harold and his own religious mission.[2] This is entirely omitted from the scenes of the Tapestry. More important is the celebrated fact that William obtained the support of the papacy and that this was symbolized by the consecrated papal banner which he took with him on his invasion. Now, this most significant symbol of what Freeman sourly refers to as a Crusade[3] is not represented in the Bayeux Tapestry. This is the view not only of Freeman[4] himself but of the greatest authority on the papal banner – Professor Carl Erdmann.[5] When embarking from France, the Norman fleet was met with adverse winds and William 'fighting', as one chronicle says 'with his prayers' even had the relics of the local Saint Valéry carried in procession.[6] Though crowned with success, this fine example of the piety of William and the support of the Deity goes unrecorded in the Bayeux Tapestry. When the army reaches England, the chronicles preface Hastings with prayers but the Tapestry offers instead a feast (pl. 18). And this is, indeed, the whole spirit of the Tapestry. Everything is read in feudal and secular terms. There is no spirituality. The concern is with feasts rather than prayers, warfare rather than piety, feudal equity rather than religious edification.

It is true, of course, that the Tapestry was probably made for Odo who was a bishop. But this half-brother of William was certainly not a bishop in the tradition of Lanfranc and Anselm. He was simply a feudal baron with benefit of clergy. As such he is unashamedly represented in the Tapestry where he is much in evidence in the service of Mars but never seen in the service of God. He is seen in the thick of the battle (pl. 24) and advises in war-council (pl. 18) but (apart from saying grace before a feast) is never seen in prayer or meditation and is never even shown in ecclesiastical vestments. Such, indeed, is the picture of him handed down to us by other sources. It was not religious feeling but stark secular ambition that took him from Normandy to England, made him there earl of Kent and William's vice-regent, and induced him to build up great wealth on the spoils of the churches It was not anxiety for reform but a simple desire for power that led him to plot for the English crown and to sow dissension in the Duchy of Normandy. With some truth, William might say, when taking him prisoner for treasonable activity, that he was arresting not a bishop but a secular magnate.[7] We know from chroniclers of Odo's interest in artistic objects. This could even lead him to purloin from Durham Cathedral a

2 Guillaume de Poitiers, *Histoire de Guillaume le Conquérant*, ed. Raymonde Foreville (Paris, 1952), pp. 180–2.
3 Edward A. Freeman, *The History of the Norman Conquest of England* (Oxford, 1867–76), III, pp. 284 ff.
4 *Idem*, p. 464.
5 Carl Erdmann, *Die Enstehung des Kreuzzugsgedankens* (Stuttgart, 1935), pp. 181–3.
6 Guillaume de Poitiers, ed. Foreville, p. 160.
7 Orderic Vitalis, *Historiae ecclesiasticae*, ed. Augustus le Prevost (Paris, 1839–55), III, p. 191: '*Cumque nullus in episcopum auderet injicere manum, rex ipse primus apprehendi eum. Illo autem reclamante: "Clericus sum et minister Domini: non licet pontificem damnare sine judicio Papae", providus rex ait: "Ego non clericum nec antistem damno sed comitem meum que, meo vice mea praeposui regno …"*'.

pastoral staff of rare workmanship.[8] When he turned his ambitions towards the very chair of St. Peter, the Book of Hyde tells us that he built for himself at Rome a palace so magnificently adorned that it had no parallel in that great city[9] and Ordericus Vitalis also refers to its sumptuous decoration.[10] I would suggest that the Bayeux Tapestry was a memorial to just this private ostentation and that it formerly decorated one of Odo's great palaces. Even if we allow for its present incompleteness, a hall about 85 by 35 feet would have provided an appropriate setting.

We certainly know that hangings and tapestries were used in secular palaces and castles. As early as the eighth-century Anglo-Saxon poem *Beowulf* we read how:

> The wall hangings shone
> Embroidered with gold with many a sight of wonder
> For those that delight to gaze on them.[11]

In French epic poetry of the eleventh and twelfth centuries there are other references. In the *chanson of Girard de Roussillon*, for example, we read that the guest chamber of one count's palace was 'everywhere spread with tapestries and hangings'[12] and other rooms were so covered around with hangings that you could not see the stone and wood of the walls behind.[13] Perhaps even more to the point

See also Wace, *Le Roman de Rou*, lines 14332–6:

> 'Vos me faites, dist Odes, tort
> Eveske suis è croce port,
> Ne devez metre main en mei.
> Par mon chief, dist li Rei, si dei
> Jo prendrai li comte de Kent'.

8 *Symeonis Monachi Historia Ecclesiae Dunelmensis*, ed. T. Arnold, Rolls Series (London, 1882), I, p. 118: '*Quaedam etiam ex ornamentis ecclesiae, inter quae et baculum pastoralem materia et arte mirandum, erat enim de saphiro factus, praefatus episcopus (Odo) anstulit.*'

9 *Liber de Monasterii de Hyda*, ed. E. Edwards, Rolls Series (London, 1866), p. 296: '*Eodem fere tempore Oddo, frater regis et episcopus Baiocensis, Comesque Canciae, in superbia elatus inter caetera praesumptionis suae opera apostolatum Romanae affectaverat. Etenim infinitum auri et multitudinem quibusdam Romanis quos muneribus illexerat per occultos nuntios destinavit, sibique palatium summo decore tantoque aedifico et vallo munitum fabricari fecit, ut nulla ei domus in Roma, ut aiunt, possit compari.*'

10 *Op. cit.*, III, p. 189; '*palatiumque suum sumptibus et superfluis apparatibus exornavit*'.

11 Lines 994–6, ed. F. Klaeber 3rd ed. (New York, 1941):

> 'Goldfag scinon
> web æfter wagum, wundorsiona fela
> secga gehwylcum, þara þe on swylc staraδ'

12 CXVII, 1842–3:

> 'Don, vostre ostaus e genz [a] mauviz
> Toz portenduz de pailes e de tapiz'

13 See LV, 52–3:

> 'Tan espez jat sos pailes e siglaton
> Qu'on'n'i'veit mur ne piere, fust ne carbon'

and CXIX, 1897–1900:

> 'N'i chausiz mur ne pere, fus ni asclaz
> Mais cortines de sede ellui buschaz
> Envols mes mellos pailes qu'ainc veissaz'.

historically is the statement in both Ordericus Vitalis[14] and Wace[15] that, after the death of William the Conqueror, several dishonest servants carried off hangings from his palace at Rouen.

Of some interest in this connexion is the poem of Baudri de Bourgueil[16] which was addressed to William's daughter, Adèle, countess of Blois. This was written in the late eleventh or early twelfth century – possibly before but, in any case, not long after[17] the death of Odo of Bayeux who did not himself die until 1097. It gives an account of Adèle's chamber. Baudri describes the enormous size of the room and speaks with admiration of the beauty of the hangings, on which were depicted epic deeds from biblical story and classical legend. These, however, were surpassed in richness by the embroidery hung round the large recess which contained the bed of the countess (lines 207–572). On this was depicted the Norman Conquest. Now, though there are bound to be a few similarities in the depiction of the same well-known theme, the description which Baudri gives is not of our tapestry – even the materials are different. But what is significant is that this type of hanging was associated in the contemporary mind with a secular context. And if a hanging with this theme could – whether in fact or imagination – decorate the spacious bed-chamber of a countess then we might well suppose that something comparable but larger might have ornamented the palace of her more ambitious and splendour-loving uncle.

Such a view should, I think, be given serious consideration, especially since I think that the Tapestry has much in common with contemporary secular poetry – I mean the French heroic epic, the *chansons de geste*.

That *chansons de geste* were known at the time of the Bayeux Tapestry seems probable. Whatever our assessment of the different views of their origins represented by the writings of Joseph Bédier[18] and R. Menéndez Pidal [19] it is generally considered that they were known in some form in the second half of the eleventh century. It even seems probable that there was a *jongleur* at the Battle of Hastings. The late twelfth-century evidence of Wace[20] on this score is, of course, inconclusive, but the

14 Ed. cit. III, p. 249: '*Inferiores vero clientuli … vestes et linteamina omnemque regiam supellectilem raptuerunt …*'
15 *Le Roman de Rou*, lines 14366–9:

> '*Véissiez mult servenz errer,*
> *E cels issir é cels entrer:*
> *Veles e covertours embler*
> *E quent k'il porent trestorner.*

16 *Les Oeuvres poétiques de Baudri de Bourgueil*, ed. Ph. Abrahams (Paris, 1926), pp. 197–231.
17 It is dated in *ibid.*, p. xlix to 1099–1101 but without reasons given.
18 Joseph Bedier, *Les Légendes epiques*, 4 vols (Paris, 1914–21).
19 Ramon Mendez Pidal, *La Chanson de Roland et la tradition épique des Francs* (Paris, 1960).
20 *Le Roman de Rou*, lines 13149–55:

> '*Taillefer, ki mult bien cantout,*
> *Sor un cheval ki tost alout,*
> *Devant li Dus alout cantant*
> *De Karlemaine è de Rollant,*
> *Et d'Oliver è des vassals*
> *Ki morurent en Renchevals*'.

almost contemporary poem of Guy of Amiens[21] and the early twelfth-century chronicle of William of Malmesbury[22] is important testimony.

This brings us to the fundamental question of what was a *chanson de geste*.

On its most elementary level, its entertainment value certainly lay primarily in the description of battles and the thrills and spills of action, even though, today, these can become tedious to the reader. The distinguished Spanish authority, Professor R. Menéndez Pidal has even compared them, in this regard, to the modern Western. 'Voici un cavalier qui en frappe un autre, brisant sa lance, disloquant son heaume, fendant son écu ou son armure, l'arrachant de sa monture et le jetant sur le sol' c'etait toujours un spectacle désiré, comme aujourd'hui, dans les salles de cinéma, les monotones combats, luttes et bagarres que nous offrent les "Westerns".[23] This overwhelming interest in warfare is expressed quite freely in the *chansons* themselves.

> 'Plaist vus oir de granz batailles ed de forz esturs'

begins the chanson of *Guillaume* (line 1).

> 'Bone chançon plest vos que ge vos die,
> De haute estoire et de grant baronnie'

commences the *chanson of Girart de Vienne* (lines 2 and 3); and

> 'Plest vous oir d'une estoire vaillant'

is the opening of the epic *Le Couronnement de Louis* (line 2). There can be no *chanson de geste* without military action. A *chanson* without a battle is as unthinkable as an Italian opera without an aria.

On this level, the parallel with the Bayeux Tapestry needs no underlining. Here, we shall naturally remember the considerable amount of space given up to the Battle of Hastings (pls 20–6) and the various preparations for it (pls 18–19), but we should also recall that a good deal of interest had already been shown in the warfare in Normandy (pls 8–9) when William fought with Harold as his ally against Count Conan of Brittany and captured Dol and Dinan. This emphasis on fighting, the amount of space given up to warfare, the interest in detail, are the same in the Tapestry as in the *chansons*. The attitudes of mind are also similar. The battlefield is not simply a stage for pride and plumage. We are not spared the bloodshed and gore and simple self-interest – 'la hideur miséable des mourants et des morts … décrite sans ménagement'.[24] As the border scenes of the Battle of Hastings (pls 21–3) register the stark realities of warfare with horses fallen and corpses littering the ground, some with heads or arms or legs cut off, so the epics, too, record such gruesome facts. 'What a fierce battle you might have seen there', says the poet of *Raoul de Cambrai*, 'lances

21 Menendez Pidal, p. 271.
22 Quoted *ibid.*
23 *Op. cit.*, p. 434.
24 Jean Frappier, *Les Chansons de Geste du Cycle de Guillaume d'Orange* (Paris, 1955), p. 200; cf. also pp. 304–5.

broken, shields splintered ... horses that will never neigh again, hands and feet on the ground ... so many knights disembowelled.'[25] Or, again, in *La Chanson de Roland*: 'There you would have seen much distress with many men killed and wounded and bleeding, lying on each other, on their faces and on their backs'.[26]

In this context, it is worthy of comment that, when William, urges his men to battle, he himself uses just the idiom of the *chanson de geste*. The inscription in the Tapestry tells us that he exhorted them to fight *viriliter et sapienter* – valiantly but sensibly (pl. 20). Now, the conventional idea of the epic hero (to which a whole literature has been devoted) was that he should exhibit just this combination of valour and good sense – that he should be *sage et preu* or *sage et hardi*.[27] In *Raoul de Cambrai*, Guerri remarks to Raoul that he would not give a glove for knighthood where valour is not combined with good sense[28] and, of course, in the *Chanson de Roland* itself the two virtues are typified by the two heroes, Roland and Oliver:

> *'Rollant est proz e Oliver est sage'* (line 1093)

It would be generally agreed that the action of the *chanson* is battle, but this needs some motivation and here we come more closely to the relationship between the Tapestry and the *chansons de geste*.

The existence of the two types of *chanson* – the crusading and the feudal – does something to obscure the problem as a whole though, even here, the differences are perhaps more apparent than real for religion itself tends to be seen in terms of feudalism and (as a later quotation will indicate) the pagan is someone denying allegiance to his rightful spiritual *seigneur*. Questions of weakness and pride and *démesure* and emotional relationships certainly enter into the picture but one primary concern of the *chansons* is with the principles of feudalism itself – in a word, with feudal loyalty and disloyalty. In particular, the themes of the *chansons* are much concerned with treason and treachery. This, indeed, is so much to be expected that one poet will even find it necessary to warn us when this is not to be his topic. This, we find, in the *chanson of Girart de Vienne* which says (lines 4 and 5):

25 Jessie Crosland's translation in text. CLXXI, 3469–75 and CLXXII 3484–5:
> *'En l'estor vait le chaple maintenir.*
> *Et tuit li sien: fierent par air,*
> *Dont veissiés fier estor esbaudir,*
> *Tante anotre fraindre et tant escu croissir,*
> *Tant bon hauberc desrompre et dessartir,*
> *Tant bon destrier qui n'a soign de henir*
> *Tant pié, tant poing, tante teste tolir;*
> *Il esgarda contreval la vaucele,*
> *Voit tant vasal trainant la boele'.*

26 Lines 1665–8:
> *'La veissez si grant dulor de gent,*
> *Tant hume mort et nasfret e sanglent*
> *L'un gist sur l'aitre e envers e adenz'.*

27 See Bedier, III, p. 432, Frappier, pp. 160 and 185, Menendez Pidal, pp. 340–3.

28 CXCII, 4031–2:
> *'Chevalerie ne pris je pas.j. gant*
> *Ne vasalaige, se n'i asens grant'.*

'Ceste n'est pas d'orgueil ne de folie
De traison ne de losengerie'.

The obvious archetype for the motivation of the French epic is the *Song of Roland* where feudal and crusading themes intermesh with each other. The action of the *chanson* is, of course, the battle of the Franks in Spain under the leadership of Roland who epitomizes feudal loyalty to his seigneur. But what led to the battle itself, what was its motivation? It is the felony of Ganelon, the epic traitor –

'Ganelon qui par sa tricherie
En grant dolor mist France la garnie'.[29]

It was his betrayal of his duties as vassal by making cause with the Saracens that caused this particular fateful battle. And let us remember that when his action was known, it was not the deflowering of the Frankish army and the deaths of the warriors Roland, Oliver and Turpin that led to his downfall. The barons could exculpate all this if it was only prompted by personal revenge.[30] What brought him to his ultimate judgement was the charge of treason. As this is the issue of his trial by combat[31] so a major part of the motivation pivots on the treachery of Ganelon which is already anticipated at the beginning of the poem:

'Ganelon was there who performed the treason'.[32]

The theme of so many *chansons* of treason and deception is, of course, also the theme of the Bayeux Tapestry. It is the story of feudal allegiance developed and finally confirmed, of feudal allegiance betrayed and inevitably punished. Indeed, Harold's treachery is seen on different levels. It is the treachery of an earl who betrays the will of his own king – Edward the Confessor. It is the treachery of a man to the saints on whose relics he has sworn. But primarily it is the treachery – as in so many *chansons* – of a vassal to his legitimate feudal seigneur, a treachery made all the more infamous – as in some of the *chansons* themselves – by the fact that, on a personal level, the seigneur has already shown himself to be the vassal's saviour and friend.

The very first scene finds Harold committed to William's party for (following the Norman[33] but not Anglo-Saxon version of events) he accepts from King Edward

29 *Girart de Vienne*, lines 22 and 23.
30 Lines 3761–3835.
31 Menendez Pidal, p. 137 (also pp. 322 and 323). On the question of treachery see also Andrew Burger, 'Les deux scènes du Cor dans la Chanson de Roland', p. 114 in *La Technique littéraire des Chansons de Geste*, Actes du Colloque de Liège, September 1957 (Paris, 1959); and Jessie Crosland, *The Old French Epic* (Oxford, 1951), p. 167.
32 Line 178: *'Guenes i vint, ki la traisun fist'.*
33 The narrative, as a whole, certainly reflects the Norman view of Conquest and there is nothing here which conflicts with French literary sources. English accounts were, of course, not less coloured than French ones but we should at least, realise that we are seeing historical events through the eyes of the Norman. Later English versions claimed that Harold was on a pleasure trip when he was shipwrecked on the coast of Ponthieu (Freeman, III, p. 671 ff.) and the most reliable of the English chroniclers (William of Malmesbury) says he was on a fishing expedition (*ibid.*, pp. 677 ff.). In the Tapestry, however, he is shown leaving England with hounds and falcons – not the most

the leadership of the embassy that is to promise William the crown (pl. 1). Treason now will already represent betrayal not only of a Norman duke but of an English king. The following scenes show Harold becoming more and more involved on a personal level in the duke's allegiance, so that William might later say with even more justification than Charles Martel in the *chanson* of *Girart de Roussillon*[34] that he has been betrayed by one who has eaten of his bread and drunk of his wine. Shipwrecked on the French coast (pl. 3), he is imprisoned by Guy, count of Ponthieu, but is rescued by William who meets him in person and escorts him to his palace (pls 6–7). Harold's entry into William's service in the war of Brittany is at once an acknowledgement and intensification of the new personal relationship underlined by the account of Harold's personal prowess (pl. 8). We may note that, on the feudal level, Harold is apparently already depicted rendering to William the two primary services of the vassal – *consilium et auxilium*. This is not without ironic comment on his own later position for – according to the Norman version – this was a campaign to put down the rebellion of a disloyal feudal vassal. What follows is the formal contract of allegiance. This is seen in the ensuing episode where Harold is given arms by Duke William. The arms which Harold receives from William have understandably been given much emphasis in the light of the inscription above, but the pennon which he holds may carry overtones. Carl Erdmann's researches into the concepts of the period have shown that the banner was the symbol of feudal vassalage.[35] In other words, there may possibly be a hint here that Harold is not simply receiving knighthood from William, but the investiture of his own possessions which is in complete consonance with the Norman version of events where Harold anticipates William's own coronation by offering fealty for his lands in England.[36] The succeeding oath on the relics (pl. 10) is certainly momentous, but it does no more than heighten and epitomize what has gone before. It is the seal on the document which has already been written. Such oaths on relics are, in fact, a familiar ingredient of the *chanson* tradition. In the epic of *Girart de Roussillon* the betrothal of Berthe to Charles was confirmed on relics,[37] Fouque promised on relics to marry Aupais,[38] and later swore on relics that

obvious equipment for catching fish at sea! Their presence accords perfectly with the Norman story that Harold was sent by King Edward to promise William the crown (cf. Guillaume de Poitiers, *Gesta Guillelmi*, ed. Foreville, p. 100) for these are gifts intended for William. We know from secular epics that falcons and hounds were much prized gifts – they were, for example, among the presents promised by the pagan king, Marsile, to Charlemagne in *La Chanson de Roland* (lines 127–9); and Wace specifically says – though in a different context – that Edward gave William dogs and birds and 'whatever other good and fair gifts he could find that became a man of high degree' (lines 10548–52). We may note that they stay with Harold despite his vicissitudes until he reaches William's palace at Rouen when they disappear. The subsequent course of events is seen from the Norman standpoint and, though more balanced and less prejudiced than chronicles like that of William of Poitiers, this is still history as seen by the Norman conqueror.

34 CCCLX, 5540–4.
35 Erdmann, *Die Enstehung*, p. 173 ff.
36 Cf. Guillaume de Poitiers, *Gesta Guillelmi*, ed. Foreville, p. 104 and note 2.
37 XIX, 243–53.
38 DLXXV, 8393–5.

he had never touched her honour.[39] In the *chanson* of the *Covenant de Vivien*, the whole action pivots on an oath made by the hero on a Gospel Book. In *Raoul de Cambrai* the emperor and the forty hostages promised Raoul his fief by an oath on relics;[40] it was on relics that Gautier swore that Bernier was a traitor[41] and on relics that Guerri made his vow to avenge Gautier.[42]

This part of the Tapestry concerned with Harold's embassy to Normandy is then by no means a simple chronicle of events. It is an explanation at various levels of Harold's obligations and indebtedness to William so that when Harold does accept the crown the full depths and breadths of his treachery can be gauged by the medieval spectator. And once Harold is crowned, the future is certain – the inescapable scenes of warfare and carnage, the unavoidable fate of the feudal traitor. As Ganelon's betrayal brought death to himself, so Harold's betrayal brought death to himself and defeat to his nation. 'A traitor', as the Song of Roland says, 'causes both himself and others to perish'.[43]

If there is some relationship between the Bayeux Tapestry and the *chansons de geste* both in terms of entertainment and of motivation, there are also points of comparison in the characterization. When Professor Frappier describes the *chansons de geste*, he might, in fact, be describing the Bayeux Tapestry: *plus vigoureux que nuancé, plus enclin à l'expression dramatique des élans collectifs qu'à l'analyse des sentiment individuels.*[44] The figures of the Tapestry, like those of the *chansons*, are indeed types rather than persons but, as types, they are still in keeping with the traditions of the secular epic.

It may well surprise us today, for example, to see how the stature of Harold, the villain, is never diminished. He is even given the title of *Dux Anglorum* to which in reality he had no claim for he was, of course, simply earl of Wessex. In some ways, he is seen in a better light even than William. For instance, he is the only leading character who actually goes to church to pray (pl. 2). At Hastings, he is certainly shown as no coward and in the earlier wars in France when he fought as William's ally, his strength is extolled over that of the rest of the army. On the way to Brittany, the army have to ford a river and he is depicted using his great frame and superior strength to save the Norman horsemen who have fallen into the quicksands. (pl. 8). This is in striking contrast to clerical accounts like that of William of Poitiers[45] where every attempt is made to demean his character. All the same, this does not indicate the impartiality of the Tapestry as some historians have suggested. It is simply part of the tradition of the French epic. For the traitor of the *chanson* was never weak or feeble. On the contrary, he may be more strong and powerful than the hero who is proportionate in all things. (In the crusading *chansons*, the pagans are often giants[46]

39 CXCIV, 8688–92.
40 XXXVII, 791.
41 CCXXVIII–CCXXIX, 4948–60.
42 CCXXXIV, 5101–4.
43 Line 2959: '*Ki hume traist sei ocit e oltroi*'.
44 Frappier, *Chansons de Geste*, p. 89.
45 Cf. ed. cit., pp. 204–6.
46 Crosland, p. 273; also Bedier, I, p. 228; and Frappier, pp. 91, 94.

and, in the *Chanson de Roland*, we may remember that Charlemagne was only saved from the superior prowess of the pagan Baligant by the intercession of the angel Gabriel.[47] He is handsome and vigorous and always courageous. If he has a fault, it is that of *démesure* but primarily his flaw is of feudal allegiance – whether allegiance as feudal baron to his secular, or as infidel warrior to his spiritual seigneur.

So the archtraitor, Ganelon himself, was conscientious in religious observance and when threatened with death alone among the pagan host, was completely intrepid. In appearance, he was 'noble of form and of large physique – so handsome is he that all his peers gaze on him'.[48] Or again, 'his body was strong and his face the colour of a good man. Had he been but loyal, he would have looked a fine baron'.[49] The same attitude with precisely the same reservation in religious-feudal terms is shown in descriptions of the pagans. Compare, for example, that of the pagan leader, Baligant: 'He is of fine physique with large arched legs, lean flanks and deep chest. His shoulders are broad, his face very bright, his countenance fierce and his head curly … He has often proved himself as a soldier. God! what a baron had he been but a Christian'.[50] The villain of the *chanson*, like that of the Tapestry, may be heroic – even gigantic – in form but, for all that, he is no less a villain. For villainy lies not in feebleness of frame or cowardice in battle, but in terms of feudal loyalty, whether this be expressed in secular or in religious terms.

To some degree, the Tapestry might seem a Song of Roland without its hero, Harold is comparable in some ways with Ganelon but, where is the embodiment of feudal loyalty, the faithful Roland? There is, in fact, no Roland but there is a Turpin. Archbishop Turpin, we may remember, was – with Oliver – Roland's companion at Roncesvalles, and it is in at least a comparable role that Bishop Odo is depicted.

Archbishop Turpin was certainly ready in the French heroic epic to perform ecclesiastical office and in warfare to absolve the warriors before battle, offering them the last consolations in death. But he was primarily depicted in a more secular sense as the valiant baron, the loyal feudal vassal.[51] In the *Chanson de Roland* he is first introduced to us as the feudal baron in council[52] and, thereafter, he is primarily sustained

47 Lines 3602–19.
48 Lines 284–5: 'Gent out le cors e les costez out larges;
 Tant par fut beis tuit si per l'en esguardent'.
49 Lines 3761–4: 'Devant le rei la s'estut Guenelun
 Cors ad gaillard, el vis gente color,
 S'il fust leials, ben resemblast barun'.
50 Lines 3157–64: 'La forcheure ad asez grant li ber,
 Graisles es flancs e larges les costez,
 Gors ad le piz, belement est mollet,
 Lees les espalles e le vis ad mult cler,
 Fier le visage, le chef recercelet
 Tant par ert blancs cume flur en estet.
 De vasselage est suvent esprovet.
 Deus! quel baron, s'oust chrestientet'.
51 Edmond Faral, 'A propos de la Chanson de Roland', *La Technique littéraire des Chansons de Geste*, pp. 275–6.
52 Line 170.

in this role. 'No tonsured clerk', says the poem, 'ever sang mass who wrought such physical acts of prowess'.[53] He himself exhorts his comrades: 'Lord barons, Charlemagne left us here and we should die for our king'.[54] Or, again, 'A good soldier will never be untrue while he is alive'.[55] The archbishop speaks much of his loyalty to the emperor and his faithfulness as a vassal. He aids in councils of war, encourages and leads the troops, cleaves the pagan in twain and kills hosts of the enemy and, even in death, he is first the proud baron – 'Turpin is dead, the warrior of Charlemagne.'[56]

The fate of Odo is not that of Turpin but his role is at least comparable – the belligerent and loyal feudal vassal, perhaps in some ways the antitype to Harold. Like Turpin, Odo joins with his seigneur in council of warfare (pl. 18), leads his troops into action, gives blow for blow in combat and exhorts his followers to action (pl. 24). Unlike Turpin, however, he is never seen at ecclesiastical office. The closest he gets to religious service is to say grace before a great feast which is here portrayed with the affectionate detail of any *chanson* (pl. 18). As Harold resembles the epic traitor Ganelon, so Odo, in fact, resembles the epic bishop, Turpin. Like Turpin, we can imagine him with weapon in hand rather than prayer on lips crying: 'for our king it behoves us to perish'.[57]

Religion did, of course, have a part to play in the epic poem but it is a religion far removed from the spirituality of St Anselm. The conventions are certainly observed, masses are said and relics may be mobilized to secure divine intimidation but primarily religion is seen as a support to the whole feudal system. In *Girart de Roussillon* the pious hermit faced with the person who had dared attack his seigneur declares: 'Theology and writers show us in the law of the Redeemer what justice should be meted out to the traitor. He should be torn apart by heroes, burnt on a fire and where his ashes fall nothing will ever grow.'[58] 'Serve thy seigneur' says the nun in *Raoul de Cambrai*, 'and God will be thy portion.'[59]

There are obvious dangers in attempting to make generalizations about the religion of the feudal *chansons*, but it is certainly a religion seen from the point of view

53 Lines 1605–8: *'Par le camp vait Turpin, li arcevesque*
 Tel coronet ne chantat unches messe
 Ki de sun cors feist tantes proecces'.

54 Lines 1127–8: *'Seignurs Baruns, Carles nus laissat ci:*
 Pur nostre rei devum nus ben murir'.

55 Line 2088: *'Ja bon vassal nen ert vif recreut'.*

56 Line 2242: *'Morz est Turpin, le guerreier Charlun'.*

57 Line 1128: *'pur nostre rei devum nus ben murir'.*

58 DXXIII, 7505–11: *'Que la divinitaz e li autor*
 Nos mostrent en la lei au Redenptor
 Qual justise on deit faire de tracor:
 Desmenbrar a cheval, ardre a chalor;
 La poudre de celui, lai o chai por,
 Ja pois n'i'cresit(e)ra erbe ne labor
 Arbres ne rins qui traie a verdor'.

59 LXVII, 1386–8: *' "Fix", dist la mere, "par ma foi, droit en as.*
 Ser ton signor, Dieu en gaaingneras".'

of the lay aristocracy rather than that of the cloister. Monks are even obliquely associated with cowardice in *Raoul de Cambrai*[60] where also the Countess Aalais contemptuously equates the nun with the waiting maid.[61] In another epic, the monastic life can be held up to some ridicule.[62] Strangest of all, to modern sensibilities, is the way in which religion as a universal ethic can be subordinated to the expediency of secular power-politics without incurring the obloquy that would attach to feudal infraction. Girart de Roussillon, for example, burns a monastery with its inhabitants and the knights seeking sanctuary therein[63] and despoils religious houses of their reliquaries, crosses and sacred vessels[64] but, as we have seen, in the eyes of the hermit this is not his sin but his attack on his lay seigneur. In *Le Couronnement de Louis*, the hero, Guillamme, commits murder in church. In *Raoul de Cambrai*, Raoul, though meticulous in religious observance, wishes to have the church on his enemy's territory desecrated, the buildings destroyed and the nuns raped by his knights[65] and his subsequent actions certainly lead to the nuns being burnt alive in their quarters.[66] These intentions and deeds are not, of course, condoned but, nevertheless, the poet is soon able to say of their author: 'In the whole of France there was no fairer knight nor better fitted to bear arms'.[67]

Religion, then, in the epics may be a support to the feudal system but it can also at times be subordinated to it. It must share its influence with other criteria and other sanctions. It is not so much the dominating power of social society as an integral part of it, closely and easily related to other less spiritual aspects of contemporary life that a more clerical literature would eschew.

We find at least some reflection of this attitude of mind in the Bayeux Tapestry. Such scenes of religion as there are emerge simply as aspects of a wider feudal context. The oath scene is one feature of those personal and feudal relationships between William and Harold that has so far absorbed all the time of the artist (pl. 10). The death of Edward and the coronation of Harold are represented because they change the balance of feudal relationships (pls 12–13). Even the representation of the church at Bosham (pl. 2) may be an oblique reference to a purely secular theme – namely to the tradition that the manor on which it was placed had been obtained by a trick from Archbishop Robert by Harold's father Godwin.[68] The concept of treachery running in families is by no means alien to the *chanson* tradition.[69] We may certainly observe here that the feast at Bosham is given as much emphasis as the visit

60 CLI, 3013–4.
61 XLIX, 1009–10.
62 Brian Woledge, 'Valeur Littéraire du Moniage Guillaume', *La Technique littéraire des Chansons de Geste*, p. 23.
63 CCCCXVII, 6190–4.
64 CCCCXVIII, 6201–9.
65 LX, 1229–44.
66 LXXI, 1477–95.
67 LXXIII, 1549–50: *'En tout France n'ot plus bel chevalier*
Ne si hardi por ces armes baillie[r]'.
68 Freeman, *Norman Conquest*, II.
69 Crosland, *Old French Epic*, p. 183.

to the church which precedes it, thus evincing the same balance between religious observance and social custom that we find in the *chansons de geste*. A more startling association of religion with the secular manners of the time is seen in an enigmatic scene which follows Harold's arrival at Rouen. Here, a priest – shown with a woman conspicuously identified as Ælfgyva – is associated with a pornographic scene in the border (pl. 7). The same ingenuous juxtaposition of the soul and the flesh is found in the *chansons* where, in *Girart de Roussillon*, Pierre de Mont-Rabel goes happily to mass at daybreak after a night spent in fornication.[70] The identity of the Ælgyva in the Tapestry has eluded all historians despite an ingenuity which sees her in roles varying from that of William's daughter or Harold's sister[71] to that of a witch.[72] But, whatever the actual episode represented, was this prominence given to the name Ælfgyva in a dubious context to remind onlookers of another form of treachery? For scandal affirmed that a former king of the Anglo-Saxons, Cnut, had been betrayed by his Danish wife, Ælfgyva of Northampton, who had passed on to him one son, Svend, by a priest, and another Harold, by a shoemaker.[73]

If it is clear from all this that the Bayeux Tapestry reflects some at least of the attitudes of mind of the *chansons de geste*, it will also even adopt comparable techniques.

When Harold has been enthroned we are shown an augury from heaven in the form of a comet which is brought to full significance by the gesticulating spectators below (pl. 14). Such portents are familiar enough in the French epics – storms and flames from the skies in *Girart de Roussillon*, the eclipse of the sun and division of the sea in *Gui de Bourgogne* and the darkness at noon of *La Chanson de Roland*. However, they are also familiar enough in other forms of literature, including contemporary chronicles and the poetry of other periods, so it is important to give attention to a device which, though not unknown in classical literature,[74] is more familiar to the *chansons de geste* as a genre.

This is the device of what we might call the 'editorial aside'. Quite often, we find the poet will interrupt his action in order to address himself direct to the listener about what is to happen. By this means he can heighten present tension by anticipating future action. When, for example, we are already a short way through the Song of Roland and the ill-omened council of Charlemagne begins, the poet foretells something of the unhappy future ahead in an aside: 'Ganelon came there who [later] made the betrayal and then begins the council which turns to such ill'.[75]

70 CCCIII, 4641–6.
71 Freeman, *Norman Conquest*, III, pp. 696–9.
72 Vilhelm Kil, 'Hliðskjalf og seiðhjallr', *Archiv för Nordisk Filologi* 75, p. 88 – a reference I owe to the kindness of Mrs P. Dronke.
73 Freeman, *Norman Conquest*, I, p. 453.
74 For example, Professor Erwin Panofsky has most kindly drawn my attention to Aeneid I, 712 and to the description of the Shield of Aeneas which, like a pictorial 'editorial aside' foretells the future of the Roman Empire up to the time of Vergil's writing.
75 Lines 178–9: 'Guenes i vint, ki la traisun fist.
 Des ore cumencet le cunseill que mal prist'.

Most *chansons de geste* provide a few example of this 'editorial aside'.[76]

Now I would suggest that we can find two examples of this device of the *chansons de geste* in the Bayeux Tapestry itself. The first is the depiction of the future Norman invasion which is shown very simply in the border when Harold, after his coronation, listens to the news about the comet (pl. 14). This is, in effect, a pictorial aside in which the artist foretells the future disaster that will face Harold as a result of his disloyal action in receiving the crown that rightly belongs to another. Compare with this the editorial asides of the epic *Raoul de Cambrai* which prophesy the calamitous future when Gibouin accepts the fief which rightly belongs to another: 'and Gibouin on his side acted like a felon when he desired the land of another as his fief. It caused him afterwards to die a shameful death'[77] and 'Now, if God … prevent it not, a fief is about to be given and bestowed as a result of which many a knight will lie prone in death'.[78] In *chansons* like *Raoul de Cambrai*, we find the editorial aside used not only to anticipate a particular event but also the whole motivation of the plot. I would suggest that we find this also in the Bayeux Tapestry. Here, I am thinking of the fable scenes which follow in a sequence in the lower border and which Dr H. Chefneux has shown were taken from an Anglo-Saxon collection of fables now only known to us through the twelfth-century French translation of Marie de France.[79] I am aware, of course, that some of the borders of the Tapestry contain purely decorative figures. But some scenes of the borders are clearly associated with the main narrative and are meant to be 'read' in conjunction with it – for example, the gory details of the carnage below the narrative account of the Battle of Hastings (pls 21–3), the eels and the fish below the quicksands from which Harold rescues the Norman knights in the Breton campaign and which comment on their poisonous and aqueous nature (pl. 8) and, again, the premonition of invasion below the scene of Harold enthroned which we have just discussed (pl. 14). For at least two reasons we must place the sequence of fable scenes in the latter category. We may note that they accompany Harold when, after leaving the saintly presence of King Edward and the religious atmosphere of Bosham, he embarks from England on his path to perfidy and treason in Normandy. But what is particular significant about them, when we read the collection as a whole[80] is that they have all been selected to

76 Professor D. H. Green, to whom I am considerably indebted for general discussions of points raised in this article, has drawn my attention to the fact that there is a close parallel to these 'editorial asides' in the Millstätter Exodus where the 'anticipatory formulas' are (as in the Bayeux Tapestry) particularly connected with the idea of feudal loyalty.

77 X, 136–9: 'Et Gibrouin refist molt grant outraige
 Quant autrui terre vost avoir par barnaige
 Puis en fu mors a duel et a hontaige'.

78 VIII, 110–21: Se Dex n'en pense qi de l'aigue fist vin
 Tex onnor est donnez et traiz a fin
 Dont mains frans hom en giront mort souvin'.

79 H. Cheveneux, 'Les fables dans la Tapisserie de Bayeux' *Romania* 60 (1934), pp. 1–35 and 153–94. For the more abbreviated fables, see now Leon Hermann, *Les fables antiques de la broderie de Bayeux*, Collection Latomus LXIX (Brussels, 1964).

80 Kark Warnke, *Die Fabeln der Marie de France* (Halle, 1968), and pp. xlvi–vii and 327–8 for their Anglo-Saxon origin.

point the same kind of moral. It is, indeed, the very moral of the main narrative –
the moral of treachery and betrayal. One tells of how the wolf is made king in the
lion's absence.[81] Fearing that the wolf's appetite is stronger than his allegiance, the
lion makes him swear an oath (in which relics are referred to)[82] that he will never eat
flesh. This the wolf does but with every intention of perjury. And, indeed, by
various subterfuges culminating in sheer brute force, he finally does succeed in
eating up all the lion's subjects, thus breaking his oath and his allegiance to the real
king. Another portrays the lion who this time breaks his word and betrays his
companions and, instead of sharing the quarry they have together caught with the
cow, sheep and goat, he takes the four quarters for himself – the first three by guile,
the fourth by sheer force.[83] We find the goat who asks the wolf to give his life a short
reprieve so that he can say mass, but who immediately betrays his word and calls to
the shepherd and dogs from the hilltop.[84] We see the pregnant bitch who obtains
the house of her companion on the pretext that she must have a place in which to
give birth to her litter but who breaks her word by refusing to release it after her
delivery;[85] the wolf who refuses to give the crane the promised payment for remov-
ing the bone from its throat;[86] the fox who by lies and guile steals the cheese from
the crow,[87] the wolf full of deception to the lamb on the river[88] and the frog who
offers the mouse a home across the water but who betrays it.[89]

Particular parallels with the Harold story are not far to seek – animals who, like
Harold break their word and their faith, animals who, like Harold, seek what does
not belong to them, animals who, like Harold, at Hastings, will ultimately offer
brute resistance. They are brutal, they are covetous, they are perjurers. But what
characterizes them all is that they are betrayers. This, of course, is the essence of
the main narrative of the Tapestry. In fact, the very 'editorial aside' device of the
chanson tradition is here used to foretell the time so dear to the epic poets – the
theme of treachery and betrayal.

From all this, one may be justified, perhaps, in suggesting that – whether the
association be conscious or unconscious – there is some consonance between the
Bayeux Tapestry and the *chanson de geste*. Both base their stories on events of actual
history: both seek the same form of entertainment and think in similar terms of
motivation and of characterization: both reflect similar attitudes of mind and even
use similar technical devices. Both in fact, represent the secular art of the same
feudal society.

This is not without significance both from the particular point of view of the
date of the Tapestry and from the more general point of view of its place in the
contemporary cultural context.

If the Tapestry was not specifically intended for Bayeux Cathedral, then it is no
longer necessary to assume that it was made before the date of its consecration in

81 Warnke, XXIX.
82 *Ibid.*, line 31
83 Warnke, XI.
84 Warnke, XCIII.
85 Warnke, VIII.

86 Warnke, VII.
87 Warnke, XIII.
88 Warnke, II.
89 Warnke, III.

1077. The *terminus ante quem* is the death of Odo in 1097. It is not entirely impossible that it was made as a *pièce justificative* after William's death and Odo's release from imprisonment in 1087, but it would clearly be historically more plausible to place it before Odo's arrest in 1083 when he was at the height of his power.

Finally, in the general contemporary context, it merges with new claims to distinction and even to uniqueness. It not only shows an association with contemporary secular poetry unparalleled in the period but is, in fact, the only important monument of secular narrative art that has come down to us from the eleventh century.

8

The Authority and Interpretation of the Bayeux Tapestry

N. P. BROOKS and the late H. E. WALKER[1]

The Bayeux Tapestry is a major work of art as well as a major historical source for a crucial episode of European history. Herein has lain its great interest for historians and antiquarians ever since its rediscovery by Lancelot and Montfaucon in the early eighteenth century. This huge embroidered frieze or strip-cartoon is the only surviving work of its kind; and such is the vigour and quality of its design that it dominates our conception of what Normans and Englishmen of the eleventh century looked like. It can even survive being repeatedly ransacked by modern political cartoonists and poster artists. But the qualities that make the Tapestry (it would be pedantic to call it anything else) fascinating and popular also make it difficult for historians and archaeologists to use. It is not easy to establish the authority and provenance of a unique, anonymous and undated work; nor can we determine whether its pictorial narrative is in any way dependent upon extant written sources until the interpretation of crucial scenes is settled. But similar difficulties also arise in interpreting the Tapestry: the inscriptions above each scene are necessarily very short and often imprecise, whilst the significance of apparent visual parallels with works in different media – manuscript illumination, wall-painting, sculpture and carving – must remain uncertain until the Tapestry can be accurately dated and located.

The authority and interpretation of the Tapestry are therefore closely interrelated. There is a danger of a circular argument in which neither the interpretation nor the authority are independently established. If we are to understand the conventions and purposes of the designer and embroiderers of the Tapestry we must begin with intensive study of the Tapestry itself. And although we can now do this

1 H. E. Walker, who was formerly senior History master at Winchester College and who died in 1964, made a lifetime study of the Tapestry through using it for teaching purposes, but never worked up his ideas for publication. This paper is based on a lecture that he delivered to the Winchester Historical Association in 1962, on conclusions that we evolved in correspondence and discussions over a number of years and on my own subsequent research into the problems that our discussions provoked. For much help in the interpretation of the Tapestry, I am also indebted to another of H. E. Walker's pupils, Professor C. N. L. Brooke. For any errors and for the form in which the argument is presented I am alone responsible.

with the aid of several excellent modern photographic reproductions,[2] we still lack a full critical edition. In particular we need to know which figures in the Tapestry are in original medieval wools and which are the work of nineteenth-century restorers. Since photographic reproductions obscure the differences in the wools it is still necessary for the scholar to travel to Bayeux. This is also particularly necessary since the pages of a book break the sequence and flow of the scenes of the Tapestry that are often crucial for their elucidation. As with manuscripts then, we must study the original itself, and not rely on facsimiles alone.

It may be best to begin therefore by reminding ourselves of some basic facts about the Tapestry and the conventions imposed by the limitations of its technique. The Tapestry is a huge embroidery – some 230 feet long and 20 inches high (70.34 metres by 50 cm.) – worked in coloured wools on a linen ground. Its technique is simple: the great masses of colour are covered by couch and laid work and the outline in stem or outline stitch. The back-ground is left blank, as are men's faces and hands. The eight different wools in the Tapestry are used carefully, but their purpose is decorative, not to be realistic. Thus men's hair may be blue or green as well as more natural red or brown. Horses are green, blue, yellow, red – in fact whatever colour provides variety and contrast. For the same reason the off-side legs of the horses are picked out in a different colour from the rest of their bodies. This decorative use of colour is one of the most important points to grasp about the Tapestry. It is for instance perfectly possible for the same man or the same horse to appear in consecutive scenes in utterly different colours.[3] This can make the problem of identifying figures a little difficult, and it is always necessary to think back beyond the colour to the original outline drawing of the artist/designer.

We will probably never know how many embroiderers worked on the Tapestry. Occasionally it is possible to point to a figure worked in two different directions – possibly by two different workers.[4] Changes in the colour of the wool used are not significant – they may only mean that one colour has temporarily run out. But we can learn something of how the Tapestry was produced. A close examination shows, as S. Bertrand has explained, that it was made in eight separate pieces.[5] These pieces are of uneven length which is one of several hints that the Tapestry workshop was experimenting as it proceeded with the work. The first two pieces are each over 13.5 metres long, but each of the next five pieces are only about half as

2 *The Bayeux Tapestry*, ed. Sir Frank Stenton, 2nd ed. London 1965 (hereafter cited as *BT*). This work is accompanied by a number of excellent critical studies. Important additional information may be found in S. Bertrand, *La Tapisserie de Bayeux* (La Pierre-qui-Vire, 1966). There is a full colour reproduction in L. Thorpe, *The Bayeux Tapestry and the Norman Invasion* (London, 1973); and there are some colour plates in C. Gibbs-Smith, *The Bayeux Tapestry* (London, 1973).

3 E.g. the horses of William's messengers in *BT*, pls 12 and 13, and Harold in *BT*, pls 7 and 8.

4 *BT*, colour pl. XIII.

5 Bertrand, *Tapisserie*, 24–5. The joins are not easily visible on modern reproductions. They occur in the following places: (i) *BT*, pl. 17, extreme left, immediately before the formalized trees. (ii) *BT*, pl. 33, between the words *Et* and *hic* of the inscription *Et hic defunctus est*. (iii) *BT*, pl. 41 extreme right. (iv) *BT*, pl. 48, after *ministraverunt ministri*. (v) *BT*, pl. 54, immediately before *ad prelium*. (vi) *BT*, pl. 62, between *Anglorum* and *exercitum*. (vii) *BT*, pl. 69, between *Hic* and *Franci*.

long, varying from 6.6 metres to 8.35 metres. The last piece, which is of course damaged and incomplete at the end, now measures only 5.25 metres which suggests that from 1.35 to 3 metres may have been lost from the end of this piece. The eight pieces of the Tapestry would seem to have been embroidered separately and then joined up. Some of the pieces even have distinctive treatment of the plants and animals in the border, perhaps indicating that different embroiderers or different teams of embroiderers, worked each piece.[6]

It would also seem that the workshop which produced the Tapestry had never made so large a work before, for the early joins of the separate pieces are not well done, so that the border in one piece is not at the same height as that of the adjoining piece.[7] Later the work was better managed and subsequent joins are difficult to detect, because the first few feet of each piece were left unembroidered until after the join had been made. There are other indications that the workshop was learning as it proceeded: for instance in its portrayal of coats of mail. The earliest attempts to represent the mailed 'hauberks' of the Norman knights try to be too realistic and the effect is fussy and unconvincing. Later after various experiments with square and diamond patterns (pls 9, 16), a consistent technique is achieved by portraying mail as a series of rather large contiguous circles (pls 20–1).[8] In these ways we can begin to get a picture of the tapestry workshop: the eight pieces of linen being worked – probably in turn – by a team of embroiderers; despite a few signs of carelessness and misunderstandings by the embroiderers,[9] the work is of remarkably consistent quality and this implies careful control; it would also seem from the joins and from the treatment of the mail that the workshop had never made a tapestry of this type or length before.

The artist who was responsible for the design of the Tapestry must have been provided with a narrative of the conquest, and from this he produced his designs and probably also the explanatory inscriptions. That this narrative was written and not derived orally from eye-witnesses is suggested by one scene,[10] where the artist appears to have misunderstood his narrative. In the Tapestry William is shown attacking the Breton town of Dol, and his enemy, Conan of Brittany escaping down

6 Thus the first two pieces alternate trefoils and animals in the border, but the third piece (from *BT*, pl. 33) omits the trefoils and substitutes twirly foliage and vines. The artist, rather than the embroiderers, may have been responsible for this; more probably attributable to the embroiderers is the different treatment of the inscription: very dark blue wool is consistently used in the first four pieces, thereafter alternating colours (from *Et hic episcopus cibum et potum benedicit, BT*, pl. 49). The previous inscription, *Hic fecerunt prandium*, was added after the pieces had been joined.

7 E.g. at the first join in the top border (*BT*, pl. 17, extreme left).

8 *BT* pl. 21 (too detailed), 24–5, 26, 27, 28 (squares, diamonds and circles), 40 (diamonds and squares); contiguous circles consistent from pls 54–5.

9 A common mistake in the embroidering is the mis-colouring of legs so that they belong to the wrong bodies, e.g. *BT*, pl. 14 where the legs of William's messengers are confused, as are those of the crowds at Harold's coronation (pls 34–5). There are also a good many figures which have not been properly filled in, e.g. *BT*, pl. 33, leg of man about to pick up the corpse, pl. 34, leg of noble pointing to sword of state; pl. 35, top of sword of messengers; pl. 42, leg of horse below *Willelm dux*; pl. 62, ground left unfilled beneath leading Norman horsemen.

10 *BT*, pls 23–4.

a (conveniently bent) rope. In fact we learn from the nearly contemporary and more detailed account in William of Poitiers[11] that Conan was never inside Dol at all, but was besieging it when William's relieving army appeared. The designer of the Tapestry has made an error, but it should be noticed that there is no mistake in the inscription which simply states, *Venerunt ad Dol et Conan fuga vertit* – which is perfectly accurate.

Human and animal figures in the Tapestry are nearly always shown in profile but occasionally full-face. The Tapestry is intended to be viewed from a distance, and the figures have therefore to be large and clear. Perspective is almost never attempted, for small figures in the background would be indistinct.[12] Within these limitations, imposed by his medium, there can be no doubt that the designer was an artist of genius. He captures brilliantly, for instance, the crucial stage in the battle when the Norman cavalry charges were being bloodily repulsed with great loss of life on both sides (pls 21, 23).[13] He portrays the straining, tumbling and terrified horses and men with an economy of line and a sense of composition that makes the whole lively and memorable. Few artists of any age have been able to portray horses so assuredly and so vividly. The designer of the Tapestry was an artist of the first order who portrayed the story he was commissioned to tell with accuracy, economy, and power. What then was this story?

The Tapestry records the events of the years 1064–6, culminating in the battle of Hastings. As portrayed, it is a tale with a moral: the story of the sure retribution that meets the man who is disloyal and who breaks his oath. Harold the greatest noble-man in England (*Dux Anglorum*), the trusted confidant of the pious king, Edward the Confessor (pl. 1), is portrayed going on a diplomatic mission across the Channel, and taking suitable gifts – hounds and hawks – with him. On landing he was arrested by Count Guy of Ponthieu (pl. 3), but released on the orders of Duke William. Harold's indebtedness to William is further increased when, after campaigning with William in Brittany, he receives arms from William, and thereby becomes his man.[14] Finally the theme of Harold's obligation to William reaches its peak in the scene where Harold swears an oath to William – which he did not keep (pl. 10). Swears it more-over at Bayeux with one hand on a great reliquary with the sacred relics of the church, the other hand on the altar with the host laid out plain for all to see – though twentieth-century historians have missed it.

Thereafter the Tapestry moves swiftly. Harold on his return to England is crowned king immediately on Edward's death (pls 12–13). Harold's disloyalty, and above all his perjury, are proclaimed by God in the form of Halley's comet, and the Tapestry makes use of the border to show the fleet of Duke William that is to be

11 *Gesta Guillelmi*, 110.
12 Exceptions are *BT*, pl. 21, where Mont St Michel is shown in the background, and *BT*, pls 42–3 where some ships of the Norman fleet are shown in the background.
13 *BT*, pls 66–7
14 For the interpretation of this scene, see N. P. Brooks, 'Arms, status and warfare in late-Saxon England', *Ethelred the Unready, British Archaeological Reports* 59 (1979), 92–3.

God's means of bringing retribution to the terrified king (pl. 14).[15] The artist's depiction of the king anxiously hearing the news of the comet – a far cry from the magnificent figure sitting in majesty at his coronation in the previous scene but one – is particularly brilliant. William's invasion and the fall of Harold at Hastings follow in their inevitable course.

Thus stated the Bayeux Tapestry has much in common with the other early Norman accounts of the conquest of England, namely with William of Jumièges[16] and William of Poitiers. Like them it reflects a version of the events of the years 1064–6 that was current among and acceptable to the Norman ruling class. Three recent investigations, those of Drögereit, Körner and Werckmeister, have concluded that the designer of the Tapestry actually knew William of Poitiers' work;[17] but it cannot be said that their arguments carry conviction. The verbal parallels between Poitiers and the inscriptions are unimpressive. Moreover whilst there is no doubt that the Tapestry depicts some scenes that are described by Poitiers, it also depicts episodes that only occur in other written works, and it diverges at times from William of Poitiers' account on both major and minor points of fact and interpretation.[18] It is always difficult to determine the relationship of a work of art and a written account, but there seems no good reason for excluding the probability that, where the Tapestry has episodes in common with the Norman written accounts, it is independently depicting events that were well known in the entourage of Duke William and his vassals.

It is equally difficult to establish the relationship of the Tapestry to works of art in different media. O. K. Werckmeister has recently argued that the designer of the Tapestry knew the triumphal column of Trajan in Rome (and perhaps also that of Marcus Aurelius).[19] Trajan's column like the Tapestry depicts the equipping of horses, the shipping of troops, river crossings and battle scenes, but in the form of a sculpted frieze spiralling up the column. Though there are faint visual correspondences between certain scenes in the two works, it is difficult to accept that these exceed what could be expected from the similarity of their subjects and the limitations of pictorial narrative in frieze or strip form. Two scenes in the column are of particular importance, since they have been said to have been misunderstood or misremembered by the designer of the Tapestry: two workmen are shown in the

15 *BT*, pl. 35.
16 Jumièges, 132–6. I have omitted the *Carmen* whose identification as the work of Bishop Guy of Amiens remains controversial. See R. H. C. Davis, 'The Carmen de Hastingae Proelio', *EHR* 93 (1978), 241–61. In a forthcoming study Professor D. D. R. Owen has shown that the *Carmen* makes extensive use of the *Chanson de Roland*.
17 R. Drögereit, 'Bemerkungen zum Bayeux-Teppich', *Mitteilungen des österreichischen Instituts für Geschichtsforschung* 70 (1962), 261–76; S. Körner, *The Battle of Hastings: England and Europe 1035–66* (Lund, 1964), 100–5; O. K. Werckmeister, 'The political ideology of the Bayeux Tapestry', *Studi Medievali*, 3rd ser. 17/2 (1976), 535–95, especially 548–54. Körner's position is not very clear: he rejects the idea that the Tapestry is an independent source from the same milieu as the other Norman accounts, but concludes only that 'the Tapestry proves to be especially dependent on the tradition which the Poitiers chronicle reproduces'.
18 Below, pp. 68–9, 72–4, 79, 90–1 and above, p. 66.
19 Werckmeister, 'Political Ideology', 535–48, and pls I–VI.

Tapestry apparently fighting with spades when ordered to dig the castle at Hastings. This could conceivably derive from a misunderstanding of the column's depiction of pairs of workmen constructing a fort. But the Tapestry artist may have been depicting an episode known to him or to his patron; in which case there is no need to assume any misunderstanding or knowledge of the column. Even less convincing is the suggested parallel between the triple-arched building used to terminate a scene in the Tapestry where William's newly constructed ships were tethered and the single arch standing in the water at the embarkation scene on Trajan's column. The parallels then are tenuous in the extreme. Moreover the Roman columns must have been as difficult to view then as they are today without the aid of photographs. As solitary survivors of forms of *secular* pictorial narrative it is tempting but hazardous to conjecture that the columns had a direct or indirect influence on the Tapestry. To go on to suggest that the designer of the Tapestry used the columns because he recognized that he had a comparable political and ideological purpose in mind is to heap conjecture upon conjecture.

A more fruitful approach to understanding the Tapestry lies in identifying the distinctive features of its account of the Norman conquest of England. For both in details and in the treatment of major themes and personalities, the Bayeux Tapestry has features that are unique. Most striking is the important part played by Bishop Odo of Bayeux, the half-brother of William the Conqueror. Odo, an ambitious, acquisitive and arrogant baron-prelate whom William had in the end to crush, plays a part in the Tapestry far greater than any other account credits him with. He even appears to suggest the plan for the invasion of England (pl. 15),[20] and at the crucial moment in the battle,[21] when panic spread in the Norman army at the rumour of William's death, it is Odo carrying a mace who is shown rallying the lads (pl. 24). That the Tapestry was in some way connected with Odo is confirmed by the fact that, apart from the major historical figures (Harold, Edward, William, Odo, Robert, Eustace, Guy) and the mysterious Ælfgyva, only three persons are singled out by name in the Tapestry – Turold, Wadard and Vital. They occur in no other account of the Norman conquest, and there is nothing in their actions depicted in the Tapestry to indicate why they should be named. There must have been some reason for either the sponsor of the work, or the designer, or the embroiderers to mention them by name. In fact it can be shown that men bearing these names were all tenants of Odo in England, with the bulk of their lands in Kent where Odo was earl.[22] Vital's English lands were restricted to eastern Kent and it is significant that

20 *BT*, pl. 37.
21 *BT*, pl. 68. Odo is also depicted blessing the food in pl. 49 and counselling William at Hastings in pl. 50. He may also be the armed figure with the mace behind William in pls 55–6.
22 Turold is a common Norman name compared with Vital and the otherwise unique Wadard. But a Turold 'of Rochester' was one of Odo's most powerful tenants and was heavily involved in the trial at Penenden Heath. See J. Le Patourel, 'The Reports of the Trial on Penenden Heath', in *Studies in Medieval History presented to F. M. Powicke*, ed. R. W. Hunt, W. A. Pantin and R. W. Southern (Oxford 1948), 22, 24. It seems unnecessary to follow Sir Frank Stenton in avoiding identifying this vassal with the messenger of the Tapestry (*BT*, 24, n. 2), for this is the only Turold who can be associated with a Wadard and Vital. By 1086 Turold had been succeeded by his son Ralf. In

he was known as Vital of Canterbury.[23] In the absence of a Domesday Book for Normandy we cannot prove whether all three were also tenants of Odo there. But Vital certainly held properties in Caen from Odo, and is found in Normandy before the conquest in association with Wadard. Turold, since the name is common cannot be identified so certainly in Normandy; but his son Ralf lost his England lands and joined Odo in Normandy after Odo's unsuccessful rising against William Rufus in 1088.[24]

With the special prominence given to Odo of Bayeux and his three tenants belongs the placing at Bayeux of the oath which Harold swore to Duke William on holy relics (pl. 10). This oath was the crux of the Norman claim to the English throne and of William's grievance against Harold. Yet William of Poitiers locates the oath at Bonneville, whilst Orderic Vitalis amends this to Rouen.[25] If we ask who would commission such a huge embroidery of the Norman conquest of England starring the role of the relics of Bayeux, of Bishop Odo and of his three tenants, the obvious and widely accepted answer is Odo himself. But the possibility that it was rather one of his immediate successors should not be overlooked. Certainly the Tapestry would seem to have been made for a Bayeux audience at a time when Turold, Wadard and Vital were either still alive or at least still fondly remembered.

In 1476 when we have our first record of it, the Tapestry was displayed each year in the nave of Bayeux Cathedral during the feast and octave of the relics.[26] It was presumably precisely because it was only shown for a short period each year and was not part of the permanent furnishings of the cathedral that the Tapestry has

Domesday Ralf fitz Turold held Hartley, Addington, *Witenamers*, Eccles, Milton, Luddesdown, Stockbury, Wateringbury, Little Wrotham and Ockley from Odo in Kent (*Domesday Book*, i. fols. 6r–8v); he also held from Odo a comparable number of estates in Essex, several of which are said to have been 'seized' (*praeoccupavit*) or 'invaded' (*invasit*) by Turold (*Domesday Book*, ii. fols. 6r–25v); some of them are later known to have owed castleguard at Rochester (J. H. Round, 'Castle Guard', *Archaeological Journal* 59 (1902), 152 and n. 1). Wadard held lands from Odo at Farningham, Maplescombe, Nursted, Buckwell, Combe and Wye – all in Kent – as well as some dwellings in Dover (*Domesday Book*, i. fols. 6r, 7v, 10v); he also held land at Northbourne and Mongeham from St Augustine's at Canterbury (*Domesday Book*, i. fol. 12v); outside Kent he held from Odo a considerable lordship in Surrey, Dorset, Oxfordshire, Warwickshire and Lincolnshire (*Domesday Book*, i. fols. 32r, 77r, 155v–156v, 238r, 342r–343v), which later formed the core of the barony of Arsic or Cogges and owed castleguard at Dover (I. J. Sanders, *English Baronies* (Oxford, 1960), pp. 36–7). Vital held land in Kent at Stourmouth and at Westgate in Canterbury from the archbishop, at Sifflington and Swalecliffe from Odo, and at Preston from St Augustine's (*Domesday Book*, i. fols. 3v, 7r, 10r and 12v). He was one of the knights of the archbishop; see D. C. Douglas, *Domesday Monachorum* (London, 1944), 105.

23 Vital was known as *Vitalis de Cantebire* when together with Ranulf de Columbels he was charged with plundering the urban gild of its lands around Canterbury. See A. Ballard, *An 11th Century Inquisition of St Augustine's, Canterbury, British Academy Records of Social and Economic History*, IV, ii. 10, quoted by W. Urry, 'The Normans in Canterbury', *Canterbury Archaeological Society*, Occasional Papers 2 (1959), 10 ff., who has collected the evidence for Wadard's and Vital's Kentish holdings and shown that Odo and his tenants had no less than 94 dwellings in Canterbury.

24 D. R. Bates, 'The Character and Career of Odo, Bishop of Bayeux', *Speculum* 50 (1975), 1–20 at 11. For Wadard and Vital in Normandy, see H. Prentout, 'Essai d'identification des personnages inconnus de la tapisserie de Bayeux', *Revue Historique* 176 (1935), 14–23 (repr. as Ch. 4 above).

25 *Gesta Guillelmi*, 102–4, Orderic ii, 134–6.

26 S. Bertrand, 'History of the Tapestry', in *BT*, 88.

been preserved at all and in such an astonishingly intact and unfaded condition. It may well be that the Tapestry was commissioned by Odo for the festival of the relics of his church, perhaps at the time of the dedication of the cathedral in 1077; but since neither the original length of the Tapestry nor the dimensions of Odo's romanesque cathedral are known we cannot know how the Tapestry would have fitted.

In 1966 Professor C. R. Dodwell denied that the Tapestry could have been designed for a church at all.[27] He argued that the Tapestry reflects the same secular taste and the same dramatic conventions as the *chansons de geste* of the twelfth century. But his argument implies a clear contrast between the secular and ecclesiastical ethic that cannot be said to have existed in the essentially pre-Gregorian world of Odo of Bayeux. Nor does the depiction in the border of naked men and women in explicitly sexual postures (pl. 7) exclude the Tapestry's having been commissioned for the cathedral. The figures are certainly intended to hint at familiar stories which are now largely lost to us. But they did not prevent the Tapestry being displayed in the cathedral during the octave of the relics in the fifteenth century and they are mild in comparison with some romanesque carving on churches. Nor are they inconsistent with what Orderic Vitalis tells us about Odo as a voluptuary.[28] We must therefore leave open the question of whether the Tapestry was commissioned for Bayeux Cathedral or for the bishop's hall in his palace. All that is certain is that it was preserved because of its connection with the cathedral and with the relics of Bayeux.

The dating of the Tapestry is dependent upon the location of the workshop where it was made. If Odo commissioned the work in England, it could scarcely be later than his imprisonment by William in 1082. For his release at Rouen in 1087 was quickly followed by his rebellion against William Rufus in 1088 and his enforced return to Normandy.[29] But if the Tapestry were made in Normandy, it could also have been commissioned between 1088/9 and his death in 1097. An even later date would be possible if one of his successors had ordered it from a Norman workshop; the *terminus ante quem* would then be provided by those early twelfth-century Anglo-Norman writers who seem to depend upon the Tapestry.[30]

The case for the English origin of the Tapestry workshop rests in part on the extensive and close links between the Tapestry and late Saxon manuscript illumination adduced by the late Sir Francis Wormald in his famous chapter on the style and design of the Tapestry.[31] His conclusion that whilst certainty is not possible 'Canterbury would be a good candidate' for the location of the workshop was supported by numerous parallels with Canterbury manuscripts. Canterbury was also, of course, the chief town and ecclesiastical centre in Odo's earldom; it was the

27 C. R. Dodwell, 'The Bayeux Tapestry and the French Secular Epic', *Burlington Magazine* 108 (1966), 549–60 (repr. as Ch. 7 above).
28 Orderic, ii. 202; iv. 98–100, 116.
29 For Odo's career see Bates, 'Odo', where however the whitewashing of Odo is taken too far.
30 For the relationship of William of Malmesbury's *Gesta Regum* to the Tapestry, see below. None of Odo's immediate successors at Bayeux are known to have had Kentish connections.
31 *BT*, pp. 25–36.

preeminent centre in Western Europe for large scale works of pictorial narrative and it was also Vital's home. But Wormald recognized the limits of the argument from style, even when corroborated in this way. For Norman manuscript illumination of the late eleventh century is heavily influenced by late Saxon art,[32] and since we do not have eleventh-century illuminated manuscripts from Bayeux, we cannot be certain what were the artistic abilities and tastes of Odo's own cathedral clergy.

Nor does the English origin of the collection of fables depicted in the borders of the Tapestry provide any sure guide to the Tapestry's provenance. For this collection 'of Alfred' (*Alueredi*) was certainly available to Marie de France in the twelfth century[33] and may already have crossed the channel by the eleventh. More conclusive arguments derive from the inscriptions. A word of caution is needed here, however. The authority of the spelling of some crucial names such as AT HESTENGA-CEASTRA and GYRÐ still needs to be established, for different readings are given in Montfaucon's engraving and the inscriptions have been extensively restored.[34] Nonetheless the exhaustive investigations of M. Förster and R. Lepelley have shown that the lettering and spelling of the Tapestry inscriptions normally follow English forms.[35] They reflect the influence both of vernacular English and to a lesser extent of vernacular French – a mixture that one finds in post-conquest England rather than Normandy. Individual Englishmen did of course settle in Normandy, but comparison with Orderic Vitalis strongly confirms the Englishness of the milieu of the Tapestry's Latin inscriptions.

If an English provenance for the Tapestry is more likely than a Norman one, then this in turn argues for a date between 1066 and 1082 when Odo was earl in Kent and in political favour. It also suggests that we should look more closely at the claims of Canterbury as the design and workshop centre. For that may be the best explanation of some surprising details in the Tapestry's depiction of events. On certain issues crucial for the interpretation of the years from 1064 to 1066 the Tapestry abandons the Norman version and appears to be following traditions that are found in some of the English sources – particularly on the question of King Edward's views and policy on the succession to the English throne.

32 C. R. Dodwell, *The Canterbury School of Illumination* (Cambridge, 1954), 115–18; J. J. G. Alexander, *Norman Illumination at Mont St Michel 966–1100* (Oxford, 1970), 59–66, 70–4, 110–13, 118–21, 237–9; F. Avril, 'Notes sur quelques manuscrits benedictins normands du xie et du xiie siècles', *Mélanges d'archéologie et d'histoire* 76 (1964), 491–525; 77 (1965), 204–48. The surviving Norman figural art of this date, however, is primarily decorative, concentrating above all on the decorated initial. It seems that Norman artists seldom adopted the full page illustration and did not undertake pictorial narrative – the distinctive achievements of the late-Saxon artist.

33 H. Chefneux, 'Les fables dans la Tapisserie de Bayeux', *Romania* 60 (1934), 1–35, 153–94.

34 B. de Montfaucon, *Les Monuments de la Monarchie française*, ii (Paris 1730), pl. vi, 24 where the inscription reads A* HESTENG* CEASTRA; *ibid.*, pl. viii, 28, where Gyrth's name is spelt GVRD.

35 M. Förster, 'Zur Geschichte des Reliquienkultus in Altengland', *Sitzungsberichte der Bayerischen Akademie der Wissenschaften*, Phil.-hist. Abt. (1943), Hft 8, 16–19; R. Lepelley, 'Contribution à l'étude des inscriptions de la Tapisserie de Bayeux', *Annales de Normandie* 14 (1964), 313–41 (repr. as Ch. 6 above).

The opening scenes of the Tapestry depicting Harold's journey to and from Normandy have been subject to very different interpretations; for the inscription does not make clear why Harold went to Normandy, that is whether he was sent by Edward to confirm the succession to William as the other Norman sources assert. But as Freeman saw long ago, the chronicle account which stands closest to the Tapestry's treatment here is the *Historia Novorum* which was written soon after 1110 by Eadmer, an English monk of Canterbury.[36] Eadmer states that Harold had persuaded a reluctant King Edward to allow him to go to Normandy to recover his brother Wulfnoth and his nephew Hakon who were being held as hostages by William. When Harold returns to England having sworn the fateful oath to William, Eadmer makes him go to Edward, who says 'Did I not tell you that I knew William, and that your going might bring untold calamity upon this Kingdom?'[37] The Tapestry certainly gives no hint (as it could easily have done) that the purpose of Harold's journey was to recover his kinsmen from William, but it captures the scene of Harold's return to King Edward brilliantly (pl. 11). Harold is shown in an astonishingly but deliberately contorted stance: his head is bent low, his neck stretched out, his shoulders remarkably hunched, his hands raised in a vain attempt at explanation. The Tapestry is not here depicting the return of a man who has successfully accomplished the mission on which the king had sent him – as the Norman versions would require. The aged king receives Harold with one admonitory finger raised, and as Freeman saw, the whole scene makes sense only in terms of the tradition, which Eadmer alone records, that Edward had disapproved of Harold's journey. This may also have been the reason for the slight ambiguity of the opening scene in the Tapestry (pl. 1). The scene is carefully composed with the king's index finger touching that of Harold. It is likely that the artist intended Edward to be understood as giving instructions to Harold for in late-Saxon pictorial narrative this arrangement of hands is used to show a master instructing his servant.[38] What were Edward's instructions? To a Norman audience and to the lord who commissioned the Tapestry there could have been no doubt that Edward was shown sending Harold to confirm the designation of William as the heir to the English throne. But the brief inscription (as restored in the nineteenth century[39]) does not even state, as with some reorganization it could easily have done, that Edward was sending Harold to Normandy. Since the depiction of Harold's return fits Eadmer's story, it would therefore also have been possible to interpret the opening scene as depicting Edward warning Harold against his journey. The Tapestry, then, seems to have one message for its Norman audience, but also to hint at a version known to the Canterbury writer, Eadmer.

36 Eadmer, 6–8. It should also be noted that like the Tapestry Eadmer's whole account is centered on Harold, not on William like the Norman sources.
37 Eadmer, 8.
38 BL, Cotton Claudius B. iv. fol. 65; *The Old English Illustrated Hexateuch (Early Eng. MSS in Facsimile*, XVIII), ed. C. R. Dodwell and P. Clemoes (Copenhagen 1974).
39 Montfaucon, *Monuments*, i (Paris, 1729), pl. xxxv where the inscription reads REX...RD with the last letter uncertain. However the enlarged version in pls xxxvi and xxxvii suggests that the restoration was correct.

There is another scene of great historical importance where the Tapestry more clearly follows a tradition that is specifically English rather than Norman. The Norman chroniclers state that on Edward's death Harold immediately seized the throne, though William of Poitiers later shows that he was aware of Harold's claim to have been designated by the dying King Edward.[40] The English accounts stress the legality of Harold's accession. The Tapestry represents Edward on his death-bed surrounded by his leading subjects in the upper scene, and down beneath the shrouded corpse is about to be carried away (pl. 12). The curious arrangement of these most important scenes, one above the other, may derive from a contemporary manuscript since we find the same arrangement in late-Saxon drawings and carvings of death and of nativity scenes.[41] One English work, the *Vita Eadwardi* which was written before 1075, describes the death of Edward in terms that are remarkably reminiscent of the Bayeux Tapestry. The *Vita* states: 'When he (Edward) was sick unto death, his men stood and wept bitterly . . . Then he addressed his last words to *the queen who was sitting at his feet*, in this wise, "May God be gracious to this my wife for the zealous solicitude of her service . . ." *And stretching forth his hand to his governor, her brother Harold,* he said, "I commend this woman and all the kingdom to your protection." '[42]

The parallel between the *Life* and the Tapestry – in the position of the queen at the king's feet, and in Edward's gesture of designation by stretching out and touching Harold with his finger tips – cannot be a coincidence. The Tapestry is illustrating the same scene that the chronicler describes. We do not know whether the *Vita Eadwardi* or the Tapestry is the earlier, and we have no means of determining whether one source is derived directly or indirectly from the other, or whether they share a common source. What we do know is that the author of the *Vita* had some connections with Canterbury: he had certainly spent some length of time there and, as the most recent editor has suggested, he may have been writing at Canterbury.[43]

The visit of Harold to Normandy and Edward's own wishes about who was to be his successor were vital elements in William's claim to the English throne. It is remarkable to find the Bayeux Tapestry departing at all from the straightforward Norman version of these events. Since the Tapestry's inscriptions are so studiously non-committal for these scenes, it is unlikely that the divergence would be apparent to a Norman audience. But there can be no doubt that the artist who designed the scenes of Harold reporting back to Edward from Normandy and of Edward's death-bed was familiar with, and was hinting at, English versions of these events,

40 *Gesta Guillelmi*, 146, 172–4.
41 An English ivory of the late-tenth century representing the Nativity with the virgin reclining on a sofa-bed much like that of the Confessor and with the infant Christ down beneath in his swaddling clothes much like the shrouded corpse of Edward in the Tapestry, is illustrated by D. Talbot Rice, *English Art 871–1100* (Oxford, 1952), pl. 37.
42 *Vita Eadwardi*, 79.
43 *Vita Eadwardi*, xli–xlix, especially xliv.

versions moreover that are extant only in Eadmer's *Historia Novorum* and in the *Vita Eadwardi*, works that are closely connected with Canterbury.[44]

It may be possible to locate the Tapestry's designer even more precisely. The bulk of the evidence from manuscript illumination adduced by Wormald points to the monastery of St Augustine's at Canterbury rather than to the cathedral monastery of Christ Church. Moreover it was at St Augustine's in the years immediately before the conquest that there were artists devising a highly original cycle of narrative pictures to illustrate the Old English paraphrase of the first seven books of the Bible. Professor Dodwell has recently emphasized the numerous links between this manuscript and the Tapestry.[45] Much more decisive, however, are two scenes in the Tapestry where distinctive errors seem to point very clearly to St Augustine's models. Wormald drew attention to the first, the figure among the Norman foragers who appears to be carrying a coil of rope. This drawing seems to be copied from a St Augustine's manuscript whose artist misunderstood the portrayal of figures of Labour carrying a heavy burden on his shoulders in illustrated versions of the *Psychomachia* of Prudentius.[46]

The second remarkable scene in the Tapestry is the meal with Odo blessing the food on the eve of the battle of Hastings (pl. 18). The shape of the table is extraordinary: it rises from the floor and descends to it again in a somewhat irregular semi-circle in a manner that defies gravity and perspective. It is not the sort of table that the designer of the Tapestry would himself invent. In fact, as Laura Hibbard Loomis long ago demonstrated,[47] there can be no doubt that the artist was copying a representation of the Last Supper showing both the Institution of the Eucharist and the Indication of the Betrayal by Judas. The table is set with bread and fish, as is normal in representations of the Last Supper; Bishop Odo, blessing the food, is in the classic position of Christ saying 'This is my body'; the kneeling servant in front of the table is in exactly the position in which Judas is frequently portrayed in medieval illumination. The dependence of the Tapestry on the Last Supper scene is apparent if we compare an illumination from a north French gospel book of the second half of the twelfth century.[48] In particular the posture of Judas, grasping the dish and kneeling before the table is reminiscent of the servitor before the table in the Tapestry. The shape of the table is also similar, though in this case the ends of the table are clear and could not have given rise to the bungled table of the Tapestry.

44 (i) *Edward rex, Ubi Harold dux Anglorum et sui milites equitant ad Bosham, Ecclesia, Hic Harold mare navigavit, Et velis vento plenis venit in terra Widonis comitis* (*BT*, pls 1–6). (ii) *Hic Eadwardus rex in lecto alloquitur fideles, Et Hic defunctus est. Hic dederunt Haroldo coronam regis, Hic residet Harold rex Anglorum, Stigant archiepiscopus* (*BT*, pls 33–4).

45 C. R. Dodwell, 'L'originalité iconographique de plusieurs illustrations anglo-saxonnes de l'Ancien Testament', *Cahiers de civilisation médiévale* 14 (1971), 319–28, especially 325–8.

46 *BT*, p. 32 and figs. 14, 15.

47 L. H. Loomis, 'The table of the Last Supper in religious and secular iconography', *Art Studies (American Journal of Archaeology)* 5 (1927), 71–90. For the iconography of the Last Supper, see A. Dobbert, 'Das Abendmahl Christi in der bildenden Kunst', *Repertorium f. Kunstgeschichte*, xiii–xviii (1890–5), and L. Réau, *Iconographie de l'Art Chrétien* (Paris, 1957), II, pt. ii, 406–26.

48 New York, Pierpont Morgan Library, M 44, fol. 6v.

The type of table shown here is known as the sigma-shaped table, and derives from the Byzantine iconographical tradition. But in the Byzantine tradition Christ is seated on the extreme left, not centrally as is normal in Western manuscripts and as Odo in the Bayeux Tapestry.

In the Western iconographical scheme, the shape of the table – from the late eleventh century at least – is the long rectangular trestle-table made familiar to modern eyes in Leonardo's famous painting of the Last Supper. But for our purposes it is important to note that the rectangular table is very rare in feast scenes before the end of the eleventh century. Until then tables that are round or oval are far more common.[49] And it is from St Augustine's that the closest parallel to the meal scene in the Bayeux Tapestry is to be found, namely in the famous sixth-century *St Augustine's Gospels*, which were kept on the altar at St Augustine's, Canterbury[50] and which had an important influence on Canterbury manuscript illumination both in the eighth and in the twelfth centuries.[51] The representation of the Last Supper in this gospel-book is one miniature from a scheme of twelve arranged on one page, in separate panels and depicting the life and passion of Christ. The table should be noted first of all; a round table is intended, but the frame cuts off the front half. Here surely is the origin of that extraordinary table in the Bayeux Tapestry. Notice too the position of Christ – one hand holding a round piece of bread, the other raised in benediction – which is exactly that of Odo in the Tapestry. Notice the way in which several of the eight apostles shown have one arm forward in front of their neighbour and are touching the bread on the table. In the Tapestry's depiction of the meal at Hastings we meet a table similarly cut off by the bottom border and also without legs, we find Odo in the same central position and with an identical gesture, and the men each with one arm similarly pushed forward and their hands touching the bread or fish on the table. The borrowing is clear. Mrs Loomis, indeed, was of the opinion that the designer of the Tapestry actually had *St Augustine's Gospels* before him when he drew the scene of the meal at Hastings. It is however possible that he was rather using a copy in which a Judas had been introduced to the Last Supper in front of the table in the manner of the little servitor in the Tapestry.

Two famous cycles of Old and New Testament scenes were produced at Canterbury in the twelfth century with a format that is derived from the *St Augustine's Gospels*; one stands as a preface to the *Paris Psalter* (c. 1170–1200), the other now survives as four detached leaves but probably originally prefaced either the *Eadwine Psalter* (c. 1147) or its immediate exemplar. Both cycles include a Last Supper with

49 See for example the feast scene in BL, Cotton Tiberius C. vi reproduced by F. Wormald 'An illustrated English Psalter of the 11th Century', *Walpole Society* 38 (1960–2), pl. 1. Comparable scenes are found in the late Saxon calendars, BL, Cotton Julius A. vi. and Tiberius B. v.

50 F. Wormald, *The Miniatures in the Gospels of St Augustine, Corpus Christi College, MS 286* (Cambridge, 1954), pl. I.

51 J. J. G. Alexander, *Insular Manuscripts from the 6th to the 9th Century, Survey of MSS Illuminated in the British Isles*, i (London 1978), passim; Dodwell, *Canterbury Illumination*, 98–102. C. F. Lewine, 'Vulpes Fossa Habent', *Art Bulletin* 56 (1974), 488–504 suggests that the iconographical influence of the *St Augustine's Gospels* on the twelfth-century psalters may have been exaggerated.

Judas shown before the table,[52] like the servant in the Bayeux Tapestry; but in both manuscripts the long and straight table and other details derive from more recent iconographical fashion. Pre-conquest English depictions of the Last Supper do not survive to establish whether an exact model existed for the Hastings meal scene, combining the cut-off round table, the Institution of the Eucharist and a Judas placed in front of the table. The suggestion that an English biblical cycle might once have prefaced the *Utrecht Psalter* or the late Anglo-Saxon copy of it made at Canterbury remains itself highly conjectural.[53] We cannot therefore point to the actual manuscript used by the designer of the Tapestry with any confidence. But the fact that the *St Augustine's Gospels* stand so much closer to the Tapestry than representations of the Last Supper in Carolingian, Ottonian, Byzantine or Romanesque biblical illustration is unlikely to be a coincidence. It suggests that the designer of the Tapestry would be most likely to find his model for this remarkable scene in England and at Canterbury, probably at St Augustine's itself.

There are also more general historical reasons for regarding St Augustine's as much the most probable house in his earldom for Odo to approach to design and supervise the production of a major embroidery. From the time of the trial at Penenden Heath in 1072 the cathedral community at Christ Church and the church of Rochester were involved in prolonged litigation to recover a great number of estates from the hands of Odo and of his tenants – amongst them Turold and his son Ralf.[54] It is possible that Christ Church writers at the end of the eleventh century may sometimes have taken the easy course of blaming the disgraced Odo for usurpations that in reality had been perpetrated by Earl Godwin and his sons. But it was from Odo that they were seeking to recover them, and everything that we know of the intensity of local loyalties aroused by post-conquest land disputes makes it unlikely that Odo and his tenants would seek to procure an embroidery celebrating their role in the Norman conquest from Christ Church, the house with which they were in dispute. But this objection does not apply to St Augustine's, which was not involved in the Penenden litigation and which was itself so often a rival of the cathedral community in the post-conquest decades. Odo indeed made a series of benefactions with the king's cooperation to St Augustine's during the years from 1072 to 1078; one of the royal writs confirming and facilitating these grants was actually issued on the occasion of the dedication of Bayeux Cathedral.[55] Odo continued to enjoy a good reputation at St Augustine's despite his imprisonment from 1082 to 1087 and despite the confiscation of his estates following his leadership of the rising

52 Dodwell, *Canterbury Illumination*, pls 66, 67; there is a convenient authoritative survey of the relationship of these manuscripts and their exemplars in C. M. Kauffmann, *Romanesque Manuscripts 1066–1190, Survey of MSS Illuminated in the British Isles*, iii (London, 1975), 93–5.

53 Dodwell, *Canterbury Illumination*, 101–2.

54 The best recent accounts of this litigation are F. R. H. Du Boulay, *The Lordship of Canterbury* (London, 1966), 36–42 and D. R. Bates, 'The Land Pleas of William I's reign: Penenden Heath revisited' *BIHR* 51 (1978), 1–19.

55 Thomas of Elmham, *Historia monasterii S. Augustini Cantuariensis*, ed. C. Hardwick, RS (London, 1858), 351–4; *Regesta Regum Anglo-Normannorum 1066–1154*, i, ed. H. W. C. Davis (Oxford, 1913), no. 98 (dated *in dedicatione Baiocensi*), and cf. nos. 66, 88, 99, 175.

of 1088 against William Rufus in favour of Robert Curthose. In an account of the life and posthumous miracles of Abbot Hadrian, written at St Augustine's in the 1090s, the monk Goscelin described how Odo had given the community excellent and successful advice about how they should move the heavy sarcophagus without disturbing Hadrian's bones. A few years later a St Augustine's monk who compiled a martyrology for his house saw fit to include the obit of *Odo episcopus Baiocensis* amongst a select few benefactors to be commemorated.[56] St Augustine's then, alone among the major Kentish houses, remembered Odo with gratitude.

There would therefore seem to be rather stronger evidence than has hitherto been realized for connecting the Tapestry with Canterbury and in particular with St Augustine's. Individually none of it amounts to proof that the Tapestry was made there, but cumulatively the evidence is strong, and may be briefly set out:

(1) English provenance is indicated by the inscriptions.
(2) Canterbury was the chief town of Odo's earldom, and he held most extensive properties there.
(3) Turold, Wadard and Vital all held lands from Odo in Kent, and Vital was specifically known as Vital of Canterbury.
(4) Where the Tapestry remarkably departs from the Norman version of the events of 1064–6 it appears to be following traditions that are only found elsewhere in chronicles connected with Canterbury.
(5) Canterbury was the outstanding centre of late Anglo-Saxon drawing, especially notable for the skill of its artists in pictorial narrative. Professor Wormald demonstrated many of the stylistic similarities between the Bayeux Tapestry and Canterbury manuscripts of the period 1000–75.
(6) One figure in the Tapestry, the rope-carrying Norman forager, was copied from a mistaken figure in a late Saxon Prudentius from St Augustine's; whilst the meal scene at Hastings was derived, probably indirectly, from the Last Supper in the famous *St Augustine's Gospels*.
(7) St Augustine's, in stark contrast to the other Kentish houses, enjoyed good relations with Odo and his tenants. He was their major post-conquest benefactor during the very years that Bayeux Cathedral was being completed.

It would be difficult to account for all these points except on the assumption that the Tapestry was designed in Kent, at Canterbury and at the monastery of St Augustine's. In that house there were both the skilled artists and the manuscripts which could provide the exemplars for many of the scenes in the Tapestry. If then we accept that the Bayeux Tapestry was designed by a monk or dependant of St Augustine's, it must surely be dated before Odo's rising of 1088, and in all probability before his imprisonment in 1082. Werckmeister's suggestion[57] that the Tapestry

56 BL, Cotton Vitellius C. xii. fol. 114v; Goscelin, *Libellus de Adventu Beati Adriani abbatis in Angliam ejusque virtutibus* (BL, Cotton Vespasian B. xx. fol. 243v).
57 *Studi Medievali* 17/2 (1976), 586–9.

may have been produced at the request of Odo's three tenants during the period 1082–6 in an attempt to rehabilitate the bishop is unconvincing. Nothing suggests that Turold, Wadard and Vital were such important lords that they could commission so magnificent and vast a work. Moreover to attribute to the imprisoned bishop such an exaggeratedly prominent role in the Norman conquest would but have added another to the list of Odo's crimes.

This discussion of the manufacture, provenance and date of the Tapestry helps us to understand its value and limitation as an historical source. We can well comprehend that an Englishman at St Augustine's might misunderstand his information about Conan's flight from Dol. It is also unlikely that the English community had ever had to depict a cavalry battle before, since the English fought on foot and the workshop seems to have experimented with the depiction of mailed hauberks before settling on a satisfactory method. How does this affect the Tapestry's usefulness as a source for eleventh-century weapons, armour and battle tactics? The designer would have needed to take advice on how the Normans rode into battle; he is unlikely to have had any model or precedent at St Augustine's for the methods of using the lance or spear. The Tapestry shows some Norman cavalry couching their lances, some throwing them and some thrusting them overhand (pls 20–3), and this mixture of methods is confirmed in contemporary continental manuscript illumination.[58] On the other hand it may well be that the ignorance of the English designer of Norman warfare was responsible for one of the Tapestry's most remarkable mistakes.

The Tapestry shows Norman knights and English soldiers wearing identical mailed hauberks or byrnies. The hauberk is depicted as a close fitting garment with short sleeves and legs each of which ends in coloured bands – apparently some material sewn over the end of the mail to minimize wear and chafing. When the byrnies are shown, as on some of the English infantry in such a way that the inside of the leg can be seen, the mail is shown continuing all the way round the leg as a trouser. When mail-coats are depicted being carried to the Norman fleet, they are depicted again as mail combinations (pl. 16) although when the dead are shown being stripped, some unlacing has evidently been done, for the hauberks can apparently be pulled off in one piece (pl. 26).[59] Scholars are agreed that Norman knights could not have worn trousered hauberks, both because of the damage and discomfort to horse and rider and because the testimony of continental sculpture and manuscript illumination uniformly points to skirted hauberks.[60] Why then should the English designer of the Tapestry have repeatedly and consistently drawn the coats of mail in this impossible form? How could such a brilliant artist make such a mistake? What does such a mistake tell us about the authority of the Tapestry as a source for armour and warfare in the eleventh century?

58 D. J. A. Ross, 'L'originalité de Turoldus: le maniement de la lance', *Cahiers de Civilisation Médiévale* 6 (1963), 127–38.
59 *BT*, pls 71, 72.
60 See the manuscripts cited and reproduced by Ross, 'L'originalité', pp. 134–5, and by Brooks, 'Arms, status and warfare in late-Saxon England'.

In fact it would seem that the English designer of the Tapestry has drawn Anglo-Saxon mail on both English and Norman soldiers. For a late-Saxon frieze fragment from the pre-Conquest cathedral at Winchester depicts a warrior whose mail fits closely all around the upper leg exactly as depicted in the Tapestry.[61] Anglo-Saxon mail, then, could apparently be represented somewhat differently from that of the tenth- and eleventh-century continental knight. The difference corresponds to their different battle tactics. The English, though they rode to battle, were accustomed to fight on foot and, unlike the mounted warrior, therefore needed protection for the groin and inside leg.[62] That the English artist of the Tapestry should have failed to observe that the Norman hauberks differed from the English is a comprehensible error. What is inadmissible is that he should have drawn nearly 200 mailed figures with trousered hauberks if these were unknown in the eleventh century and if this superb artist had intended drawing skirted hauberks.

The conclusion would seem to result that the Tapestry is a more dependable source for the armour and weapons of the English than of the Normans. This indeed would be in line with the mistake of the Tapestry over Conan's flight from Dol. But it has further implications. William of Poitiers mentions that the Norman footmen were armed with arrows and bolts (*sagittis ... balistis*);[63] whilst the poetic accounts of the battle, the *Carmen de Hastingae Proelio* and Baudri of Bourgueil both distinguish the Norman bowmen and their arrows from the crossbowmen and their bolts.[64] The relationship of these three detailed accounts of the battle remains disputed, and historians have tended to minimize or to ignore their suggestion that crossbows played a significant role in the battle. The absence of any crossbows in the Tapestry has seemed decisive.[65] But the analogy of the hauberks may suggest that the English designer simply drew the Norman archers with the short bows that were known to him. Once again it may be dangerous to use the Tapestry as a guide to how the Normans fought the battle.

The basic task of the designer of the Tapestry was to show events that took place at various times over a period of at least two and a half years in pictorial form in a continuous 'strip-cartoon' or frieze. He achieves this end by dividing the action into scenes, each of which has an explanatory inscription above. The scenes are often separated from each other by convenient buildings or trees; but in the battle scenes

61 M. Biddle, 'Excavations at Winchester 1965: 4th Interim Report', *Antiquaries Journal* 46 (1966), 329–32 and pl. LXII.

62 The need was certainly known to the author of the *Carmen* (32, 11. 517–18) who, however, was certainly not an eye-witness of the battle. In a highly imaginative account he describes William cutting through the groin of an Englishman who had unhorsed him and spilling his entrails on the floor.

63 *Gesta Guillelmi*, 184.

64 Baudri of Bourgueil, *Carmen*, cxcvi (Adelae Comitissae) in *Les Oeuvres politiques de Baudri de Bourgueil*, ed. P. Abrahams, Paris 1926, pp. 409–12; *Carmen*, pp. 227–8, 381–2, 409–12.

65 Morton and Muntz (*Carmen*, 115) suggest that the Norman archer shown wearing a hauberk (*BT*, pl. 61) may have been intended to distinguish the better armed archer (i.e. a crossbowman) from the bulk of the Norman archers. But the artist makes no distinction between the bows and it is hazardous to conjecture why or how one archer should have acquired body armour.

he often dispenses with these divisions altogether, with the result that the inscriptions are then the only guide to the artist's concept of what comprised one scene. But the artist was in no way bound by the concept of a single scene, and he did not observe the unity of time. The designer was able to combine great rapidity of action with a wealth of accurate detail. One of his methods of achieving this was to combine two or three consecutive actions in the same picture. Thus under the inscription *Hic Harold mare navigavit* we find one of Harold's companions descending the steps from his first-floor dining-hall at Bosham, others wading out to the ship with their hose and shoes removed and carrying hounds and hawks, whilst aboard the ship some are already punting the boat off the beach, whilst others are even rowing it away.[66] The crowning of Harold,[67] as Professor Brooke has reminded me, provides another example (pl. 13). The scene – clearly designed by someone who knew the coronation *ordo* – represents a conflation of three quite distinct stages in the ceremony. On the left the sword of state is offered to the king; in the centre the king sits crowned in majesty holding the orb and sceptre; and on the right Archbishop Stigand with a maniple in his hand either displays the king to the acclamation of the people on the extreme right or, less probably, is summoning them to homage. Typically the artist has made for continuity with the next scene by making some of the people point to the sky, where in the next 'scene' Halley's comet is visible (pl. 14).

It is evident from these two examples that the artist did not regard a single scene as picturing a single moment in time, like a modern photograph. The designer is also quite capable of rearranging the order of events in order to achieve the re-quired dramatic effect. The scenes of Edward the Confessor's death and funeral provide a case in point (pls 11–12).[68] Edward died and was buried in the recently consecrated Westminster Abbey on 5 January 1066. On the next day, the 6th, Harold was crowned king. The Norman sources agree on the indecent haste of the proceedings.[69] The Tapestry conveys the close connection between the death of Edward and Harold's accession by illustrating them next to each other – at the cost of reversing the natural order of the two previous scenes. Thus we are shown Edward's corpse being carried to Westminster in funeral procession before we are shown Edward's death. The purpose of this device seems to have only been realized in recent years.[70] It is surely in order that the death scene and the scene where Harold is offered the crown should be juxtaposed. Had the funeral scenes followed the death of King Edward in the Tapestry, Harold's accession to the throne would have appeared widely separated from the death of the Confessor. The designer of the Tapestry emphasizes the connection of the death-bed designation of Harold with his elevation to the throne by making one of the nobles point back to the death-scene with one hand, whilst he holds out the crown to Harold with the other.

66 *BT*, pl. 5.
67 *BT*, pl. 34, For this scene and its interpretation, see C. N. L. Brooke, *Saxon and Norman Kings* (London, 1963), p. 42.
68 *BT*, pls 32–3.
69 *Gesta Guillelmi*, 146; Jumièges, 132–3.
70 Brooke, *Saxon Kings*, 39; R. Drögereit, 'Bemerkungen', 264 and n. 41.

It is in overriding the restrictions of his medium in these ways that the artist shows his ability. He divides the action into separate scenes, each with its explanatory inscription, but is able to show a number of consecutive events in one 'scene', and is constantly linking one scene to another by a significant gesture of a hand or foot. The chronological order of events imposes the sequence of depiction, but in order to achieve a desired effect the artist is willing to invert the chronological order of certain scenes.[71] All the designer's abilities were needed to the full in order to portray the battle of Hastings itself (pl. 23). Notice first of all[72] how the artist coped with the problem of depicting the Norman frontal cavalry attack up Battle hill against the English infantry drawn up on the ridge. He did not have the space to show horsemen charging up the hill and the Englishmen on the top, for he required the whole height of the Tapestry to show each single horseman distinctly. A lesser artist would have been defeated by the problem and the battle scenes would have degenerated into confusion. But the Tapestry solves it by showing the English 'shield-wall' in the centre and the Norman frontal charge coming in from both sides. It is a highly effective solution to a difficult artistic problem, and all the more impressive because it is unlikely that any English artist had ever had to portray a cavalry charge against an infantry position before. It is precisely when it is more original that the Tapestry is most satisfactory.

The scene showing the death of Harold (pl. 26)[73] bears an obvious relationship to the battle scene in pl. 23. The Norman knights are breaking through the English shield-wall on the left of the picture, but on the right the line holds. The Norman cavalry, as previously, are shown coming in from right and left, because the artist cannot show a frontal attack. It is important to emphasize that the artist is only representing one cavalry attack here – an attack which was successful in one place, but resisted in another – because one modern historian has suggested that this scene is composed of three separate and distinct scenes.[74] But to cut the picture up arbitrarily in this manner makes nonsense of the inscription (*Hic Harold rex interfectus est*) which cannot be cut up, and also utterly destroys the whole composition of the Norman cavalry charge against the English shield-wall.

The inscription is carefully arranged. It begins with the word *Hic* above a Norman knight riding up to the English line. The name *Harold* comes exactly above

71 The earlier 'reversed' scenes (*BT*, pls 12,13,14) where William's messengers arrive at Beaurain (pl. 12) before they are shown on their way (pl. 13), and before William is shown sending them (pl. 14), seem to have been a simple means of cutting out one scene. The artist has avoided showing the news of Harold's arrest being brought to William. There is no difficulty in comprehending these reversed scenes when one sees the Tapestry itself, rather than photographs divided by the separate pages of a book.

72 *BT*, pls 62–3.

73 *BT*, pls 71–2. The cutting of this scene into two in modern reproductions is particularly unfortunate.

74 C. H. Gibbs-Smith, 'The Death of Harold at the Battle of Hastings', *History Today* 10 (1960), 188–91. He divides the scene into (i) 'the fight-for-the-standards scene' (*sic*). (ii) Norman horseman striking down an Englishman (Harold). (iii) group of defending Englishmen facing right 'with which we are not concerned'.

the figure pulling an arrow out of his face.[75] The *interfectus est* is written in two lines rather than continuing along the top (for which there is space) in order to indicate that the figure being cut down by a Norman knight is Harold. Until 1957 it had been generally understood that the arrow-in-the-eye figure was also Harold. But since C. Gibbs-Smith's detailed commentary on the Tapestry, there has been widespread acceptance of his view that the Tapestry shows Harold being hacked down by a Norman horseman and that the figure with an arrow in his head is simply one of Harold's 'headquarters staff'.[76] Since the argument is a complicated one, it is as well to quote it in full from Gibbs-Smith's exposition:

> Harold is shown hacked down by a Norman knight and killed. There are a number of reasons for concluding that Harold is *not* shown in the last plate being hit in the eye by an arrow – or that he was so hit in reality: (1) The first mention of the arrow-in-the-eye was made long after the battle between 1099 and 1102 by Baudri of Bourgueil in a poem where he speaks of a contemporary embroidery; his description of the battle depicted there may well derive from the Bayeux Tapestry itself; thus a misreading of the Tapestry may have started the arrow tradition. (2) In the Tapestry apart from the isolated word *Hic*, the inscription *Harold rex interfectus est* starts above the arrow in the eye figure and ends above the falling figure: it is an invariable rule in the Tapestry (and in most mediaeval illumination) that every violent death is indicated by a falling, bent or prostrate figure – a condition properly fulfilled by the falling Englishmen. (3) In no illustrational convention does a single named individual take a secondary place in any action; and here we find two Englishmen, one of them overlapping each end of the Norman and his horse, one being struck down in front, one standing up wounded at the back. It has sometimes been said that both figures are Harold, seen first being shot in the eye and then having wrenched the arrow out, being hacked down by a Norman. This theory is quite untenable: in no part of the Tapestry, nor in any other comparable work, is the same individual introduced twice within the span of a horse, or for that matter twice in the same section of the story … There can be no doubt that … the falling Englishman … is Harold. The arrow-in-the-eye-man is plainly one of the 'Headquarters staff' around the dragon standards.[77]

It is convenient to consider this argument, which has since been twice restated with minor alterations, under two heads: (1) that Baudri of Bourgueil saw the Tapestry, misunderstood it, and that subsequent writers have taken the arrow-in-the-eye

75 Whenever possible the inscriptions are arranged so that the name comes directly above or immediately by the relevant figure: of the 53 persons named in the Tapestry, only 14 do not come beneath or adjacent to their names, and in the battle scenes every named figure seems to be portrayed beneath or by his name. For the identification of Gyrth and Leofwine, see below.

76 R. J. Adam, *A Conquest of England* (London, 1965), 129; H. Loyn, *The Norman Conquest* (London, 1965), 95; F. Barlow, *William I and the Norman Conquest* (London, 1966), 78; R. Allen Brown, *The Normans and the Norman Conquest* (London, 1969), 173 n. 154. D. C. Douglas, *William the Conqueror* (London, 1964), p. 201, n. 4 avoids committing himself on the manner of Harold's death. C. H. Lemmon, 'The Campaign of 1066', in *The Norman Conquest: its setting and impact*, ed. C. Chevalier (London, 1966), 110 and D. J. A. Matthew, *The Norman Conquest* (London, 1966), 84, accept the arrow in the eye without comment.

77 *BT*, 188.

story from Baudri's misunderstanding. (2) that within the canons of medieval illumination in general, and of the Tapestry in particular, it is not possible for the arrow-in-the-eye figure to be Harold because (a) he is not 'falling, bent, or prostrate' as a dying figure should be, (b) he is of secondary importance,[78] (c) duplication of a single figure in one scene is not possible.

In fact every stage of these two arguments can be shown to be either highly doubtful or else demonstrably false. But before considering them in detail a word of caution is necessary. The scene of the death of Harold is not in its present form the work of the designer of the Tapestry, but of a nineteenth-century restorer. Early in the nineteenth century the ends of the Tapestry were badly damaged by the winch on which it was wound and unwound. In 1842 the Tapestry was restored in machine-spun wools whose dyes are distinct from the original medieval embroidery. Enough of the inscription of the scene of the killing of Harold is in original wools to show that it has been correctly restored; but the figures have been almost entirely renewed. Only the head and shoulders of the arrow-in-the-eye figure is original; the arrow and most of the body are restoration. The Norman horseman chopping down the dying king is also mostly in modern wools; whilst of the falling figure only some of the head (but not the moustache) and a little of the mail have survived intact.

But this does not mean that the scene as we have it today is an invention of the nineteenth century. A very meticulous copy of the Tapestry in pen and ink and in water-colour was made some years before the restorations of 1842.[79] It confirms the grouping and the gestures of all the main figures, though it also shows that some crucial details, such as the arrow-in-the-eye, and the moustache of the falling king, were then no longer visible. Fortunately the scene is also arranged in the same way, but including the arrow-in-the-eye in early engravings of the Tapestry published by Montfaucon (1729), Stothard (1819) and Sansonetti (1838).[80] There can therefore be no doubt that the main elements of the scene are authentic, but it would be unwise to rely on details like moustaches and beards. Montfaucon is notoriously unreliable upon such details,[81] and Stothard's engravings showed much that did not actually survive in 1819.[82] Stothard was able to 'reconstruct' the original state of the Tapestry in his engravings by tracing the needle-holes in the linen and by noticing

78 Gibbs-Smith places particular weight on the insignificance of the arrow-in-the-eye figure in *History Today* 10 (1960), 189–91. The point is dropped, however, in his latest restatement of the theory in Gibbs-Smith, *Bayeux Tapestry* (London, 1973), 15.

79 The water-colour, once the property of Charlotte Yonge, the novelist (1823–1901), is now in the library of Mount Holyoke College, South Hadley, Massachusetts, U.S.A. I am grateful to the librarian for providing information about its condition and for permission to reproduce it.

80 Montfaucon, *Monuments*, ii, pl. ix; C. A. Stothard, 'The Bayeux Tapestry', *Vetusta Monumenta*, vi (1819), pl. xvi (31); A. Jubinal, *La Tapisserie de Bayeux … dessins engravés par V. Sansonetti* (Paris, 1838), pl. 23.

81 There is an urgent need for a detailed comparison of Montfaucon's engravings with the Tapestry in its present state. Many details in the Tapestry today are not in Montfaucon; what needs to be established is how many of these details are in original wool, and how many are restorations of a later date.

82 Stothard's description of how in his engravings he had 'restored' damaged sections of the Tapestry is to be found in *Archaeologia* 19 (1821), 184–91; repr. as Ch. 1 above.

minute traces of wool that still remained. The restorations of 1842 were directly based on Stothard's 'reconstructed' engravings. Although Charles Dawson asserted in 1907 that the restorations were fraudulent in intent, because of the divergences between the restored Tapestry and Montfaucon's engravings,[83] the charge should not be taken seriously. Dawson was a notable Hastings antiquary, but in recent years he has been recognized as the probable perpetrator of that most successful 'restoration', the skull of the so-called Piltdown Man; he also produced other less well known forgeries – stamped tiles planted at the Saxon shore fort at Pevensey and forged antiquarian maps of Sussex.[84] To such an intrepid fabricator of archaeological evidence the charge of fraud came easily, if paradoxically. There is in fact no reason to doubt that Stothard's engravings were an honest and accurate work, for they are largely corroborated by Sansonetti's comparably careful work in 1838. But we should not exclude the possibility that his reconstruction of details may have been influenced by his presuppositions.[85] Since Stothard was in no doubt that both the arrow-in-the-eye figure and the falling Englishman were Harold, he may have been more willing to interpret one or two needle-holes as a moustache in both figures than he would have been, had he been convinced that only one was Harold.

With possible reservations about details alone, we may therefore accept the scene of the death of Harold in its present form as reliable; we can now consider what sources there are for the arrow-in-the-eye story apart from the disputed scene in the Bayeux Tapestry, and whether they are likely to be based on a misunderstanding of the Tapestry, as the modern interpretation requires.

The poem of Baudri, abbot of Bourgueil, addressed to Adèle, countess of Blois, the daughter of the Conqueror, was written between 1099 and 1102. It is an imaginative tour-de-force intended to secure the author a reward.[86] His vision of Adèle's chamber includes a hanging depicting William's conquest of England, worked in silks and in gold and silver threads and decorated with pearls and jewels. There can be no certainty whether the Bayeux Tapestry provided Baudri with the idea of a conquest embroidery. We need to remember that although the Tapestry is unique today, it was made at a time when embroidered hangings were a normal means of decorating an important hall, chamber or church. After a most painstaking and thorough discussion of every detail of resemblance and disagreement between the Tapestry and the imaginary decoration described by Baudri, Miss P. A. Abrahams

83 C. Dawson, *The Restoration of the Bayeux Tapestry* (London, 1907).

84 J. S. Weiner, *The Piltdown Forgery* (London, 1955), *passim* and especially 169–88; D. P. S. Peacock, 'Forged brick-stamps from Pevensey', *Antiquity* 47 (1973), 138–40; P. B. S. Andrews, 'A fictitious purported historical map', *Sussex Archaeological Collections* 112 (1974), 165–7.

85 Stothard (*Archaeologia* 19, 190) had no doubt that duplication of a leading character in one scene was common in the Tapestry, and even thought that Harold was shown three times in the death scene: p. 5 above.

86 *Les Oeuvres Poétiques de Baudri de Bourgueil*, ed. P. Abrahams (Paris, 1926), no. cxcvi (*Adelae Comitissae*), 196–253. The accompanying poem in which Baudri reminds the Countess that he has rendered her name immortal, and that she had promised him a cope, is no. cxcvii, 253–5.

concluded that Baudri probably did not know the Tapestry.[87] Any theory that depends upon the assumption that Baudri knew the Bayeux Tapestry is therefore founded upon unsure ground.

Even if for the purposes of argument we were to allow that Baudri saw the Tapestry, we would need compelling reasons to suppose that we are today in a better position to understand the only surviving embroidery of its age and type than the abbot of Bourgueil. He, after all would have seen it at most only 35 years after it was made, at a time when such works were common and the conventions they used well known. We may conclude either that Baudri is an independent source for the tradition that Harold was killed by an arrow, or that if he had seen the Tapestry he provides the earliest evidence for how the Tapestry was understood. Even if we supposed that Baudri had nonetheless misunderstood the Tapestry, it is unlikely that he is the source for the later development of the arrow-in-the-eye story. Baudri's poems were of topical interest only and have survived in only one manuscript. Baudri's editor was unable to find any evidence that any contemporary or later medieval writer or poet used his works.[88] Moreover later writers, William of Malmesbury (c. 1125), Henry of Huntingdon (c. 1130) and Wace (c. 1160) have the arrow-in-the-eye story in a far fuller version than that given by Baudri. Baudri simply states that Harold was killed by a chance fatal arrow (*Perforat Hairaldum casu letalis arundo; Is belli finis, is quoque causa fuit*) without indicating where the arrow struck.[89] But Malmesbury and Huntingdon are much closer to the scene in the Bayeux Tapestry: they describe how Harold was shot through the brain or in the eye, and how Norman horsemen then broke through and finally dispatched the dying king.[90] Their accounts show that by the first half of the twelfth century the arrow-in-the-eye tradition was current in England in a form that unlike Baudri's account allowed a part in the killing of the king both to the Norman archers and to the knights. Their accounts may of course derive directly or indirectly from the Tapestry; but there would then be further evidence of how the Tapestry was understood at an early date.

William of Malmesbury's account of Harold's death is particularly important. His statement that Harold was struck by a lethal arrow (*lethali arundine ictus*) echoes Baudri's phrase and may suggest that Miss Abrahams underestimated Baudri's influence. But William's description of Harold being pierced by the arrow through the brain (*violato cerebro*) and of a Norman knight then breaking through and striking the prostrate Harold *on the thigh with his sword* could not derive from Baudri; rather it is so close to the Tapestry as to suggest that William had seen the Tapestry itself at

87 *Baudri de Bourgueil*, 241–7, nn. 52 and 61.

88 *Baudri de Bourgueil*, xliii–xliv. But Baudri did visit Worcester (p. 360).

89 *Baudri de Bourgueil*, 209, 11. 461–4.

90 *De gestis regum*, 303: 'at ubi sagittae violato cerebro procubuit, fuga Anglorum perennis in nocte fuit … Quapropter, ut dixi, eminus lethali arundine ictus mortem implevit. Iacentis femur unius militum gladio proscidit …'; Henry of Huntingdon, *Historia Anglorum*, ed. T. Arnold, RS (London, 1879), 203: Interea totus imber sagittariorum cecidit circa regem Haroldum; et ipse in oculo percussum corruit. Erumpens autem multitudo equitum regem vulneratum interfecit.'

Bayeux, or just conceivably had used at Canterbury either the Tapestry designer's sketches or perhaps even the account that the designer followed. For there are a number of other places where William's account of the conquest agrees with the Tapestry against the testimony of other sources. Thus William not only follows the Tapestry in mentioning that Harold took ship from Bosham before his fateful journey to Normandy, but also rejects William of Poitiers' chronology in favour of that of the Tapestry in placing the Breton campaign before Harold's oath to William.[91] If William of Malmesbury did know the Tapestry (or its source at Canterbury), then it is apparent that he understood both the arrow-in-the-eye figure and the falling Englishman to be Harold. But if he did not see the Tapestry, then his account shows that the story that Harold was shot by an arrow in the head and then struck on the thigh by a Norman knight was current in England at least by 1125. This would be important because William had access to English traditions that have not survived in any other written sources.[92] In view of the parallel between Malmesbury's description and the death of Harold in the Tapestry, it would be difficult to deny that the Tapestry is depicting the same story.

Finally Wace's account must be considered, despite its late date, because he was a canon of Bayeux and drew heavily on the Tapestry for his description of the Norman Conquest.[93] Wace conflated several different accounts of the conquest, and William of Malmesbury was amongst the authors he used.[94] But if attention is paid to its sources, the *Roman de Rou* can be an invaluable indication of how the Tapestry was understood at Bayeux. Though Wace separates the two events by a passage of some length, he describes Harold being hit by an arrow below the right eye, and later being cut down by Norman knights.[95] Wace's account may well be influenced by William of Malmesbury here, but he is following the Tapestry in locating the

91 *De gestis regum*, 279.

92 In particular the tradition that Harold was on a pleasure cruise in the channel, rather than on a diplomatic mission to Normandy, when he was shipwrecked on the Ponthieu coast ... a story for which he claimed the authority of '*alii secretioris consilii conscii*', *De gestis regum*, 279.

93 Wace, *Le roman de Rou*, ed. A. J. Holden, 3 vols. (Paris, 1970–3). A convenient comparison of Wace and the Tapestry which shows how much information they have in common is to be found in A. Marignan, *La Tapisserie de Bayeux* (Paris, 1902), 1–36. Marignan's commentary, however, suffers from his belief that the Tapestry used Wace rather than vice-versa.

94 That Wace knew William of Malmesbury's *Gesta Regum* was proved from other parts of the poem by J. H. Round, 'Wace and his authorities', *EHR* 8 (1893), 677–83. See also Wace, ed. Holden, iii. 108–10, 156–61.

95 *Wace*, ed. Holden, ii. 189, 213–14:

ll. 3161–6 Issi avint qu'une saete
qui devers le ciel ert chaete,
feri Heraut desus l'oil dreit,
que l'un des oilz li a toleit'
e Heraut l'a par air traite
getee l'a, mais ainz l'out fraite.

ll. 8805–7 Heraut a l'estendard esteit,
a son poeir se deffendeit,
mais mult esteit de l'oil grevez.

arrow-wound *below the right eye*[96] rather than William, who only informs the reader that the arrow wound entered the brain. Thus Wace's account may be taken to confirm that the interpretation of the arrow-in-the-eye figure as Harold was natural to a medieval spectator.

Three conclusions emerge from this survey of the sources:

(1) Baudri of Bourgueil is very unlikely to have been the source of the tradition that Harold was shot in the eye by an arrow.

(2) If Baudri, Malmesbury or Huntingdon[97] used the Tapestry, then together with Wace they indicate how the Tapestry was understood at Bayeux by men more used to the conventions of embroidery narratives than we can be today.

(3) If on the other hand they did not use the Tapestry, then they provide independent though late evidence for the story that Harold was shot by an arrow.

The modern theory that the Tapestry's arrow-in-the-eye figure cannot be Harold, and that this tradition has arisen from a misunderstanding of the Tapestry, therefore meets great difficulties. The question must now be asked whether the arguments based on the Tapestry itself are sufficient to overrule them. Little attention need be paid to the rule that Gibbs-Smith postulated that violent deaths in the Tapestry are always shown by falling, bent or prostrate figures, for this begs the whole question of the interpretation of this and other death-scenes. More important is his general rule that neither in the Tapestry nor in any comparable work does any figure ever appear twice within the same scene. Nothing could be further from the truth. We have already seen how the designer of the Tapestry

11. 8811–18 Vint un armé par la bataille
Heraut feri sor la ventaille
a terre le fist trebuchier;
a co qu'il se volt redrecier
un chevalier le rebati
qui en la coisse le feri
en la coisse parmi le gros
la plaie fu desi en l'os

96 The Tapestry (*BT*, pl. 72) shows the arrow-in-the-eye figure in profile, so that only the left eye can be seen. The arrow as it was restored in 1842 passes out of sight behind the nasal of the helmet exactly level with the eye. Slight variations in the angle and point of impact of the arrow in the engravings of Montfaucon, Stothard and Sansonnetti are more likely to reflect the limits of the engravers' accuracy as Werckmeister has argued (*Studi Medievali* 17/2 (1976), 560–1, n. 132) than an attempt by the restorers to make the Tapestry fit the arrow-in-the-eye tradition as Gibbs-Smith, *Bayeux Tapestry*, 15 ff. asserts.

97 G. H. White 'The Death of Harold', in *The Complete Peerage*, xii, pt. i (London 1953), appendix L, 44–7, and pt. ii (1959), appendix K, 44 and R. Drögereit ([*Bemerkungen*], 284) assume that Henry of Huntingdon's account of Harold's death is dependent upon the Bayeux Tapestry, White's argument is difficult to follow, since he accepts that the Tapestry does not show Harold being shot in the eye (pt. ii, 43–4). Apart from the death of Harold there is nothing in Huntingdon that indicates dependence upon the Tapestry. His account may rather reflect what was believed about Harold's death in England c. 1130.

could include two or more consecutive events within a single 'scene';[98] for the same reasons medieval artists often found it useful to depict the same individual twice in one scene. Duplication is in fact a very common device in pictorial narrative both in late antique and in medieval illumination.[99] It is moreover very commonly used in the major works of pictorial narrative produced at Canterbury both before and after the Norman conquest.

Duplication was for example a standard technique of the artists at St Augustine's who illustrated the Old English paraphrase of the Heptateuch in the years shortly before the Norman conquest. When it was necessary to show Jacob bowing to the ground seven times before Esau and then embracing him (Genesis 33.1–3.), Jacob was depicted as six separate identically dressed prostrate figures in one picture; in the next Jacob is shown bowing for the seventh time and then embracing Esau.[100] When the artist wished to show [pl. 16] Lot seated before the gates of Sodom and prostrating himself before the two angels (Genesis 19.1–2), it was natural for him to show Lot twice in the same picture, once seated before Sodom and once prostrating himself before the angels.[101] The duplication even extends to Lot's staff which he holds when seated, but has stuck into the ground when he makes his obeisance to the angels. Another famous late-Saxon manuscript that was probably produced at Canterbury, the so-called Cædmon manuscript, repeatedly duplicates leading figures within a single picture in order to add to the interest of the Genesis illustrations.[102] In illustrations of New Testament scenes from Canterbury, duplication is already found in the sixth-century *St Augustine's Gospels*,[103] and after the conquest in the four detached leaves from a Canterbury psalter of the mid-twelfth century,[104] and in the *Paris Psalter*.[105] These examples suffice to show that the Canterbury artists who produced the major extant works of medieval pictorial narrative were accustomed to duplicate leading figures within a single scene as a means of saving space, of making one illustration do where two would otherwise be necessary. It was a standard device which lent pace and drama to the depiction.

It remains to be shown whether the designer of the Bayeux Tapestry also made use of duplication in his enormous narrative of the Norman conquest. We cannot

98 See above.
99 K. Weitzmann, *Illustrations in Roll and Codex* (*Studies in Manuscript Illumination,* ii) (Princeton, 1947); O. Pächt, *The Rise of Pictorial Narrative in Twelfth-Century England* (Oxford, 1962).
100 BL, Cotton Claudius B. iv, fols. 50v, 51r: *The O.E. Illustrated Hexateuch,* ed. Clemoes and Dodwell, 27.
101 *Ibid.,* fol. 18.
102 Oxford, Bodleian Library, MS Junius 11: *The Cædmon Manuscript,* ed. Sir I. Gollancz (Oxford, 1927), 41, 44, 60, 66.
103 Cambridge, Corpus Christi College, MS 186, fol. 125 depicts the Agony in the Garden showing Christ both praying and speaking to the disciples saying 'Sleep now and take your rest' (Wormald, *Gospels of St Augustine,* pl. iv, 3).
104 The scene of Christ Calming the Waters shows Christ asleep in the boat and again standing up calming the waves (London, BL, Add. MS 37472, fol. lv. Reproduced in Dodwell, *Canterbury Illumination,* pl. 66).
105 Paris, BN, MS Latin 8846, fol. 3 (reproduced in Dodwell, *Canterbury Illumination,* pl. 67) shows the Devil twice in the scenes depicting the temptations on the Temple and on the mountain.

hope to achieve the same degree of certainty that is possible with biblical illumi-
nations, since we do not have the text that the designer of the Tapestry was follow-
ing. But there are a number of scenes where duplication appears highly likely. Just
before the battle of Hastings, English and Norman scouts are shown observing the
movements of the rival armies.[106] The English scout, one of the very few mailed
figures in the Tapestry shown wearing a belt, seems to be shown twice: first watch-
ing the Norman army over the brow of the hill, and then reporting back to Harold
with his arm pointing back to what he has just seen. The inscription (*Iste nuntiat
Haroldum regem de exercitu Wilelmi ducis*) makes it clear that only one scout is involved
by its use of the singular and by placing the word *iste* just above the figure on the
watch. The duplication of the belt confirms that only one scout is depicted.
Another probable example of duplication occurs in the scene showing the death of
Harold's brothers, Leofwine and Gyrth (pl. 22).[107] The Norman cavalry, as usual,
are depicted coming in from the left and right of the picture. Leofwine and Gyrth
are distinguished by being rather larger than the neighbouring figures, and they
stand immediately by their names. Leofwine wields a two-handed English axe as a
Norman knight thrusts a spear between his shoulders; Gyrth, a magnificent mous-
tached figure with a huge round shield, is pierced in the face by a Norman lance
whilst he attempts to counter with his own spear. These are heroic deaths indeed,[108]
but what is significant for our purposes is that both appear to be shown twice over:
Leofwine cartwheeling over backwards, and Gyrth down in the border with the
lance driven right through his face. Further to the right another Englishman also
seems to be shown twice, first wielding an axe as he receives a spear in the chest and
then twisting and falling backwards as he tries to pull the spear out of his chest.
There is no need to suggest that the designer of the Tapestry had developed any
conscious theory of duplication; rather that, like the artist who drew Lot and the
angels at Sodom, it was convenient to show two stages of a process, both the mortal
wound being delivered and the dying figure falling to the ground. It was the easiest
and most vivid way of depicting the death of an important figure in a fittingly
heroic and prolonged manner.

Much the most obvious example of duplication in the Tapestry, however, occurs
in the scene showing the death of Harold (pl. 26). The dragon standard of Wessex
is shown alongside the arrow-in-the-eye figure, but the standard and the standard-
bearer are shown a second time tumbling to the ground. We cannot suppose, as
does C. Gibbs-Smith,[109] that there were two dragon standards, carried (if we can
rely on this detail) by identical white-bearded twins. Medieval armies had a number
of different banners, and at Hastings William of Poitiers tells of a different English

106 *BT*, pl. 58.
107 *BT*, pls 64–5.
108 Gibbs-Smith, true to his rule that violent deaths must be shown bent falling or prostrate, will not
 allow these two figures to be Leofwine or Gyrth; he chooses instead the jackknifed and cart-
 wheeling figures (*BT*, 187).
109 *BT*, 188.

standard in the form of a fighting man.[110] But we never hear of two or more standards of the same type in a single battle. Henry of Huntingdon refers to the dragon standard of Wessex at the battles of *Beorhford* (752) and Ashingdon (1016).[111] Whether or not he had any reliable authority for the presence of the dragon standard at these battles, it is sufficient for our purposes that he conceives of one dragon standard only. Widukind of Corvey describes how the continental Saxons also had a dragon standard carried before them in battle, and an early tenth-century manuscript from St Gall, the *Psalterium Aureum* depicts Joab setting forth to make war on the Syrians and Ammonites with a dragon standard, just like that in the Tapestry, carried before him.[112] In the ninth century and later we hear of a raven banner carried before a number of Danish armies,[113] but never of more than one raven banner at a time. Such standards served to identify the commanders of armies. To have two could only cause confusion. That the Bayeux Tapestry depicts the dragon standard twice, rather than two dragon standards, is even confirmed by William of Malmesbury and by Wace who describe Harold standing by the standard, where of course the Tapestry shows the arrow-in-the-eye figure.[114] Here then we have a clear example of duplication in the very same scene as the death of Harold.

There can therefore be no theoretical objection to the arrow-in-the-eye figure being Harold. Duplication was a common device of medieval artists at Canterbury and elsewhere; it was widely used by the designer of the Tapestry in particular. Moreover it is difficult to see how the duplication of Harold in the death scene could have been made more explicit. The falling Englishman being cut down by the Norman knight has the inscription unnaturally squeezed up immediately above him. The arrow-in-the-eye figure is next to the standard where both William of Malmesbury and Wace understood Harold to be standing. The designer of the Tapestry has also indicated that the arrow-in-the-eye figure is Harold by arranging the inscription so that the name Harold comes exactly above, and contrary to what Gibbs-Smith has written about this figure being 'insignificant... not pictorially singled out in any way...fourth and last, and quite undistinguished in any respect', in a 'routine' group of figures,[115] the arrow-in-the-eye figure is in fact larger and more dignified than any of his companions, and is in the centre of the whole scene (pl. 26).

Detailed examination of the Tapestry's depiction of the death of Harold therefore confirms that the old interpretation was correct. The story of Harold's death commencing with the arrow-wound in the eye is one of the best-known traditions

110 *Gesta Guillelmi*, 224. He is followed by *De gestis regum*, ii.302.

111 Huntingdon, 121, 183.

112 St Gallen, Stiftsbibliothek, MS 22, p. 140, reproduced in A. Merton, *Die Buchmalerei in Sankt Gallen* (Leipzig, 1923), pl.xxix. i; Widukind, *Res Gestae Saxonicae* 1, ch. ii.

113 References to the raven banner are conveniently assembled by A. Campbell (ed.), *Encomium Emmae Reginae, Camden Soc.*, 3rd ser. lxxii (London, 1949), 96–7.

114 *De gestis regum*, ii. 302: 'Rex ipse pedes juxta vexillum stabat cum fratribus'; for Wace, see above, p. 28 n. 95.

115 Gibbs-Smith, in *History Today* 10 (1960), 190–1.

of English history, and it is not one that needs to be jettisoned. The Tapestry artist designed the scene with great skill. He repeated the motif of the cavalry charge up Battle hill; he used the familiar device of duplication to show two stages in the slaying of the king in a particularly dramatic form by placing it in the very centre of the scene; and he organized the inscription and positioned the standard-bearer so that the interpretation would be clear. The evidence of Baudri, Malmesbury, Huntingdon and Wace confirms the traditional interpretation of the Tapestry and gives no support for the view that a mistaken interpretation of the Tapestry lies behind the arrow-in-the-eye tradition. On the contrary the Tapestry must be recognized as the earliest and most authoritative and explicit account of how Harold met his death. For William of Jumièges simply states that Harold fell covered with mortal wounds, whilst William of Poitiers knew nothing at all of the manner of his death, though he does tell us that after the battle Harold's body, destitute of every badge of rank was identified, not indeed from his *face*, but from certain distinctive emblems.[116] If this is anything more than the eulogist's elaboration of his own and Jumièges' ignorance, it would fit well enough with the tradition that Harold was severely wounded by an arrow in the eye, which could indeed have made his face unrecognizable.

The fact that the accounts that lie closest to the Tapestry's depiction of the death of Harold are those of William of Malmesbury and Henry of Huntingdon suggests that here as elsewhere in the Tapestry the details of the depiction may derive from English rather than Norman tradition. We cannot tell whether the elaborations of Malmesbury and Huntingdon's accounts were already known to the designer of the Tapestry or whether they are derived and developed from it. But an English artist from St. Augustine's designing an embroidery for Odo of Bayeux before 1082 was in a good position to know how Harold had been killed. The only other detailed account of Harold's death, that of the *Carmen de Hastingae Proelio*, has a very different story. It tells in suspicious detail how four named Norman knights, seemingly including and led by William himself rode through the remnant of the English line and cut down the king.[117] Even if the poem's attribution to Guy of Amiens were to be reestablished, its account of the killing of Harold would in no way exclude that of the Tapestry. The Tapestry does not have room to show more than one knight cutting Harold down; and the *Carmen's* ignorance of the arrow is of no more significance than its ignorance of English topography, of Leofwine, and of other details known to the designer of the Tapestry.

When care is taken to understand the conventions and limitations of its design and technique and to distinguish the nineteenth-century restorations from the original work, the Tapestry can take its place as a major authority for the events of the Norman conquest. It is an early and well-placed source with access both to

116 Jumièges, 135; *Gesta Guillelmi*, 204: 'Ipse carens omni decore, quibusdam signis, nequaquam facie, recognitus est'.

117 *Carmen*, 34–6. The inspiration of the *Carmen's* account is argued by Professor Owen in his forthcoming study to be the execution of Ganelon in the *Chanson de Roland*.

English and Norman traditions, and its information is presented to us through the eyes of an artist of outstanding accomplishment. This does not mean that its account is in any way objective or even free from error. Its depiction of Conan at Dol, of English byrnies on Norman knights, perhaps of English bows in the hands of the Norman archers, and of the problematic oath scene at Bayeux warn us to use its evidence with caution. But when we have narrowed down its provenance and date and understood its design, we can interpret individual scenes and assess their historical value with greater confidence.

9

Towards an Interpretation of the Bayeux Tapestry*

H. E. J. COWDREY

Broadly speaking, historians approach the Bayeux Tapestry in one of two ways: it offers evidence upon which they can draw for the study of a wide range of political, military, social, and other topics; it is also a document of the first importance for an understanding of Anglo-Norman history which must be considered as a unity and in its own right. This paper adopts the latter approach. It does so very tentatively, for despite intensive study the Tapestry remains a puzzling document, both as a whole and in its details. Moreover, the present observer, at least, seldom comes back to it without noticing something new to compel him to refine or to change his current opinions. We are always learning about it, so perhaps a way forward with its interpretation is for those professionally interested to set forth for discussion something of what they see in it. There is, no doubt, a danger of subjectivity. But at least, discussion may serve to weed out supposed perceptions that are idiosyncratic or extravagant, and to focus attention upon those that are fruitful and constructive. So I am bold to say something about what I currently see in the Tapestry as a whole, and I shall place especial emphasis upon a feature that has not to my knowledge received systematic attention: the gestures with the hands of the human figures who are displayed.[1]

*Unless otherwise stated, references are to Stenton's edition of the Bayeux Tapestry (*BT*). Other editions are referred to as follows: Bertrand, *BT* = S. Bertrand, *La Tapisserie de Bayeux et la manière de vivre au onzième siècle* (La Pierre-qui-Vire, 1966); Parisse, *BT* = M. Parisse, *La Tapisserie de Bayeux. Un documentaire du xiᵉ siècle* (Bayeux, 1983); Wilson, *BT* = D. M. Wilson, *The Bayeux Tapestry* (London, 1985). I would particularly acknowledge my gratitude to Professors M. Biddle, R. H. C. Davis, K. J. Leyser, and M. Parisse for stimulating discussions about the Tapestry; they are in no way responsible for mistakes and misjudgements in what follows. Above all, I am deeply grateful to Mme Michèle Coîc, Bibliothécaire-Conservateur of the Tapestry, for making a study-visit to Bayeux so useful and enjoyable. I should also add that this paper does not take account of the as yet unpublished results of the scientific examination of the Tapestry at the time of its rehanging in 1982–3. As regards the date of the Tapestry, I concur in the conclusions of Wilson, *BT*, 212.

1 F. Garnier, *Le Langage de l'image au moyen âge. Signification et symbolique* (Paris, 1982) refers only to manuscript illumination. Comparisons with figural sculpture and metalwork would be more likely to be helpful. Analogies on Trajan's column are not convincing: O. K. Werckmeister, 'The Political Ideology of the Bayeux Tapestry', *Studi medievali* 3rd ser. 17/2 (1975), 535–95; the Bernwardsäule and bronze doors at Hildesheim Cathedral, and similar early eleventh-century items, might well be more relevant.

By way of introduction, I wish to comment on two points which are themselves familiar but about which a little more may usefully be said. The first is the prominence accorded to William the Conqueror's half-brother Bishop Odo of Bayeux, for the Tapestry underlines him perhaps even more than is generally appreciated. The named appearance of two and perhaps three of his Kentish tenants – Turold, Wadard, and Vital,[2] like his connections with Saint Augustine's, Canterbury,[3] are familiar enough. As events develop in the Tapestry, his importance is foreshadowed when Bayeux, and particularly its castle, figures prominently in Duke William's progress with Harold, earl of Wessex, to the oath-taking which is the climax of the first portion of the Tapestry (pl. 10), whether or not Harold's oath is understood to have been taken at or near Bayeux.[4]

It is after news of Harold's coronation as king of England reached Normandy that Odo himself appears four times. When William orders the building of ships (pl. 15), the unnamed, tonsured figure who sits to his left is certainly he, for no other cleric was so close to the centre of events. His role is accentuated: if he sits behind William, he also sits higher; he is made the more obtrusive by his superior place to William in the sequence of four heads, rising from the viewer's left to right, that comprises the group of figures. It is Odo's left hand, not William's, that gestures towards the busy preparation of the fleet. It is to him, rather than to William, that the shipwright appears to look for his instructions. Then, when the Norman host has arrived in England, Odo – it is sufficient to describe him as *episcopus* – presides at dinner, blessing the food and drink (pl. 18); the similarities with Christ's place at the

2 References to Ralph, son of Turold, as Odo's tenant occur in *Domesday Book* i. 6a, 7bcd, 8d, 9a (Kent), ii. 24a, 25ab (Essex); the last reference includes Turold. Wadard is Odo's tenant in i. 1a, 6b, 7c, 10c (Kent), 32a (Surrey), 66b (Wilts), 77b (Dorset), 155d, 156abc (Oxon), 238d (Warwicks), 342abcd (Lincs). *Circa* 1079 a Wadard *miles* became a tenant of St Augustine's, Canterbury: W. Thorne, *Chronica de rebus gestis abbatum S. Augustini Cantuariae*, vii, 5, in R. Twysden, *Historiae Anglicanae scriptores* x (London, 1652), 1789. See also A. Ballard, *An Eleventh-century Inquistion of St Augustine's, Canterbury* (London, 1920), 21–2; in addition a Vitalis 'de Canterbire' is Odo's tenant: 10, 18, and a Vitalis is the abbot's tenant: 19. Two, at least, of the named figures seem to relate to St Augustine's as well as to Bishop Odo. Turold's standing might imply that, in scene 12, he must be the second messenger, not the holder of the horses. But the latter's bearded appearance is not unlike the unexplained figure who half obscures Duke William at Odo's dinner (49); can this privileged figure also be Turold? (The small man in scene 12 is probably not a dwarf; the embroiderers cannot show perspective.)
3 N. P. Brooks and H. E. Walker, 'The Authority and Interpretation of the Bayeux Tapestry', *Proceedings of the Battle Conference on Anglo-Norman Studies* 1 (1979), 1–34 at 15–18; repr. as Ch. 8 above.
4 Written sources place the oath-taking at Bonneville-sur-Touques near Pont l'Evêque, near which William had a residence: *Gesta Guillelmi* i. 42, 102–7; and Rouen: Orderic iii. 11, ii. 134–7. As is pointed out by Parisse, *BT*, 51–2, 138, the Tapestry is not without ambiguity. If the captions on either side of Bayeux (28–9) are read together, so that *Ubi* refers back to *Bagias*, the oath was taken in or near the city. But if the *Ubi* is disjunctive (cf. 1, 11, 12, 19) and refers to the new scene (29), the oath may not have been so taken. (The lack of a double point after *Bagias* (28) is not conclusive: cf. 6, 13, 16, 18, etc.) Some features suggest that the oath may not have been taken near Bayeux: William seems to by-pass it (28, cf. 23, 24); Harold stands on a cobbled surface indicating an outdoor event that could have happened anywhere (29); the composition of the scene (29), with its closely integrated sequence of William sitting apparently indoors, Harold swearing outdoors, and Harold's embarkation for England, implies a rapid transit from inland Bayeux to the sea in the course of which Bonneville would be a plausible place for the oath-taking.

Last Supper in a tradition of manuscript illumination that begins with St Augustine's Gospels is familiar.[5] The accentuation of Odo's role is again self-evident; William, apparently, sits unnamed and half-concealed on his right. There immediately follows William's council of war (pl. 18), to which the figure on Odo's left at dinner emphatically points. Inside a building, William sits, holding upright in his left hand the sword which he indicates with his right and which will be the instrument of victory. To his right sits Bishop Odo, who alone in this scene is given his title. His right hand corroborates William's gesture. On William's left sits his other half-brother, Robert, count of Mortain, who unsheaths his sword in William's support. It is remarkable that the three brothers share a single bench; except that he sits in the middle, William has no pre-eminence. There seems to be deliberate emphasis upon his half-brothers' part in the enterprise of England.

Odo's final appearance is at a critical point in the Battle of Hastings (pl. 24). He is on horseback and at full gallop. In his right hand he brandishes a staff (*baculum*) to which the caption specifically refers.[6] By his presence and example he encourages (*confortat*) the young warriors (*pueros*). His words have the desired effect: whereas the horseman immediately to his right, with his lance reversed and shouldered rather than in fighting position, is fleeing the battle, those who come next redouble their efforts. Odo's *baculum* and his decisive encouragement demand comparison with the scene in which Duke William, mounted upon a stationary warhorse, exhorts his knights to do battle *viriliter et sapienter*. In his right hand, the duke, too, holds a staff (*baculum*), not brandished but resting on his shoulder; it seems to have been a habitual outdoor symbol of his authority. The Tapestry shows Bishop Odo eliciting in action the manfulness and martial skill that William has called for in words. As he did so, he held a like symbol of authority.

In the Tapestry, Bishop Odo's high standing in relation to his half-brother the duke is no less clearly depicted than his closeness and serviceability, and at one point Robert of Mortain is brought into the family picture. The public for which the Tapestry was intended was to be left in no doubt about the role of the Conqueror's kin.[7]

5 Brooks and Walker, 'Authority and Interpretation', 13–17 (pp. 74–76 above).

6 *Baculum* is translated 'staff' not 'mace' because the two should be distinguished. In the Tapestry, the *baculum* is a symbol of authority rather than an offensive weapon (21, 56, 59, 68). It is a slightly tapering, wooden baton, sometimes with small lateral projections; the use of *baculum* for a bishop's pastoral staff should be remembered: Wilson, *BT*, 225. Odo seems similarly to appear not with a sword (for there is no crossguard) but with a staff, held to his shoulder and decorated near his hand with a broad riband, in his equestrian, armoured likeness on the obverse of a seal depicted in *Sir Christopher Hatton's Book of Seals*, eds. L. C. Loyd and D. M. Stenton (Oxford, 1950), no. 431, 301 and pl. VIII. For Odo's alleged refusal to cary weapons see *Gesta Guillelmi* ii. 37, 242–3. The term 'mace' is best reserved for an offensive weapon of similar size to the *baculum* but with a heavy head. William carries a mace when proceeding to imminent hostilities, but a *baculum* when asserting his leadership. A mace can be thrown, and it is a weapon of *pedites*. It should be distinguished from a huntsman's headless club. As a translation of *baculum*, 'wand' has little to commend it.

7 Cf. the large contribution of ships that Robert of Mortain (120) and Odo of Bayeux (100) are now known to have made to the Conqueror's fleet: C. W. Hollister, 'The Greater Domesday Tenants-in-Chief' in *Domesday Studies*, ed. J. C. Holt (Woodbridge, 1987), 219–48, at 221–2, 242–3.

My second introductory point is that the Tapestry is above all the story of three kings, or at least of three men whom we think of as kings: Edward the Confessor, Harold and William.[8] They overshadow everything else, including Odo of Bayeux with his four appearances. They indicate a focus upon kings and lay leaders that makes such factors as papal interest in the Norman Conquest quite irrelevant. Edward appears only at the beginning when, in his palace and with crown and sceptre to declare his regality, he admonishes Harold before his journey to France (pl. 1), and in the middle when, crowned, he receives Harold on his return (pl. 11), just before the highly concentrated scenes of his burial, death-bed, and death (pl. 12). As for Harold, from the start he is more often than not at the forefront of events. He is at once distinguished by the title *dux Anglorum* to which he and his riding companion point by way of emphasis (pl. 1) – perhaps as an editorial comment upon his true standing, or perhaps to foreshadow his leadership of the English host in the fateful battle to come. However this may be, he is *dux* until he returns to England and receives the crown. Then, he is forthwith exhibited in regality, wearing the crown and holding the sceptre and orb: *Hic residet Harold rex Anglorum* (pl. 13). *Rex* he remains until the very moment of his death in battle. It is open for us to speculate that the lost end-scenes of the Tapestry culminated in a depiction of William's regality at his coronation on Christmas Day 1066; this would have balanced the regal depictions of Edward (pl. 1) and Harold (pl. 13), and it would have made up for the low-key set piece of William sharing a bench with his half-brothers before the battle (pl. 18). Be that as it may, as we have the Tapestry, William is *dux* throughout; and at no point is there a foreshadowing of regality, as there so easily might have been at the outset, by showing Edward's promise of the crown to him. A reference to it at the end may have been emphatic but it is likely to have been brief, for there is reason for thinking that not more than some 2m have been lost of a Tapestry that is now about 68.38m long.[9] Given the Norman view that William became *rex* only at his coronation,[10] the Tapestry's reticence about William's regality is understandable. But the effect that is produced is a marked accentuation of Harold.

Harold, indeed, is highly conspicuous throughout the Tapestry. Some crude but telling points bring this home. In Stenton's edition Harold is there from scene 1 and he dies in the penultimate remaining scene (72: pl. 26); William first appears in scene 14 (pl. 7) and finally in scene 68 (pl. 25) when he merely raises his helmet and flourishes his *baculum* to dispel a rumour that he has been killed. As Stenton presents his seventy-three scenes, there are certain or probable representations of Harold in

8 Parisse, *BT*, 44–50, 53–61; Wilson, *BT*, 14–17.
9 The Tapestry is made up of eight strips of unequal length which were carefully sewn together. The last three complete strips measure 6.60m, 7.05m, and 7.15m; 5.25m of the final strip survives. The suggestion that some 2m of the final strip may be lost assumes it to have been of approximately the same length as its three predecessors: Bertrand, *BT*, 23–5; Parisse, *BT*, 141; Wilson, *BT*, 12, 228 n. 5.
10 G. Garnett, 'Coronation and Propaganda: some implications of the Norman Claim to the Throne of England in 1066', *TRHS* 5th ser. 36 (1986), 91–116.

twenty-six but of William only in twenty.[11] And in the Latin captions, up to the appearance of the comet (scenes 1–35) Harold's name figures fourteen times to William's ten; thereafter William's appears nine times to Harold's seven. Harold is very prominent indeed among the three kings with whom the Tapestry is concerned.

We do not know whether William the Conqueror ever set eyes upon the Tapestry; we may reasonably wonder whether, if he did, he was pleased by what he saw. Especially after Odo of Bayeux's fall from favour in 1082 he would hardly have welcomed the depiction of the Conquest as something of a consortium of himself with his half-brothers. A king so insistent as he upon his regality would not have warmed to an emphasis upon that of Edward and Harold but to reticence with regard to his own.[12] Whatever the origins of the Tapestry, it was not designed with William's sensibilities in view, or, probably, for regular or occasional display in a royal context, whether in Normandy or in England.

So much by way of introduction about some of the persons in the Tapestry; I now turn to the story. It may be divided into three portions of unequal length. The first follows Harold's adventures from his dismissal to France by Edward the Confessor (pl. 1) to his return *ad Anglicam terram* (pl. 11). The second, sharply defined as a unity by a tower and a tree such as often serve in the Tapestry for 'punctuation',[13] and placed a little before the mid-point of the Tapestry, is much more concisely, even densely, presented: it covers events from Edward's reception of Harold to the appearance of the comet (pls 11–14). Finally comes the much more spacious depiction of the preparations for and the events of the invasion of England up to the Battle of Hastings (pls 15–26). I shall say something about each of these portions in turn.

The first centres upon Harold; everything leads up to the critical scene of his oath-taking to William (pl. 10), immediately after which he returns by ship to England. It is well known that the Tapestry reverses the order of events in William of Poitiers, according to whom the oath-taking occurred before the Breton expedition.[14] Here as elsewhere in the Tapestry, it is the substance not the sequence of events that matters; their order and the intervals between them can be freely overridden in order to bring out what is deemed to be of lasting and fundamental importance. Events are given significance, not as they fit into the story as a true and accurate historical progression or to achieve consistency in the presentation of personality and character, but as the designer wishes them at any juncture to strike the observer. In order to impress it upon him, the oath-taking is not only emphasised by being placed last amongst the events in France; the scene itself is also carefully

11 Of the three kings, Edward is shown in scenes 1, 31–3; Harold in 1–8, 10, 11, 15, 17, 18, 21, 22, 27–31, 33–5, 58, 71, 72; William in 14, 16–18, 21, 26–9, 37, 42, 43, 49–51, 53, 55, 56, 59, 68.

12 One needs refer only to the account of the crown-wearings in *ASC anno* 1087 (1086), 164, or to the tone of the *Gesta Guillelmi*.

13 Parisse, *BT*, 59. Trees provide punctuation in scenes 2–3, 9–10, 11–12, 14, 17, 35, 36, 53, 57–8, 58–9, 73, as do towers in 17–18, 19, 31, 52.

14 *Gesta Guillelmi*, i. 43, 102–7.

presented. Two figures to William's left and one to Harold's right gesture upwards towards the word *sacramentum* in the caption, while under William's solemn gaze and as directed by his right index finger Harold takes his oath upon two reliquaries: his left hand touches a portable reliquary, and his right touches another placed upon an altar.[15] It is imprinted on our memory that Harold took his oath with both hands – his left as well as his right.

According to Stenton, the events depicted in the first portion of the Tapestry are 'designed to show that, before the oath was required from him, Harold was already bound to Duke William by many different forms of obligation – that of a captive to his deliverer, a guest to his host, a soldier to his commander, and a vassal to his lord.'[16] This is true, but there is more to be said. For if we consider the main story in this portion, disregarding the margins, it may reasonably be read as presenting Harold in a wholly favourable light in his own person and conduct.[17] He appears as a confidant of the old king (pl. 1), and as *Dux Anglorum* who travels to the continent with a retinue appropriate for a high-born magnate. At Bosham he attends to his religious duties and feasts nobly in his manor-house (pl. 2). In France, he is a valiant warrior who accompanies Duke William on his campaign against Count Conan II of Brittany (pl. 9), on the way to which he distinguishes himself by rescuing two Normans from the quicksands near Mont Saint-Michel (pl. 8). At the end of the campaign William honours Harold by giving him arms; Harold's debt is made the more manifest because, until he rides to the Battle of Hastings, it is only here that he wears a hauberk; even on campaign in Brittany he conspicuously does not do so (pl. 8). William and Harold return to Normandy together, and Harold takes his oath to the duke honourably (pl. 10). D. M. Wilson has observed that 'there is no real condemnation of Harold in the Tapestry as a whole'.[18] Perhaps we may go further: so far as the main story in the first portion of the Tapestry is concerned, Harold is, and when William arms him he is declared to be, *chevalier sans peur et sans reproche*.

This raises one of the most teasing questions in the interpretation of the Tapestry: what are we to make of the possible comment on the main story which occurs in the upper and lower margins? So far as the first portion of the Tapestry is concerned, discussion must centre upon particular animal and human figures, and upon citations from fables. As regards particular figures, the enigmatic Ælfgyva incident (pl. 7) suggests that marginal comment may sometimes be specifically relevant to the interpretation of the main story: the similarity of gesture between the clerk and the nude male in the lower margin confirms the sexual nature of the transgression

15 Harold does not swear his oath upon a eucharistic host; all the round objects are ornaments either of the reliquary or of the altar frontal. At least one set of relics, probably that in the portable reliquary, seems to have been William's own: see *Gesta Guillelmi*, ii. 14, 180–3.

16 *BT*, 9–10.

17 A possibly unfavourable comment on Harold may be implicit in his somewhat hunched posture when talking with Count Guy of Ponthieu (pl. 4). But it need express no more than Harold's situation as an involuntary detainee.

18 Wilson, *BT*, 203.

concerned.[19] In a similar way, marginal figures under Harold sometimes make us wonder whether they do not convey a warning that he is not the model knight that he seems to be. Thus, while he and his companions pray devoutly, two birds of uncertain species are locked in combat; the two companions kneel but the birds' heads grovel in the dust (pl. 2).[20] When Harold feasts nobly two crafty wolves lick their paws so that they may hunt more stealthily (pl. 2). When Guy of Ponthieu apprehends Harold, a brutal and lawless-looking hunting scene seems to parody the noble hunting entourage with which Harold set out (pl. 3). As Guy takes him to Duke William he rides honourably, but an obscene sketch in the margin seems to insist upon his notorious *luxuria* (pl. 6). More generally, from the threatened dog-fight beneath King Edward's dismissal of Harold (pl. 1) pairs of animals or birds, often in confrontational poses, help to create an atmosphere of insecurity and subliminal tension that contrasts with the favourable, even heroic, presentation of Harold in the main story.

Much the same may be said of the fables.[21] It is likely that the designer of the Tapestry was familiar with a lost Middle English collection of fables identical with, or similar, to that which Marie de France a century later translated into French;[22] a Latin collection in Oxford, Bodleian Library, MS Rawlinson G. 111 (SC 14836), may also stand close to it.[23] Almost all the fables in the Tapestry occur in the

19 In this most puzzling incident, it is just possible that the tower is that of a church with its double doors, approached by steps, shut against the clerk. His right foot leaving the steps would then highlight the canonical penalty for his fornication. The Ælfgyfa incident is associated by the 'punctuating' towers with a scene in William's palace where he sits formally, and the three leading figures point towards the lovers (pl. 7). William legislated in 1064 against clerical incontinence at the synod of Lisieux: canons 2–3, L. Delisle, 'Canons du Concile tenu à Lisieux en 1064', *Journal des savants* (1901), 516–21 at 517.

20 For the beast and birds of the Tapestry see W. B. Yapp, 'Animals in Medieval Art: the Bayeux Tapestry as an Example', *Journal of Medieval History* 13 (1987), 15–73.

21 The starting-point for a study of the fables in the Tapestry remains H. Chefneux, 'Les fables dans la tapisserie de Bayeux', *Romania* 60 (1934), 1–35, 153–94; Yapp, 'Animals in Medieval art', 34–40, is very useful. Assessments of the value of the fables for interpreting the Tapestry have tended to polarise between the excessive and the dismissive. L. Herrmann, 'Les fables antiques de la broderie de Bayeux', *Collection Latomus* 69 (Brussels-Berchem, 1964), goes much too far and is often fanciful. He errs in concentrating upon Phaedrus' version of Æsop, although it was known and copied in early medieval Europe (Phèdre, *Fables*, ed. and trans. A. Brenot (Paris, 1924), pp. xi–xiii); not all of the fables in the Tapestry occur in Phaedrus. Assessments in *BT*, 27–8 (by F. Wormald) and in Wilson, *BT*, 51, 209, 229, n. 51, are underestimates; Parisse, *BT*, 127–32, is alive to the purpose of the fables but uses Phaedrus. The best discussion is C. R. Dodwell, 'The Bayeux Tapestry and the French Secular Epic', *The Burlington Magazine* 108 (1966), 549–60 at 559; repr as Ch. 7 above; but it is by no means certain that Marie de France's moralisations were current a century before she wrote.

22 K. Warnke, *Die Fabeln der Marie de France* (Halle, 1898). For the English tradition that she followed see xlvi–xlvii, 327–8.

23 L. Hervieux, *Les Fabulistes latins depuis le siècle d'Auguste jusqu'à la fin du Moyen Age*, 5 vols (Paris, 1893–99), II, 653–713. Interlineated Latin and vernacular glosses in two collections of fables that comprise the late eleventh-century manuscript point to its use as a schoolbook.

margins of the first portion.[24] In the lower margin, and precisely below events from Harold's embarkation at Bosham to his setting foot on French soil, there is an uninterrupted sequence of seven fables – the Crow and the Fox, the Wolf and the Lamb, the Pregnant Bitch, the Wolf and the Crane, the Wolf who Reigned, the Mouse and the Frog, and the Wolf and the Goat. The predominant theme is the hidden danger presented to the unwary by the crafty and deceitful. There is no question of specific references from the margin to events above in the main story. But the message seems clear: fair appearances like those of Harold are deceptive. The warning is, surely, heightened and confirmed when two of the fables – the Wolf and the Crane, and the Crow and the Fox – recur in the upper margin as Harold returns to English soil (pl. 11). They are well chosen to point up Harold's situation: the wolf mocks the crane for a benefit lately conferred (we recall William's recent generosity to Harold in giving him arms); proud of what he has just stolen (we recall that Harold is about to seize the crown), the black-feathered crow sits aloft eager for flattery (we shall soon see Harold in false regality) but the fox cuts him down to size.

Many of the figures, and some of the fables, in the margins simply provide decoration and animation; it would be perverse to claim that they do more. But, in the first portion of the Tapestry, some figures, and most of the fables, serve to call into question the fair-seeming Harold of the main story. Things are not as they seem. There is a cryptic reminder that Harold's fine appearance conceals an inner man who is flawed and false.

In the second portion of the Tapestry what has hitherto been cryptic about Harold breaks through into the main story. Harold comes to King Edward (pl. 11). But whereas in the Tapestry so far great men who have been received by another have stood honourably inside the hosts' palaces, Harold is now left outside.[25] He is unarmed, and his figure is bowed and distorted. Perhaps prefiguratively of something to come for which we must watch, he gestures to the enthroned king with an accentuated left hand to which his right seems to point. No longer is he *chevalier*

24 The fables that, in Chefneux's table, 28, figure most clearly and significantly in the Tapestry are as follows. References are to the editions cited in nn. 22–3, and are by number of the poem and by pages.

Fable	*BT*	*Rawlinson G. 111,* ed. Hervieux	*Marie de France,* ed. Warnke
The Crow and the Fox	4–5, 20, 31	xii, 664–5	xiii, 47–9
The Wolf and the Lamb	5	ii, 655	ii, 8–10
The Pregnant Bitch	5, 59	viii, 660	iii, 29–32
The Wolf and the Crane	6, 30	vii, 659	vii, 26–8
The Wolf who Reigned	6–7	xxxiv, 695–7	xxix, 96–104
The Mouse and the Frog	7	iii, 656	iii, 11–17
The Wolf and the Goat	7–8, 61		xciii, 299–303
The Lion and the Ass Hunting	10		xi, 40–3
The Swallow and the Birds	11–12	xvi, 670–1	xvii, 61–3

25 A point well made by Parisse, *BT*, 63.

sans peur et sans reproche: he is an outcast, devoid of honour; his hunched and twisted figure announces his moral pervertedness much as does that of Shakespeare's Richard III.

By comparison with the spaciousness of the first and third portions of the Tapestry, the second is densely compressed. The time-scale is foreshortened. Harold seems to come straight from his oath in Normandy to Edward at Westminster at the time of the completion and consecration of the church on 28 December 1065; for the building inside which the king sits adjoins an abbey church to which the final touch of a weathercock is being added, while God's right hand confers consecration. In fact, Harold had long since returned – at the very latest by 1 August 1065.[26] At the end of the sequence, the compact transition within a single complex of buildings from Harold's assumption of the crown to the sighting of the comet (pls 13–14) makes it hard to remember that, far from being at maximum brightness on 5–6 January when Edward died and Harold was crowned, the comet was not seen until April and reached full brightness in England only after 24 April.[27]

Not only are events compressed, no doubt to bring out their true bearing on each other, but at a critical point their order is reversed: Edward's body is borne to burial before he makes his death-bed address to his *fideles* and then dies (pl. 12).[28] This reversal is anything but incompetent or simplistic; it is intentional and sophisticated. The draftsmanship is superb. Rather unusually in the Tapestry, there is strong movement from the viewer's right to left as the royal bier, followed by the chanting Westminster monks, proceeds outdoors to the abbey; birds and beasts in the margins confirm the backwards movement. But the flow of events continues: only the narrowest of gaps separates the hindmost monk from the palace where Edward lies dying; movement to the right is resumed by the pitch of the buildings and by human gestures and faces. Thus, what happened at Edward's death-bed is shown, without interruption by his burial, to be the momentous event from which the future directly and inevitably develops.

To Edward's death-bed we may now turn (pl. 12).[29] The details are certainly not self-explanatory, and the caption, *Hic Eadwardus rex in lecto alloquitur fideles*, does not help greatly; although there seems to be irony in the word *fideles*. However, it is widely recognized that the *dramatis personae*, at least, can be identified from the description of the royal death-bed in the *Vita Edwardi*, which was written before 1075 while Edith,

26 The Chronicle is blank for 1064. For 1065, *ASC*, 137–40.
27 *ASC* CD texts, 140. For a survey of references to the comet, see E. A. Freeman, *The History of the Norman Conquest of England*, 6 vols, 2nd and 3rd ed. (Oxford, 1870–7), III, 645–50, and additional references in G. Meyer von Knonau, *Jahrbücher des Deutschen Reiches unter Heinrich IV. und Heinrich V.*, 7 vols (Leipzig, 1890–1909), I, 522–4. There is also some information in P. Lancaster-Brown, *Halley and his Comet* (Poole, 1985), 113.
28 For an earlier deliberate reversal of events, see scenes 11–15, and on the Tapestry's technique of narration, Parisse, *BT*, 74–7.
29 For further discussion of this scene and its contemporary background see H. E. J. Cowdrey, 'Death-bed Testaments', forthcoming in *Fälschungen im Mittelalter*, Internationaler Kongress der Monumenta Germaniae Historica, München, 15–18 September (Schriften der Monumenta Germaniae Historica 33, i–vi), vol. IV.

Edward's queen and Harold's sister, was still alive, and which was bitterly hostile to Stigand, in 1066 the archbishop of Canterbury.[30] The figures are thus, from the left, Edith, Harold, Stigand, and (to the king's right) the royal steward Robert fitzWimarch.[31] All five make expressive gestures with their hands and upon these gestures I would like to venture some very tentative comment.

Edith may provide the key. At first sight her left hand uses her veil to wipe her tears, while her right hand indicates the dying husband who is the reason for her grief. That may be all. But her left hand is accentuated by the six black lines on the forearm which her veil shrouds from her companions; her finger points to, rather than past, her forearm. It seems to direct the observer to pay attention to the left hand – the symbol of the adverse, baleful, and perverted. We recall the somewhat similar disposition of Harold's hands as he returns to Edward (pl. 11), and also the fact that Harold swore to William with both hands (pl. 10); his left hand, as well as his right, sanctioned his oath. A confident interpretation of the death-bed scene is not possible. But, given the hints that hands are significant, it is remarkable that the king, who is crowned, extends his right hand to touch Harold's; there was similar contact at the beginning of the Tapestry (pl. 1), when Harold set out for France with a purpose not made clear but probably connected with Edward's earlier promise that Duke William should be his heir. What Edward then confirmed he holds to now, as he makes a death-bed disposition that his laid-out body below (pl. 12) serves to hallow: Harold is to be the executor of Edward's continuing purpose that William shall be his heir. Robert fitzWimarch, as he supports the king, points to the two right hands with his left as though casting doubt on Harold's probity. He does so with reason, for with strikingly identical gestures Harold and Stigand raise emphasised left hands towards Edward's crown. A possible interpretation is that, on the side of what should be, Edward confirms his earlier promise that the crown should pass to William and, with his right hand, renews his long-standing commission to Harold to bring this about; but that, on the side of falsity, Harold left-handedly conspires with Stigand to seize the crown for himself.

A marked emphasis upon the left hand seems to continue.[32] It is with the left hand that the crown is given to Harold; the lack of a subject and the plural verb in the caption, *Hic dederunt Haroldo coronam regis* serve to dissociate the gift from Edward's

30 *Vita Edwardi*, ii, 20, 75–9. The likely date of Book ii is 1067: xxv–xxx. See E. John, 'Edward the Confessor and the Norman Succession', *EHR* 94 (1979), 241–67, esp. 264–7.

31 Since the Tapestry does not show consistency in depicting individuals, there seems to be no obstacle against taking all the clerical figures in scenes 33–4 as representing Stigand. The changes in presentation seem intended to present him to the observer in different lights: the unshaven Stigand who hears the king's testament is deceitful; the bowed figure by the king's corpse who gestures upwards to the testament and downwards to the dead king, echoing the curved stance of the superior depiction, is exhibiting formal piety; the Stigand who stands upright beside the crowned Harold reflects his flawed regality.

32 It must be allowed that, in a Tapestry that is full of dynamic movement from the viewer's left to right, the emphasis on the left hand often serves simply to sustain the movement in scenes where its significance may be anything but perjorative. But nowhere else in the Tapestry does the emphasis figure so strongly and frequently as in the second portion.

intention (pl. 13). We are forthwith shown Harold resplendent in regality: *Hic residet Harold rex Anglorum* (34). This scene should probably not be understood as depicting the stages of Harold's coronation on 6 January 1066, but as an icon of his king-ship.[33] Crowned and holding the orb and sceptre, he looks the very image of a king. He sits foursquare upon a throne that is rigidly rectangular, while the embroiderers have taken exceptional pains to make the palace perpendicular. In both margins are lions, royal beasts, to add to the appearance of regality. But we should watch the left hands. Harold's swordbearer holds the sword of state upright – but in his left hand. More interesting still is *Stigant archiepiscopus*, arrayed in his pontificals: in his left hand is a maniple which is so emphatic that it calls for explanation. Its contem-porary meaning is illustrated by the prayer of the clerk who assumed it: *Da, Domine, virtutem manibus meis ad abstergendam omnem maculam immundam* ('Give strength, Lord, to my hands to wipe away every unclean blemish').[34] But for the *Vita Edwardi* as for current Norman propaganda, Stigand's own hands were indelibly stained. The maniple looks like biting irony; a like irony may also pervade Harold's stiff regality.

In any case, the regality was short-lived. In an adjacent antechamber, five watchers, three with upwards-extended left hands (pl. 14), grope with them towards a fate that is clearly indicated by the left hands of, it seems, the same men who, from another antechamber of the same building, wonder at the comet (35).

Under its baleful influence there is presented another image of Harold which in-vites comparison with his recent regality, now unmasked as the falsehood that it is (pl. 14). Once again, Harold sits crowned, enthroned, and in a palace; but all is declared to be lost. *Harold rex Anglorum* is simply *Harold*. His slender and powerless body slumps towards the comet; even his moustache has gone. For the confidently proclaimed orb and sceptre, there is substituted a limply held lance. The sword-bearer retains the sword of state in his left hand, but it is reversed and only the lower half has been embroidered. As for Stigand, he has vanished. Harold's throne, formerly so rectangular, slews over and its back looks broken. The palace in which he pretended to regality was as straight as a plumbline; this one totters to the right. Everything, in fact, is wonky and askew. By a final, brilliant touch, five ghostly ships in the lower margin foreshadow what is in store for Harold. The hand of God blessed Edward's work (pl. 14); the comet sets a curse upon Harold. In those five ships, the rest of the Tapestry is implicit.

Helped by the dramatic unity and forward movement that the Tapestry through-out maintains, the few, dense scenes of the second portion hold the key to the whole Tapestry and control our overall reaction to it. In them the falseness that always

33 This view is advanced in view of the deliberately contrasting depictions of Harold's regality that are offered in pls 13 and 14, and perhaps of an intended contrast with the low-key depiction of Duke William in pl. 18. If pl. 13 is dissociated from the event of Harold's coronation, there is no necessary contradiction with Florence of Worcester's statement that Harold was crowned by Arch-bishop Aldred of York: Florence, i. 224 (although William of Poitiers names Stigand: *Gesta Guillelmi* ii. 1, 30, 146, 220).

34 J. A. Jungman, *Missarum Sollemnia. Eine genetische Erklärung der römischen Messe*, 2 vols, 4th ed. (Vienna, 1958), I, 369.

lurked in the fair-seeming Harold becomes plain for all to see. In them his kingship is weighed and found wanting. And they foreshadow the nemesis that awaits Harold in the rest of the story.[35]

A remarkable feature of its third portion is how little this nemesis and the reasons for it are alluded to, and how much depends upon the vivid memory that the second portion has impressed upon our minds. It is as if story-telling for its own sake takes over. It has to, for everyone knew that Harold still had it in him to be the victor of Stamford Bridge. So let us consider the depiction of Harold himself. Despite the emptying of his regality under the influence of the comet (pl. 14), in the third portion he is *rex* until his death. His death-scene (pl. 26) is particularly remarkable. I find convincing the argument of N. P. Brooks and H. E. Walker that the death is duplicated: Harold receives an arrow in the eye, and then he is hacked at by the sword of a Norman knight as he falls helplessly to the ground.[36] But the cardinal point made is that he dies manfully, 'with harness on his back'. The vast, charging Norman on the black horse confirms that military opposition is now overwhelming. Harold's straits are made clear: the stripping and disarming of English corpses begins in the lower margin to show that the battle is lost (pl. 26); the English dragon-standard lies on the ground, its bearer killed. Yet even here there is a remarkable touch. Brooks and Walker have convincingly argued that the English had only one dragon-standard.[37] We should notice how, just before Harold's death, another Englishman has seized it and defiantly holds it aloft, while a companion defends Harold against the charging Normans. Only then comes Harold's arrow-wound in the eye, as he stands honourably and heroically embattled.

There is dishonour at Harold's death, but not among the English; it shames the Normans who frame the scene in which Harold receives the fatal arrow. After it, a mounted Norman, his head bowed to betoken his disgrace, hacks at a dying Harold who is prostrate, disarmed, and defenseless (pl. 26). William of Malmesbury, who perhaps knew the Tapestry, commented that William branded the knight with ignominy and stripped him of his knighthood.[38] This incident is paired to the left of the charging Norman on the black horse, when another Norman shamefully beheads a stripped and defenseless Englishman with his own sword.[39] Harold dies nobly in a gallant English last stand; he is in no way arraigned now for his perjury, while Norman knights are shamed for besmirching their knighthood. It would be

35 For a comparable view of Harold as 'Callida vi veniens ad regnum, ideoque passus in eo detrimentum', see Hermann, *Miracula Sancti Edmundi*, 34 in *Ungedruckte Anglo-normannische Geschichtsquellen*, ed. F. Liebermann (Strassburg, 1879), 246. Hermann wrote after 1095.

36 For the possibility that the fallen Harold may originally have been depicted with the arrow still in his eye, see D. Bernstein, 'The Blinding of Harold and the Meaning of the Bayeux Tapestry', *Anglo-Norman Studies* 5 (1982), 40–64, at 45–6, 64; but there is a note of caution in Wilson, *BT*, 200.

37 32–3.

38 *De gestis regum*, iii, 243–4, ii, 303–4. William's comment about the Battle of Hastings that 'Emicuit ibi virtus amborum ducum' and his comparison of Harold and his opponent are valuable as a standard of reference for the Tapestry.

39 It should be observed that the Norman's sword is sheathed. A beheading in the lower margin adds emphasis to the incident.

no surprise if the lost ending of the Tapestry included some such scene as William allowing Harold's mother to give him honourable burial.[40]

The purpose of the third portion of the Tapestry is not to moralise by placarding Harold as a wicked man who pays the price for perjury; it is to tell a story of hard-fought warfare, for the most part honourably waged by both sides. If there is a message, it is that fighting men should likewise do a good professional job. For large tracts – between the giving of orders for building a fleet and the departure of the Norman host from Hastings town, and between Duke William's address before the battle and the final Norman victory – the story is unbroken by 'punctuation' by trees or towers. The logistic near-miracle of building, arming and victualling a fleet is depicted in loving detail, but simply and directly. Ignoring William's transfer of his fleet from the Dives to the Somme, the Tapestry moves at once to a magnificent tableau, to be fully appreciated only by viewing the original, of a sea crowded with ships that break into the upper margin as they sail to Pevensey for disembarkation (pl. 17). Then a vivid sequence of scenes depicts, straightforwardly and undidactically, the varied activities of the camp: foraging, feasting, a council of war, castle-building (pls 18–19). Next, in a scene clearly punctuated by the town-gate of Hastings and a clump of trees, William is presented simply as the Norman general in the battle to come. It is a remarkable depiction. William is the military leader of his host as he stands in hauberk and with sword, holding his lance with its gonfanon, and pointing to the battle that the direct observer can see stretching ahead in scenes to come. Not only is there no inkling of future regality, but the duke is identified only by the two pendants at the back of his helmet and by his magnificent warhorse with its prodigious masculinity.[41] Even the caption *Hic milites exierunt de Hestenga* alludes, not to the duke, but to the next scene after the 'punctuation'.

The caption is extended with great dramatic effect in the sequel, as the Norman cavalry sets out from Hastings and gathers speed as if already charging in battle. In two splendidly contrasted scenes, William and Harold seek intelligence about each other's armies. William sits on horseback still and composed. He has a worthy opponent in King Harold, for *rex* he still is; it is a far cry from the earlier dereliction of his regality and strength. As if straight from his victory at Stamford Bridge, he advances fully armed and on horseback. With his moustache restored, he points with Lord Kitchener-like urgency to the new enemy whom he advances to engage. There may be implicit criticism of his over-readiness to rush into an engagement; there is none of his royal rank or moral conduct.

The narrative at once passes to the Battle of Hastings. It repays examination in great detail; I can now select only a few points. The battle begins under the longest and most majestic caption of the Tapestry as we now have it: *Hic Willelm dux allo-quitur suis militibus ut prepararent se viriliter et sapienter ad prelium contra Anglorum exercitum.*

40 *De gestis regum*, iii, 247, ii, 306–7.
41 For the duke's pendants cf. scenes 21, 27. Is the horse's masculinity a scherzo on William's later exhortation to his knights *ut prepararent se viriliter ... ad prelium* (60–1)? And do the nude scenes in the upper margin of the advancing Norman army in scene 54 express similar satire?

In Stenton's edition, the caption extends over four scenes. As in the previous scenes, William is mounted; but, unlike the impetuous Harold, he once more stands still and composed. His exhortation that his knights fight *viriliter et sapienter* can be invested with biblical and sacral overtones of holy war,[42] but it probably should not: he simply urges them to fight manfully and professionally. Below the caption, by the same visual device of accelerating motion that was used as the host left Hastings, the battle array of knights supported by archers gains momentum until it encounters the English shield wall (pl. 21). Thus far we have been invited to notice William's control of his army, the speed with which his initial exhortation was put into effect, and the standard of courage and training that he expected Norman knights to display. For the rest, the Tapestry will be concerned with the vicissitudes of battle – the fog of war. It disguises neither English resilience nor Norman setbacks, and in the context of battle William's men are (as in the Anglo-Saxon Chronicle) *Franci*, not proudly self-styled *Normanni*. Surprisingly, after Bishop Odo's decisive intervention and Duke William's rather desperate gesture of raising his helmet to show that he is still alive (pls 24–5), William does not appear again to lead his forces to victory. If the Normans gradually gain the upper hand, from the deaths of Harold's brothers Leofwine and Gyrth (pl. 22) through the slaying of his companions, to his own death (pl. 26) whereafter the English flee, it is nowhere disguised that, like another Anglo-French engagement many centuries later, the Battle of Hastings was 'a damned close-run thing'. The story is all. So far as the depiction of the battle is concerned, no providence or fate ordains its conclusion. For such an interpretation we must, as we are undoubtedly meant to, recall the second portion of the Tapestry – a powerful memory, but a long way back.

My final point about the presentation of the battle is how marginal comment insists that it was a 'damned close-run thing', and what an unexpected twist this commentary gives to the story.[43] Until the initial Norman cavalry charge met, and failed to break, the English shield-wall (pl. 21), it is doubtful whether, in the third portion of the Tapestry, either margin comments directly or otherwise upon the substance of the main story. As always the margins provide animation, vitality, and a unifying power, but nothing more. After the two sides engage at close quarters, however, the lower margin never ceases to comment upon the battle above.[44] Comment begins with the many dead warriors still in their hauberks and with discarded weapons and shields; we infer that there are many casualties, and that the fighting is too intense and dire for spoils. Then, suddenly, from Bishop Odo's intervention to rally the wavering Normans and Duke William's raising of his helmet (pls 24–5), the lower margin becomes filled with archers – nineteen in unbroken

42 *Viriliter.* Josh. 1: 18, 1 Macc. 2: 64, 6: 31; cf. the prayer for a warrior before battle, *Domine deus omnipotens, rex regum* in London, British Library, MS Cotton Nero A. II, fols 11v–12v, and Cotton Galba A. xiv, fols 3r–6r, with its petition, 'ut … bene pugnare viriliterque agere valeam': *A Pre-Conquest English Prayer-Book*, ed. B. J. Muir, HBS 103 (1988), nos 6, 11–12, pp. 21, 29–30.
43 In the following paragraph I am conscious of a particular debt to a conversation with Karl Leyser.
44 No doubt the significant comment, here as elsewhere, is concentrated in the lower margin for the convenience of the observer.

succession and two further pairs. Their effective deployment at this point carries the important implication that William is still in tactical control of the battle. They tirelessly discharge relays of arrows that are eventually replenished from free-standing containers; the last pair of archers seems to take aim at Harold himself. Only when Harold and his companions fall does the margin turn to the stripping and spoliation of corpses, as a proclamation that the Normans have at last won the day.

From the margin, the archers give the story this unexpected twist: now, they really mattered. The first part of the battle belonged to the cavalry, who had also monopolised the scenes of embarkation and crossing. Up to Odo's intervention, the Tapestry shows only four Norman archers, advancing before the Norman host as battle begins. When the English shield-wall holds, only a few arrows have rather indecisively become embedded in the shields (pl. 21). The later stages of the battle, as the Tapestry presents them, tell a very different story. After Odo intervenes, the cavalry rally and press on; but it is the archers who turn the tide of the battle. A prominently displayed Englishman falls from the main story amongst the archers in the margin with an arrow in his face. As Harold's bodyguards resist and fall, arrows pepper their shields (pl. 26). Finally, it is to an arrow that Harold succumbs while a Norman knight disgraces himself (pl. 26). Norman knights are still in the battle, but at the end of the day they fight singly to consolidate a victory that the archers are critical in securing. Whoever designed the Tapestry saw to it that the Norman archers had due credit.

What do these reflections suggest about the date, purpose, and original location of the Bayeux Tapestry? Perhaps the problem of its date can be clarified just a little. It has long been recognised that Edward's death-bed scene in the Tapestry (pl. 12) has much in common with that in the *Vita Edwardi*,[45] whether through direct reading or dependence on a common source or tradition. A feature of the *Vita*'s account is the obscurity and ambiguity in which the dying king's intentions for his kingdom are wrapped. He commits Queen Edith to Harold, who is described as her protector (*nutricius*) and brother: 'Hanc, inquit, cum omni regno tutandam tibi commendo'. He also commends to Harold his servants from overseas, asking that they may be allowed either to attach themselves by fealty to Harold's protection and service or else to have safe conduct home. There is no clear statement about on what terms or for how long Edward committed the kingdom to Harold, although the transfer of his servants' fealty suggests durability. Any earlier promise of the kingdom to William is ignored. By contrast with this obscurity, the Bayeux Tapestry seems designed to display the events of the death-bed much more clearly, by showing how with his right hand Harold received Edward's charge to implement the king's earlier grant of the crown to William, while with his left hand he plotted with Stigand to seize the crown for himself. Since it is so much clearer, this version of events is likely to be later, though not necessarily much later than the *Vita* of, at very latest, 1075. But it seems to predate the dissemination in England of the story that, on his death-bed, Edward himself disregarded his earlier promise to William, and by his *verba*

45 74–81.

novissima designated Harold;[46] of this, the Tapestry, I think, shows no knowledge. Thus, a date for the Tapestry soon after 1075 is acceptable.

As regards its purpose, the quality of the story-telling makes attractive a comparison with English heroic poetry and French *chansons de geste*.[47] For example, such a comparison helps to explain the favourable presentation of Harold: comparing him with Ganelon in the *Chanson de Roland*, C. R. Dodwell notes that the epic villain is never weak or feeble; 'he is handsome and vigorous and always courageous'.[48] Yet the epic tradition does not explain the different views of Harold taken in the different portions of the Tapestry. The Tapestry is powerful enough as a work of art to create a narrative form of its own, which must be interpreted in its own way. It is also important that it was concerned with a historical, not a fictitious character; a recent hero, not a long dead one. Perhaps an eye was directed to Harold's persisting reputation as a noble exemplar. The *Vita Eadwardi* shows how, even c. 1075, his memory was cherished. 'For strength of mind and body', it declares, 'he stood out among the people like another Judas Maccabeus. The friend of his race and country, he kept most diligently to his father's ways and followed in his footsteps, by showing patience and mercy and by his courtesy to men of good will. But it was with the fearsome countenance of the lion that this righteous champion threatened the disorderly, thieves, or robbers.'[49] Given the currency of so favourable a view, the Tapestry may be designed to perform two contrasting but not altogether incompatible purposes, directed to a partly English public: one was to show that Harold had not been all that he purported to be but bore a tarnished image, while the other was to honour what was truly heroic in his memory amongst Englishmen for whom he was the victor at Stamford Bridge as well as the vanquished at Hastings. Upon such Englishmen, it should be remembered, the Normans partly depended for military and other service. The Tapestry is generally acknowledged to have been made in England; there may be respects in which it was also made for England.

It seems to have had in view a mixed and secular audience of fighting men – no doubt Normans first but English as well, *pedites* as well as *milites*;[50] it is designed to raise morale and promote loyalty among, as well as simply to entertain, a broad

46 *ASC* E text *anno* 1066, 140; *Gesta Guillelmi*, ii, 11, 25, 172–4, 206–7; Worcester i, 224; Eadmer, 8. For the legal background see esp. M. M. Sheehan, *The Will in Medieval England* (Toronto, 1963), 5–106, and A. Williams, 'Some Notes and Considerations on Problems connected with the English Royal Succession 860–1066', *Anglo-Norman Studies* 1 (1979), 144–67 at 165–7.

47 See esp. Dodwell, 549–60 (pp. 47–62 above); S. A. Brown, 'The Bayeux Tapestry and the Song of Roland', *Olifant* 6 (1979), 339–50, and 'The Bayeux Tapestry: History or Propaganda?' in *The Anglo-Saxons: Synthesis and Achievement*, eds. J. D. Woods and D. A. E. Pelteret (Waterloo, Ont., 1985), 11–25.

48 557 (p. 56 above).

49 i. 5, 30–1, cited by Wilson, *BT*, 16; the translation is mine. The danger of a cultus of a king slain in battle is illustrated by the German anti-king Rudolf of Swabia, killed in 1080: see esp. H. Sciurie, 'Die Merseburger Grabplatte König Rudolfs von Schwaben und die Bewertung des Herrschers im 11. Jahrhundert', *Jahrbuch für Geschichte des Feudalismus* 6 (1982), 173–83.

50 Cf. the instruction given in the household of Hugh of Avranches, earl of Chester: Orderic vi, 2, iii, 216–7.

spectrum of Anglo-Norman society. Much of it depicts its members' life-style, and the warfare that was their business and delight. Its message that knights should fight *viriliter et sapienter*, its preparedness to show up Norman lapses and to acknowledge English valour, and its frankness about the military effectiveness of knights and archers at the Battle of Hastings, suggest an audience largely drawn from military households and establishments in England where French and English rubbed shoulders. Odo of Bayeux's conspicuous appearances point to his patronage and direction. Odo's interests may also explain artistic borrowings from Saint Augustine's, Canterbury, a house where English-born monks were tenacious of their aspirations.[51]

Where was the Tapestry intended to be displayed? A starting-point for discussion is the matter of observation that it is designed for close viewing; it is best seen at a distance of two or three adult paces, and at about eye level. One must, therefore, postulate buildings large enough to permit the close viewing of a work some 70 metres in length; moreover, its placing at a height of some 2 metres must not unacceptably impede human circulation. Many features of the Tapestry render attractive the hypothesis that it was meant for display in secular buildings.[52] But unspecific assertions that, in the 1070s and 1080s, and so before the construction of Westminster Hall and the Hall of the Exchequer at Caen, there were secular halls of sufficient size, excite scepticism,[53] particularly if the royal halls at Winchester and Gloucester, the dimensions of which are unknown, are excepted on the grounds that the Tapestry's restrained treatment of William I makes it unlikely to have been intended for royal occasions during his lifetime.[54] If display in secular halls is proposed, the onus rests with its advocates to establish that there were suitable examples and to produce measurements. Such examples seem hard to find.

Meanwhile it is necessary to think of ecclesiastical buildings. We know that display in them was feasible and acceptable, for an inventory of the treasures of Bayeux Cathedral in 1476 records that the Tapestry was then exhibited annually on the

51 Cf. the resistance of what seems to be a party of English monks to the election in 1087 of Abbot Guy, whom Archbishop Lanfranc of Canterbury and Bishop Odo of Bayeux are said to have cooperated to install: *Acta Lanfranci* in *Two of the Saxon Chronicles Parallel*, ed. C. Plummer after J. Earle, 2 vols (Oxford, 1892–9), I, 290–1.

52 Dodwell, 549–50 (pp. 47–50 above); Wilson, *BT*, 203. Dodwell supposes a hall about 85 feet by 35 feet.

53 See, e.g., the diagrams in *The History of the King's Works, I–II: The Middle Ages*, eds. R. A. Brown, H. M. Colvin, and A. J. Taylor (London, 1963), I, 44.

54 The same consideration suggests scepticism about the relevance of the tapestry showing the battle of Hastings which, according to the poet Baudri of Bourgueil, the Conqueror's daughter Adèle, countess of Blois, kept in her chamber, and especially about whether Baudri's description of it can be used to attempt a reconstruction of the Bayeux Tapestry's lost ending: Parisse, *BT*, 36–40. Parisse proposes that Adèle's tapestry, which he estimates to have been some 12m long, extracted from the Bayeux Tapestry the events after the appearance of the comet that were most flattering to her father. It seems wise to keep an open mind about a relationship that can neither be proved nor disproved. For Baudri's poem see *Les Oeuvres poétiques de Baudri de Bourgueil (1046–1130)*, ed. P. Abrahams (Paris, 1926), no. cxcvi, lines 207–572, 202–11; *Baldricus Burgulianus, Carmina*, ed. K. Hilbert (Heidelberg, 1979), no. 134, lines 207–572, 154–64, presents a better text.

feast and in the octave of the Cathedral's relics.[55] Some four hundred years earlier there were certainly English as well as Norman ecclesiastical buildings, either complete or in building, where it could similarly have been shown. The church at Saint Augustine's, Canterbury, as begun by Abbot Scotland (1070–87) and completed by Abbot Guy (1087–93), is but one of a number.[56] Given its dimensions, the Tapestry would have been an inconvenient object to display in one such place for very long; if at the best height for viewing it could well have impeded liturgical and general circulation. But, folded rather than rolled, it would have been readily portable.[57] We may, perhaps, envisage that it was intended to be taken round ecclesiastical buildings in England and perhaps Normandy for brief periods of public display. It may have been accompanied by guides and interpreters to offer an approved commentary, perhaps in the vernacular, upon its by no means self-evident detail.[58] As things turned out, Odo's fall from favour in 1082 may have sooner or later led to its transfer to Bayeux with his chattels for storage that was permanent and seldom disturbed. That would account for its preservation in such fine and unfaded condition. But, since we have no information whatever before 1476, we cannot proceed beyond guesswork.

55 *BT*, 88; facsimile in Bertrand, *BT*, 18–19. Of Odo's cathedral, consecrated in 1077, only the crypt and the façade towers survive; they suggest that the building would have been large enough for at least the occasional display of the Tapestry, though there is no direct evidence about when the custom recorded in 1476 began.

56 A. Clapham, *St Augustine's Abbey, Canterbury, Kent* (London, 1955), 4–5, 7–21. Plan at the end.

57 Parisse, *BT*, 50–1.

58 The guides may have been important, for it cannot be assumed that the Tapestry's audience was all that 'sophisticated' or 'knowledgeable': Wilson, *BT*, 18. If, as is not unlikely, Henry of Huntingdon had seen the Tapestry, his statement that, as William harangued his troops before the battle, they impatiently hurled themselves against the enemy and left the duke talking to himself, ludicrously misunderstood scenes 59–61: Huntingdon, vi. 30, 202.

10

The Bayeux Tapestry: a stripped narrative for their eyes and ears*

RICHARD BRILLIANT

The Bayeux Tapestry, a masterpiece of medieval narrative art, tells the highly politicized story of the contested accession to the English crown, held by Edward the Confessor. The historical narrative begins in 1064, while Edward was still king (pl. 1), and ends in 1066, when Harold, formerly the earl of Wessex, and the domestic claimant, lost his life and the crown to the foreigner, William, duke of Normandy, at the Battle of Hastings (fig. 1; pl. 26). There is some scholarly agreement that the Tapestry was made in England not long after 1066, possibly at Canterbury, and even more that the work was done at the behest of Norman patrons, perhaps even for Odo, William's half-brother, and artfully composed to present the Norman side of the story. Yet, there is very little agreement over how the Tapestry was originally displayed, although a secular rather than an ecclesiastical environment seems likely. Almost no attention has been paid to the way this magnificent artwork was seen by Normans, or English, or both.[1]

I. The Visual Display, or what Anglo-Norman eyes might have seen

The Tapestry is a multicoloured embroidered strip of linen, almost 231 feet long and 20 inches high. Like the enormous scholarly bibliography it has elicited, the Tapestry is materially incomplete and its narrative lacks closure. The Tapestry now

* For Kurt Weitzmann.

1 The bibliography on the Bayeux Tapestry is huge but very little bears on the issues discussed here. I have made use of the following: F. M. Stenton (ed.), *The Bayeux Tapestry* 2nd ed. (London, 1965); C. H. Gibbs-Smith, *The Bayeux Tapestry* (London, 1973); D. M. Wilson, *The Bayeux Tapestry* (London, 1985); D. J. Bernstein, *The Mystery of the Bayeux Tapestry* (London, 1986); S. A. Brown, *The Bayeux Tapestry: history and bibliography* (Woodbridge, 1988); J. B. McNulty, *The Narrative Art of the Bayeux Tapestry*, AMS Studies in the Middle Ages, no. 13 (New York, 1989); O. K. Werckmeister, 'The Political Ideology of the Bayeux Tapestry', *Studi medievali*, 3rd ser., 17/2 (1976), pp. 536–94.

 An early version of this article was delivered in the Robert Branner Forum for Medieval Art, 'Story and Image in Medieval Art', held at Columbia University, 8 April 1989. I am grateful for the stimulus offered by the invitation to participate in the Branner Forum, which led, in turn, to the reproduction of the Bayeux Tapestry at one-seventh scale and to the close consideration of its display.

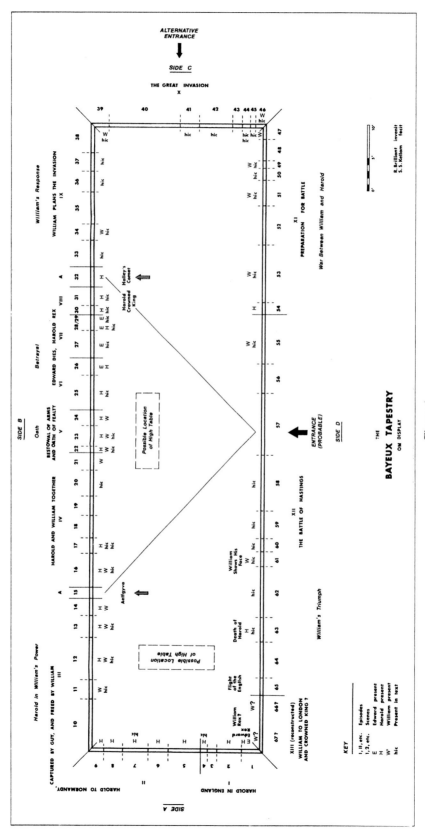

Figure 1

terminates in a tattered remnant, showing the English in flight after the Battle of Hastings, but the original ending has been lost, thus depriving the visual narrative of a fitting, well-embroidered conclusion, comparable to the formal, elegant beginning of the Tapestry and its history (figs 1, 2a). Hundreds of human and animal figures, often placed in well-defined architectural or landscape settings, are carefully arranged by scene and episode (tables I, IV) in a manner recalling the helical reliefs of Trajan's Column in Rome, especially in the reiterated presence of the principal protagonists of the historical drama, Harold and William (fig. 1; table IIb).[2] Unlike that ancient monument, the Tapestry retains its brilliant colours – reds, blues, greens, yellows – enhancing the visual distinction of each element of the composition. In addition, the Tapestry bears an extensive, if simple, Latin inscription, similarly embroidered in coloured letters, usually more than an inch high and thus easily read at some distance, even in poor light (figs 2–4; table II).[3]

In view of the care bestowed on the design of the Tapestry and on its execution, the unwieldy size and weight of the material, and the political significance of its narrative message, the Tapestry must have been intended for public display and for display in its entirety. Only then would the complexity and subtlety of its organisation have made visual and narrative sense, only then would the closure of the historical narrative have been readily apparent.

David Bernstein and Shirley Brown have recently come out in favour of a secular setting for the Tapestry, placed along the walls of some great baronial hall, above the entrances.[4] There is fragmentary evidence for the existence of such halls in the eleventh and twelfth centuries, sufficiently large and lofty to permit the hanging of a very long, colourful tapestry to delight and edify a company of notables assembled, perhaps at table, for some ceremonial occasion. These halls differ in dimension and plan, but characteristically they have an oblong shape with a length to width ratio of from about two to almost four to one.[5] There is no reason to believe that such an installation of the Tapestry had to be permanent, since it could be fairly easily taken down, folded into some chest, and stored.

2 See S. Settis, *La Colonna Traiana* (Turin, 1988), pp. 86–255.

3 According to my eye doctor, Dr Milton Zaret, to whom I showed photographs of the Tapestry and colour reproductions at scale, coloured letters an inch high should be visible from forty to fifty feet away, even in poor light. And Norman eyes were probably not much weakened by reading, and they had no TV.

4 Bernstein, *The Mystery of the Bayeux Tapestry*, pp. 105–7, fig. 65; Brown, *The Bayeux Tapestry*, pp. 34, 35. [Cf. also Ch. 7 above.]

5 As a non-medievalist I thought it would be easy to find out from the recognised authorities how one entered a great hall and where the high table would be placed; it was not, although many were asked, and one Professor Peter Ferguson was especially helpful. But see M. Wood, *The English Medieval House* (London, 1965), pp. 13–34, esp. pp. 13, 20, and 35–48 on the aisled hall, including Westminster; T. Tatton-Brown, 'The Great Hall of the Archbishop's Palace', *The British Archaeological Association Conference Transactions for 1979, V. Medieval Art and Architecture at Canterbury before 1220* (1982), pp. 112–19 on the late eleventh-century great hall and its thirteenth-century remodelling; P. A. Faulkner, 'Some Medieval Archiepiscopal Palaces', *The Archaeological Journal* 127 (1970), pp. 130–46, esp. on Croyden, pp. 133 ff. Several of these halls are large enough to hold the Bayeux Tapestry but the site of their entrances is both varied and often asymmetrically placed on the side or on the end.

The Bayeux Tapestry itself cannot now be handled. In order to determine how the Tapestry might have been hung and what the assembled Anglo-Norman company might have seen, I recreated a reduced version of the whole at one-seventh scale; in a series of trials I attempted to arrange the Tapestry along the walls of an oblong hall, much longer than it is wide, placing the beginning, Episode I, Scene 1 (fig. 2a) at a corner, because that seemed to make the most sense visually and conceptually (cf. fig. 1). It soon became apparent that Scenes 15–32 possessed a distinct unity and importance (table I), in effect constituting the dense textual and iconographic core of the narrative programme. The focalising prominence of this unit of formal, highly confected narrative would be most evident if this extended section of the Tapestry were placed in the centre of one of the long walls of the hall (figs 3a–b, 4a). Once this was established, the corners fell properly into place as points of transition in the narrative: II.9/III.10 (Harold to Normandy, captured by Guy), IX.38/ X.39 (Normans ship war supplies, William leaves for England), and X.46/XI.47 (end of the Norman invasion, the beginning of war). In turn, the loosely extended visual narrative of the Battle of Hastings (Episode XII) occupied the other long side of the hall, opposite the densely narrated core (figs 1, 4b), as if Harold's infidelity led inevitably to his defeat.

However, the flight of the English after the Battle of Hastings (Episode XII, Scene 65) does not effectively conclude the historical narrative, nor does it take the Tapestry to the fourth corner in its present fragmentary condition. Given the apparent integrity of the narrative and the tendentious nature of the historical record that concludes with the elevation of William as King of England, it seemed to me that a concluding episode was warranted; Episode XIII, Scenes 66, 67, as reconstructed, first presents William's triumphal passage from Hastings to London and, last, his subsequent coronation at Westminster (fig. 2c). Then the Bayeux Tapestry would end with William at Westminster, thereby completing the entire narrative programme in the very place in which it began (fig. 2a, I.1) but with a new, Norman occupant of the English throne. Based on calculations determined by the present dimension of the Tapestry and the relative length of its episodes (table IVd), this conjectural restoration of Episode XIII would add some 6.5 feet for a total length of about 237 or 238 feet.[6] Thus, the Tapestry would have required a hall with an interior perimeter of that length, about 93 feet long and slightly less than 26 feet wide. The reconstruction of the Tapestry's layout, presented here (fig. 1), does not follow the exact plan of any surviving hall of the period – but then, few survive; nor do I argue that such a hall must have been built specifically to house the Tapestry, although that is possible. I suggest, instead, that since the Tapestry was made to be

6 The reconstruction of the Tapestry was partly based on the illustrations in Gibbs-Smith, *The Bayeux Tapestry*, and on the coloured fold-out provided at Bayeux, both at one-seventh scale; the resulting scroll, some 33 feet long, was then analysed to produce the episodic and scenic divisions indicated in fig. 1, and the whole arranged in an oblong format to uncover the probable arrangement of the Tapestry discussed in the article. The reconstruction of XIII.67 (fig. 2c) is based on VIII.31 (fig. 4a) with an appropriate change in the inscription. My thanks to Shelley Smith Kellam for her fine drawings.

displayed in its entirety, and since an oblong hall seems to have been the most likely site for its display, then the narrative logic of the Tapestry's composition should properly come into play in laying out such a hall, because the Tapestry must have been designed with an eye to the way it would be hung and to the comprehensibility of its narrative. Therefore, it seemed reasonable to posit both the existence of this hypothetical hall as the first site of the Tapestry's display, inasmuch as a hall of this kind would fall within the range of Anglo-Norman halls of the period insofar as they are known, and its length to width ratio of about 3.5:1.

Because the actual site of the intended display of the Bayeux Tapestry is unknown and the archaeological record for such baronial halls in Anglo-Norman architecture is so incomplete, one cannot be sure whether the principal entrance would have been on the long or on the short side, or whether it would have fallen in the middle of either. I have reconstructed the plan of the great hall with possible entrances on the short end, Side C, the usual location in later medieval buildings, and also on the middle of the long side, Side D (fig. 1). A location of the main entrance into the hall on the long side would be more consistent with the strong visual enframement of the narrative core, especially because two singular scenes, Scenes 15 and 32, lie just about equidistant from an entrance below XII.57, the Battle of Hastings. Both Scenes 15 and 32 constitute emphatic visual and thematic stops in the narrative flow (figs 3a, 4a; table IV). Scene 15 (pl. 7), the Ælfgyva motif, has recently been interpreted as a negative gloss on Harold's claim as a legitimate heir to the English throne;[7] Scene 32, the vision of Halley's Comet, immediately following Harold's investiture as king (fig. 4a; pl. 14), has long been understood as a bad omen. Thus, Harold and William, once peacefully associated in friendship, go their separate ways after Edward's death, divided by ambition and honour, but Harold is doomed.[8] The signs of his unworthiness in both the human, genealogical realm (Scene 15) and in the heavens above (Scene 32) are there for all to see.

The stretch of the Tapestry from Scene 15 to 32 would have made an impressive, formal backdrop for the high table of the master of the house. However, it is not easy to state with any certainty where such a high table might have been placed, even temporarily, although in later medieval practice the high table was placed near an end, parallel to one of the short sides (fig. 1). If the high table had been set near Side A, its noble occupants would have been in easy viewing range of William's rescue of Harold (III.10–14; pls 6–7) on their left and of Harold's defeat and death (XII.62–5; pl. 26) on their right. Furthermore, William's triumph and subsequent coronation (XIII.66, 67) would have been at the lord's preferred right side, just where it belonged.

7 J. B. McNulty, 'The Lady Aelfgyva in the Bayeux Tapestry', *Speculum* 55.4 (1980), pp. 659–68.

8 The reverse chronological order representing the death and burial of Edward (VII.27–9) that runs counter to the temporal flow of events has troubled many observers (fig. 4a; pls 11–12). However, this asymmetrical treatment of time emphasises effects rather than causes and serves to situate Harold's assumption of the crown as an unnatural, fatal action at the end of a process beginning with Scene 26 and ending at Scene 32.

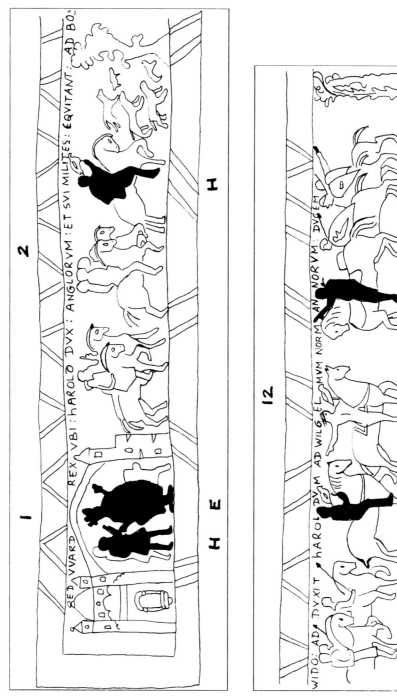

2a

2

1

SED VVARD REX VBI : hAROLD DVX : ANGLORVM : ET SVI MILITES : EQVITANT : AD BO

2b

12

WIDO : AD : DVXIT hAROL DVM AD WILG ELMVM NORMANNORVM : DVCEM

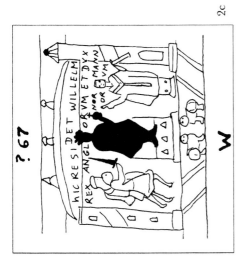

? 67

HIC RESIDET WILLELM
REX ANGL ORVM ET DVX
NOR MAN
OR VM

2c

W

Figure 2a. I.1 Edward and Harold I.2 Harold to Bosham
Figure 2b. III.12 Guy brings Harold to William
Figure 2c. XIII.67 William, King of England, in state (conjectural reconstruction)

This suggested arrangement of the Bayeux Tapestry in a great baronial hall also manifests a number of visual and thematic relationships that appear too closely integrated and too firmly set in a network of correspondences to be coincidental.[9] First, the narrative flow exhibits a coherent sense of the physical and temporal passage of the actors from England to Normandy and back, complementing the eventual transfer of the crown: Harold moves from England to Normandy (Side A), then the action is located in Normandy until Harold returns to England and William plans to follow him (Side B), then the Great Norman Invasion takes place (Side C), and finally in England the Battle of Hastings is fought and William is victorious (Side D). Topographically and institutionally the Tapestry ends (XIII.67) where it began (I.1) at Westminster with the king in state, but now William of Normandy in place of Edward the Confessor. This coming together of past and future, of Normandy and England, might have reminded a well-informed member of the viewing audience that Edward himself had once taken refuge in Normandy in the 1030s before he returned to England to become its rightful king.

Secondly, if the narrative course of the Tapestry first emphasises Harold's presence, it comes more and more to focus on William as the narrative draws to its historical and institutional conclusion (fig. 1; tables I, IIb, IVa), when both Norman and Englishman, both Normandy and England, fall under the rule of one man, William, duke and king (fig. 2c). The relative frequency of the protagonists' names and of their personal appearance in the action responds to their changing fortunes. This may be an expression of the slanted historical account, embedded in the text of the inscription (table IIb), but it also manifests in visible terms the gradual supremacy of the ultimate victor, William, over Harold. Third, the transition from Harold's betrayal to William's justification (fig. 1) offers a strongly moralising view of the historical process and is not merely the self-serving political agenda of a pro-Norman image-maker. The political argument moves along the perimeter of the hall from preamble (Side A) to a major statement (Side B), and finally to its demonstration and resolution (Sides C and D), closely following the logical order of medieval rhetoric. In the Tapestry, of course, the quiddity of the demonstration is not primarily textual but visual.

And finally, God's will is done when Harold is struck down in the eye (Scene 63; pl. 26). Then the acute observer might also have noticed that this too was ordained, that there were visible precedents for this fatal strike of a Norman's arrow. In Scene 15 (fig. 3a) an offending cleric rudely touches Ælfgyva on her face, near her eye (pl. 7); in Scene V.25 (fig. 3b), when Harold returns to England after swearing his oath of fealty to William (pl. 10), he is observed by a watchman on the English shore who holds his hand to his eye in a typical gesture (pl. 11). In the context, however, his gesture and the cleric's (fig. 3a) have a proleptic import. Later, near the end of the Tapestry and its story, when the Norman army is beset and there are rumours that William has fallen, the Duke turns to his men (Scene 61; pl. 25), lifts the visor of his

9 Unfortunately, far too many discussions of the Bayeux Tapestry treat it as if it were a codex and not a continuous strip, publicly displayed in its entirety.

helmet, and fearlessly, hand near his eye, shows himself to his men, confident in his own good fortune (fig. 3c) and in Harold's bad (Scene 63). Gestures are commonly employed throughout the Bayeux Tapestry, but these strong movements of the hand to the eye seem particularly programmatic, even if their significance could be comprehended only through the closest well-informed scrutiny of the visual narrative.[10]

Many of the grand, overall themes would have been visible and comprehensible to an attentive viewer who took the time to look hard at the Tapestry. Some themes and motifs might have been less accessible, perhaps because they were more subtly expressed, more recondite in their imagery, more dependent upon the accompanying inscription, or were less dominant in the visual field. When viewers failed to pick up the visual clues or could not hold the texture of the narrative in their visual memory, additional help might have been needed to bring them to a satisfactory understanding of what they saw. Such assistance might well have come to them through the mediation of a speaker or singer, a *jongleur* or interlocutor who could help the inattentive, the unobservant, the faint-eyed, or the ignorant to discover the wondrous history spread out before their eyes.

II. The Oral Dimension of the Bayeux Tapestry, or what the ears heard while the eyes looked on

The Bayeux Tapestry combines an extensive visual narrative with a brief chronicle, written irregularly, if pointedly, throughout its length (table II). The complementarity of image and text has long been recognised but the dynamic of that relationship has been subordinated to the mental condition of the reader, as if such a text were for the eyes only. There is an alternative mode and to find it, contemporary or near-contemporary texts must be invoked.

> 'Count William came from Normandy into Pevensey on the eve of Michaelmas and as soon as his men were able they constructed a fortification at the market of Hastings. This was told to King Harold and he then collected a large army and met William at the old apple tree, and William came upon him unexpectedly before his army was drawn up. Nevertheless, the king fought very hard with him together with the men who would stand by him, and there were many slain on either side. King Harold was killed there, and Earl Leofwine his brother, and Earl Gyrth his brother, and many good men, and the Frenchmen had possession of the field, as God granted them for the people's sins.'[11]

This laconic statement with its concluding moral is the only contemporary account in English; it is hardly less informative than the Tapestry's inscription, almost three times as long.[12] With the exception of Geffrei Gaimer's *L'Estoire des Engleis* of about 1139, a chronicle-poem on the Battle of Hastings from the English side, the rest of

10 See J. M. Pizarro, *A Rhetoric of the Scene: Dramatic Narration in the Early Middle Ages* (Toronto, 1989) on the basic elements of scene construction; dialogue, gestures, and significant objects.
11 The Anglo-Saxon Chronicle (D), *sub anno* 1066.
12 D. Wilson, *The Bayeux Tapestry*, p. 9.

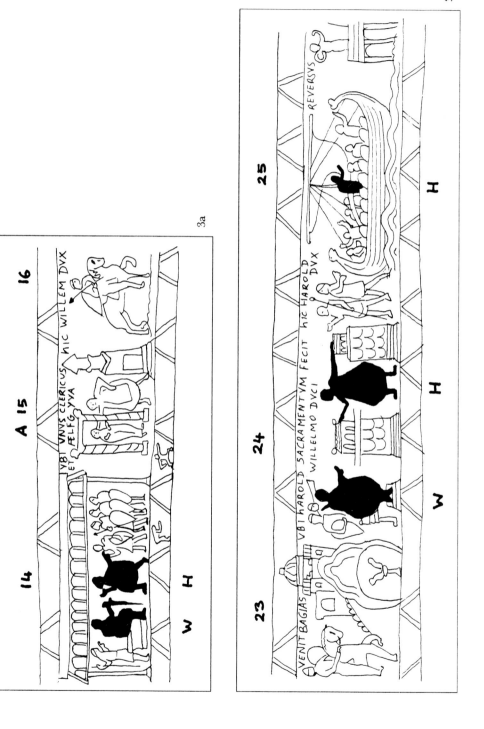

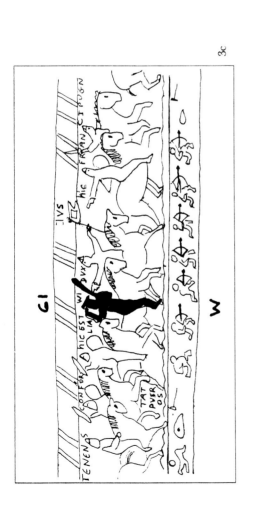

Figure 3a. III.14 William in his palace 15 Ælfgyva, an aside IV.16 William off to Mont-St-Michel
Figure 3b. V.23 William and Harold to Bayeux V.24 Harold swears oath of fealty to William V.25 Harold returns to England
Figure 3c. XII.61 William shows his face to his men

the important eleventh- and twelfth-century accounts of the conflict between Harold and William are both pro-Norman and long, their language prolix and adulatory. Typical of this genre are the *Gesta Guillelmi ducis Normannorum et regis Anglorum* by William of Poitiers, *c.* 1071, and the *Historia ecclesiastica* (of England and Normandy) of Ordericus Vitalis, probably written in the second quarter of the twelfth century. Ordericus Vitalis' *Historia* is especially learned, long, and extremely tedious; in Book III, chapters 11 and 14 he provides an extensive account of the political background, a partisan view of Harold's usurpation of the English crown, and a concentrated narrative of the invasion of England, the Battle of Hastings, and William's triumphal march to London where he was crowned on 25 December 1066 (cf. fig. 2c).[13] But his text lacks energy and has none of the pageantry visualised in the Tapestry.

A similar, or more poetic, posture was adopted by Robert Wace in his *Roman de Rou et des Ducs de Normandie* begun about 1160.[14] Wace's father was at Hastings and perhaps that parental connection with the great event encouraged the poet to take about 4,000 lines to move from Edward and Harold to William's coronation as *reis et dus* in London (III, l. 9016), the same ground traversed by the Bayeux Tapestry with greater economy. Despite the flatness of its trajectory, the *Roman de Rou* has its moments, especially in the lively conversations between the principals and their associates, in the vivid account of the fierce fighting at Hastings (III, ll. 8011–8884), and in Harold's terrible death (III, ll.1 8830–8856). These conversations have their visual counterpart in the Tapestry (figs 2a, 2b, 3a, 4a) as do the fierce battle scenes (fig. 4b), but Wace, like the designer of the Tapestry, devotes less than half of his artistic effort to the Battle of Hastings.

Quite different in character and emphasis is the fiery *Carmen de Hastingae Proelio*, written by Guy, bishop of Amiens, within a year or two of 1066.[15] This Norman Latin poem glorifies men at war caught up in the heat of battle in a manner reminiscent of the Anglo-Saxon poetic tradition preserved in the Old English poem known as *The Battle of Maldon*, probably composed by one of the participants in the battle, fought in 991.[16] At Maldon, as at Hastings in 1066, the English were defeated on their home ground by invading Norsemen, but not without a struggle. Of interest here is the rich treatment of the battle motif in the Anglo-Norman poetic traditions of the eleventh century, a textual model that could be successfully transferred to an equally vivid, fully visualised medium, the Bayeux Tapestry. This transfer would have been facilitated by the audience's familiarity with both the bold poetic tradition

13 Ordericus Vitalis, *The Ecclesiastical History of England and Normandy*, trans. T. Forester (London, 1853), I, pp. 458–65, 480–91; Latin text edited by M. Chibnall (Oxford Medieval Texts, 1969); see A. C. Danto, *Narration and Knowledge* (New York, 1985), pp. 112 ff. on history and chronicle.
14 H. Andersen (ed.), *Maistre Wace's Roman de Rou et des Ducs de Normandie* (Heilbronn, 1877).
15 C. Morton and H. Muntz, *The Carmen de Hastingae Proelio of Guy, Bishop of Amiens* (Oxford, 1972), xv–xxx, translation and text pp. 2–53; R. H. C. Davis, 'The *Carmen de Hastingae Proelio*', *English Historical Review* 93 (1978), pp. 241–61; L. J. Engels *et al.*, 'The *Carmen de Hastingae Proelio*: a discussion', *Proceedings of the Battle Conference on Anglo-Norman Studies* 2 (1980), pp. 1–20, nn. 165–7.
16 M. Alexander, *The Earliest English Poems: a bilingual edition* (Berkeley, 1970), pp. 159–81, *The Battle of Maldon*.

and the fierce reality of battle. This does not mean, however, that either of these poems or any written account necessarily constituted a prior text for which the images of the Tapestry served as an illustration. Instead, the simple inscription, consisting of declarative or demonstrative statements (table II), could refer ambivalently to an external textual tradition and to the images that contained it, both readily accessible to an audience whose memories of the Norman Conquest were still very fresh.

An especially important poetic treatment of William's triumph over Harold is embedded in Baudri de Bourgueil's poem, *Adelae Comitissae*, lines 207–578, written about 1099.[17] This elegant Latin poem, full of classical allusions and rhetorical devices, complements the other contemporary or near-contemporary accounts of the *casus belli*, of the Battle of Hastings and death of Harold, and of William's final establishment as duke and king. However, the significant relationship of this poem to the Bayeux Tapestry lies in the very indirectness of its historical narrative, inasmuch as the poet has adopted the ekphrastic technique of describing not the events themselves but, rather, their representation on a wonderful tapestry (*mirabile velum*) surrounding the bed of his lady, the Countess Adèle, to whom the poem is dedicated. Whether or not Baudri actually based his poetic account on the Bayeux Tapestry or on another version of the same events, or whether he indulged in an imaginative vision (ll. 83/4) which he extended to other tapestries in the countess's great house (ll. 97 ff.), there is ample evidence for the existence of large pictorial textiles in the eleventh century, even if nothing quite like the Bayeux Tapestry has survived.[18]

In Baudri's poem, the narrative imagery of the tapestry in Countess Adèle's bedroom represents a reduction of the historical account as well as a translation of medium from text to image. His poetic conceit also represents the reversal of that process, that is, the poet's extensive retranslation of the tapestry's images into the slow-developing language of court poetry. Thus, the poem consciously offers to the reader or to the listener the spoken narrative of a visual narrative,[19] as if Baudri's voice accompanied a leisurely passage along the richly embroidered tapestry, interpreting its images, reading aloud the inscriptions, and narrating expansively the great history manifested therein.

> In short, the brilliance and beauty of the Tapestry was so great
> you might say that they excelled the splendour of Phoebus.
> Moreover, you could reckon by reading the script of the titles
> that new and true stories are contained in the hanging.[20]

17 *Les oeuvres poétiques de Baudri de Bourgueil (1046–1130)*, ed. P. Abrahams (Paris, 1926), pp. 203–11, n. 61, pp. 243–7; S. A. Brown, *The Bayeux Tapestry*, pp. 167–77, trans. by M. W. Herren, based on the newly edited Latin text of K. Hilbert (Editiones Heidelbergenses 19, Heidelberg, 1979), pp. 154–64; see O. K. Werckmeister, 'Political Ideology', pp. 554 ff. [Cf. also Ch. 11 below.]

18 Bernstein, *Mystery of the Bayeux Tapestry*, pp. 90–2; cf. P. de Palol, 'Une broderie catalane d'époque romane: La genèse de Gérone', *Cahiers archéologiques* 8 (1956), pp. 175–215: 9 (1957), pp. 219–51, dated 1050–1100; see F. P. Pickering, *Literature and Art in the Middle Ages* (Coral Gables, 1970), pp. 147–55, 'Pictorial tapestries', esp. on the fourteenth-century tapestries at Wienhausen representing the story of Tristan and Isolde.

19 See J. M. Blanchard, 'The Eye of the Beholder: on the semiotic status of paranarrative', *Semiotica* 2 (1978), pp. 235–68, esp. pp. 236 ff. on ekphrasis based on tapestries.

20 *Adelae Comitissae*, ll. 231–4, trans. by Herren in Brown, *The Bayeux Tapestry*, p. 168.

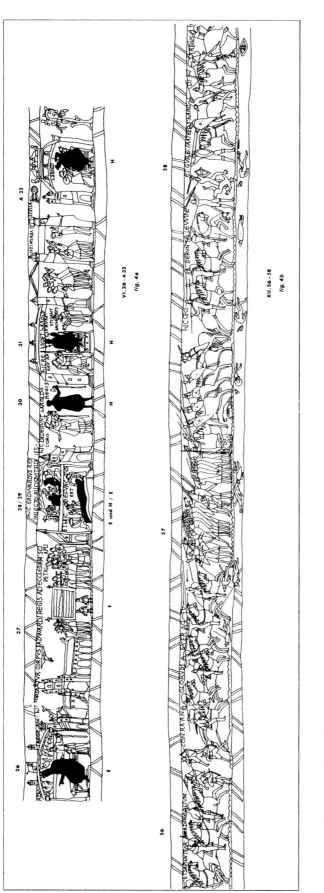

Figure 4a. VI.26: Harold reports to Edward.
VII.27: Body of Edward brought to Westminster for burial.
VII.28/29: Edward makes deathbed statement, and dies.
VIII.30: English crown offered to Harold.
VIII.31: Harold, King of England, in state.
32: Halley's Comet, an aside.

Figure 4b. XII.56, 57: Normans attack the English Army at Hastings.
XII.58: Death of Harold's brothers.

To tell his story as effectively as possible, the poet enhanced his work by reference to a material object, another artwork, however imaginary it might have been, because the visual record provided a material and familiar form of evidence that confirmed the truth of his poetic statement.[21] One can imagine Baudri de Bourgueil as an especially literate interlocutor, forming his embroidered version for his own benefit as a Norman, for the well-educated Countess Adèle, and eventually for an audience not otherwise present nor capable of seeing the visual narrative except through his poet's eyes.

Although Baudri is not the only Norman author to bestow the hero's mantle on Duke William, his language and his heroic conception drew on an epic tradition that, even by his time, combined antique models and recent historical figures to present the worthiness of great leaders, such as King Arthur, the quasi-legendary Briton. Some twenty years ago Chiara Settis-Frugoni investigated the intertwined motifs of Alexander the Great and King Arthur that dominate the twelfth-century floor mosaic of the Cathedral of Otranto in the heel of Italy. She posited a likely textile source for the iconography and composition of this vast mosaic and she believed that the narrative impulse for the combined representation had been introduced into southern Italy by the Normans in the eleventh and twelfth centuries.[22]

The rich coloration of the Otranto mosaic closely resembles the pictorial tapestries of Baudri and Bayeux, suggesting a Norman taste for extensive visual narratives, complemented by texts. Both the Otranto mosaic and the Bayeux Tapestry are mixed media, incorporating elements of language in the form of inscriptions inserted into their essentially pictorial repertory of persons, places, and actions (figs 2–4; tables II, IV). These inscriptions served to indicate the protagonists of the action and, when more extensive, as narrative markers to specify the action depicted. They also required some degree of literacy among the viewing public or at least a literate intermediary, if that public was unlettered. Being unlettered, of course, does not mean without a knowledge of texts – oral texts – committed to memory or so frequently heard as to become familiar enough to be brought readily to mind by key words and expressions, or by the verbal/visual formulae suitable to the stories of heroes and great events.

Wace's *Roman de Rou* (III, ll. 8013–8048) tells the story of Taillifer, 'that splendid singer', who sang the *Song of Roland* to the Normans before he charged the English at Hastings. Although the *Roman* was written a century after the battle, Taillifer's charge may be historic because it appears in the *Carmen de Hastingae Proelio* (ll. 389–407) and, possibly, in the Bayeux Tapestry as well (XII.57, fig. 4b; pl. 23). Taillifer's recitation of the *Chanson de Roland* may have preceded his charge, if not immediately,

21 Cf. Pickering, *Literature and Art in the Middle Ages*, p. 152.
22 Chiara Settis-Frugoni, 'Per una lettura del mosaico pavimentale della cattedrale di Otranto', *Bollettino dell'Istituto Storico Italiano per il Medio Evo* 80 (1968), pp. 213–56, noting the probable textile source on p. 214; and, 'Il mosaico di Otranto: modelli culturali e scelte iconografiche', *idem* 82 (1970), pp. 243–70, esp. on the narrative traditions introduced by the Normans, pp. 249 ff.; for a recent study of the Otranto mosaic see W. Haug, *Das Mosaik von Otranto* (Wiesbaden, 1977), esp. pp. 31 ff. on Arthur.

but Wace's inclusion of it in his account is not incidental, because it bespeaks an appreciation of the heroic model consolidated in the romance of Roland at Roncevaux. With that story Taillifer incited the Normans to emulate Roland and his companions in the service of their king; with that story, Wace stimulated the reader's mind to contemplate William's glorious deed, supported by a fitting paragon from the world of early chivalric romance.[23] What makes this paragon so effective is the power of song to create a common phonic space for the singer, the hero, and the audience.[24] And memory bridges the gap between past and present, between present and future, the memory preserved in song, in texts, in images.

The relationship between the *Song of Roland* and narrative versions of the Conquest, including the Bayeux Tapestry, have long been recognised.[25] However, it is the *Song of Roland* itself and not the representation of his heroic epos in Romanesque art[26] that bears a close affinity to the Tapestry. Both the *Song* and the Tapestry are distinguished by the prominence of their heroic protagonists, the centrality of battle in the ensemble, the significance of portents, the emphasis on betrayal,[27] an editorialising of events in the form of marginal glosses and asides (fig. 3a), frequent set speeches, the presence of animals, especially in a symbolic mode, and a narrative structure dominated by the hero's journey through space and time into danger.[28]

Many of these elements also appear, somewhat reduced, in the story of Rodrigo Diaz of Bivar, better known as El Cid, who died in 1099. The *Poema de Mio Cid* relates historic events in the last two decades of the eleventh century and was probably composed in the latter part of the twelfth.[29] However, the oldest surviving copy of the *Poema*, made in 1307 after an older, lost manuscript, contains 3,730 verses, comprising a vocabulary of only 1,200 words, further reduced in variety by the abundance of personal names.[30] This brief, dense, and evocative poem of the Cid's history accomplishes much with little, concentrating its effects in a direct form of expression that resembles the character and organisation of the Bayeux Tapestry

23 See H.E. Keller, 'Changes in Old French Epic Poetry and Changes in the Taste of its Audience', in H. Scholler (ed.), *The Epic in Medieval Society: aesthetic and moral values* (Tübingen, 1977), pp. 150–77.

24 After E. Vance, *Marvellous Signals: poetics and sign theory in the Middle Ages* (Lincoln, 1986), pp. 56–85.

25 C. R. Dodwell, 'The Bayeux Tapestry and the French Secular Epic', *The Burlington Magazine* 108 (1966), pp. 549–60 (repr. as Ch. 7 below), also opts for a secular location, pp. 549, 550; S. A. Brown, 'The Bayeux Tapestry and the Song of Roland', *Olifant* 6 (1979), pp. 339–50.

26 See R. Lejeune and J. Stiennon, *La légende de Roland dans l'art du Moyen Age* 2 vols (Brussels, 1966), I, pp. 19–134, citing French, Italian, and German examples.

27 E.g. in the *Song of Roland* ll. 520–716, the treachery of Ganelon; G. J. Brault, *The Song of Roland II: Oxford Text and English Translation* (University Park, 1978), pp. 35–47; see K. L. Schwartz, 'Shapes of Evil in Medieval Epics: a philosophical analysis', in Scholler (ed.), *The Epic in Medieval Society*, pp. 37–63, esp. on the Cid, pp. 47 ff., on Roland, pp. 51 ff.

28 See E. A. Heinemann, 'Network of Narrative Details: the motif of the journey in the *Chansons de Geste*', in Scholler (ed.), *The Epic in Medieval Society*, pp. 178–92.

29 C. Smith (ed.), *Poema de Mio Cid* (Oxford, 1972), dated 1207; L. B. Simpson, *The Poem of the Cid* (Berkeley, 1970), dated 1140, following R. M. Pidal; J. J. Duggan, *The Cantar de Mio Cid: poetic creation in its economic and social contexts* (Cambridge, 1989), dated c. 1200; R. Fletcher, *The Quest for El Cid* (New York, 1990), last quarter of the twelfth century; etc.

30 Simpson, *The Poem of the Cid*, p. xi.

(fig. 1; tables I, II, IVb) in its power to expand the imagination of an audience. And like the Bayeux Tapestry, the *Poema de Mio Cid* narrates a secular history, even if the protagonists are Christian.

Although the visual narrative in the Tapestry adopts many of the features of the *Chansons de Geste* and of medieval romance, it is not a romance itself. In Frederic Jameson's view, romance as a genre demands a metaphorical mode, a form in which 'the world-view of world reveals itself'.[31] Even if one were to accept David Bernstein's allegorical interpretation of the narrative based upon the biblical concept that Harold suffers divine retribution because of his 'transgression',[32] the essential structure of the Tapestry's narrative is historical, emphatically secular, and determinedly political, rather explicitly so. William, the conqueror, is no Roland, no Tristan, principally because he triumphs in the world and remains in and of the world.[33]

The *Song of Roland* is much more historical drama than history, although both the *Song* and the Tapestry responded to a commemorative intention. In *Roland* the conflict arises between Christian France and Moslem Spain, or between two distinct religio-geographical realms and states of being; in the Tapestry, the conflict remains personal and dynastic, having a practical, political dimension that involves not the nature of kingship as an abstraction, but its rightful possession. Furthermore, the Battle of Hastings, as represented in the Tapestry, is an extraordinarily violent event (fig. 4b; pls 21–6) that resolves the human conflict begun earlier (fig. 3b).[34] Unlike Roncevaux, however, Hastings constitutes the culminating but not the conclusive event in the narrative, although the battle leads to that subsequent event, the coronation of William (fig. 2c) at the end (fig. 1).[35]

At the end of what: of the Tapestry as a whole, of its central frieze, of its varied borders, or of its Latin text? Indeed, the Bayeux Tapestry consists of four strips, three of them continuously running from the beginning and usually quite separate, although not necessarily functionally or iconographically independent. Of these three figured strips, the central frieze is by far the largest, the most elaborately composed, and it bears the weight of the narrative programme.[36] In this central frieze, explicit divisions and well-marked changes in visual rhythm make discrete temporal and/or spatial distinctions, the smaller bracketed units quickly comprehended as scenes, the larger units more slowly followed as episodes (fig. 1; table Ia, Ib). The border strips lack scenic division, although they too are divided into simple units by

31 F. Jameson, 'Magical Narratives: romance as genre', *New Literary History* 7 (1975), pp. 135–63, esp. 135–42, quotation after Heidegger.

32 Bernstein, *Mystery of the Bayeux Tapestry*, pp. 166–91.

33 See J. Duggan, 'Medieval epic as popular historiography: appropriation of historical knowledge in the vernacular epic' in *La littérature historiographique des origines à 1500 I: Partie historique*, eds. H. V. Gumbrecht *et al.*, Grundriss der romanischen Literatur des Mittelalter 11 (1986), 285–311.

34 See E. Vance, 'Roland and the Poetics of Memory' in J. V. Harari (ed.), *Textual Strategies: perspectives in post-structuralist criticism* (Ithaca, 1979), pp. 374–403, esp. on the intrusion of writing into the oral text, pp. 399 ff.

35 The restored inscription in XIII. 67 (fig. 2c) is not included in the lists.

36 See E. Goffman, *Frame Analysis* (New York, 1974), p. 10.

short lines, or accents (table III), except when the action of the central frieze intrudes upon them (e.g. Scene 61, fig. 3c; Scenes 28, 32, fig. 4a; Scenes 57, 58, fig. 4b). The interaction among the three strips has occupied the attention of much of the recent scholarship on the Tapestry, especially McNulty,[37] but the relationship between the marginal glosses (the borders) and the central, narrative frieze could bear even closer analysis because of its effect on the linear flow of the narrative. That flow is frequently interrupted by the enframement or bracketing of particular important features (e.g. Scenes 15–16, fig. 3a), while other modifications of the sequencing of activity are produced by design complications (e.g. Scenes 26–32, fig. 4a). All of these features contribute to the exchange between narrative flow and narrative stops (table IV), or between relay and anchorage, that articulates the narrative, gives significant pause to the eye and the mind, and yet maintains the continuous movement of the Tapestry's narrative towards its conclusion.[38]

The fourth strip is not a strip at all in the sense of the others. Composed of coloured letters rather than figures, its existence as a strip is established by the distinctive symbolic character of a Latin inscription, presented for the most part in short declarative sentences or demonstrative affirmations (table II). This strip lacks the discrete special integrity of the other three: it is discontinuous and varies considerably in density from scene to scene (table IV). The central figured frieze contains the entire inscription, with the exception of a few textual intrusions into the upper border that are visually and iconographically significant (e.g. Scene 61, fig. 3c; Scenes 28, 32, fig. 4a). The inscription appears close to the events described pictorially and usually at the upper edge of the frame where the background is clear of impediments to its legibility (figs 2–4). As a strip of language, it comprises approximately 378 words; about ninety of them include the repeated names of Harold, William, Edward, and Odo, or the frequently employed locatives, *hic* and *ubi*, while the remainder of the text shows several instances of *et* and many place names. In effect, therefore, this strip of text constitutes a very reduced, understated,[39] or 'stripped-down' chronicle of marginal, but not insignificant, importance, apparently subordinated visually and functionally to the larger figural imagery of the Tapestry.

Still, the letters, about an inch high, are quite large enough to have been read at a distance by literate persons in the audience (fig. 1). Alternatively, the text could have been read aloud by some literate person to the members of that audience who lacked that skill but who could see this inscribed text in the visual context of the scenes of the Tapestry and knew, or were made to know, the connection between word and image as the narrative unfolded. It is important to emphasise the intimate connection between text and image in the composition of the Tapestry. They exist in close physical and denotative association, establishing an intense mutuality of

37 McNulty, *The Narrative Art of the Bayeux Tapestry Master*, pp. 24–58.
38 Goffmann, *Frame Analysis*, pp. 10, 40–5; see also S. Ringbom. 'Some Pictorial Conventions for the Recounting of Thoughts and Experiences in late Medieval Art' in F. G. Anderson *et al.* (eds), *Medieval Iconography and Narrative* (Odense, 1980), esp. pp. 41 ff.
39 'Understated' is McNulty's term, in *The Narrative Art of the Bayeux Tapestry Master*, pp. 1–3, 59 ff.

reference to persons, places, and actions (tables II, IV), all fixed within the scenic unit as the primary container of a comprehensible slice of activity, set in the larger strip of continuous narrative.[40] Whether the text functions as an *ancilla* to the work or as its foundation depends in part on the qualifications of the audience. In either case, it is a problem in cognition, comparable to the role of inscriptions in paintings, especially in the Middle Ages. Such inscriptions have been defined by Mieczyslaw Wallis as 'semantic enclaves', or 'that part of a work of art which consists of signs of a different kind or from a different system than the signs of which the main body of that work consists. Different kinds of signs are, e.g., conventional signs versus iconic signs. Different systems are, e.g., different systems of ethnic spoken languages or different systems of writing … In the case of paintings we find semantic enclaves in the form of music scores, maps, coats-of-arms, inscriptions … When defining inscriptions in paintings as semantic enclaves I wish to emphasise that these enclaves are autonomous entities within those paintings in which they occur, that they have a different semantic structure and speak a different "language" … In order properly to interpret the iconic signs that occur in a painting we need certain knowledge of visible objects and we must be familiar with artistic conventions current in a given culture area and in a given epoch. In order properly to interpret an inscription … we need the knowledge of two systems of conventional signs: the writing in question, and, at least to some extent, the ethnic language in question. A person who looks at the painting may therefore sometimes be able to interpret its iconic signs without being able to interpret the inscriptions in it. That is why semantic enclaves in the form of inscriptions in paintings usually appeal to a narrower circle of spectators than do the iconic signs that occur in those paintings.'[41]

Formally, the relative density of the inscription both established and responded to the static or dynamic nature of the action or situation depicted. The former often required a greater degree of explanation than the latter, especially when the visual record tried to show how some complex event, not readily translatable into images, has transpired (e.g. Scenes 26–30; fig. 4a).[42] Perhaps, the very agglutination of words in certain scenes endows them with greater ceremonial importance, literally forcing a longer visual and mental engagement with the contents of such a scene or even a full, reflective stop in the narrative (fig. 4; tables IIb, IV). When the principal narrative personae are both represented and named (table IIb), the design heightens their noticeability as foci, or punctuation points, in the course of the narrative, articulates the historical discourse in terms of its protagonists, and establishes a hierarchy of meaning in the continuous, but uneven, passage of the eye from one scene to another.[43]

40 Goffman, *Frame Analysis*, p. 247.
41 M. Wallis, 'Inscriptions in Paintings', *Semiotica* 9/1 (1973), pp. 1–28, quotation pp. 1–2.
42 See L. Stern, 'Narrative versus Description in Historiography', *New Literary History* 21 (1990), pp. 555–67.
43 After A.-M. Bassy, 'Du texte à l'illustration: pour une sémiologie des étapes', *Semiotica* 11 (1974), pp. 297–334.

The complex relationships of words and images affect the Tapestry's design throughout. They also call into question the very process of the Tapestry's reception by its audience and the intertextuality of its composition, especially in the light of Wallis's observations on the nature of inscriptions in paintings: whether individual members of the audience primarily saw or read the narrative, whether the Latin text served as an *ancilla* or as a foundation, whether prior knowledge determined the priority or particularity of either medium, or whether there was some mitigating factor that enhanced rather than limited the congruity of image and text and made their simultaneous perception possible.

Images and words occur in the same visual space in the Tapestry, but that does not imply the necessary identification of the visual with the mental space. Their coexistence in the total message involves the complementarity or redundancy of the iconic and the linguistic, joined in a syntagmatic relationship[44] that can emphasise separation and dependency at different places in the Tapestry. The colourful images constitute a grand, expansive code, while the limited, even bald text is primarily denotative. Given the great preponderance of image over text, the inscription appears to be a subordinated participant in an artwork dominated by pictures. Then the distinction between 'seeing' and 'reading' the Bayeux Tapestry has to be examined, especially in the context of late eleventh-century society when reading was an uncommon skill and Latin an uncommon possession. To put the question another way, were the pictures 'text-substitutes' for a largely illiterate, mixed audience that *somehow* had either prior or immediate access to the story being told, sufficient to understand what they saw? If the group memory was weak, then some agency was required to make this splendid, but mute, pictorial narrative intelligible to the public assembled in the great hall (fig. 1).[45]

The connection between seeing and knowing must have been accomplished by word of mouth in the form of an oral text, keyed by the words of the inscription but not restricted by them. Gregory the Great's famous dictum, that 'pictures are the books of the illiterate', stimulated remarkable responses in medieval art as well as among medievalists, most recently Michael Camille.[46] The Tapestry is obviously no book; its audience is not a reader at a desk but a sizeable viewing audience, grouped together in a public hall and enjoying the common experience of a public artwork. Even the literate members of the audience spoke usually in the vernacular, not in Latin, however simple (table II). The experience of reading was certainly not normative in the eleventh century and the language of written texts – Latin – was not the language of daily speech. The iconic language of the Tapestry would have

44 The concept developed by M. Rio, 'Images and Words', *New Literary History* 7 (1976), pp. 505–12.
45 The issue is raised by L. G. Duggan, 'Was Art really the "Book of the Illiterate"?', *Word and Image* 5 (1989), pp. 227–51, esp. 228, 243 ff.
46 M. Camille, 'Seeing and Reading: some visual implications of medieval literacy and illiteracy', *Art History* 8 (1985), pp. 26–49; for a discussion of the artistic response see O. Pächt, *The Rise of Pictorial Narrative in Twelfth Century England* (Oxford, 1962), esp. pp. 5–11 on Anglo-Saxon narrative, including the Bayeux Tapestry; and Bernstein, *Mystery of the Bayeux Tapestry*, pp. 60–100; also Duggan, '"Book of the Illiterate"'.

to have been translated into common speech in order to make it comprehensible; then, 'seeing and reading' by a mixed audience would have needed at least one literate, well-spoken interlocutor who could have bridged the gap between the literate and the illiterate, between those who already knew and those who wanted to know the story, between the brief Latin keys to a complicated history and the presentation of an extended narrative in the vernacular language that seemed most appropriate for the occasion.[47] Guy of Amiens acknowledged the importance of addressing a crowd in its own language, or languages, when he set the finale of his Latin *Song of the Battle of Hastings*: 'Thereupon a certain Norman bishop, mounting the dais, addressed such words as these to the renowned men of France: "If the king presented please you, declare it to us, for it is fitting that this be done by your free choice." The people thus addressed consented; the clergy and also the Witan applauded, intimating by their hands what they were unable to say. Afterwards a speech was delivered by the metropolitan; this set forth the same thing in the English tongue.'[48]

The oral accompaniment of the Bayeux Tapestry has left no transcription, unlike the sound-track of a foreign-language film that complements or competes with the printed captions in the audience's language, set at the bottom of the picture frame, often with little visual sensitivity. Although cinematic adaptation reverses the relationship between the inscription and local speech, implied by the Tapestry, anyone who has seen and listened to such a film must acknowledge the tension between the voluminous spoken language of the actors and the synopic brevity of the captions, as if the latter were but a sign of the narrative space in the original.[49] Like the film's captions, the Latin text of the Tapestry functioned as a sign of a larger discourse that was tied to the full presentation of the artwork to the public.

Here one should consider the similarities between the Bayeux Tapestry and comparable visual narratives developed in the ancient artistic traditions of India and China. For the modern inhabitants of India and Pakistan the public recitation of secular, heroic stories, remains popular despite the encroachment of locally made motion pictures that share many of their features. The recitation is accompanied by an elaborate picture cycle, painted in bright colours on large panels or cloths containing many scenes, shown to the audience while the speaker or singer chants the words of a well-known tale, pointing to the individual scenes as he goes along. The length of his oral narrative is very flexible, depending on the speaker's energy and ability, and on the warmth and generosity of his audience.[50]

However, it is not necessary to go so far away from the Norman environment to find even closer parallels, expecially in the Exultet Rolls of southern Italy, dating

47 See F. H. Bäuml, 'Varieties and Consequencies of Medieval Literacy and Illiteracy', *Speculum* 55 (1980), pp. 237–65; Camille, 'Seeing and Reading', pp. 32 ff.; Duggan, '"Book of the Illiterate"', pp. 249–51; W. J. Ong, *The Technologizing of the Word* (London, 1982), pp. 36–49.
48 Trans. by Morton and Muntz, *The Carmen de Hastingae Proelio*, p. 53, ll. 811–18.
49 See S. Heath, 'Narrative Space' in *Questions of Cinema* (Bloomington, 1981), pp. 19–75.
50 See V. H. Mair, *Painting and Performance: Chinese Picture Recitation and its Indian Genesis* (Honolulu, 1988), pp. 1–37, 111–31; cf. Camille, 'Seeing and Reading', pp. 27 ff., '*Vox significans rem*'.

from the late tenth to the twelfth century.[51] In them, the biblical text was written large for a clerical reader and still larger illustrations were shown to the assembled congregation in church, as the scroll was unrolled, passing over the lectern into the sight of the crowd. These Rolls involved two distinct audiences: the text faced the reader, while the illustrations faced in the opposite direction so that they appeared progressively 'right-side-up' for the audience. The two systems of narration were complementary, but even here one must imagine that the clerical reader could or would extend the narrative, perhaps by some bit of homiletic sermonising. Indeed, the congregation would not have been able to verify the reader's adherence to the written text.[52]

When the written word is embedded in a large pictorial cycle, intended for public display, it need not constrain the reader's imagination. Because of the brevity of the Tapestry's synoptic text, the reader or interlocutor would have been allowed, even encouraged, to improvise in public, stimulated by the vivid pictures, by his memory, and by the audience's enthusiasm.[53] In doing so, he would have become a performer, liberated by the text but not completely so, because that text, inscribed in tall, coloured letters on the fabric of the Tapestry, could also have been read at a distance by the literate or semi-literate members of the audience.[54] Perhaps it is at this conjunction of seeing, reading, speaking, and listening that the Bayeux Tapestry would have come most quickly to life, its vivid imagery actualised by performance. Still, this performance would have been governed by the reality of the Tapestry's physical presence and its salient visual properties, tying the speaker's words to the visual images, to the order of the narrative contained therein, and to the dominating presences of the principal characters in this *historia visiva*.[55]

By its very nature the oral performance is ephemeral. Traces of its existence survive in the Tapestry, in the frequent repetition of names (table IIb), in the emphasis upon present, often violent actions, in its well-defined spaces, in its closeness to the facts of human life and death (figs 4a, 4b), and in the very explicit representation of details of costume, weapons, and architecture.[56] Even more powerfully evocative of an oral performance is that sense of the present so natural to speech, especially to dramatic story-telling, preserved in the simple diction of the Latin inscription (table II). This strong sense of the historical present, invigorated by linguistic immediacy, raises the level of the visual drama at certain intense moments. Perhaps the most powerful instance of this intensification of the visual and emotional experience of

51 M. Avery, *The Exultet Rolls of South Italy* (Cambridge and Princeton, 1927, 1936).

52 Cf. J. Balogh, 'Voces paginarum', *Philologus* 82 (1926), pp. 202–40, on the difference in antiquity between reciting aloud what is read (out) and what is written.

53 Bäuml, 'Medieval Literacy and Illiteracy', pp. 244–8.

54 See B. Stock, *Listening for the Text: on the uses of the past* (Baltimore, 1990), pp. 19–23, on the relation between oral and written traditions in the eleventh century and the rise in the number of users of texts.

55 In the sense of W. Iser, *The Act of Reading: a theory of aesthetic response* (Baltimore, 1978), pp. 118–25, 135–51.

56 Noted by R. Finnegan, *Oral Poetry: its nature, significance, and social context* (Cambridge, 1977), pp. 16–28, 52–8; Ong, *Orality and Literacy*, pp. 31–77.

the Tapestry appears in Scene 61 (fig. 3c; pl. 25): there, William reveals himself to his men to allay their fears in a time of great danger and his abrupt act is accompanied by the arresting words in the present tense, *Hic est Dux Wilelmus.* The spectator beholds William, as do William's men; through the interlocutor, the spectator can also hear William's voice raised in a great shout. At this point in the narrative, at this place in the Tapestry, the transcendent present seems to demand a voice to achieve its most complete realisation.[57]

Speech, that is, the performer's speech, need not always be triggered by the words of the inscription. In fact, the infrequency of words in the long battle sequence (Scenes 47–65; table IIa) suggests that, although historical, the battle itself constitutes such a set piece of heroic narrative that the speaker could freely improvise because his audience would know full well what battles and battle songs were like.[58] They had this knowledge in part because heroic battle poetry, such as *The Battle of Maldon*, was deeply rooted in their culture and because battles formed such an important feature of the *chansons de geste*, particularly in the *Song of Roland*.

The similarity between the Tapestry and the *Song of Roland*, noted by scholars, rests on more than the sharing of common motifs, or on the importance of place, or on the central role of protagonists in conflict, or on the use of certain verbal/visual formulae.[59] Both the *Song of Roland* and the Tapestry were performance pieces, one offered by a *jongleur* who was probably illiterate,[60] and the other by a literate interlocutor. Furthermore, both works emphasise the immediate concrete situation not simply by the vivid construction of their scenes but verbally as well. The author of the *Song of Roland* – who ever that might have been – employed the expression, *as/ais vos/vus* or *as les vus* many times in the poem to heighten the direct immediacy of his narrative. The chanting *jongleur* could have emphasised these scenic moments by drawing his audience's attention to the approach of an important figure, hoping to fix that person in the listener's visualisation of the scene.[61] Surely, the counterpart to the poet's 'you see' in the Bayeux Tapestry is the much repeated word, *Hic*, which appears as often as the names of William and Harold combined (tables IIb, IVa). *Hic* engages the viewer, shortening the distance between past and present time, and thereby functions as a linguistic device to focus the mental participation of the spectator. But in the visual context of the Tapestry *Hic* is also powerfully demonstrative (e.g. Scene 61; fig. 3c), drawing the spectator's eye to the place indicated, especially if the interlocutor pointed directly at the Tapestry.

57 Other examples of this sense of the present are provided by Scenes 2 (fig. 2a), 12 (fig. 2b), 32 (fig. 4a), and XI. 53, 54.

58 See F. H. Bäuml, 'Medieval Texts and the Two Theories of Oral-Formulaic Composition: a proposal for a third theory', *New Literary History* 16 (1984), pp. 31–49.

59 J. J. Duggan, *The Song of Roland: formulaic style and poetic craft* (Berkeley, 1973); Finnegan, *Oral Poetry*, pp. 67–73; Mair, *Painting and Performance*, p. 128; J. Opland, *Saxon Oral Poetry: a study of traditions* (New Haven, 1980), pp. 74–96, 172–83.

60 G. J. Brault, *The Song of Roland* I (1978), pp. 112–13.

61 Brault, *Song of Roland* I, ll. 263, 413, 889, 1183, 1889, 1989, 2009, 3403, and p. 113.

Hic locks oral and written language together in the visual field, at least for a significant moment.[62] Because there are so many *Hics* in the course of the Tapestry, each one assumes the property of a narrative stop whose duration or importance is also affected by the saliency of the scene in which the word occurs (e.g. Scenes 26–32; fig. 4a; table IVa-d). The viewer can almost pin-point the more important scenes by following the *Hics* around the great hall (fig. 1), especially when the *Hic* coincides with the presence of Harold or William or Edward. As the interlocutor, or raconteur, was encouraged to linger at these places, so too was the viewer who followed his lead.

As the story-teller punctuated his tale with the demonstrative or locative *Hic*, he might have found that the intervals between *Hics* required further modulation, affecting the rhythms of his discourse. When the *jongleur* chanted his song, rhythm was essential, although no *chanson de geste* survives with its full musical notation. It is known, however, that long poems like the *Song of Roland* were divided into sections called *laises*, each with its own melodic formula.[63] In long poems, just as in long pictorial narratives, the rhythm had to be varied to maintain the audience's interest, to preserve the speaker's voice, and to distinguish the important elements in the recitation from the rest. Accent or cantillation signs were developed as a form of pre- or early musical notation to provide the cantor with suggestions of rhythm or pitch to aid in his delivery.[64] By the ninth or tenth century ekphonetic or lectionary systems were in use to facilitate the cantillation of texts; these cantillation signs took the form of acute or obtuse lines, of simple baseless triangles, or dots placed over each line of text.[65]

The Bayeux Tapestry has such lines, not set over the words of the inscription specifically but in the upper and lower borders. These lines occur singly or in pairs, often parallel; the lines are set at acute or obtuse angles, and sometimes form loose triangles (figs 2–4). Altogether these lines fall into irregular rhythmic patterns, often visually complementary to the composition or iconography of the central frieze (table III), but their very irregularity makes it unlikely that the primary function of these lines is decorative. Instead they appear to serve as a kind of notation, imposed on the narrative flow of the pictorial cycle for the benefit of the eye, imparting a distinctive rhythm to its passage. These same short accent marks could also have served the interlocutor's voice, especially a story-teller already trained to respond to the super-linear notations in contemporary texts, so marked because they were meant to be read, or sung, aloud.

62 Ong, *Orality and Literacy*, pp. 12, 71–2.

63 I. Parker, 'Chanson de geste', in *The New Grove Dictionary of Music and Musicians*, ed. S. Sadie, 20 vols (London, 1980), IV, pp. 145, 146; J. Stevens, *Words and Music in the Middle Ages: song, narrative, dance and drama 1050–1350* (Cambridge, 1986), pp. 199–234; J. Chailley, 'Etudes musicales sur la chanson de geste et ses origines', *Revue de musicologie* 27 (1948), pp. 1–27.

64 C. Parrish, *The Notation of Medieval Music* (New York, 1957), pp. 42 ff.; J. Caldwell, *Medieval Music* (Bloomington, 1978), pp. 103 ff., 128, 129; G. Reese, *Music in the Middle Ages* (New York, 1940), pp. 198–230, esp. pp. 206 ff.

65 G. Engberg, 'Ekphonetic Notation', in *New Grove Dictionary*, ed. Sadie, VI, pp. 99–103, with several illustrations; Stevens, *Words and Music in the Middle Ages*, pp. 439 ff.; L. Treitler, 'Reading and Singing: on the genesis of occidental music-writing', *Early Music History* 4 (1984), pp. 135–208, esp. pp. 152–78, 190 ff.

III. Vox Imaginarum

The colourful strands that make up the Bayeux Tapestry compare with the many lines of communication this splendid artwork used to reach the public. One may first consider the Tapestry as an intertextual work, incorporating oral and written records of Anglo-Norman history as the basis of its visual narrative, a tale subsequently expanded and enriched by repeated public presentation and by the appearance in the eleventh and twelfth centuries of new texts interpreting and embellishing this history. That the audiences for the Tapestry and for these new texts – Latin poems of great length – were the same, seems incontrovertible.

Short declarative statements constitute the body of the restricted text that accompanies the pictorial cycle and served as a legible guide to the interpretation of the voiceless images by any close reader. These same statements provided a key to the elaboration of the ensemble of text and image when orally presented to an attentive public. This productive correspondence of text and voice, in effect, extended the linguistic dimension of the narrative so that the story heard by an audience became the equivalent of the story seen, adding much to the substance of each medium of expression.[66]

At a deeper level of analysis, the communication network operates on double lines, offering descriptive and narrative systems, both subjected to marginal glosses in the upper and lower strips. These two systems of discourse either run separately or interact along the four strips that together comprise the Bayeux Tapestry; they incorporate diverse codes representational and symbolic, connected vertically and horizontally in such a way that their apparent correlation depends on the continuing dominance not only of the central strip but also of the prominently named principals, primary agents of the actions depicted (table IV).[67] Within the narrative matrix, however, Scenes 15 and 32 (figs 1, 3a, 4a) interrupt the linear flow of the narrative because their vertical extension gives them special saliency. These two scenes are visibly extraneous to the linear flow of the narrative except as 'asides', pregnant commentaries on the course of events and indicators of an underlying argument about the legitimacy of the contestants for the English throne.[68] In fact, the Tapestry's tendentious narrative is informed by a political agenda implying that the unfolding historical process was justified. A similarly informed viewer could have so interpreted the pictorial record rather easily, especially if the posited arrangement of the Tapestry (fig. 1) fairly captures the designer's original intention to tell a great story, to tell it well and forcefully, to delight an audience, and to explain to that audience how the Anglo-Norman world had changed.[69]

66 P. Zumthor, 'The Text and the Voice', *New Literary History* 16 (1984), pp. 67–92, esp. pp. 86–90.
67 See A. J. Greimas, *Du Sens: essais sémiotiques* (Paris, 1970), pp. 39–44; Blanchard, 'Eye of the Beholder'.
68 Ringbom, *Medieval Iconography and Narrative*, pp. 41 ff.
69 Note P. A. Roth, 'How Narratives Explain', *Social Research* 56 (1980), pp. 449–78; cf. W. B. Gallie, *Philosophy and Historical Understanding* (New York, 1964), p. 64, who writes that following a story is 'a teleologically guided form of attention'.

Some truths are not self-evident, even when those truths are commonly held. The Bayeux Tapestry is a very, very long piece of embroidered textile whose historiated frieze weaves together space and time materially and visually. Despite the bookish attitude of several scholars about the nature of its imagery, the Tapestry is not a book to be held close to the eye of a reader and to be seen, or read, in small isolated bits; despite its continuous pictorial structure, the Tapestry is unlike a motion picture whose rapidly changing images seem to pass before the stationary observer but actually remain fixed within the same oblong frame.[70] The Tapestry did not move but hung in place on four walls; its images did not move but the public eye could move from one colourful scene to another in those large sections of the Tapestry that could be taken in with a single look. The directional flow of scene to scene and their progressive cohesion into episodes were the products of an overriding design that guided the eye towards the viewer's right along the continuum of the narrative from the beginning to the end. That rightward shift was aided by the reading order of the inscription and abetted by the voice of the interlocutor, pitched to respond to the gesture of his pointing finger at the many *Hics* strewn along the narrative pathway. The passage of the great events along the body of the Tapestry took place in narrative time; the passage of the viewer's eye from place to place in the Tapestry took up the viewer's time and the Tapestry's space. That very measure of narrative time passing coincided with the visual passage over the Tapestry's spacial fabrication of time, thus uniting narrative and experiential time in the act of perception.

However long the Tapestry, that long is the historic tale. The viewer's eye traverses the length of the Tapestry in step with the journeys of the two protagonists, Harold and William, who also stopped from time to time and from place to place on the course of their destiny. The spacial form of the Bayeux Tapestry establishes the perceptual basis for the audience's sense of narrative time, of a beginning and an ending that coincides exactly with the pictorial medium itself.[71] It therefore fulfils Barthes' dictum that, 'the form of narrative is essentially characterised by two powers: that of distending its signs over the length of the story and that of inserting unforeseeable expansion into these distortions.'[72] The entire fabric of the Tapestry holds a rich crop of narrative and diegetic signs, ready to be harvested by the canny, attentive viewer. Along the narrative track, however, the principal strip also exhibits several stretches of great importance that concentrate the viewer's experience of the story.

70 But see A. Prah-Pérochon, 'Le film animé de la Tapisserie de Bayeux', *Stanford French Review* 1/3 (1977), pp. 339–65.
71 For the special properties of time, its relation to memory and narrative see R. Arnheim, 'Space as an Image of Time', in K. Krocher and W. Walling (eds), *Images of Romanticism* (New Haven, 1978), pp. 1–12; W. J. T. Mitchel, 'Spacial Form in Literature: toward a general theory', *Critical Inquiry* 6 (1980), pp. 539–67, esp. pp. 548 ff.; S. Heath, 'Narrative Space' in his *Questions of Cinema* (1981), pp. 19–75, esp. pp. 38 ff.; Bäuml, 'Medieval Literacy and Illiteracy', p. 248.
72 R. Barthes, *Image, Music, Text*, trans. S. Heath (New York, 1977), p. 117.

The greatest visual expansion of the narrative occurs in the extended representation of the Battle of Hastings (Episode XII; fig. 4b; pls 20–6), indicative of the importance of heroic action; yet, within the context of the battle, William's uncovering stops that action abruptly, if momentarily, because in the end the narrative is his story (Scene 61; fig. 3c). Another focalisation of attention involves William's gift of arms to Harold, followed by the oath of fealty in visual proof of the justness of William's cause (Episode V; fig. 3b). A similar concentration of effects for political ends shapes the heavily inscribed depiction of Edward's death and burial (Episodes VI, VII; fig. 4a; pl. 12); the reversal of chronological order, unique in the narrative flow, exposes the tendentious political argument underlying the narrative as a whole. And always, the sign of greater emphasis, the signal of intense concentration, is *Hic*, a common fixing device in many medieval texts.

Hic, so often repeated in the Tapestry's inscription (table IIb), is a sign of immediacy, of the *nunc praesans*, uniting beholder and immanent representation, as if the latter were actually present.[73] *Hic* keys the oral performance of the transparent interlocutor, marking his dual role as a respondent to the narrative and as a mediator between the narrative spectacle and the audience.[74] *Hic* connects place and time, thus articulating the objective 'here-and-now' points in the pictorial narrative. When the 'here' of *Hic* is transposed to the 'there', visible at the other side of the great hall (fig. 1), the viewer could understand that both past and present in the Tapestry's narrative were present at once.[75] *Hic* opens the gates of memory.

'And therefore God, who so loves man that he wishes to provide him with all that he needs, has given to man a power and force of the soul that is called memory. This memory has two doors, sight and hearing, and to each of these doors there is a path by which one can reach them; these paths are painting and speech. Painting serves for the eye, speech for the ear. And the manner in which one may make one's way to the house of memory, both by painting and by speech, is thus made clear: the memory, guardian of the treasure won by man's senses through the excellence of the imagination, makes what is past seem as if it were present. And to this same end, one can come either by painting or by speech. For when one sees a story painted, whether a story of Troy or of some other thing, one sees the deeds of the brave men who were there in past times as if they were present. And so it is with speech. For when one hears a tale read, one perceives the wondrous deeds as if one were to see them taking place. And since what is past is made present by those two means, that is by painting and speech, therefore it is clear that by these two things one can come to remembrance.'[76]

73 Noted by H. Kessler, 'Diction in the "Bibles of the Illiterate"', in *World Art: themes of unity in diversity* II, Acts of the Twenty-sixth International Congress in the History of Art, ed. I. Lavin (University Park, 1989), pp. 297–304, esp. p. 300.

74 See P. Zumthor, *Essai de poétique médiévale* (Paris, 1972), pp. 286 ff., 429–66, and esp. pp. 242, 243.

75 After E. Husserl, *The Phenomenology of Internal-Time Consciousness*, trans. J. S. Churchill (Bloomington, 1964), pp. 22 ff., 33, 102 ff.

76 From an early fourteenth-century miniature illustrating Richard de Fournivall's *Le Bestiaire d'amours*, Paris, Bibliothèque nationale, MS fr. 1951, fol. 1; V. A. Kolve, *Chaucer and the Imagery of Narrative: the first five Canterbury Tales* (Stanford, 1984), p. 25 and n. 27, p. 381.

11

The *Adelae Comitissae* of Baudri of Bourgueil and the Bayeux Tapestry

SHIRLEY ANN BROWN and MICHAEL W. HERREN*

One of the ongoing issues in Bayeux Tapestry studies is the relationship between the embroidery and the 'Adelae Comitissae', a poem written by Baudri of Bourgueil. Baudri is one of those literary figures bridging the eleventh and twelfth centuries whose writings have remained fairly inaccessible except to scholars of medieval Latin literature.[1] The available information about Baudri comes largely from his own writings, namely his poems and *Itinerarium*.[2] There are also scattered references

* This article was co-authored in the truest sense. The authors are listed in alphabetical order.

1 Léopold Delisle, 'Notes sur les poésies de Baudri, abbé de Bourgueil', *Romania* 1 (1872), 23–50; Henri Pasquier, *Un poète latin à la fin du XIe siècle: Baudri, abbé de Bourgueil, archevêque de Dol* (Paris, 1878); Max Manitius, *Geschichte der lateinischen Literatur des Mittelalters* (Munich, 1931) III, 885–96; Otto Schumann, 'Baudri von Bourgueil als Dichter', *Studien zur Lateinischen Dichtung des Mittelalters: Ehrengabe für Karl Strecker zum 4 September 1931* (Dresden, 1939); repr. K. Langosch, *Mittellateinische Dichtung* (Darmstadt, 1969), 330–42; *Les Oeuvres poétiques de Baudri de Bourgueil 1046–1130*, ed. Phyllis Abrahams (Paris, 1926); F. J. E. Raby, *A History of Secular Latin Poetry in the Middle Ages* 2nd edn (Oxford, 1957) I, 337–48; Karl Forstner, 'Das Traumgedicht Baudris von Bourgueil (Carmen 37)', *Mittellateinisches Jahrbuch* 6 (1970), 45–57; N. Bartolomucci, 'Note lessicali al Carme CXCVI di Baldrico di Bourgueil', *Giornale italiano di filologia* 7 (1976), 192–96; Sabine Schuelper, 'Ovid aus der Sicht des Balderich von Bourgueil, dargestellt anhand des Briefwechsels Florus-Ovid', *Mittellateinisches Jahrbuch* 14 (1979), 93–118; Jean-Yves Tilliette, 'Culture classique et humanisme monastique: Les Poèmes de Baudri de Bourgueil', *La Littérature angevine médiévale: Actes du colloque de samedi 22 Mars 1980* (Angers, 1981), 77–88; *idem, Rhétorique et poétique chez les poètes latins médiévaux: recherches sur Baudri de Bourgueil* (Thèse de 3ème cycle dactylographiée; Université de Paris IV, 1981); id., 'La Chambre de la Comtesse Adèle: Savoir scientifique et technique littéraire dans le C. CXCVI de Baudri de Bourgueil', *Romania* 102 (1981), 145–71; Peter Dronke, 'Personal Poetry by Women: the eleventh and twelfth centuries' in his *Women Writers in the Middle Ages: a critical study of texts from Perpetua to Marguerite Porete* (Cambridge, 1984), 84–106; Gerald Bond, '"Iocus Amoris": the poetry of Baudri of Bourgueil and the formation of the Ovidian subculture', *Traditio* 42 (1986), 143–93.

2 The poems were collected into a manuscript of 152 leaves probably by the mid-twelfth century. In the seventeenth century this manuscript appeared in the collection of Alexandre Petau from which André Duschesne transcribed a selection, several of which were published in 1641 in *Historiae Francorum scriptores coaetanei*, IV, 251–77. The published poems were reprinted in Migne, *Patrologia Latina* 166, cols 1181–1208; the other copies are in the Bibliothèque nationale, Collection Duschesne, nos 20 and 49. In 1650 the manuscript was among those sold by Petau to Queen Christina of Sweden, who gave it to the Vatican. The manuscript was sent, upon demand, to Paris in 1797 but was returned to the Vatican in 1815 where it resumed its position as Biblioteca Apostolica Vaticana, Reg. lat. 1351 in the collection of the Queen of Sweden. For a discussion of a newly-discovered

to him by contemporary writers such as Orderic Vitalis and Hildebert of Lavardin, bishop of Le Mans, then archbishop of Tours.[3] A number of letters written to him as well as some charters dealing with his administration of the monastery of Bourgueil have survived.[4]

Baudri was born in 1046 at Meung and studied in nearby Orléans, then possibly at Angers and Cluny. He entered the Benedictine monastery at Bourgueil at an unknown date and became its abbot in 1078. He failed in his candidacy for the bishopric of Orléans in 1096, but was appointed to the newly created archbishopric of Dol in Brittany in 1107. It would appear that Baudri was a less-than-distinguished ecclesiastic, spending much of his time away from his See. In his *Itinerarium* he reveals his disdain for the Bretons – a condition which drove him to travel in England and Normandy. He journeyed on at least three occasions to Rome. Baudri died at a ripe old age in 1130 and was buried at Préaux.[5]

Baudri, perhaps, enjoyed more success as a writer. He left a fairly large collection of occasional poems, several saints' lives, an account of the translation of the head of St Valentine martyr, a history of the First Crusade entitled *Hierosolymitae historiae*, the *Itinerarium*, written in the form of a letter to the monks of Fécamp outlining his travels through England and Normandy, and a treatise entitled *De scuto et gladio S. Michaelis*. Apart from the poems, Baudri's work has scarcely been studied. Only the poems have been critically edited, while the other writings remain buried in the *Patrologia Latina*. One of the saints' lives, the *Life of St Samson*, and the *De scuto* remain unpublished.[6] It is noteworthy that very little has been written on Baudri's treatment of the First Crusade, especially in view of the fact that he was a contemporary of the event and came from the region where it was launched.

If historians have largely neglected Baudri's prose, medieval Latinists have certainly made a good beginning in the study of his poetical writings. There are three modern editions of the poems: the first, by Phyllis Abrahams appeared in 1926; a second, relatively little-known edition of 1936 by M. T. Razzoli; a third by Karlheinz Hilbert, completed in 1979.[7]

The first of two poems which Baudri addressed to Adèle, countess of Blois and daughter of William the Conqueror, is best known for the rather lengthy section

fragment (*s.* xiv) see Patrick Gauthier Dalché and Jean-Yves Tilliette, 'Un nouveau document sur la tradition du poème de Baudri de Bourgueil à la comtesse Adèle', *Bibliothèque de l'Ecole des Chartes* 144 (1986), 241–57. The *Itinerarium* was published in Migne, *PL* 166, cols 1173–82.

3 Orderic Vitalis, *Historia ecclesiastica*, X, 20 (ed. M. Chibnall, V, 324–5); Epistolae Hildeberti Cenomanensis Ecclesiae Episcopi, II. xxxv (19), Migne, *PL* 171, cols 258D–259A.

4 See Manitius, *Literatur des Mittelalters*, III, 883 f.; *Oeuvres poétiques*, ed. Abrahams, xx–xxii.

5 For summaries of Baudri's life see Manitius, *Literatur des Mittelalters*, III, 883–98; *Oeuvres poétiques*, ed. Abrahams, xx–xxii; but most recently, Bond, '"Iocus Amoris"', 145–9.

6 See Michael Lapidge and Richard Sharpe, *A Bibliography of Celtic-Latin Literature* (Dublin, 1985), 234–6.

7 *Oeuvres poétiques*, ed. Abrahams; M. T. Razzoli, *Le epistole metriche di Baldericus Burguliensis* (Milan, 1936); *Baldricus Burgulianus, Carmina* ed. Karlheinz Hilbert (Heidelberg, 1979). There is general agreement that Phyllis Abrahams' edition was highly unsatisfactory: it is marred by errors of transcription and the failure to correct even the most obvious errors in the principal manuscript, Vat. Reg. lat. 1351.

which purports to describe a tapestry in her possession which depicts the events culminating in her father's being crowned King of England on Christmas Day, 1066.[8] What has heightened interest in Baudri's poem is not so much that he incorporated a Battle of Hastings narrative into it, as the fact that he says he is describing a pictorial wall hanging decorated with these scenes. Historians and art historians alike have leapt upon Baudri's words, in the hope that they have cast some light on the early history of the Bayeux Tapestry, one of the most famous works of art of the Middle Ages. This textile depicts episodes from the story of the Norman invasion of England and has been considered as an historical source for the Norman Conquest.[9]

The reason for this scholarly interest is evident when it is remembered that the first trustworthy, documented reference to the Bayeux Tapestry occurs in the 1476 Inventory of the Treasure of Bayeux Cathedral, Item 262. Since scholars now generally agree that the Bayeux Tapestry was produced during the 1070s or 1080s, this leaves an uncomfortable four hundred-year gap in the record of its known whereabouts.[10]

Baudri's poem has been attributed to the years between 1099 and 1102.[11] It has been used by some historians as evidence that the Bayeux Tapestry was in existence by the time the poem was composed and it has also been suggested that Baudri was

8 The poem was first published in its entirety in Léopold Delisle, 'Poème adressé à Adèle, fille de Guillaume le Conquérant par Baudri, abbé de Bourgueil', *Mémoires de la Société des Antiquaires de Normandie* 3rd ser. 8 (1871), 187–224. The poem appears as no. CXCVI in Abrahams, 196–253; and as no. 134 in Hilbert, 154–64. There is a separate edition of the poem in N. Bartolomucci, 'L' epistola CXCVI di Balderico di Bourgueil: testo critico', *Annali della Facolta di lettere e filosofia, Bari* 22 (1979), 5–52. There is a partial translation of no. CXCVI (134) by M. W. Herren in S. A. Brown, *The Bayeux Tapestry: history and bibliography* (Woodbridge, 1988), 167–77. A full translation of this poem by M. Herren is published in *The Journal of Medieval Latin* 5 (1995). Poem CXCVII (135 in Hilbert) is a follow-up to the longer poem and reminds Adèle of Baudri's request for compensation.
9 Since many of the articles have been written in response to published suggestions, the following list has been arranged chronologically: Delisle, 'Notes sur les poésies', 41–2; A. Marignan, *La Tapisserie de Bayeux: étude archéologique et critique* (Paris, 1902), xiv–xxi; M. Lanore, 'La Tapisserie de Bayeux', *Bibliothèque de l'Ecole des Chartes* 64 (1903), 83–93, esp. 88; J. Steenstrup, *Die Bayeux-Tapete: ein Leitfaden für Besucher des nationalhistorischen Museums im Schlosse Frederiksborg* (Copenhagen, 1905), 443–4; Ph. Lauer, 'Le Poème de Baudri de Bourgueil adressé à Adèle, fille de Guillaume le Conquérant, et la date de la Tapisserie de Bayeux', *Mélange d'Histoire offerts à M. Charles Bemont* (Paris, 1913), 43–58; H. Prentout, 'La Conquête de l'Angleterre par les Normands – Les Sources – La Tapisserie de Bayeux', *Revue bimensuelle des cours et conférences* 2nd ser. 23/2 (1921–2) 16–29, 193–200, 302–12, esp. 311–12; Abrahams, 244–7; S. Turgis, *La Reine Mathilde et la Tapisserie de Bayeux* (Paris and Caen, 1928), 88; E. Maclagan, *The Bayeux Tapestry* (London, 1943), 18; C. H. Gibbs-Smith, 'The Death of Harold at the Battle of Hastings', *History Today* 10 (1960), 188–91; R. Drogereit, 'Bemerkungen zum Bayeux-Teppich', *Mitteilungen des Instituts für Österreichische Geschichtsforschung* 70 (1962), 257–93, esp. 293; S. Bertrand, *La Tapisserie de Bayeux et la manière de vivre au onzième siècle* (La Pierre-qui-Vire, 1966), 40–6; O. K. Werkmeister, 'The Political Ideology of the Bayeux Tapestry', *Studi Medievali* 17/2 (1976), 535–95, esp. 554–63; N. P. Brooks and H. E. Walker, 'The Authority and Interpretation of the Bayeux Tapestry', *Proceedings of the Battle Conference for Anglo-Norman Studies* 1 (1979), 1–34, esp. 26–8 [repr. above as ch. 8]; M. Parisse, *The Bayeux Tapestry* (Paris, 1983), 36–40; D. J. Bernstein, *The Mystery of the Bayeux Tapestry* (London, 1986), 90.
10 For the controversy over the dating of the Bayeux Tapestry see S. A. Brown, 'Bayeux Tapestry', 26–31; also her, 'The Bayeux Tapestry: why Eustace, Odo and William?', *Anglo-Norman Studies* 12 (1989), 8–28.
11 *Oeuvres poétiques*, ed. Abrahams, 232.

using the embroidery as one of his sources.[12] Others, particularly literary scholars, have argued that Baudri's highly developed literary style and ironic technique leave many of his factual assertions open to doubt and have concluded that the poem is of limited value in Bayeux Tapestry studies.[13]

There are really two questions that interest the historian and the art historian: (1) Did Baudri himself have direct experience of the Bayeux Tapestry? (2) If so, did he see it in the chamber of Adèle, countess of Blois?

To answer the first question, it will be necessary to determine if elements of Baudri's account of Adèle's Conquest hanging can be explained *only* by reference to the Bayeux Tapestry, assuming, independently of Baudri's poem that this work of art already existed and was theoretically available to him. In this attempt to answer the question as definitively as possible, Baudri's words will be compared closely to parallel scenes in the Bayeux Tapestry and also to the accompanying tituli. The similarities of individual scenes as well as the ordering of the scenes will be taken into account.[14] It will be necessary to examine other parts of Baudri's poem as well as what is known of Baudri's methods and poetical techniques.

The section of the *Adelae Comitissae* which purports to describe what is usually referred to as a tapestry depicting the Norman Conquest comprises 337 lines (vv. 235–572) of the total of 1,367. Baudri constantly uses the word *uelum* to refer to this object, a word which refers to a wall hanging of any material and technique and does not necessarily have to be understood as a tapestry. Baudri claims that Adèle's hanging is made of precious materials: gold, silver, and silk (vv. 211–12), studded here and there with bright gems and pearls (vv. 229–30), the whole exhibiting a technique unsurpassed even by the mythical skills of Pallas and Arachne (vv. 217–28). This should alert the reader immediately that Baudri is not providing a factual description of the Bayeux Tapestry with its much humbler materials. As is well known, the so-called Bayeux Tapestry is actually an embroidery of wool on a linen carrier. Baudri has signalled that the hanging which he is describing is part of a very luxurious interior and reflects the courtly love of gold and glitter.

Baudri then proceeds to describe the 'new and true stories' which were depicted on the hanging, saying that they were all accompanied by titles (vv. 233–34).[15] Tituli indeed play an important role in the Bayeux Tapestry, for although cursory, they are essential for an identification of people and places, and for an understanding of what is being depicted. On the embroidery, people and places are identified by single epithets, such as *Willelmus, Harold, Turold, Ecclesia, Bagias*; actions are introduced

12 Lauer, 'Poème', 57–8; Gibbs-Smith, 'Death of Harold', 188; Werkmeister, 'Political Ideology', 561; Parisse, *Bayeux Tapestry*, 40, among others.

13 Marignan, *Tapisserie de Bayeux*, xxi; Prentout, 'Conquête de l'Angleterre', 311–12; *Oeuvres poétiques*, ed. Abrahams, 247; Bernstein, *Mystery*, 90; Bond, '"Iocus Amoris"', 181; Tilliette, 'Chambre d'Adèle', 153, among others.

14 Although several scholars have compared the poem's account of Adèle's textile with the Bayeux Tapestry, none so far has published a full analysis in which the sequence and details of the embroidery's scenes are compared to Baudri's version.

15 Porro recenseres titulorum scripta legendo / In uelo ueras historiasque nouas. (Hilbert, 155).

by *Hic*, while *Ubi* introduces actions associated with a particular location just mentioned.[16]

Baudri launches into his narrative about William of Normandy, starting with a short reference to the difficulties the young duke overcame while establishing, and then maintaining, his control over the duchy (vv. 235–42). He continues with a lengthy description of the comet of Spring 1066 and the people's dumbfounded reaction to it (vv. 243–59). The real narrative gets underway with a council called by William, where, in the first of several great speeches, William explains why his allies have been gathered and what he expects from them – support for his invasion of England (vv. 260–328).

By inserting full-fledged speeches into his narrative, Baudri has moved away very quickly from describing a visual narrative depicted on an art object to writing in a literary mode. The speeches pull the reader into the story in a manner very different from the less dramatic effects of medieval pictorial narrative which must rely on depicted gesture and disposition of figures. Baudri takes advantage of the emotion-heightening possibilities inherent in reported speech.

When Baudri returns to the description of Adèle's wall hanging, the building of William's fleet follows, with emphasis on the all-out effort put into the enterprise which results in three thousand ships, all filled quickly with cavalry and horses (vv. 329–56).[17] The cross-Channel sailing is immediate and uneventful, although in the poem, much is made of the grief and wailing issuing from the families and friends who remained at home in Normandy (vv. 357–86). In Baudri's narrative, the Duke, upon reaching England's shore, promises to rescue the country from the hands of the usurping perjurer (vv. 387–94). Contrary to the delays indicated in the Bayeux Tapestry, in the poem the fighting between the Anglo-Saxons and the French begins almost immediately. The first clash occurs when the invaders encounter the famous Anglo-Saxon shield wall. In the poetical battle, the feigned flight which drew off English stragglers to the slaughter is quickly passed over, so that much more attention can be paid to a more central issue – the rout of the Normans. To counteract this potential disaster, William removes his helmet and takes the opportunity to harangue his fleeing men. The fighting resumes with Duke William at its head, Harold is killed by an arrow, and the demoralised, leaderless English flee (vv. 395–494). Baudri's poem continues, describing the continuation of the Norman campaign until the capitulation of the city, probably London, and William's acceptance by the inhabitants as their king (vv. 495–556).

Let us now closely compare Baudri's poetical images and the visual images on the Bayeux Tapestry, starting with the first correspondence, the appearance of the

16　*Pace* Parisse, *Bayeux Tapestry*, 53–4 and 138, who thinks *Hic* and *Ubi* are merely undifferentiated 'bardic signals' to the Tapestry's observer.

17　This of course may be poetical exaggeration. The ship list written *c.* 1070 indicated 776 ships were given by the magnates, but in the second section it indicates the total number was 1000; it was apparently augmented by many more ships given by men according to their means. William of Jumièges placed the number at 3000. See Elizabeth van Houts, 'The Ship List of William the Conqueror', *Anglo-Norman Studies* 10 (1987), 159–83, esp. 169–70.

comet. The Bayeux Tapestry incorporates a comet with a red tail in the upper border, to which a group of men are pointing in agitated surprise or wonder (pl. 14). The caption reads: 'Isti mirant stellam'. In Baudri's Latin text, the comet is described as a *stella* (v. 245) as well as *cometes* (v. 243), and *miratur* (v. 251) is also used. Baudri then proceeds at some length to represent popular astonishment (vv. 251–58). At vv. 255–6 he says:

> A younger generation seeks answers from its elders,
> and inquisitive boys hang on the lips of old men.[18]

On the Bayeux Tapestry, the small figure in the group, who has established eye-contact with the solitary tall figure, looks as if he is seeking instruction. Even though the 1066 appearance of Halley's comet occurs in other sources, the correspondence between Baudri's words and the Bayeux Tapestry's images explains Baudri's comet passage much better than any literary source. The closest written source is the *Carmen de Hastingae proelio* at vv. 125–6: 'And blazing from heaven the streaming hair of a comet proclaimed to the English foreordained destruction'.[19] But its author has transposed the appearance of the comet to the landing in England and does not mention popular reaction. William of Jumièges (VII, 13) mentions the comet as a star with three tails; William of Poitiers does not mention the comet.

Baudri appears, at first, to omit the next section shown on the Bayeux Tapestry for he proceeds immediately to describe William's war council at vv. 261–2:

> William himself, sitting in an exalted place,
> orders the court to sit, as was proper according to custom.[20]

In the corresponding Tapestry scene (pl. 15) we see William seated in the middle on a double lion throne; to the right and slightly behind is his half-brother, Bishop Odo of Bayeux, also seated; to the left is a standing figure who appears to be an excited messenger; to the right of Odo is another standing figure with a tool in his hand. The setting seems to be a palace. The titulus reads, 'Hic Willelm Dux iussit naves edificare'.

In Baudri's text, William launches into a long speech in which he outlines his claims to England, based doubly upon consanguinity and the promise of the English king Edward brought by his legates. He then says at vv. 281–2:

> A certain perjurer was also sent to us
> to usurp the crown that is our due.[21]

This desire to justify the decision to invade England is in line with the accepted interpretation of the first third of the Bayeux Tapestry which depicts the voyage of Harold Godwineson to Normandy in 1064, culminating in his swearing to support

18 A patribus responsa petit sibi iunior etas / Atque rogando senis pendet ab ore puer. (Hilbert, 155–6).
19 *Carmen de Hastingae Proelio of Guy Bishop of Amiens*, ed. C. Morton and H. Muntz (Oxford, 1972), 19.
20 Ipse loco residens Guillelmus in ediciori / Quo decuit proceres more sedere iubet. (Hilbert, 156).
21 Quidam periurus quod nos diadema deceret / Usurpat nobis missus et ipse fuit. (Hilbert, 156).

William's claim to the English throne (pls 1–10). William then calls on his legates who have just returned from England to speak, and these confirm what William has said. At the end of the speech William's court immediately ratifies the decision to build ships. In lines 335–9 the summoning of craftsmen is reported.

This entire passage in Baudri is best explained with reference to the sections of the Bayeux Tapestry immediately preceding the council scene which depict the crowning of Harold and the voyage of an English ship to Normandy, presumably to relay the message of Harold's coronation (pls 13–14). The Tapestry depicts a legate excitedly relaying the news to William at the war council, where Odo represents the councillors, and the decision is taken to build ships, as reported in the caption (pl. 15). A craftsman stands waiting to execute the royal command. The chain of events represented by Baudri and the speed with which things occur reflect exactly the same chain of events seen in the Tapestry. Indeed, the Tapestry is the only known source, pictorial or literary, that can explain precisely the concatenation of events in Baudri's poem.

Baudri next describes the building and the fitting of the ships in some detail in vv. 341–6:

> Bilge-holds, oars, sailyards, cross-banks, yardropes,
> and other items of use are fitted by everyone.
> Forests are cut down – the ash, the oak, and the ilex fall;
> the pine is uprooted by the trunk.
> The aged fir is hauled down from the steep mountains;
> labour gives value to all trees.[22]

The Bayeux Tapestry also depicts the building and outfitting of the ships in some considerable detail. We see the chopping down of trees, the lopping of branches and a figure who is planing a stripped log that has been wedged into the 'V' of a tree. Next we see groups of craftsmen working on the interior of two boats, possibly installing benches.

Although the correspondences between poem and artefact are not precise – Baudri gives more details – both agree in relating the cutting of trees and the building of the ships. Again, no other source can explain the appearance of this section in Baudri. The actual building of the ships is not described in the *Carmen*. William of Jumièges (VII, 14) and William of Poitiers (II, 2) likewise pass over the construction of the ships, saying only that a fleet was prepared.

One detail of the sailing raises the question of whether Baudri employed the Tapestry or the *Carmen de Hastingae Proelio* as his source. Baudri writes at vv. 353–4:

> Moreover, there were separate ships for the infantry;
> some ships carried the cavalry; others, the horses.[23]

22 Sentinas, remos, antemnas, transtra, cherucos / Et reliquos usus omnis adaptat homo. / Ceduntur silue cadit ornus, quercus et ilex / Deque suo pinus stipite diripitur / Aduehiturque senex abies a montibus altis / Cunctis arboribus fecit opus precium. (Hilbert, 158).
23 Has preter turbe fuerat sua cimba pedestri / Altera fert dominos, altera nauis equos. (Hilbert, 158).

In the *Carmen* at vv. 84–5 we find:

> ... the most part forced the knights' horses aboard
> the ships, the rest hurried to stow their arms.

In the large section on the sailing, the Bayeux Tapestry depicts three classes of ships: large ones carrying a mixture of horses and men, other large ones carrying only men and their arms (represented by the shields), and small ones in the background carrying only men (pl. 17). At the end of the scene in the Tapestry there is the titulus, 'Hic exeunt caballi'.

A possible – and we think plausible – reading of the Tapestry here is that the horses and men in some of the large ships are the war horses and their grooms; the men's status as grooms is shown in the final scene of the crossing, where a horse is led off by the bridle, not ridden by a knight. The men with shields in the other large ships are the cavalry; the men in the small boats might well be the infantry, specifically the archers, who are depicted later on; the smaller boats would represent their lower status, rather than being an attempt at perspective or functioning as mere space fillers, as is the usual suggestion. At all events, the Tapestry presents a tripartite division of ships, corresponding to Baudri's tripartite division. The *Carmen* poet, on the other hand, refers only to the stowing of arms and the boarding of the horses; there is no mention of separate ships with different functions. Again, it seems virtually certain that Baudri's depiction of the crossing can be ascribed to a reading of the Bayeux Tapestry.

One final scene of the crossing demands our attention: the landing itself. Baudri writes at vv. 381–4:

> And now the steersman watches the wind and the stars,
> and the men immediately fall to their tasks.
> Turning the folds of their sails, they veer into the wind.
> At length their oars fall silent and they gain the shore.[24]

Surely these lines can be based on a plausible reading of the Tapestry. Sailyards are being turned, and it looks as though the sails are at a wide angle to the path of the ships. The lookouts are looking out intently, and there is a great flurry of activity. No literary source available to Baudri described the landing in this way.

At the end of the section on the crossing (vv. 385–6), Baudri's Latin text says:

> Naves et proceres procerumque uocabula uelum
> Illud habet uelum si tamen illud erat.

In our first translation we were misled by the word *uelum*, taking it for a synonym of *carbasa* in line 383, hence a word for 'sail'. It is much more plausible, however, that

24 Iamque gubernator uentos et sidera spectat / Incumbuntque suo iugitur officio. / Obliquando sinus in uentos carbasa uertunt / Tandem tranquillo remige littus habent. (Hilbert, 159).

Baudri is once again talking about the wall hanging, for which *uelum* is his usual word. What the line therefore means is this:

> This hanging contains ships and leaders and names of
> leaders, if however, this hanging existed.[25]

For the moment we shall leave aside the problem of the 'if'-clause and concentrate on the main statement. It is impossible to identify the leaders of individual ships in the Bayeux Tapestry. Each crew consists of a helmsman to manage the rudder, some of whom also manoeuvre the sail-yard, while at the opposite end of the boat there is a lookout. But the word *proceres* implies more than nautical captains; it would mean something like the commanders of a body of men. The tituli of the Bayeux Tapestry frequently identify the leaders and important men on both sides of the conflict, like Odo of Bayeux, Robert of Mortain, Eustace of Boulogne, Harold Godwineson and his brothers Leofwine and Gyrth, among others. Once more we seem to have a correspondence between Baudri and the Bayeux Tapestry.

In Baudri's poem, as in William of Jumièges, there is no preamble between the landing of the French in England and the onset of the fighting. In the other sources – the *Carmen*, William of Poitiers and the Bayeux Tapestry – there are descriptions of messengers, spies, meals, and fortification building.

In the battle section of the poem, Baudri refers specifically to three events which had been depicted on the Bayeux Tapestry: the attack on the English shield wall (vv. 405–16), William's lifting his helmet to prove to his troops that he is still alive (vv. 429–32), and the death of Harold, (vv. 463–4). The first two events are mentioned in too many of the sources to allow for a nexus solely between the Tapestry and Baudri's poem. In fact, there are very close correspondences between Baudri's version of the initial encounter between the French and the English and that found in the *Carmen*, such as the statement in both that the Anglo-Saxon defenders stood so tightly packed that the dead could not fall (*Carmen*, vv. 415–16). The Bayeux Tapestry image gives the same impression (pl. 21).

The incident of the Norman rout and William baring his face is found in all the Norman sources as well as the Bayeux Tapestry, but there are noticeable differences in the personages involved (pls 24–5). In the Tapestry, Odo of Bayeux and Eustace of Boulogne are given important roles in this incident, probably for reasons having to do with the purpose for which the Bayeux Tapestry was created.[26] In Baudri's version, William is the sole hero and the poet takes the opportunity to put a rousing speech into his mouth (vv. 433–48). The Duke asserts that he is still alive and well and that victory is almost within reach. They should remember past Norman victories and the possibility of gain. Besides, where would they flee, for the ships are far from shore and there is neither refuge nor escape for them. They must all fight or

25 The previous translation was 'Commanders and orders hold ships and sails in check / that is, if the ships really had sails'.
26 Brown, 'Eustace, Odo, William'.

perish! This closely echoes the parallel speech written by the author of the *Carmen de Hastingae Proelio* (vv. 444–64).

According to Baudri's vision the fighting resumed with an increased viciousness and both sides suffered terrible losses. At lines 459–60 he wrote:

> Victory without injury is granted to neither side,
> and the dry earth runs with the blood of the slain.[27]

The analagous Bayeux Tapestry caption reads, 'Hic ceciderunt simul Angli et Franci in proelio', as the carnage spreads into the borders of the fabric (pl. 23). This is a common theme in the various versions of the battle.

However, it can be argued that Baudri used the Bayeux Tapestry *and no other source* for his description of Harold's death (pl. 26). Baudri writes (vv. 473–4):

> A shaft pierces Harold with deadly doom;
> he is the end of the war: he was also its cause.[28]

Baudri was the first writer to describe the death of Harold in this way. Both William of Jumièges and William of Poitiers stated merely that Harold was killed near the end of the day. The author of the *Carmen* (vv. 533–50) depicts Harold's slaughter in close combat at the hands of four knights, including William. In fact, the Tapestry can be read as being in agreement with this version.[29] However, the presence of the caption 'Haroldus Rex interfectus est' with *Haroldus* written directly over a foot soldier with an arrow in his face undoubtedly gave rise to the long and popular tradition, initiated by Baudri, that Harold was killed by an arrow.[30] More probably, Harold is the figure whose leg is being hewn off by a mounted knight. In any event, a misreading of the Tapestry scene and the caption is the only explanation – apart from oral tradition that cannot be confirmed – why Baudri describes the death of Harold in the manner he does.

This is where the Bayeux Tapestry now ends, but the poem continues. Baudri describes in lengthy and gory detail how the blood-roused Normans pursue and slaughter the hapless English, so that future war will be avoided. Only nightfall mercifully puts an end to the carnage and allows the vanquished to crawl away into hiding or to die. At daybreak, William pressed his fighters forward with another speech, in which he indicates they had best strike while the English were still disorganised and the cities and towns vulnerable. It was their only chance for a quick victory and the establishment of peace. The fighting progresses to the city walls – presumably London – for which the English had rallied the only people left within – girls, old men and boys. In a moment of magnanimity to allow the inhabitants to save face, William offers terms of peace, which are immediately accepted and the

27 Indemnis neutri cedet uictoria parti / Arida cesorum gleba cruore fluit. (Hilbert, 161).
28 Perforat Hairaldum casu letalis arundo / Is belli finis, is quoque causa fuit. (Hilbert, 161).
29 Brown, 'Eustace, Odo and William', 17–18.
30 The further embellishment that the arrow pierced Harold's eye first appeared in William of Malmesbury's *Gesta Regum*, c. 1125. Gibbs-Smith, 'Death of Harold', 188, was incorrect when he claimed that Baudri was the first to say that Harold had been killed by an arrow in the eye.

gates are opened to him with rejoicing. William is proclaimed King, as had been announced by the star trailing blood.

Baudri ends this section of the poem by taking his reader out of the mode of battle poetry and returning to his claim that he had seen all this indicated on the hanging in Adèle's chamber. He wrote (vv. 561–4):

> The wealth of the king, his glory, his wars and triumphs –
> each could be seen and read on the tapestry.
> I would believe that the figures were real and alive,
> if flesh and sensation were not wanting in the images.[31]

He reiterates the reference to the tituli that he had made in lines 233–4 when he began to describe the hanging. He now says (vv. 565–6):

> Letters pointed out the events and each of the figures in such a way
> that whoever sees them can read them, if he knows how.[32]

This is an intriguing statement for it would seem to indicate that Baudri was indeed familiar with the format of the Bayeux Tapestry and the functioning of the text it contains.

Perhaps to tease the baited reader further, Baudri then includes the following (vv. 567–8):

> If you could believe that this weaving really existed,
> you would read true things on it, O writing paper.[33]

And so Baudri casts doubt upon the veracity of his own words. What can be made of this, almost nine hundred years later?

It is now possible to summarise the evidence that would indicate that Baudri had had direct contact with the Bayeux Tapestry.

1. The poet describes a wall hanging of the Norman Conquest that is supplied with tituli that point out events and the leading individuals, even though he himself does not name them.

2. Baudri's account of the events in his tapestry follows the exact order found on the Bayeux Tapestry allowing for items omitted and the section at the end of the poem, which the lost portion of the Tapestry might be expected to have contained in some abbreviated fashion.

3. Baudri's narrative includes details of the Conquest known only from the Bayeux Tapestry. Especially close are the details of the appearance of the comet and the reaction of the people; William's council of war; the cutting of the forest and the building of the ships; the tripartite classification of the ships; the actions of the crew during the landing; and the death of Harold.

31 Regis diuitie, sua gloria, bella, triumphi / In uelo poterant singula uisa legi. / Ueras crediderim uiuasque fuisse figuras, / Ni caro, ni sensus deesset imaginibus. (Hilbert, 164).
32 Littera signabat sic res et quasque figuras, / Ut quisquis uideat, si sapit, ipsa legat. (Hilbert, 164).
33 Hec quoque, si credas, hec uere uela fuisse / In uelis uere, cartula nostra, legas. (Hilbert, 164).

This evidence supports the notion that Baudri had studied with particular care the scenes of the Tapestry from the appearance of the comet to the landing in England.

The contradictory evidence should also be set out.

1. Baudri describes a tapestry made of gold, silver, and silk threads and studded with gems and pearls. The Bayeux Tapestry is made of wool on a linen base and contains no gems or pearls.

2. Baudri's described artefact mentions only William and Harold by name. The Bayeux Tapestry names numerous individuals on both sides of the conflict.

3. Baudri undercuts his claims with remarks such as (v. 386): 'If however this hanging existed'; or (v. 567): 'If you believe this weaving really existed'.

These objections can be disposed of:

1. Baudri's description of a luxury tapestry can be explained by two factors: (1) his desire to enhance his description of the chamber of his would-be patron and his claim to describe objects worthy of her beauty (vv. 567–72); (2) his reliance on a literary source. Baudri borrows his description from Ovid, *Metamorphoses* VI, which depicts a tapestry with gold and silver threads and also portrays the weaving contest of Pallas and Arachne, a theme which finds a reverberation in Baudri's poem in vv. 217–27.

2. In reading the 337 lines which Baudri dedicated to his description of the Conquest Tapestry in Adèle's bedchamber, we can quickly see that he has set out deliberately to create a panegyric to her father in the form of a narrative. William is the sole hero of the story, and its true focus. Baudri's intent seems to be to draw a portrait of William as a legitimate ruler of England and Normandy. It was not his primary concern to recreate events which had occurred some thirty-five years earlier, shortly before Adèle herself was born, and when Baudri was twenty-five years old.

3. Baudri casts doubt on the tapestry he depicts precisely because it is an imaginary tapestry – one that is very like, but also different from, the Bayeux Tapestry. Baudri expects that Adèle, his ideal reader, has a close acquaintance with the details of the Bayeux Tapestry and would be amused by his literary tapestry which, while embellishing and editing the real object, remains strikingly like the original.

An answer to the question of whether or not Baudri had seen the Bayeux Tapestry can now be advanced. Evidence indicates that Baudri had indeed seen that embroidery and had studied it carefully. He edits its narrative to make it focus on William, the father of Adèle, to whom he is offering a lengthy panegyric. He fills out the narrative of the Conquest with borrowings from other accounts, particularly the *Carmen de Hastingae Proelio* and William of Poitiers. However, references to the narrative and format of the Bayeux Tapestry are unmistakable, and only a hypothesis allowing for Baudri's close knowledge of the famous artefact can account for the structure and details of this section of his poem.

It is here that we would ask our readers to consult their own experiences of view-
ing the Bayeux Tapestry *in situ* rather than through a reproduction. We believe that
all would agree that because the Tapestry is very long and exceptionally detailed,
viewer fatigue sets in at some stage before everything is seen. It is also impossible to
devote the same level of attention to all parts of the visual narrative. If one wishes
to retain visual details, then one must study a portion of the Tapestry on one day,
and return on another to take up a new section. It seems to us that Baudri studied
two sections of the Bayeux Tapestry in detail: from the appearance of the comet
(pl. 14) to the landing at Pevensey, and from the first battle encounter (pl. 21) to the
death of Harold (pl. 26). He was at least generally familiar with the rest.

The second question – did Baudri see the Bayeux Tapestry in Adèle's chamber? –
can be disposed of somewhat more easily. The poet begins this section of the poem
by telling us that he is going to describe a wonderful hanging that surrounds Adèle's
bed. The actual Bayeux Tapestry, which is incomplete at the right end, still measures
an impressive seventy metres in length. The suggestion that it was used as a bed
hanging can be disposed of without controversy. The Bayeux Tapestry is a very large
object, suitable for a great hall, and far too big for a private chamber, especially one
which, according to Baudri's account, was already crowded with other tapestries.
One could invoke the theory that Adèle had commissioned a miniature of the actual
Bayeux Tapestry, perhaps ordering up a luxury copy.[34] But there is no evidence to
support this idea and there is no indication that it was a practice in this period to
commission copies of secular-subject embroideries.

If Baudri's poem cannot be used as a witness to the exact location of the Bayeux
Tapestry at the time that the poem was written, it can be used as proof that the
embroidery was in existence by then. The dating of the poem becomes crucial at
this point. Baudri makes a reference to Adèle's married state which implies that her
husband is absent, but living (vv. 61–6):

> Her probity and chaste heart adorn her,
> so too her noble offspring and the love of her husband.
> There are many men, whose manners and character
> and good looks would commend them to girls,
> who might have tempted her; but what would it profit to try?
> She keeps inviolable the bond of her marriage bed.[35]

Stephen of Blois joined the First Crusade and was in the Holy Land between 1096
and 1099. After a short stay at home, he returned to the East in 1101 and was killed
there in 1102. Abrahams favoured a date of *c.* 1100 for the composition of the poem.

Since the Bayeux Tapestry is not referred to in any other sources found so far, it
must be assumed that it was not available to a general public and probably not

34 Parisse, *Bayeux Tapestry*, 37.
35 Hanc morum probitas, hanc castum pectus honestat, / Nobilis hanc soboles ornat amorque uiri. /
 Sunt tamen et multi, quos commendare puellis / Et decus et probitas et sua forma queat, / Hanc
 qui temptassent sed quid temptasse iuuaret? / Seruat pacta sui non uiolanda thori. (Hilbert,
 150–1).

exhibited in Bayeux Cathedral at this early date, as is commonly held today. There is no hard evidence that the embroidery was originally meant for Bayeux Cathedral even though its connection with Odo, bishop of Bayeux, is no longer disputed, since he seems so inextricably interwoven into the narrative it relates. Nobody has uncovered any evidence that it was ever in the actual possession of either William the Conqueror or his wife Matilda, although this may have been its intended destination.[36]

If the Tapestry was designed, sewn, and stitched in England, as internal evidence would indicate, then it obviously found its way across the Channel sometime before 1476, possibly shortly after it was completed. For Baudri to have seen it before composing the *Adelae Comitissae*, it would have had to be on the Continent before 1100, for there is no indication that Baudri visited England before that.[37] One possibility is that the Tapestry may have come back with Odo of Bayeux, the man who was probably responsible for its creation, when he was finally expelled from England in 1088 by William Rufus. It is possible that the Bayeux Tapestry remained in Odo's possession until his death during the winter of 1096–7. Baudri may have seen the Tapestry somewhere in Bayeux, which is not too far from Bourgueil. But there is no evidence in his written works that he was in contact with Odo of Bayeux. There are several persons named Odo addressed or mentioned by Baudri in his poems, but none of these, apparently, is the Bishop of Bayeux.[38] It can be hazarded that if he were familiar with so powerful a man, Baudri would have either written to him or at least mentioned him.

Wherever it was in Northern France, and however it was exhibited, Baudri had enjoyed leisurely access to the Bayeux Tapestry and was able to use it as a source when he composed his long poem to William's daughter Adèle. In the light of Baudri's writing, we cannot disregard the possibility that by 1100 the Bayeux Tapestry had found its way into Adèle's possession, although certainly not into her bedroom.

The plain fact which emerges from the poem is that it is very unlikely that Baudri had ever met Adèle in person, much less visited her in her chamber. He tells us as much in lines 83–6:

> Scarcely did I see her, yet I recall having seen her,
> just as I remember the dreams I have seen.
> In the same way I often recall having seen a new moon:
> either I just caught a glimpse of it or believe that I did.[39]

36 Its size and long, narrow format made the Bayeux Tapestry an awkward object to exhibit or trundle from one place to another. The amazingly intact condition of the embroidery today attests to the fact that it has not been exposed to handling and exhibition conditions during most of its existence.
37 Baudri did visit England, but it was after he became Archbishop of Dol in 1107, as attested in his *Itinerarium*.
38 See Abrahams' index, 386.
39 Vix ideo uidi uidisse tamen reminiscor, / Ut reminiscor ego somnia uisa michi. / Sic me sepe nouam lunam uidisse recordor / Uel, cum uix uideo meue videre puto. (Hilbert, 151).

It appears that Baudri, unprompted, sent his panegyric to Adèle with a plea for patronage: he asks for a *cappa* or *tunica* as a sign of her favour (v. 1358). At the very end of the poem (vv. 1367–8) he tells Adèle that he has sent a messenger to recite his *libellum*, but is prepared to come in person, if only she would bid him.

The plea for patronage and a private audience caps a long panegyric that praises the daughter of William by praising her surroundings, namely the objects in her chamber. Everything in her room, mentioned by Baudri, reflects her learning, her piety, and her connection to her father. The walls are covered in tapestries with scenes from the Bible and from pagan mythology. The central tapestry, of course, is the one portraying her father's conquest. The ceiling is bedecked with the signs of the zodiac and other constellations as well as the planets – all purporting to demonstrate her avid interest in astronomy. The floor contains a map of the known world – oceans, rivers, mountains, nations and races – all claiming to prove Adèle's deep knowledge of geography. On the bedposts are carved Philosophy – at the head – and the seven liberal arts – at the foot. It would seem that there is no science or art that Adèle has not mastered. Behind the hyperbole and poetic licence hides an honest rogue. Baudri tells us in several places that he has invented much in the pursuit of patronage. At the end of the section on the Conquest Tapestry, Baudri says frankly (vv. 567–72):

> If you could believe that this weaving really existed
> you would read true things on it, O writing paper.
> But you might also say: 'What he wrote ought to have been;
> a subject like this was becoming to his goddess.
> He wrote by arranging matters which behoved
> the beauty of his Lady – and they are worthy of her'.[40]

And near the very end of the poem (vv. 1353–4) the same sentiment is repeated:

> Verily so great a chamber befits so great a countess,
> but I sang of more than what was, as was fitting.[41]

And finally, an open admission of his jesting character (vv. 1343–7):

> While I labour over these matters, Adèle, I trifle;
> with my verses I have painted a lovely chamber for you.
> As for you, requite us with something worthy of our fable;
> consider how much our fable is worth.[42]

40 Hec quoque, si credas, hec uere uela fuisse / In uelis uere, cartula nostra, legas / Sin autem, dicas 'quod scripsit, debuit esse / Hanc diuam talis materies decuit. / Ipse coaptando, que conueniant speciei / Istius domine, scripsit et ista decent'. (Hilbert, 164).
41 Nempe decet talem talis thalamus comitissam / At plus, quod decuit, quam quod erat, cecini. (Hilbert, 184).
42 Dum tibi desudo, dum sudans, Adela, nugor, / Depinxi pulchrum carminibus thalamum. / Tu uero nostre fabelle digna repende / Et pensa, quanti fabula constiterit. (Hilbert, 184).

In another poem, Baudri stresses the fictional quality of his poems: 'I utter words in many roles and describe myself now as rejoicing, now as sorrowing; and speaking like a young man "I hate" or "I love something or other" ... but it's not true, I make it all up.'[43]

Thus, Baudri probably never saw Adèle, he certainly was never in her chamber, and therefore he did not see a tapestry of any kind in that location. His poem is largely a skilful fiction designed to gain him an introduction to Adèle. That he failed in this attempt is shown by the poem immediately following in the collection, where Baudri repeats his plea. But Baudri *had* seen the Bayeux Tapestry. The imagined tapestry in his poem is, we believe, demonstrably based upon first-hand knowledge of the famous artefact. The pleasure to be derived from Baudri's poem by sophisticated contemporaries, including Adèle, was, in large part, the pleasure of recognition.

The idea of recognition leads to a literary matter, namely the question of the poem's genre. It is perfectly apparent that the *Adelae Comitissae* is a panegyric. There are several examples of medieval panegyric which achieve their aim by reference to works of art or buildings associated with the ruler or magnate addressed. Among these are Ermoldus Nigellus' poem to Louis the Pious that describes a series of frescoes in the emperor's palace and church at Ingelheim.[44] Another example is Walahfrid Strabo's poem to the same emperor on the statue of Theodoric placed in a courtyard before the palace.[45] A third is John Scottus' poem to Charles the Bald on the church of St Mary built by Charles at Compiègne to serve as a royal chapel.[46]

In all three cases there is documentary or archaeological-cum-art historical evidence to show that the objects or buildings described actually existed. This fact seems to indicate that poets did not strain their patrons' credulity by referring to an object or building associated with the patron which was imaginary. Baudri, therefore, adopted the conventions of earlier Latin panegyric *in large part*. Adèle, who is described by Baudri as a reader of books and patroness of poets, would have seen through Baudri's hyperbole and recognised the reference to an object bearing her family's history as factually based.

43 See Abrahams, Poem CXLVII, vv. 35–9; Hilbert, Poem 85; trans. Bond, '"Iocus Amoris"', 177, n. 101. The Latin text is as follows.

> Quod uero tanquam de certis scriptito rebus / Et quod personis impono uocabula multis / Et modo gaudentem, modo me describo dolentem / Aut puerile loquens uel amo uel quidlibet odi, / Crede michi: non uera loquor magis omnia fingo. (Hilbert, 89).

44 'In honorem Hludovici Liber IV', vv. 179–282, ed. Dümmler, *Monumenta Germaniae Historica: Poetae Latini Aevi Carolini* II (Berlin, 1884), 63–6. See also W. Lammers, 'Ein karolingisches Bildprogramm in der Aula regia von Ingelheim', *Vestigia mediaevalia ausgewählte zur mittelalterlichen Historiographie, Landes- und Kirchengeschichte* (Wiesbaden, 1979), 219–83.

45 M. W. Herren, 'The "De imagine Tetrici" of Walahfrid Strabo: edition and translation', *The Journal of Medieval Latin* 1 (1991), 118–39; earlier edition *Poetae Latini* II, ed. Dümmler, 370–78.

46 'Aulae Sidereae', ed. and trans. M. W. Herren in *Iohannis Scotti Eriugenae Carmina*, Scriptores Latini Hiberniae 12 (Dublin, 1993), 116–21; earlier edition *Poetae Latini* III ed. L. Traube (Berlin, 1896), 550–2.

Recently, literary scholars have made much of the innovative qualities of Baudri's poetry, especially his 'courtliness', and the ironic character of his poetry cast in the Ovidian mould.[47] However, in writing a major panegyric work with its plea for patronage, Baudri remained steadfastly in the Carolingian tradition of objectivity when dealing with an artefact that held close and powerful association for the potential patron. We must therefore disagree with the conclusion of Jean-Yves Tilliette in his otherwise important and perceptive study of Baudri's poem: 'Il est donc vain de chercher dans ce poème la moindre indication archéologique précise; c'est une oeuvre littéraire, faite de mots, et qui doit d'abord être étudiée comme telle.'[48] The case is more complicated.

47 Dronke, 'Personal Poetry'; Bond, '"Iocus Amoris"'.
48 Tilliette, 'Chambre d'Adèle', 153.

Postscript. After our paper had gone to press, we became aware of the important new book by Christine Ratkowitsch, *Descriptio Picturae: Die literarische Funktion der Beschreibung von Kunstwerken in der lateinischen Grossdichtung des 12. Jahrhunderts* (Vienna, 1991), which devotes more than a hundred pages (17–127) to an interpretation of Baudri's poem. This work should certainly be consulted for its literary insights, chiefly those regarding the poem's overall structure and purpose. However, Ratkowitsch did not undertake the close comparison of image and text that we have presented here, and we do not believe that there is anything in her work that would challenge or weaken our conclusion.

12

The Origin, Art, and Message of the Bayeux Tapestry

RICHARD GAMESON

The Bayeux Tapestry is simultaneously one of the most informative and enigmatic artefacts of the early middle ages.[1] It was designed to convey a vast amount of information, and it still does. The great size of the work (which is more than 68 metres long in its present, incomplete state) indicates that it was intended to communicate in a public rather than a private context, and to reach a large rather than a small number of people. It is easy to grasp, at least superficially, what the Tapestry is about. Yet many of the issues that are central to a balanced understanding of the work – in particular where it was made, why, and what exactly it says – are not so clear. They continue to be debated, sometimes quite heatedly.

One point of which we can be fairly certain, ironically, is that the answers to many of the questions that now exercise us – who made it, for what purpose, and where and how was it displayed – will have been common knowledge to virtually everyone who saw it in the late eleventh century. This simple fact is central to understanding the work today – or at least to understanding what it was *not* designed to tell us. We might speculate that information about the patron and possibly also the designer was originally incorporated at the end of the lost final section of the Tapestry. Such would be consonant with contemporary practices, for plentiful patrons and some craftsmen were commemorated in inscriptions on their works (and this includes

1 The standard modern 'edition' remains F. M. Stenton (ed.), *The Bayeux Tapestry: a comprehensive survey* 2nd ed. (London, 1965). The standard old edition was F. R. Fowkes, *The Bayeux Tapestry: a history and description* (London, 1875) [here cited from the edition of 1913]. Of the numerous published reproductions, undoubtedly the best in terms of the quality of the photographs is D. M. Wilson, *The Bayeux Tapestry* (London, 1985), which, however, unfortunately fragments the work into tiny sections. The most useful reproduction for assessing the Tapestry as a whole is the one-seventh scale fold-out version available from Bayeux itself. Other readily available full reproductions accompanied by useful discussions include: E. Maclagan, *The Bayeux Tapestry* (London, 1943); S. Bertrand, *La Tapisserie de Bayeux et la manière de vivre au onzième siècle* (La Pierre-qui-vire, 1966); L. Thorpe, *The Bayeux Tapestry and the Norman Invasion* (London, 1973); C. H. Gibbs-Smith, *The Bayeux Tapestry* (London, 1973); M. Parisse, *The Bayeux Tapestry* (Paris, 1983); D. J. Bernstein, *The Mystery of the Bayeux Tapestry* (London, 1986); and W. Grape, *The Bayeux Tapestry: monument to a Norman triumph* (Munich, 1994). For a comprehensive annotated bibliography to 1986 see S. A. Brown, *The Bayeux Tapestry: history and bibliography* (Woodbridge, 1988).

textiles), and we even have a few portraits of monastic scribes and illuminators.[2] However, it is equally likely that this was not the case; and as the end has well and truly vanished, the speculation ultimately gets us nowhere. In the absence of other documentation, such light as may be shed on these issues must come from analysis of the artefact itself. And here the one paradoxical fact mentioned earlier is directly relevant: what survives was not designed to tell its audience who the patron was or where it was made. The only way the modern student can approach these issues, therefore, is by intelligent reading between the lines – scouring the work for information it was not intended to provide.

On the other hand, there can be little doubt that the Bayeux Tapestry was designed to convey some general messages, and that they are there still. If we cannot see them, we are looking in the wrong place, in the wrong way, or perhaps we are just looking too hard.

As with all things, what exactly you see in the Bayeux Tapestry and the return you get from the experience depends upon how you look and what you bring to it in the first place. It is a mark of the work's greatness that so many people get so much out of it when looking with twentieth-century eyes. The patron and designer would, no doubt, have been flattered to know how compelling their imagery remains after nine hundred years, and how effectively they have wooed modern beholders to regard it in terms of technology and modes of depiction, especially cinematography, which lay eight hundred years in the future.[3] I do not want to debate the pros and cons of such approaches; suffice to say that I wish to look at it, as far as possible, with eleventh-century eyes.

Now there are considerable problems here. The specific mental and visual 'baggage' of an eleventh-century beholder is, of course, irrecoverable. This is both because of uncertainty concerning the context and nature of the experience, and because of the certainty that the viewer in question was a protean character. How the beholder interpreted and responded to certain scenes in the Tapestry depended upon his assumptions, not to mention his race – as remains true today. The scenes of the Norman troops ravaging in England before the Battle of Hastings, which include the motif of a woman and child fleeing their burning house, provide a case to consider (pl. 19).[4] For the Norman or pro-Norman beholder, pillaging and devastation

2 Ælfflæd, the patron of the extant stole and maniple of Bishop Frithestan of Winchester was commemorated in an inscription (see *The Relics of St Cuthbert*, ed. C. F. Battiscombe (Oxford, 1956), pp. 375–432); an inscription on one hanging at Augsburg recorded both the patrons and the craftsmen, while another at the same place had depictions of the four donors each identified by inscriptions (see O. Lehmann-Brockhaus, *Schriftquellen zur Kunstgeschichte des 11. und 12. Jahrhunderts für Deutschland, Lothringen und Italien* 2 vols (Berlin, 1938), I, nos 2597 and 2595). See further in general J. J. G. Alexander, *Medieval Illuminators and their Methods of Work* (New Haven and London, 1992), pp. 9–12; and R. G. Gameson, *The Role of Art in the Late Anglo-Saxon Church* (Oxford, 1995), pp. 76–95.

3 E.g. G. Noxon, 'The Bayeux Tapestry', *Journal of the Society of Cinematologists* 7 (1967–8), 29–35; A. Prah-Pérochon, 'Le film animé de la tapisserie de Bayeux', *Stanford French Review* 1 (1977), 339–65; and Parisse, *Bayeux Tapestry, passim*.

4 Wilson, *Bayeux Tapestry*, pls 50–1. Comment: Fowke, *Bayeux Tapestry*, pp. 112–13. The view that this is derived from Trajan's column has little to recommend it, despite its similarity to a motif there depicted.

were inevitable parts of a successful campaign; and, revealingly, such events were actually celebrated by the poet of the near-contemporary *Carmen de Hastingae proelio*: 'Your [William's] people invaded the land, laid it waste and incinerated it. This was not to be wondered at, since the stupid people had denied you as king; thereby they perished justly, and went to oblivion.'[5] For the Anglo-Saxon or pro-Anglo-Saxon beholder, however, these scenes and above all the motif of the woman and child will have been rich in pathos, and to that extent seem to be a positively anti-Norman touch. Harold Godwineson going to church in Bosham before his momentous expedition to Normandy is another instance (pl. 2).[6] For the Anglo-Saxon beholder, the scene demonstrates the Earl's pious nature; indeed some modern writers have commented on the apparent emphasis that is thereby laid on Harold's good character. For the Norman, on the other hand, it represents man before the fall; and it might even have been perceived to allude to the hypocrisy of Harold and his family, who were known for appropriating church lands.[7] The extended depictions of the Normans building ships and their invasion fleet in full sail provide a final example (pls 15–17).[8] For the Anglo-Saxon beholder, these are sinister moments; for the Norman, triumphant ones. Moreover for Odo, bishop of Bayeux, they may have had a particular personal resonance since we know that he had made a substantial contribution to the fleet.[9]

It is thus very difficult to generalise concerning the responses that these and other scenes may have evoked in contemporaries. There were probably as many reactions as there were viewers – though I do not agree with those commentators who believe the Tapestry contained one message for Normans, and another for Anglo-Saxons.[10] Much the same applies to the borders of the work, with their menagerie of birds and beasts, sometimes illustrating recognisable fables. Modern

5 *The Carmen de Hastingae Proelio of Guy Bishop of Amiens*, ed. C. Morton and H. Muntz (Oxford, 1972), ll. 146–8 (p. 10): '[tua gens] invadit terram; vastat et igne cremat / Nec mirum, regem quia te plebs stulta negabat; / Ergo perit iuste, vadit et ad nichilum'. The status of this work, which was impugned by R. H. C. Davis ('The *Carmen de Hastingae Proelio*', *English Historical Review* 93 (1978), 241–61) and has since been fiercely debated, receives knowledgeable and balanced treatment from E. M. C. van Houts, 'Latin Poetry and the Anglo-Norman Court 1066–1135: *The Carmen de Hastingae Proelio*', *Journal of Medieval History* 15 (1989), 39–62, who upholds its very early date and its connection with Guy of Amiens, and realises that it is poetry. The analysis of F. Barlow, 'The *Carmen de Hastingae Proelio*' repr. in his *The Norman Conquest and Beyond* (London, 1982), 182–222, remains valuable. One can, incidentally, compare *Ruodlieb*, III, 25–6, ed. C. W. Grocock (Warminster, 1985), pp. 42–3.

6 Wilson, *Bayeux Tapestry*, pl. 3. Comment: Fowke, *Bayeux Tapestry*, p. 30.

7 A. Williams, 'Land and Power in the Eleventh Century: the estates of Harold Godwinson', *Anglo-Norman Studies* 3 (1980), 171–87 and 230–34, at 181–4; R. Fleming, *Kings and Lords in Conquest England* (Cambridge, 1991), pp. 79–86; also R. Eales, 'An Introduction to the Kent Domesday' in *The Kent Domesday*, ed. A. Williams and G. Martin (London, 1992), pp. 39–41. For a tabulation of Harold's lands according to Domesday Book see P. A. Clarke, *The English Nobility under Edward the Confessor* (Oxford, 1994), pp. 169–91.

8 Wilson, *Bayeux Tapestry*, pls 35–44.

9 C. W. Hollister, 'The Greater Domesday Tenants-in-Chief' in *Domesday Studies*, ed. J. C. Holt (Woodbridge, 1987), pp. 219–48 at 221–2.

10 E.g. R. D. Wissolik, 'The Saxon Statement: code in the Bayeux Tapestry', *Annuale Mediaevale* 19 (1979), 69–97; and Bernstein, *Mystery of the Bayeux Tapestry*, pp. 114–95.

opinion differs widely concerning the extent to which these decorative images in the upper and lower margins can be interpreted as a commentary on the scenes they frame,[11] and it seems likely that this has always been the case. While some eleventh-century beholders may have had the time, knowledge and inclination to draw parallels between certain beasts or fables and the nearby historical narrative, others probably did not.

Nevertheless we can, I think, make some headway with the issue of the eleventh-century beholder. We may not unfairly categorise eleventh-century viewers as belonging to one of two broad groups; and we can reasonably assume that the Tapestry will have in some sense catered for both. On the one hand, there was the comparatively uninformed beholder, the person who may not have known too much about the events depicted, or may not have had a refined iconographic vocabulary; and who may only have seen the work on a couple of occasions or for a short period of time. On the other hand, there was the better informed, visually sophisticated beholder; and the person who may have had the opportunity to see the work repeatedly and to scrutinise every detail. As anyone who has attempted to study the Tapestry *in situ* in Bayeux will know, it is actually very difficult to combine these two approaches. The work is too vast and too rich for the serious student to be able to sustain a high level of concentration throughout. Even today, one either studies details, or 'runs' with the flow of the story. Ideally, the patron and designer had to satisfy both types of viewer: providing sufficiently bold and blatant images for the uninformed, with sufficient nuance, subtlety and accuracy for the knowledgeable. One of the fallacies of some Bayeux Tapestry scholarship is to believe that we can place ourselves in the position of the well informed beholder. Armed with our modern works of reference, it is easy to forget that, while we can be familiar with a far wider selection of works in general than our medieval predecessors, we cannot know the spectrum of art possessed by a given place in any detail, nor its immediate cultural context. We have lost most of the large scale artworks of the period, not to mention its pre-suppositions and beliefs. By and large, we are likely to have more success if we try to approach the work from the point of view of the hypothetical eleventh-century general beholder. I do not fool myself that we can recreate this elusive character: it is just that our own state of unknowing makes us more akin to him.

There is also another, more positive reason for following such a course. Much of the art that survives from before the twelfth century is of small scale, and it is reasonably interpreted in relation to a restricted circle of beholders. It is all the more important, therefore, to take advantage of the Bayeux Tapestry, a unique

11 Cf. Fowke, *Bayeux Tapestry, passim*; Parisse, *Bayeux Tapestry*, pp. 127–32; H. E. J. Cowdrey, 'Towards an Interpretation of the Bayeux Tapestry', *Anglo-Norman Studies* 10 (1988), 49–65 (repr. as Ch. 9 above); C. Hicks, 'The Borders of the Bayeux Tapestry', *England in the Eleventh Century*, ed. Hicks (Stamford, 1992), 251–65 (particularly negative); and Grape, *Bayeux Tapestry*, pp. 42–4. Fundamental on the fables depicted is H. Chefneux, 'Les fables dans la Tapisserie de Bayeux', *Romania* 60 (1934), 1–35 and 153–94. For comment on the representation of the animals see B. Yapp, 'Animals in Medieval Art: the Bayeux Tapestry as an example', *Journal of Medieval History* 13 (1987), 15–73.

early medieval monumental work, as a rare opportunity for trying to reconstruct something of the perspectives and points of view of a wider public.

Proceeding with this in mind, I shall take a broad look at six principal themes. These are: the origin of the Tapestry; the depiction of secular and sacred in it, particularly in relation to Odo of Bayeux; the inscriptions; the visual language, especially the techniques of pictorial narrative; the historicity of the work; and last but by no means least, its overarching message. Much of what I have to say may be familiar to some readers, and may strike others as blatantly obvious. I can only plead that my focus is old rather than new views; and that what is blatantly obvious is generally true.

As a last preliminary, it would undoubtedly be helpful to summarise my assumptions concerning the date and circumstances of production of the Tapestry, two crucially important areas where fact is lacking and certainty impossible. We can be confident that the Tapestry was executed after 1066 (!), while the style makes it highly unlikely that it is much later than *c.*1100. Between these two fairly secure outer limits we have only inference and hypothesis to guide us. Like many other commentators, I believe the content and nature of the work strongly favour production near to, rather than further from, the events it depicts.[12] Its numerous 'local' details, its attention to figures of seemingly minor significance, not to mention the character of the main story itself, undoubtedly make best sense in the years immediately after 1066. If the hypothesised and widely accepted connection with Odo of Bayeux is correct, as seems likely, then this favours the period before his fall and imprisonment in 1082.[13] Circumstantial evidence concerning the designer on the one hand (to be presented in due course), and the consecration of Bayeux Cathedral on the other, points to 1072 x 77 as the most likely time within this period for work to have begun.

There is no specific information concerning the circumstances of production, and although we can assume that time was of the essence, we have no idea how long it took to design and make the work.[14] We can be confident, given the scale of the artefact, that many hands were involved in embroidering it; while the homogeneity of conception points to one principal designer, if not necessarily to a single designer. On the other hand, there is not a shred of evidence concerning the location of the embroidery workshop or workshops responsible,[15] and speculation on the subject is

12 Cf., *inter alios*, E. A. Freeman, 'The Authority of the Bayeux Tapestry' in his *The Norman Conquest* 6 vols (Oxford, 1867–79), III, 563–75, esp. 570–2 (repr. as Ch. 2 above).

13 The suggestion that the work was commissioned in 1081/2 by Odo for William as an attempt to regain his favour (S. A. Brown, 'The Bayeux Tapestry: Why Eustace, Odo and William?', *Anglo-Norman Studies* 12 (1990), 7–28) seems highly improbable given that the imagery is unlikely to have endeared Odo to William – not to mention the practical difficulties of organising its manufacture from imprisonment in Rouen.

14 The fact that thirty-five members of the Leek Embroidery Society could embroider a full reproduction between 1885 and 1886 is of little help here, given that we do not know how many hands were involved in the production of the original, nor how much time was allotted to it on a daily basis. Moreover, it is self-evident that the creation of such a work *de novo* was more demanding and would take longer than simply replicating it.

15 If one workshop seems *prima facie* more likely on visual and practical grounds, the scale of the work might be held to favour multiple workshops, if time were felt to be of the essence. Our ignorance of the practical details of eleventh-century needle-work ateliers leaves the question insoluble.

pointless. We do not know from what sources the designer worked – whether from written texts, a series of consultations with the patron, from other conversations, from other images, or (perhaps most likely) from some combination of all these. The hypothesis of a single, underlying text seems to me to reflect modern thinking rather than eleventh-century reality, and I have yet to see compelling evidence for its existence.[16] We do not know how closely the patron supervised the designer, nor how closely the designer oversaw the embroiderers. Nor do we even know whether the same person was responsible for devising both the inscriptions and the imagery. It is, however, quite clear that considerable time and effort was devoted to designing the work as a whole, and that its words and images are intimately interwoven (a point discussed further below). There are, moreover, certain clues which shed light on the affiliations of the principal designer. The broad question of the work's origin, and the connections of the principal designer are my first main theme.

Origin

I must spend rather longer on this subject than if I had been writing a few years ago. There has long been a consensus of opinion that the Bayeux Tapestry was made in England, which, after Francis Wormald's seminal essay of 1957,[17] turned into almost universal agreement. This, however, changed dramatically in 1994 with the publication of Wolfgang Grape's monograph on the Tapestry.[18] Grape vigorously refuted the theory of English origin in favour of Normandy – in particular, Bayeux.[19] His publishers, Messrs Prestel, felt this to be sufficiently exciting (not to mention marketable) to be worth flagging in a preface of their own (p. 21). Grape, we are told, 'in a brilliantly argued exposition, as vivid as a historical novel … establishes that the Bayeux Tapestry originated in Bayeux itself'.

Before we ask whether Grape has really proved his case, it is worth making a couple of general historiographical observations. First, although numerous scholars have assented to Wormald's cautious conclusions, very few have had much to add to

16 E.g. S. Bertrand, 'Etude sur la Tapisserie de Bayeux', *Annales de Normandie* 10 (1960), 197–206 (repr. as Ch. 5 above); N. P. Brooks and H. E. Walker, 'The Authority and Interpretation of the Bayeux Tapestry', *Proceedings of the Battle Conference for Anglo-Norman Studies* 1 (1979), 1–34 and 191–9 (repr. as Ch. 8 above); B. Bachrach, 'Some Observations on the Bayeux Tapestry', *Cithara* 27 (1987), 1–28. The most persuasive of these is Brooks and Walker; however their 'evidence' is open to alternative interpretation: see p. 204 below. It is above all the inscriptions that encourage this line of thought. However there is no reason to believe they predated the imagery, as opposed to being developed in tandem with it. In my opinion, the attempts to make them into a narrative text only underline how unlikely this is to have been their origin.

17 F. Wormald, 'Style and Design' in Stenton (ed.), *Bayeux Tapestry*, 25–36; repr. in Francis Wormald, *Collected Writings I: studies in medieval art from the sixth to the twelfth centuries*, ed. J. J. G. Alexander, T. J. Brown, and Joan Gibbs (London, 1984), 139–49 and 181–2.

18 Grape, *Bayeux Tapestry*; he reaches his conclusion on the subject at p. 54. E. F. Freeman, 'The Identity of Ælfgiva in the Bayeux Tapestry', *Annales de Normandie* 41 (1991), 117–34, esp. 130–4, had already offered alternative views on the questions of the Tapestry's origin and patron; however, as they are wholly unsubstantiated, they need not detain us.

19 This is by no means a new view: cf, e.g., C. J. Laffetay, *Notice historique et descriptive sur la Tapisserie dite de la Reine Mathilde, exposée à la Bibliothèque de Bayeux* (Bayeux, 1873); and Fowke, *Bayeux Tapestry*, p. 23.

his evidence,[20] and some have built on them incautiously. Grape has rightly pointed to the complacency of scholarship in this area. Secondly, as Wormald stressed, there was a close relationship between English and Norman art in the eleventh century, and this inevitably problematises the task of attributing an unlocalised work to one side of the Channel as opposed to the other, purely on grounds of appearance. This is particularly so in relation to an artefact which is unique. His conclusion was that an English origin was more likely than a Norman one; however some subsequent writers have gone further, analysing the Tapestry as if it were in some sense 'English'.[21] Grape has reacted against this, asserting that it is altogether Norman. But is this the right way to approach the question? Is it meaningful to try to decide whether the work is English *or* Norman? I suggest it is not. The Bayeux Tapestry reflects the interpenetration of Anglo-Saxon and Norman culture, and it should be understood in these terms. In his zeal to refute the extravagant view of its 'Englishness' and locate it in an exclusively Norman context, Grape has himself denied the essential Anglo-Norman, bi-cultural nature of the work.

Grape has set the art of the Bayeux Tapestry in a broad context, using a wide range of analogues from early medieval Europe as a whole. He has not, I think, proved his own case for manufacture at Bayeux; however he has highlighted the weakness of *some* of the arguments for English workmanship. The fact that the patron of the work was a Norman is hardly in doubt, and Grape, like most scholars, believes Odo of Bayeux to be the prime candidate. The evidence for the affiliations of the designer and embroiderers, on the other hand, must now be looked at afresh. Let us, then, review the main points in favour of English involvement in the production of the Tapestry, and assess the challenge that has been mounted against them.

First, there is the well-attested fact that England had a flourishing tradition of needlework in the Anglo-Saxon period, as indeed in later centuries.[22] Such work included at least one piece which was in some sense narrative. This was the hanging (now unfortunately lost) that depicted the deeds of Ealdorman Byrhtnoth of Essex.[23] Byrhtnoth is principally famous today for his tragic death at the Battle of Maldon in 991,[24] but what was shown on his hanging is unknown. Various early fragments survive from Scandinavia, attesting to the use of pictorial, even narrative,

20 Probably the most substantial additions from an art historical perspective were those of C. R. Dodwell, pointing to the correspondences between the Tapestry and details in the illustrated Old English Hexateuch, British Library, Cotton Claudius B. iv: 'L'originalité iconographique de plusiers illustrations anglo-saxonnes de l'Ancien Testament', *Cahiers de civilisation médiévale* 14 (1971), 319–28. The most important discussion from a historical perspective is Brooks and Walker, 'Authority and Interpretation'.

21 E.g. Wissolik, 'The Saxon Statement'; Bernstein, *Mystery of the Bayeux Tapestry*, pp. 114–95; also Bachrach, 'Observations'.

22 See C. R. Dodwell, *Anglo-Saxon Art: a new perspective* (Manchester, 1982), pp. 129–69; and, more generally, A. G. Christie, *English Medieval Embroidery* (Oxford, 1938).

23 *Liber Eliensis*, ed. E. O. Blake, Camden Society 3rd series 92 (London, 1962), II, 63 (p. 136): 'Uxor quippe [Brithnothi] ... cortinam gestis viri sui intextam atque depictam in memoriam probitatis eius huic ecclesie donavit'. See further M. Budny, 'The Byrhtnoth Tapestry or Embroidery' in D. Scragg (ed.), *The Battle of Maldon AD 991* (Oxford, 1991), 263–78.

24 See Scragg (ed.), *Battle of Maldon, passim*.

designs on textiles there.[25] But although it is theoretically possible that this tradition was exported to Normandy, there is no concrete evidence that such was the case. And since the only northern examples with even distant visual connections to the Bayeux Tapestry come from Scandinavia itself and certainly postdate it, the light they shed on its place of origin is negligible. Documentary references attest to the countless textiles of early medieval Europe as a whole which have perished; however no specifically Norman tradition of embroidery can be adduced to counterbalance the undoubtedly flourishing English one; and the centres in France which were particularly known for textile work in the eleventh and twelfth centuries, namely Poitiers and Limoges,[26] are a long way from the Duchy. Moreover, it is clear that the Normans admired English textiles. William of Poitiers, the eleventh-century Norman historian, declared *à propos* of the rich gifts that Duke William presented to Normandy after the Conquest, that 'the women of the English race excel in embroidery and cloth of gold';[27] while Matilda, the wife of William the Conqueror, bequeathed to the Abbaye aux Dames, Caen, a chasuble that had been made for her at Winchester by an Anglo-Saxon embroideress and 'another robe now being embroidered in England' (along with other treasures).[28] Thus *prima facie* a wholly outstanding eleventh-century embroidery is more likely to have been made in England than in Normandy. Grape cannot gainsay this fact, and simply ignores it.

Secondly, there is the circumstance that a couple of the spellings in the inscriptions (the language of most of which is racially undiagnostic) follow English rather than Norman or French conventions.[29] Moreover, there are a few features that seem to be specifically Anglo-Saxon, namely the use of the tironian *et*, the eth in one personal name (Gyrth: pl. 22),[30] the ash in another (Ælfgyva: pl. 7),[31] and the spelling of *castra* as *ceastra*[32] and *Edward* as *Eadward* (pl. 12).[33] By themselves these do not point conclusively to England (particularly given that there is also one word,

25 Notably the twelfth-century fragments from Røn and Baldishol: respectively Oslo, Universitetets Oldsaksamling, and Oslo, Kunstindustrimuseet (Wilson, *Bayeux Tapestry*, figs 3 and 4; Stenton (ed.), *Bayeux Tapestry*, figs 22 and 24). The Old Norse 'Second' or 'Old' Lay of Guthrún, which perhaps dates from as early as the tenth century, describes Thóra, Hákon's daughter, in Denmark embroidering a narrative tapestry which depicted sailing and martial scenes: *The Poetic Edda*, trans. L. M. Hollander, 2nd ed. (Austin, Texas, 1962), pp. 271–2.

26 See Bertrand, *Tapisserie de Bayeux*, pp. 39–40.

27 William of Poitiers, *Gesta Guillelmi ducis Normannorum et regis Anglorum*, II, 42: *Guillaume de Poitiers, Histoire de Guillaume le Conquérant*, ed. R. Foreville (Paris, 1962), pp. 256–8: 'Anglicae nationis feminae multum acu et auri textura … valent'.

28 *Les actes de Guillaume le Conquérant et de la Reine Mathilde pour les abbayes caennaises*, ed. L. Musset, Mémoires de la société des antiquaires de Normandie 37 (1967), no. 16 (pp. 112–13).

29 See further R. Lepelley, 'Contribution à l'étude des inscriptions de la Tapisserie de Bayeux', *Annales de Normandie* 14 (1964), 313–21 (repr. as Ch. 6 above).

30 Probably rather than certainly original, the current cross stroke being a restoration. Wilson, *Bayeux Tapestry*, pl. 64.

31 *Ibid.*, pl. 17.

32 *Ibid.*, pls 49–50.

33 *Ibid.*, pls 29 and 30. It is *Edward* in pls 1 and 28 (but note that the beginning of the word on the first occasion does not appear in Montfaucon's reproduction, and the spelling is not necessarily, therefore, original).

parabolant, with strong French connections: pl. 4); however they are more likely in an Anglo-Saxon context than in a Norman one. Grape can only minimise their significance, and suggest they might reflect an Anglo-Saxon written source, or an Anglo-Saxon presence in Normandy.

Thirdly, there is the fundamental artistic point that the creation of such a complex and successful visual narrative presupposed a context in which pictorial narrative was flourishing. *Faute de mieux* we are largely dependent on manuscript art for our information here. Various pictorial cycles were produced in northern French and Flemish scriptoria during the eleventh century. One can point, for example, to the historiations of the Odbert Psalter of *c.* 999; the miniatures in the Saint Vaast Bible dating from *c.* 1040; the scenes in the Sacramentary of Saint Denis, also from Saint Vaast of *c.* 1050; the illustrated Life of St Omer produced *c.* 1070; the Life of St Amand made between *c.* 1070 and *c.* 1110; and the Life and Miracles of St Quentin of *c.* 1100.[34] But whatever weight we place on such works (which are a far cry from the Bayeux Tapestry), it is an inescapable fact that Saint Bertin, Saint Omer, Saint Amand, Saint Quentin and Saint Vaast are not in Normandy, and never were. This is not to deny that Normandy interacted with northern France and Flanders in the eleventh century; nevertheless these books do not in any respect comprise evidence for pictorial art in the Duchy.

From Normandy itself we have four main relevant works. These are: the Sacramentary of Mont Saint-Michel, which contains a series of hieratic images illustrating specific feasts and which dates from the 1050s or 60s;[35] the giant Bible of Jumièges containing historiated initials, which dates from the fourth quarter of the

34 Boulogne, Bibliothèque municipale, 20: J. Porcher, *Manuscrits à peintures du viie au xiie siècles* (Paris, 1954), no. 111; R. Kahnitz, 'Der christologische Zyklus im Odbert-Psalter', *Zeitschrift für Kunstgeschichte* 51 (1988), 33–125.

 Arras, Bibliothèque municipale (now 'Médiathèque'), 559: A. Boutemy, 'Une bible enluminée de Saint-Vaast à Arras', *Scriptorium* 4 (1950), 67–81; S. Schulten, 'Die Buchmalerei des XI. Jahrhunderts im Kloster Saint Vaast in Arras', *Münchener Jahrbuch der Bildenden Kunst* 7 (1956), 49–90, at 51–7 with cat. 3.

 Paris, Bibliothèque nationale, lat. 9436: Porcher, *Manuscrits à peintures*, no. 239; Schulten, 'Buchmalerei', pp. 66–72 with cat. 17; D. Gaborit-Chopin, *et al.*, *Le trésor de Saint Denis* (Paris, 1991), no. 14.

 Valenciennes, Bibliothèque municipale, 502: Porcher, *Manuscrits à peintures*, no. 159; B. abou-el-Haj, 'Consecration and Investiture in the Life of Saint Amand', *Art Bulletin* 61 (1979), 342–58; C. Deremble, 'L'enluminure' in H. Oursel *et al.*, *Nord Roman* (La Pierre-qui-vire, 1994), 259–340 at 301–2; and B. Abou-el-Haj, *The Medieval Cult of Saints: formations and transformations* (Cambridge, 1995), 85–106 and 156–9.

 Saint Omer, Bibliothèque municipale, 698: Porcher, *Manuscrits à peintures*, no. 118; Deremble, 'L'enluminure', pp. 293–7; A. Boinet, 'Un manuscrit à peinture de la bibliothèque de Saint-Omer', *Bulletin Archéologique du comité des travaux historiques* (1904), 415–30.

 Saint Quentin, Trésor de la Basilique, sn: Porcher, *Manuscrits à peintures*, no. 180; Deremble, 'L'enluminure', pp. 313–14.

35 New York, Pierpont Morgan Library, M 641 (with Rouen, Bibliothèque municipale, Mm. 15, suppl. ms 116): J. J. G. Alexander, *Norman Illumination at Mont Saint-Michel* (Oxford, 1970), pp. 127–72.

eleventh century;[36] the Saint Ouen Augustine, dating from the end of the century,[37] and the Préaux copy of Gregory's *Moralia* of *c.* 1100,[38] both of which are likewise decorated with historiations. There can be no doubt that this is altogether less impressive, not to mention chronologically later, than the showing from southern England. Here around the millenium we find the production of several fully or nearly fully illustrated copies of Prudentius' *Psychomachia*,[39] and more inventively an elaborately illustrated codex of vernacular biblical poetry.[40] In the first quarter of the eleventh century we can point to the Sacramentary of Robert of Jumièges, whose text is interspersed with narrative and hieratic images.[41] In the second quarter of the century we find the production (in multiple copies incidentally) of a vernacular Hexateuch with over 400 narrative scenes, the most densely illustrated surviving book to that date;[42] while from the third quarter there is the Tiberius Psalter with an extensive, self-contained prefatory cycle of full-page images.[43] In the fourth quarter there are the intermittent pictorial initials in Durham Cathedral Library, B. II. 16;[44] while at the end of the century we find the illustrated life of St Cuthbert,[45] and the initials in the passional, British Library, Arundel 91[46] – to mention only the highlights. Three of the volumes mentioned, we may note in passing, the Hexateuch, Durham B. II. 16, and Arundel 91, are certainly or probably from Saint Augustine's Abbey, Canterbury. Once again, in so far as surviving material is an adequate guide, England would seem to have been a far more favourable context for the production of an ambitious narrative tapestry than Normandy.

This leads on to the fourth point. Grape's contention is that the Bayeux Tapestry was made in Normandy, most probably at Bayeux. But the development of pictorial

36 Rouen, Bibliothèque municipale, A. 6: F. Avril, *Manuscrits normands xi-xiieme siècles* (Rouen, 1975), no. 20; *Trésors des abbayes normandes* (Rouen and Caen, 1979), no. 136.

37 Rouen, Bibliothèque municipale, A. 85 (Augustine, *In euangelium S. Iohannis*): Avril, *Manuscrits normands*, no. 33.

38 Rouen, *Bibliothèque municipale*, A. 123: *Ibid.*, no. 58.

39 London, British Library, Add. MS 24199; Cotton Cleopatra C. viii; Cambridge, Corpus Christi College, 23: E. Temple, *Anglo-Saxon Manuscripts 900–1066* (London, 1976), cats 49, 51, 48, and 58.

40 Oxford, Bodleian Library, Junius 11: *Ibid.*, cat. 58; facsimile: *The Cædmon Manuscript of Biblical Poetry*, ed. I. Gollancz (Oxford, 1927). The problems that beset its production suggest that this was a first attempt at combining text and images in this way: see further H. Broderick, 'On the Method of Illustration in MS Junius 11 and the Relationship of the Drawings to the Text', *Scriptorium* 37 (1983), 161–77.

41 Rouen, Bibliothèque municipale, Y. 6: *The Missal of Robert of Jumièges*, ed. H. A. Wilson, Henry Bradshaw Society 11 (London, 1896); Temple, *Anglo-Saxon Manuscripts*, cat. 72.

42 British Library, Cotton Claudius B. iv: Temple, *Anglo-Saxon Manuscripts*, cat. 86; *The Old English Illustrated Hexateuch*, ed. C. R. Dodwell and P. Clemoes, Early English Manuscripts in Facsimile 18 (Copenhagen, 1974).

43 British Library, Cotton Tiberius C. vi: Temple, *Anglo-Saxon Manuscripts*, cat. 98; F. Wormald, 'An English Eleventh-Century Psalter with Pictures', *Walpole Society* 38 (1962), 1–13; repr. in Wormald, *Collected Writings I*, 123–37.

44 R. A. B. Mynors, *Durham Cathedral Manuscripts* (Oxford, 1939), no. 35 with pl. 24.

45 Oxford, University College, 165: C. M. Kauffmann, *Romanesque Manuscripts* (London, 1975), no. 26; M. Baker, 'Medieval Illustrations of Bede's Life of St Cuthbert', *Journal of the Warburg and Courtauld Institutes* 41 (1978), 16–40.

46 British Library, Arundel 91: Kauffmann, *Romanesque Manuscripts*, cat. 17.

art there seems to have been predominantly a phenomenon of the late eleventh century. Most Norman books dating from before *c.* 1066 have minimal pictorial matter, much of it of a low quality. In the last third of the eleventh century and the early twelfth century we find an increasing range of imagery used in books, but it is still limited in quantity and restricted in context. The decoration of the masterpieces of this phase of Norman illumination, such as the Jumièges Bible and Gospels, the Carilef Bible, the copy of Jerome's commentary on Isaiah illuminated by Hugo Pictor, and the Préaux Gospels,[47] is confined to author portraits and historiated initials. Nor is there much in the corpus of Norman sculpture from the eleventh century to alter this picture, for figural subjects are extremely rare.[48] Bayeux does seem to have been in the vanguard of Norman artistic activity – the best available sculptors were employed on the cathedral which was consecrated in 1077,[49] and the highly talented Carilef Bible scribe (active between *c.* 1085–*c.* 1125) appears to have worked there[50] – but it can show nothing which is even remotely comparable in style or technique, let alone scope, to the Tapestry. The one important exception to the general paucity of Norman pictorial art during the eleventh century is the abbey of Mont Saint-Michel, where the development of book production and decoration was more precocious, and whose illustrated sacramentary has already been

47 Rouen, Bibliothèque municipale, A. 6: Avril, *Manuscrits normands*, no. 20.
 British Library, Add. MS 17739: *Trésors des abbayes normandes*, no. 138; J. Backhouse, D. H. Turner, and L. Webster (eds), *The Golden Age of Anglo-Saxon Art* (London, 1984), no. 262.
 Durham Cathedral Library, A. II. 4: Mynors, *Durham Cathedral Manuscripts*, no. 30 with pls 16–18; M. Gullick, 'The Scribe of the Carilef Bible: a new look at some late eleventh-century Durham Cathedral Manuscripts' in *Medieval Book Production: assessing the evidence*, ed. L. L. Brownrigg (Los Altos, 1990), 61–83; D. Rollason (ed.), *Anglo-Norman Durham: a catalogue for an exhibition of manuscripts in the Treasury, Durham Cathedral* (Durham, 1993), no. 3.
 Oxford, Bodleian Library, Bodley 717: O. Pächt and J. J. G. Alexander, *Illuminated Manuscripts in the Bodleian Library, Oxford I: German, Dutch, Flemish, French and Spanish Schools* (Oxford, 1966), no. 441; O. Pächt, 'Hugo Pictor', *Bodleian Library Record* 3 (1950), 96–103; with colour plate in C. de Hamel, *A History of Illuminated Manuscripts* (Oxford, 1986), ill. 81.
 British Library, Add. MS 11850: *Trésors des abbayes normandes*, no. 128; Backhouse *et al.*, *Golden Age*, no. 261.
48 M. Baylé, *Les origines et les premiers développements de la sculpture romane en Normandie*, Art de Basse-Normandie 100 bis (Caen, 1992). See pp. 86 ff. with ills 242 and 246 for the rare examples at Lonlay and Goult, both *s.* xi^ex; and ill. 484 for La Trinité, Caen.
49 Baylé, *Sculpture romane en Normandie*, pp. 118–24 with ills 418–28 (where they are dated to between 1055–75); for better reproductions see L. Musset, *Normandie romane* 2 vols, 3rd ed., (La Pierre-qui-vire, 1987), I, ills 104–7. The crypt capitals that are *in situ*, although boldly cut, are decorated with fairly simple foliate motifs (not all of them fully finished) or masks. The two *ex situ* figural capitals which are of a much larger scale are very rudimentarily carved: the figures are not rounded, rather they are flat-fronted, as if simply incised onto the surface of the original block. Given that Grape (*Bayeux Tapestry*, pp. 52–3) places considerable weight on these capitals, it is worth stressing that neither the figures of the *ex situ* capitals, nor the foliate motifs on the *in situ* ones have any stylistic correspondence with the Bayeux Tapestry.
50 *Teste* his writing of Bayeux Cathedral Library, 57–8; the Bayeux entry in the 1122 mortuary roll of Abbot Vitalis; and Paris, Bibliothèque Mazarine, 404 (729), a sacramentary for the use of Bayeux: see further Gullick, 'Scribe of the Carilef Bible', pp. 72–4.

mentioned.[51] This house may in fact be indirectly relevant to the origin of the Bayeux Tapestry, and we shall return to it in due course. Nevertheless, Mont Saint-Michel notwithstanding, there is little in the corpus of eleventh-century Norman art, particularly before *c.* 1080, to suggest an artistic setting for the production of the Tapestry; and certainly nothing to match the auspicious artistic context provided by English material.

The fifth point is stylistic. The lively pictorial style of the Bayeux Tapestry has often been compared to the draughtsmanship of Anglo-Saxon manuscripts. Now Grape rightly points out how incautious some such comparisons have been. The Tapestry does not have the fluidity of many of the English drawings to which it has been likened, nor their agitated hemlines. He, for his part, points to one page in the Bible of Saint Vaast, Arras, and observes that its stiffer style of draughtsmanship is more closely akin to that of the Tapestry.[52] This is certainly true of the drawing he cites, however other decorated pages in the Bible, some of which are appreciably cruder, do not offer such good parallels.[53] Moreover, it remains difficult to see how comparisons with northern French and Flemish art can *prove* that the Tapestry originated in Normandy when there is nothing so close in Norman art.[54] It is, of course, a moot point how far one should expect the stylistic mannerisms of manuscript art to be maintained in a textile medium. The process of embroidery may well have stiffened lines which were originally more fluid – in which case the idiom of the 'cartoon' is likely to have been closer to that of an Anglo-Saxon drawing than a northern French one. But one need not push this point too far, since there are in fact Anglo-Saxon works which are stylistically more akin to the Tapestry than those whose degree of affinity to it Grape rightly minimises. The highly agitated manner of drawing was only one trend of English draughtsmanship, albeit an influential one. More stolid work had been done alongside it in the tenth century, and continued to be produced in the eleventh.[55] The Old English Hexateuch is one instance. Closer in time to the Tapestry, one may point to works like the Tiberius Psalter, the

51 See further in general Alexander, *Mont Saint-Michel*; and M. Dosdat, *L'enluminure romane au Mont Saint-Michel xie–xiie siècles* (Avranches, 1991).

52 For which see n. 34 above.

53 He cites vol. III, fol. 70v, which is indeed animated, lively, and well drawn. Vol. I, fol. 170r, on the other hand, is far less well drawn, and the figures are dumpy and wooden. These two pages may be conveniently compared in Deremble, 'L'enluminure', pls 119–20.

54 The degree of special pleading involved is apparent in sentences such as, 'In the mid-eleventh century the monastery of Saint-André at Le Cateau-Cambrésis (near Cambrai, *again not far from the north east borders of Normandy*) [my italics] was producing illuminated manuscripts that have a far better claim than any Anglo-Saxon work to be regarded as stylistic antecedents of the Tapestry' (p. 52). Readers whose sense of geography is better developed than Professor Grape's will be aware that Bayeux is in western Normandy, some 320 km from Cambrai, as the crow flies. Moreover, anyone who has actually seen the 'Le Cateau' Gospels (Cambridge, Fitzwilliam Museum, McClean, 19), the example Grape cites, will be aware that it is a poor comparison for the style of the Bayeux Tapestry.

55 See F. Wormald, *English Drawings of the Tenth and Eleventh Centuries* (London, 1952), pp. 24–9. Further on mid-eleventh-century drawing styles see R. G. Gameson, 'English Manuscript Art in the Mid-Eleventh Century', *Antiquaries Journal* 71 (1991), 64–122, esp. 79–81.

Caligula Troper, 'St Wulfstan's Portiforium', and the Exeter Gospels.[56] Another good parallel is provided by the aforementioned Durham B. II. 16, produced at Saint Augustine's Abbey in the last third of the eleventh century.[57] Here one sees a combination of lively gestures and solid forms akin to the art of the Tapestry. The same features appear in English works of *c.* 1100 such as the Durham *Vita Cuthberti*[58] and the 'Lewes Group' of wall paintings in Sussex;[59] however by this time the forms have an additional solidity and the style has moved beyond the phase we see reflected in the Tapestry.

The sixth point concerns specific visual parallels between the art of the Tapestry and works of English origin or early provenance.[60] Some of these Grape simply ignores, others he tries to minimise. There are, for instance, the correspondences between details of daily life shown in the Old English Hexateuch on the one hand and the Tapestry on the other (pl. 5). Grape actually illustrates several of these correspondences but holds them to be of no particular significance for the origin of the work. One might perhaps argue that any eleventh-century work which illustrated daily life would show such connections, and in theory this is probably true; however since so very few surviving eleventh-century works do illustrate contemporary life, the relevance of the one highly unusual book that does so *in extenso* is all the greater.[61]

Then there are the pervasive jutting jaws, hunched shoulders and gesticulating, outstretched hands to be seen throughout the Tapestry. These are the hallmarks of the Utrecht Psalter derived style that was prominent in late Anglo-Saxon art, especially at Canterbury.[62] Though echoed in some Norman works dating from the end of the eleventh century, the mannerism was not as popular in Normandy as in England, and it had no demonstrable progeny in Bayeux. Of this Grape makes no

56 Respectively: London, British Library, Cotton Tiberius C. vi (Temple, *Anglo-Saxon Manuscripts*, cat. 98, ills 302–11); Cotton Caligula A. xiv (*Ibid.*, cat. 96, ills 293–5); Cambridge, Corpus Christi College, 391 (Wormald, *English Drawings*, cat. 11, pl. 39); and Paris, Bibliothèque nationale, lat. 14782 (Kauffmann, *Romanesque Manuscripts*, cat. 2, ills 3–6; also F. Avril and P. Stirnemann, *Manuscrits enluminés d'origine insulaire viie-xxe siècle* (Paris, 1987), no. 26, col. pl. C).

57 See n. 44 above. For a further illustration see Gameson, 'Mid-Eleventh Century', fig. 25.

58 See n. 45 above.

59 E. W. Tristram, *English Medieval Wall Painting: the Twelfth Century* (Oxford, 1944), pp. 113–15 and 128–33 with pls 28–44; D. Park, 'The "Lewes" Group of Wall Paintings in Sussex', *Anglo-Norman Studies* 6 (1984), 201–35, esp. 222–7 (for style).

60 Bernstein, *Mystery of the Bayeux Tapestry*, pp. 37–47, illustrates these fully.

61 Moreover, the few other examples are to be found in English and not Norman art, namely the calendar illustrations in London, British Library, Cotton Julius A. vi, and Tiberius B. v, both of possible Canterbury, Christ Church, origin: Temple, *Anglo-Saxon Manuscripts*, cats 62 and 87. The most famous examples in manuscripts produced in France date from the early twelfth century and are some of the initials in the copy of Gregory's *Moralia* produced at Cîteaux during the abbacy of the Englishman Stephen Harding (Dijon, Bibliothèque municipale, 168 + 169 + 170, and 173), which may in fact reflect English influence. See Y. Zaluska, *L'enluminure et le scriptorium de Cîteaux au XIIe siècle* (Cîteaux, 1989), cats 3 and 4; also C. T. Davidson, 'Sources for the Initials of the Cîteaux *Moralia in Job*', *Studies in Cistercian Art and Architecture* III, ed. M. P. Lillich (Kalamazoo, 1987), 46–68.

62 Wormald, *English Drawings, passim*; D. Tselos, 'English Manuscript Illumination and the Utrecht Psalter', *Art Bulletin* 41 (1959), 137–49; R. G. Gameson, 'Manuscript Art at Christ Church, Canterbury, in the Generation after St Dunstan' in N. Ramsay, M. Sparks and T. Tatton-Brown (eds), *St Dunstan: His Life, Times and Cult* (Woodbridge, 1992), 187–220 at 206–9.

mention. Nor can he counter the circumstance that good parallels for some of the architectural features are also found in English rather than Norman manuscripts.[63] Conversely, he points to the use of faces in profile in the Tapestry, citing it as a northern French characteristic. There are considerable difficulties here. The extent to which profile faces are utilised in the Tapestry is unusually great in the context of eleventh-century art as a whole. The main reasons for this have nothing to do with race, but are rather the lateral flow of the narrative, and the fact that it is easier to embroider profile faces than three-quarter ones. In point of fact the use of profile faces was increasing in England as much as in Normandy and France during the later eleventh century, and the feature cannot, therefore, be regarded as racially diagnostic. Furthermore, profile faces were considerably more prominent in English art of the first half of the eleventh century than Grape acknowledges.[64] Indeed, with supreme irony, the very example he uses to illustrate his contention that the motif is a northern French one is actually an Anglo-Saxon drawing.[65] Finally, there is the well-known specific parallel between the scene of Odo blessing the food (pl. 18) and the type of Last Supper depicted in the Gospel Book of St Augustine, a sixth-century Italian manuscript, traditionally associated with St Augustine of Canterbury, and certainly owned by Saint Augustine's Abbey in the eleventh century.[66] Wriggle and bluster as he does, Grape cannot escape from the fact that this is by far the best visual parallel for the scene. His riposte (p. 31) – that this rare type might have been more generally current than the evidence suggests, and that the designer cannot have known this very version because Christ has a chalice in front of him whereas Odo has a fish – rings hollow.

Grape's *modus operandi* is to draw upon European art as a whole between the tenth and the twelfth century to show that there are equally good, occasionally better, parallels for the art of the Bayeux Tapestry elsewhere than in England. The fact that he can do this is not surprising and it is certainly not significant. The existence of isolated parallels scattered across France, Germany, Scandinavia and Spain simply shows that the Tapestry fits into a general context of contemporary European art. It in no way counterbalances the fact that by far the greatest collocation of parallels and analogues is to be found in southern England. It is particularly difficult to understand how he can believe that drawing good stylistic parallels with northern

63 V. S. Mann, 'Architectural Conventions in the Bayeux Tapestry', *Marsyas* 17 (1974–5), 59–65.
64 As perusal of the plates in Temple, *Anglo-Saxon Manuscripts*, confirms.
65 Paris, Bibliothèque nationale, lat. 6401, fol. 5v: Temple, *Anglo-Saxon Manuscripts*, cat. 32; Avril and Stirnemann, *Manuscrits enluminés d'origine insulaire*, no. 19.
66 The scene is Wilson, *Bayeux Tapestry*, pl. 48. The manuscript is Cambridge, Corpus Christi College, 286, on which see F. Wormald, *The Miniatures in the Gospels of Saint Augustine* (Cambridge, 1954); repr. in his *Collected Writings I*, pp. 13–35. For discussion of the parallel between the Bayeux Tapestry and the scene of the Last Supper on fol. 125r see L. Loomis, 'The Table of the Last Supper in Religious and Secular Iconography', *Art Studies* 5 (1927), 71–90; and Brooks and Walker, 'Authority and Interpretation', pp. 14–17 (pp. 74–6 above). For discussion of possible correspondences between the Tapestry's depictions of warfare and those in Canterbury manuscripts (Christ Church and Saint Augustine's) see J. Kiff, 'Images of Warfare in early Eleventh-Century England', *Anglo-Norman Studies* 7 (1985), 177–94, esp. 191–4.

French and Flemish art (his largest concentration of material) can possibly prove that the Tapestry was made at Bayeux. In general, Norman material is conspicuous by its absence from his discussion; and this in itself makes a very strong counterpoint, demonstrating the lack of an artistic context for the work in Normandy. Grape usefully reminds us that the case for an English origin is merely a hypothesis, and that it has been used incautiously by some scholars. But he cannot point to any other single place where embroidery flourished, techniques of pictorial narrative throve, lively draughtsmanship was practised, the Utrecht Psalter and the St Augustine's Gospels were owned – not to mention where the Normans were in control.

There is, in fact, additional circumstantial evidence that the designer of the Bayeux Tapestry had strong English affiliations; or, to be more precise, that he had connections with Saint Augustine's Abbey, Canterbury.[67] Because of the Bayeux provenance of the Tapestry, because of the emphasis it places on the relics of Bayeux (pl. 10),[68] and because of the prominence it gives to Bishop Odo of Bayeux (pls 15, 18, 24), it is generally assumed that Odo, half-brother of William the Conqueror, was its patron. This hypothesis is strengthened by the circumstance that certainly two and possibly three of the very few minor characters who are named in the Tapestry – Wadard, Vital and Turold – can be documented as Odo's tenants.[69] Now as well as being the bishop of Bayeux, Odo was from 1066/7 until his downfall in 1082 the earl of Kent.[70] Thus if Odo were the patron (something which Grape does not doubt), the most obvious place for him to obtain an English designer would be Kent, and above all Canterbury, the principal town of his earldom and a major centre of art production. Circumstantially, therefore, Canterbury is a likely location for the commissioning and design of the Tapestry at least; and the nature and high quality of its surviving art is in accord with this.[71] Historical considerations suggest that Odo is far more likely to have approached Saint Augustine's Abbey, with which he enjoyed good relations, than Christ Church Cathedral, with which he was locked in dispute over land ownership. Odo is known to have been a benefactor of St Augustine's, and the community sought his advice on the translation of Abbot Hadrian's relics.[72] We also know, incidentally, that a Wadard held land from Saint Augustine's, an arrangement made in the time of Abbot Scotland.[73]

67 See further Brooks and Walker, 'Authority and Interpretation', pp. 13–18 (pp. 74–7 above).
68 Showing Harold swearing his oath on them (rather than at Bonneville or Rouen). See further n. 122 below. See D. Bates, *William the Conqueror* (London, 1989), p. 61, for an attempt to reconcile the conflicting traditions.
69 Fowke, *Bayeux Tapestry*, pp. 40–3 and 102–3; C. Prentout, 'Essai d'identification des personnages inconnus de la Tapisserie de Bayeux', *Revue Historique* 176 (1935), 14–23 (repr. as Ch. 4 above); W. Urry, 'The Normans in Canterbury', *Canterbury Archaeological Society Occasional Papers* 2 (1959), pp. 10–12; also Brooks and Walker, 'Authority and Interpretation', pp. 192–3, nn. 22–3 (pp. 68–9 above).
70 Further on Odo see D. Bates, 'The Character and Career of Odo, Bishop of Bayeux', *Speculum* 50 (1975), 1–20.
71 As Wormald, 'Style and Design', p. 34, concluded.
72 Bates, 'Odo', pp. 9–10; D. Bates, 'The Land Pleas of William I's Reign: Penenden Heath Revisited', *Bulletin of the Institute of Historical Research* 51 (1978), 1–19; also Brooks and Walker, 'Authority and Interpretation', p. 17 (p. 69, n. 22 above).
73 Urry, 'Normans in Canterbury', pp. 11–12.

Yet further evidence can be adduced in favour of the designer of the Tapestry having had a connection with Saint Augustine's Abbey. Saint Augustine's was one of the very few centres in England to maintain the production of significant numbers of high-grade books, along with a flourishing tradition of decorating them, during the last third of the eleventh century.[74] Some of these volumes include pictorial imagery, among which we find interesting parallels for the art of the Bayeux Tapestry. Its figure style is matched in Durham B. II. 16, as we have seen; its images of kingship are echoed in the depiction of King Æthelberht enthroned in British Library, Cotton Vespasian B. xx;[75] while an interest in pictorial narrative re-emerges in some of the initials of British Library, Arundel 91, the one surviving unmutilated volume of a seven-volume passional set.[76] Now, we alluded earlier to the fact that there was one centre in Normandy which had a fairly flourishing artistic tradition in the earlier eleventh century, namely Mont Saint-Michel. It just so happens that the first Norman abbot of Saint Augustine's, a certain Scotland (Scollandus), had come from Mont Saint-Michel, where, incidentally, we know he had worked as a scribe.[77] He was abbot between 1072–87, and, unlike his successor, he does not appear to have sparked off dramatic resentment among the community. It seems likely that the presence of an abbot from the most decoratively active Norman scriptorium contributed to the continuing tradition of fine book production and decoration at Saint Augustine's during this period. Thus in addition to possessing the St Augustine's Gospels and the Old English Hexateuch, Saint Augustine's Abbey in the 1070s and 80s was where the best and most vigorous English and Norman artistic traditions met. Moreover, with its Norman abbot it would have been approachable as well as geographically convenient for Bishop Odo, earl of Kent. Could this be one of the reasons, one wonders, why the Bayeux Tapestry actually depicts and stresses Mont Saint-Michel itself, with the designer apparently showing some knowlege of its eleventh-century architecture (pl. 8)?[78]

There might seem to be a problem here. It is quite clear that the designer of the Tapestry knew the world around him very well: countless details, not least the

74 See R. G. Gameson, 'English Manuscript Art in the late Eleventh Century: Canterbury and its Context' in R. Eales and R. Sharpe (eds), *Canterbury and the Norman Conquest* (London, 1995), 95–145. Further on these books see the fundamental account of C. R. Dodwell, *The Canterbury School of Illumination* (Cambridge, 1954), esp. pp. 6–32.

75 A collection based around Goscelin's *Vitae sanctorum*. Gameson, 'Late Eleventh Century', pl. 11.

76 See n. 46 above.

77 Alexander, *Mont Saint-Michel*, pp. 17–18.

78 Wilson, *Bayeux Tapestry*, pl. 19. It is emphasised by the inscription: 'Hic Willelm dux et exercitus eius venerunt ad montem Michaelis'. For comparison with the eleventh-century architecture see Alexander, *Mont Saint-Michel*, pp. 16–17. The depiction of Mont Saint-Michel underlines the fact that William is leaving Normandy for Brittany; however this is unlikely to have been the main reason for its inclusion, since the river Couesnon in the very next scene conveys the same point quite clearly. It might also perhaps allude to the piety of the Normans, a point elaborated by S. Bertrand, 'Le Mont-Saint-Michel et la Tapisserie de Bayeux' in *La Normandie bénédictine au temps de Guillaume le Conquérant* (Lille, 1967), 137–40; cf. also her *Tapisserie de Bayeux*, p. 87. Fowke, *Bayeux Tapestry*, pp. 58–9, points to a further connection with Odo, whose re-founded monastery of Saint-Vigor in Bayeux received personnel from Mont Saint-Michel (cf. Alexander, *Mont Saint-Michel*, pp. 12–13).

depictions of combat, attest to the fact. Is this compatible with the hypothesised connection with Saint Augustine's Abbey? The answer must be: yes. The aforementioned Old English Hexateuch suggests that an artist who knew and could evoke the world had been active there before the Conquest. We know that some monks travelled (sometimes extensively) and interacted with the world at large. Nor was every monk a child oblate: in fact the number of adult recruits may have risen sharply in the wake of the Conquest. Moreover by no means everyone associated with Saint Augustine's was a professed monastic.[79] Indeed it is eminently likely that some Saint Augustine's artwork of the early post Conquest period, particularly stone sculpture but possibly also manuscript decoration, came from the hands of hired professionals – we have documentary references to paid 'professional' scribes working for Abingdon and Saint Albans around this time.[80]

The final point I wish to make on the subject of the origin of the Tapestry is more general and harks back to the comments at the beginning of this section. Because of Grape's assertion that the Tapestry was made in Normandy, my discussion has focused on its English elements and dimension. It is all the more important, therefore, to stress here that the only meaningful term that can be used to describe its origin is Anglo-Norman. The likelihood that the embroidery was done by English hands, and the probability that the designer had connections with Saint Augustine's, Canterbury, does not make the Tapestry an English work. Nationalistic traditions of historiography have polarised the issue: is it an English work *or* a Norman one? Common sense should make us see that the distinction is artificial. England and English artists had been interacting with France, Flanders and Normandy throughout the eleventh century, processes which intensified during the reign of Edward the Confessor. The first generation of manuscripts produced in England after the Conquest shows the participation of both Norman and Anglo-Saxon hands, and reveals the intertwining of Norman and Anglo-Saxon approaches to texts and their presentation.[81] Contemporary sculpture, such as survives, shows similar themes. The background for the Bayeux Tapestry is self-evidently Anglo-Norman: its patron was undoubtedly Norman; its embroiderers were probably English; its inscriptions include both Anglo-Saxon and French usages;[82] and its designer was arguably an Englishman familiar with a context where the best of Anglo-Saxon and Norman pictorial art met. The Bayeux Tapestry is the first major monument of Anglo-

79 See, e.g., Urry, 'Normans in Canterbury', pp. 2–3.
80 Thomas Walsingham, *Gesta Abbatum Monasterii Sancti Albani*, ed. H. T. Riley, 3 vols, Rolls Series (London, 1867–9), I, 57–8; *Chronicon Monasterii de Abingdon*, ed. J. Stevenson, 2 vols, Rolls Series (London, 1858), II, 289.
81 See further Gameson, 'Late Eleventh Century'; also R. M. Thomson, 'The Norman Conquest and English Libraries' in *The Role of the Book in Medieval Culture*, ed. P. Ganz, 2 vols, Bibliologia 3–4 (Turnhout, 1986), II, 27–40.
82 Lepelley, 'Contribution à l'étude des inscriptions', concludes: 'Bien qu'écrites en latin, elles nous permettent en effet de déceler les premiers résultats de l'interpénétration de deux langues: le français et l'anglais. Aussi pouvons-nous affirmer qu'elles constituent le premier monument écrit de la civilisation anglo-normande ou, pour employer une expression plus juste, de la civilisation anglo-française' (translated at p. 45 above).

Norman culture; its magnificence provides an excellent foretaste of the fruitfulness of that union.

Sacred and Secular

My next subject is sacred and secular in the Tapestry. Not only is this a theme of central importance for understanding the work itself, it also has a bearing on the thorny issue of where it might have been displayed.

It has long been debated whether the Tapestry was designed to be hung in a hall or a church, and part of the argument against the latter setting is the 'secular' nature of the imagery.[83] This, however, is a deeply flawed line of reasoning, which rests on an anachronistic and oversharp division between the sacred and the secular. We know that lay society commissioned and owned religious art as a matter of course, and equally that religious foundations possessed overtly secular art. This was true of hangings as much as anything else. The *uelum* showing Ealdorman Byrhtnoth's deeds that his widow presented to the abbey of Ely, for instance, is likely to have depicted some secular actions;[84] and we are specifically told that the church of Marienburg possessed a textile on which were displayed 'certain deeds, concerns, and secular labours' of the founders, Udalric and Uta.[85] Above all, it is a moot point how secular the Bayeux Tapestry is.

Before, however, I offer my thoughts on its secular nature or otherwise, let us consider a little further the question of where the Tapestry may have been hung. The key point here, it seems to me, is that although the Tapestry may have been designed with one particular context in mind, and while it is undoubtedly bulky, it is nevertheless a transportable artefact rather than a permanent fixture.[86] The earliest known documentary reference to the work underlines the point: the 1476 inventory of the treasures of Bayeux Cathedral (item 262) records that the Tapestry was displayed annually around the nave of Bayeux Cathedral during the feast and octave of the relics.[87] How far back this practice extended is unknown. Nevertheless, I very much doubt that the Tapestry was ever intended to hang *ad infinitum* in a single place – if such had been the intention, a mural painting could have done the job more

83 C. R. Dodwell, 'The Bayeux Tapestry and the French Secular Epic', *Burlington Magazine* 108 (1966), 549–60 (repr. as Ch. 7 above), is an influential exponent of the secular nature of the Tapestry and hence by extension of a secular setting for it. The view is developed in his *The Pictorial Arts of the West 800–1200* (New Haven and London, 1993), pp. 11–14. It was followed, for example, by Gibbs-Smith, *Bayeux Tapestry*, pp. 3–5; and R. Brilliant, 'The Bayeux Tapestry: a stripped narrative for their eyes and ears', *Word and Image* 7 (1991), 98–125 (repr. as Ch. 10 above). For a useful practical discussion see Bernstein, *Mystery of the Bayeux Tapestry*, pp. 104–7.
84 See n. 23 above.
85 'Aliud velum de quibusdam curis ac laboribus secularibus post se reliquerunt': *Chronicon Marienbergense auctore Goswino*, ed. B. Schwitzer in *Tiroler Geschichtsquellen* II (Innsbruck, 1880), p. 62.
86 Cf. Parisse, *Bayeux Tapestry*, pp. 50–1. Grape, *Bayeux Tapestry*, pp. 77–80, is a balanced discussion.
87 Bayeux, Bibliothèque du Chapitre, MS 199 [deposited in Caen], fols 71–93. Facsimile: Bertrand, *Tapisserie de Bayeux*, p. 19; cf. E. Deslandes, 'Le Trésor de l'église Notre-Dame de Bayeux d'après les inventaires manuscrits de 1476, 1480, 1498 conservés à la bibliothèque du chapitre de Bayeux', *Bulletin archéologique du comité des travaux historiques et scientifiques* 1896, 340–450, esp. 356–8 and 394.

effectively. Correspondingly, I see no reason why it could not have been displayed in several locations during its early history. If the arguments about its manufacture presented above are correct, then the Tapestry probably crossed the Channel soon after it was made; and it is difficult to believe that it was not shown somewhere in southern England before it left for Normandy. I am also of the opinion that the work is wholly appropriate for a sacred as well as a secular setting – my reasons will unfold in due course – and that it could have been hung in both at different times.

As we have no evidence concerning how the Tapestry was hung in the eleventh century – be it in cathedral, hall, or both – specific comment on its arrangement is of little value. Nevertheless, five points of a general nature can usefully be made. First, the remarkably good, surprisingly unfaded condition of the artefact suggests that it was never on display for a prolonged period, and certainly not in a bright environment. In the fifteenth century it seems to have been kept in store, except for the period in June when it was on display. Secondly, assuming that the inscriptions were meant to be read, it is unlikely to have been suspended much above head height. Thirdly, given that it was not a permanent fixture, hanging it sufficiently low that it could easily be seen would have constituted only a minor, temporary inconvenience at worst. The comment that the Tapestry looks out of place arranged around the nave of the present cathedral[88] misses the point (irrespective of the fact that the present nave is not Odo's, not to mention the possibility that it might have been hung around the side walls and the apse). When the Tapestry was on display, that was what the beholder was meant to see. Whether or not it was an effective accessory to the architecture was definitely of subsidiary importance. Fourthly, although the interior of the building or buildings in question are likely to have been dark (another unconvincing point that is sometimes raised against display in the cathedral), the work itself is bright with clear contrasts. Once the eye had adjusted to the general light level, there is every reason to believe that the bold images and words, sharply silhouetted against a pale ground, would have been legible. One might even hypothesise a guided tour by candle light – the additional illumination from an upraised candelabra serving very effectively to focus the beholder's attention on one scene after another. Fifthly, though specific information is lacking, we can be confident that the arrangement of the Tapestry when it was hung will have influenced the beholder's perception of the depicted story.[89] Events that appeared immediately after a change in the direction of the strip, or against a different background space, will have been subtly emphasised. More speculatively, great resonance could have been given to a few scenes by a particular physical setting – for instance, if the oath swearing scene was positioned near to an altar or reliquary in the cathedral; or if a depiction of Odo appeared close to the area that the real Odo regularly occupied in his cathedral or hall.

88 See Bernstein, *Mystery of the Bayeux Tapestry*, ill. 62 for a photograph of one such arrangement – in which, however, the Tapestry is hung too high.
89 Some of the ramifications of this are explored by Brilliant, 'The Bayeux Tapestry: a stripped narrative' (Ch. 10 above). See also the interesting but unprovable suggestion of A. M. Cetto, *The Bayeux Tapestry* (Berne, 1970), pp. 7–8.

So what sort of story is depicted here: sacred or secular? At one level the answer is obvious – a secular tale. The Tapestry does, after all, recount the events leading up to, and including the Norman Conquest of England. Comparison is sometimes made with works of literature such as the Old French *Chanson de Roland*[90] and the fragmentary Old English *Battle of Maldon*[91] to underline its secular tone and artistry. The comparisons are fair enough, and I would not wish to deny that they provide helpful parallels. But are *Roland* and *Maldon* purely secular stories? The answer, of course, is that they are not: *Maldon* is implicitly religious and *Roland* overtly so.

In reality it is quite clear that the answer to my question about the nature of the story is not obvious, at least to modern eyes. We invariably see events as just that – things that have happened. Our eleventh-century predecessors, by contrast, saw earthly events as the unfolding of a divine plan under the guidance of the Deity. The Bayeux Tapestry is a visual rendition of what happened in Normandy, Brittany and England between 1064–6 – the deeds of certain individuals, how they lived, and in some cases how they died – but the eleventh-century beholder, we can be quite confident, will have seen God's hand pervading it all. There are, to be sure, points when man's interaction with the Divine is especially signalled – Harold going to Bosham church, for example (pl. 2), the swearing of the oath at Bayeux (pl. 10), the completing of Westminster Abbey (under the hand of God), Odo blessing the food (pl. 18)[92] – but God's implicit involvement in the rest of the events is none the less for that.

Odo of Bayeux is the most overtly religious character among the main protagonists. Understanding the way he is depicted is thus crucial if we are to comprehend the interrelation of sacred and secular in the Tapestry as a whole.

We see Odo four times.[93] The first time he appears he is seated beside his half-brother William in the latter's castle after news has reached Normandy that Harold has been crowned King of England (pl. 15).[94] At this point, we are told by the inscription, 'Here Duke William ordered ships to be built',[95] and Odo is shown to be intimately involved in this decision, seemingly playing a decisive role. Whereas William of Poitiers claims that William took counsel with his magnates, bishops and abbots,[96] here Odo alone is the counsellor. He next appears after the Normans have invaded England. They are cooking and eating, and Odo presides over their meal, blessing the food (pl. 18).[97] 'And here the bishop blesses the food', declares the inscription;[98] and any shadow of doubt concerning the identity of the said bishop[99]

90 *La Chanson de Roland*, ed. F. Whitehead (Oxford, 1942).
91 *The Battle of Maldon*, ed. D. Scragg (Manchester, 1981).
92 Wilson, *Bayeux Tapestry*, pls 3, 25–6, 29, 48.
93 The visual language of the four scenes is examined by Bernstein, *Mystery of the Bayeux Tapestry*, pp. 136–43.
94 Wilson, *Bayeux Tapestry*, pls 34–5.
95 'Hic Willelm dux iussit naves edificare'.
96 William of Poitiers, *Gesta Guillelmi*, ed. Foreville, II, 1 (p. 148).
97 Wilson, *Bayeux Tapestry*, pl. 48.
98 'Et hic episcopus cibu[m] et potu[m] benedicit'.
99 Bishop Geoffrey of Coutances was also with the Norman force, according to William of Poitiers.

is removed by his table companion who points (for the beholder's benefit) to the inscription *Odo episcopus* written over the very next scene. Odo's third appearance follows immediately afterwards.[100] He is seated under the afore-mentioned inscription, participating with William and Robert in a council of war (pl. 18). Significantly, it is patently Odo who is advising William, while Robert looks on. William of Poitiers celebrated Odo's role as a counsellor, saying that he struck fear into the hearts of warriors 'for he helped in war with invaluable counsel when necessity required, in so far as he could while keeping his religion intact'.[101] Fourth and finally, we see Odo in the thick of the fighting at Hastings (pl. 24). He is now clad in armour and a distinctive tunic, mounted on a black charger, and brandishing a *baculum*. This is the turning point in the battle, leading to the Norman victory, and the inscription informs us: 'Here bishop Odo, holding his staff, rallies the lads'.[102] No other source for the battle specifies that the bishop played such a role. Odo may have appeared again in the end section of the Tapestry, but as this is lost, that is all we can say on the subject.

Odo is probably the most famous early medieval careerist cleric who is known to have participated in war, and his life was particularly turbulent. He was intimately involved in the Conquest of England, and as early as 1067 he ruled the new kingdom while William was in Normandy.[103] He became (in the words of the *Anglo-Saxon Chronicle* (E)) 'the foremost man after the King, and he had an earldom in England'.[104] He was the wealthiest of the Norman tenants-in-chief, and he led a ruthless campaign in the north of England in 1080.[105] Then in 1082 William had him arrested – exactly why is uncertain, though reputedly because he was aspiring to the papacy and removing knights from England to pursue this aim.[106] On William's death in 1087, he was freed; but the following year he was a prime mover in the unsuccessful revolt against William Rufus, as a result of which he lost his lands in England and retreated to Normandy. These are stirring events; yet they are only part of the story. Odo was also an energetic supporter and builder of the church at Bayeux, where he had a good reputation, a point echoed in William of Poitiers' eulogy of him: 'first and foremost, the church of Bayeux attests to his goodness and prudence, for with great

100 Wilson, *Bayeux Tapestry*, pl. 48.
101 William of Poitiers, *Gesta Guillelmi*, ed. Foreville, II, 37 (p. 242): 'Bellum namque utilissimo consilio, cum necessitas postularet, juvabat, quantum potuit religione salva'.
102 Wilson, *Bayeux Tapestry*, pl. 67. 'Hic Odo episcopus baculum tenens confortat pueros'. For comment on *pueros* see Fowke, *Bayeux Tapestry*, p. 128. Note, however, that the entirety of *pueros*, along with the *tat* of *confortat* is restoration.
103 *Anglo-Saxon Chronicle* (D) *sub anno* 1066: *English Historical Documents II: 1042–1189*, ed. D. C. Douglas and G. Greenaway 2nd ed. (London, 1981), p. 150: 'And Bishop Odo and Earl William [fitzOsbern] stayed behind and built castles far and wide throughout this country and distressed the wretched folk...'. See further D. Bates, 'The Origins of the Justiciarship', *Anglo-Norman Studies* 4 (1982), 1–12 and 167–71, esp. 2–5.
104 *Sub anno* 1087 (*recte* 1086): *Two Saxon Chronicles Parallel*, ed. J. Earle and C. Plummer, 2 vols (Oxford, 1892), I, p. 220; *English Historical Documents II*, ed. Douglas and Greenaway, pp. 170–1.
105 Symeon of Durham, *Historia Dunelmensis ecclesiae*: Durham University Library, Cosin V. ii. 6, fol. 77r.
106 For modern comment see Bates, *William the Conqueror*, pp. 168–9.

effort he set it in outstanding order and embellished it'.[107] He also encouraged and sponsored the education of young clerics,[108] and (re)founded at Bayeux the monastery of Saint-Vigor.[109] In England Odo was a benefactor of Saint Augustine's, Canterbury, Saint Albans, and Rochester; and when he died in Palermo in 1097 he was on his way to the First Crusade. The parameters of his life were far from being unique in his time, and we should be careful not to judge him by modern standards. The days of such churchmen may have been in some sense numbered with the advent of the Gregorian reform in the late eleventh century, but they had by no means passed in 1066. More particularly, nothing he is shown doing in the Bayeux Tapestry is inconsistent with the dictates of eleventh-century Christianity; and it is important to understand the spirituality that is thereby represented.

Before proceeding further, we should make a fundamental point about the depiction of Odo in the Tapestry. Whether or not the real life Odo was its patron, his fictive counterpart was still subordinate to the subject and flow of the work as a whole. The Bayeux Tapestry is about the Norman Conquest; it focuses on essentials, and achieves its effect by the relentless pace of its narrative. We should not expect to find it spending valuable space and time on irrelevant, unexciting matters like Odo performing routine episcopal duties – any more than does William of Poitiers in his fulsome but carefully crafted literary account of the same events. This does not mean that Odo did not perform them.

Within this closely defined framework, Odo's depicted actions are quite appropriate for a high-ranking churchman in the mid-eleventh century. He blesses the food (pl. 18): even when the Normans are on campaign, they have their chaplain with them and they observe fundamental religious rites. He provides counsel for his duke, both in Normandy and in England (pl. 15), as did countless other early medieval ecclesiastics as a matter of course. His tonsure clearly marks him out as a churchman in these scenes, and on the latter occasion it is immediately noticeable that while William and Robert have swords, Odo does not (pl. 18). He rides into battle and rallies youthful Norman troops with his *baculum* (pl. 24). This exciting scene has repeatedly attracted attention, but not always for the right reasons. We should notice it because it is a key moment in the story, because our attention is drawn to it by an inscription, and because Odo is distinguished visually from all the other figures. We ought not to notice it because we are surprised by what we see. It is worth stressing that, despite the carnage and slaughter all around, Odo is not actually shown fighting here. Image and inscription underline the fact that his role is hortatory rather

107 William of Poitiers, *Gesta Guillelmi*, ed. Foreville, II, 37 (p. 240): 'Bonitatem eius et prudentiam primo testatur ecclesia Baiocensis, quam ipse multo studio egregie ordinavit atque ornavit'. Further on Odo in the context of the Norman Church see D. C. Douglas, *William the Conqueror* (London, 1964), 105–32, the positive side of Odo as a churchman being summarised at 129–30.
108 Orderic Vitalis, *Historia ecclesiastica*, ed. M. Chibnall, 6 vols (Oxford, 1968–80), vol. 4, pp. 114–19. It will be noted that he sent them to locations where he knew *philosophorum studia* to be pursued.
109 It survived as a priory of Saint-Bénigne, Dijon.

than combative – though it is none the less decisive for that. This depiction does not necessarily contradict William of Poitiers' claim that Odo never took up arms.[110]

In fact, many high ranking churchmen in the early middle ages had important military responsibilities, and some took to the field personally. The biographer of Archbishop Bruno of Cologne (953–65), the brother of Otto I of Germany, for instance, observed that he had seen Bruno and his archiepiscopal counterparts at Trier and Mainz not only in study and discussion, but also in the line of battle;[111] while in 1074 with the help of his rural vassals Archbishop Anno of Cologne brutally crushed the rebellion that had temporarily ousted him from his city.[112] Although particularly pronounced in Germany, the phenomenon was fairly widespread. The *Anglo-Saxon Chronicle* (C and D) for 1056 records that the newly elected bishop of Hereford, Leofgar, 'gave up his chrism and his cross, his spiritual weapons, and took his spear and his sword after his consecration as bishop, and so went campaigning against Griffith the Welsh King.'[113] Abbot Leofric of Peterborough was present at Hastings itself on the Anglo-Saxon side,[114] while Bishop Geoffrey of Coutances was with the Norman force. After the Conquest Geoffrey, like Odo, was rewarded with a lordship, and he seems to have had considerable military responsibilities. In 1069 he led a force against Anglo-Saxon rebels in the West Country, and a couple of years later we find him combatting a rebellion in East Anglia. Orderic Vitalis commented that Geoffrey was more skilful in arms than Psalms![115]

Such practices were current at the very top of the ecclesiastical hierarchy: in 1053, not receiving help from Henry III of Germany, the reforming pope Leo IX (1049–54) led a disastrous military campaign against the Normans in southern Italy. And there were even more venerable precedents. The *Miracula Sancti Benedicti* compiled at Fleury, for example, recount how in the ninth century Duke Hugh saved the community from the raiding Norsemen, and after the battle told the monks, 'St Benedict protected me throughout the whole battle, for he held the reins of my

110 William of Poitiers, *Gesta Guillelmi*, II, 37 (pp. 240–2). The text was written before Odo's campaign of 1080. See further M. D. Legge, 'Bishop Odo in the Bayeux Tapestry', *Medium Ævum* 56 (1987), 84–5.

111 Ruotger, *Vita Brunonis archiepiscopi coloniensis*, ed. I. Ott, MGH Scriptores rerum Germanicarum in usum scholarum (Cologne, 1958), ch. 37, ll. 7–8 (p. 39).

112 *Lamperti monachi Hersfeldensis Opera*, ed. O. Holder-Egger, MGH, Script. rer. Germ. in usum scholarum (Hanover, 1894), pp. 190–1. Further on German ecclesiastics in war see L. Auer, 'Der Kriegsdienst der Klerus unter den sächsischen Kaisern', *Mitteilungen des Instituts für österreichische Geschichtsforschung* 79 (1971), 316–407 and 80 (1972), 48–70.

113 *English Historical Documents II*, ed. Douglas and Greenaway, pp. 135–6. He was killed. We may also note the amount of war-gear that featured in the will of Ælfwold, bishop of Crediton (997–1016): *English Historical Documents I*, ed. D. Whitelock, 2nd ed. (London, 1979), no. 122.

114 *Anglo-Saxon Chronicle* (E) *sub anno* 1066: *ibid.*, p. 146; *Two Saxon Chronicles Parallel*, ed. Earle and Plummer, I, p. 198.

115 Orderic Vitalis, *Historia ecclesiastica*, ed. Chibnall, vol. 4, p. 278. Further on Geoffrey see J. le Patourel, 'Geoffrey of Montbray, bishop of Coutances 1049–1093', *English Historical Review* 59 (1944), 129–61; and M. Chibnall, 'La carrière de Geoffrey de Montbray', *Les évêques normands du xie siècle*, ed. P. Bouet and F. Neveux (Caen, 1995), 279–93. For observations on Orderic's depictions of bishops in general see P. Bouet, 'L'image des évêques normands dans l'oeuvre d'Orderic Vital', *ibid.*, 253–75.

horse in his left hand, and holding a *baculum* in his right, he sent many of the enemy falling to their death'.[116] Other tales from the same source recount St Benedict's miraculous appearances to individuals who had offended him or his community: he struck the reprobates with his *baculum*, leading inevitably to their demise.[117]

Although the eleventh century saw increasing debate in ecclesiastical circles about the rights and wrongs of such matters,[118] no clear consensus emerged and such examples could easily be multiplied. Plentiful sources indicate how vindictive saints could be in the interests of their foundation; and the eleventh and twelfth centuries in particular saw a growth in the production of *libelli* (with and without illustrations) that pressed this point home.[119] Moreover during the same period, the swashbuckling cleric was immortalised and apotheosised in literature in the *Chanson de Roland*. Archbishop Turpin is depicted as a stalwart warrior, exhorting the French to battle at Roncevaux, and dispatching numerous pagans to their doom (more than a thousand claims the poet). His military exploits are celebrated as an essential part of his Christianity alongside shriving the French, praying, and preaching: 'Turpin is dead, the warrior of Charles / in great battles and excellent sermons he was always a champion against the pagans'.[120] This is all highly relevant to Odo and the Bayeux Tapestry. These are outward manifestations of the fundamental truth that is at stake here. The saint and the good churchman had to combine holiness with vigour and political acumen, and sometimes also with martial valour. Saint and churchman alike were expected to defend the interests of their church or community in the world. Hence William of Poitiers could praise Odo by stating that he excelled in both ecclesiastical and secular matters.[121] An unstated but fundamental tenet of this Christian society was that God helps those who help themselves.

In blessing the food, counselling his brother, and rallying the lads, Odo was not merely a churchman of his time, he was a model muscular Christian. Destroying one's enemy when they had broken faith with the church was arguably a Christian's duty. The Bayeux Tapestry leaves little doubt that Harold had broken an oath.

116 *Miracula Sancti Benedicti*, I, 41: *Les Miracles de Saint Benoît écrits par Adrevald, Aimo, Raoul Tortaire et Hugues de Sainte Marie, moines de Fleury*, ed. E. de Certain (Paris, 1858), pp. 86–9.

117 E.g. *ibid.*, I, 18 (pp. 42–6) and II, 7 (pp. 107–9).

118 See, e.g., H. E. J. Cowdrey, 'The Peace and Truce of God in the Eleventh Century', *Past and Present* 46 (1970), 42–67, repr. in his *Popes, Monks and Crusaders* (London, 1984), as no. VII; M. de Bouard, 'Sur les origines de la Trève de Dieu en Normandie', *Annales de Normandie* 9 (1959), 169–89; and T. Head and R. Landes (eds), *The Peace of God: social violence and religious responses in France around the year 1000* (Ithaca, 1992).

119 E.g. the illustrated Life and Miracles of St Edmund, New York, Pierpont Morgan Library, M 736: Kauffmann, *Romanesque Manuscripts*, cat. 34; B. Abou-el-Haj, 'Bury St Edmunds Abbey between 1070 and 1124: a history of property, privilege and monastic art production', *Art History* 6 (1983), 1–29.

120 *La Chanson de Roland*, ed. Whitehead, ll. 2242–4: 'Morz est Turpin, le guerrier Charlun / Par granz batailles e par mult bels sermons / cuntre paiens fut tuz tens campiuns'.

121 William of Poitiers, *Gesta Guillelmi*, ed. Foreville, II, 37 (p. 240): 'Odo ille, Baiocarum praesul, cognitus fuerat talis qui optime negotia sustinere valeret ecclesiastica et secularia.' Orderic Vitalis makes similar observations, but more critically: e.g. *Historia ecclesiastica*, ed. Chibnall, II, p. 264, 'sed plus mundanis inhaerebat actionibus quam spiritualis theoriae charismatibus'.

Furthermore, as it implies that the oath was sworn at Bayeux (pl. 10), it underlines Odo's right to be actively involved in Harold's come-uppance, championing and upholding the relics of his foundation.[122] The idealistic and aggressive Pope Gregory VII (1073–85), for all that he strove to outlaw churchmen like Odo, believed intensely in this brand of Christianity. Hence why, when the German Emperor Henry IV had offended Holy Church, he declared him deposed and incited his subjects to rebellion. The philosophy was to flourish most spectacularly at the end of the century with the launching of the First Crusade, spurred on by Pope Urban II (1088–99) and under the leadership of his legate, Bishop Adhemar of Le Puy.[123] The Investiture Contest and the First Crusade make abundantly clear how inextricably interwoven secular and sacred were in the eleventh century. Sacrality did not stop at the edge of the battle field: it continued right on to it. This is a crucial point for understanding the over-arching message of the Bayeux Tapestry, and it is something to which we shall return.

The Inscriptions

Let us now turn to the inscriptions.[124] We shall consider their form, language and, above all, their functions. An elementary point to make first of all, however, is that inscriptions were widespread in the pictorial arts of the period, on textiles as much

122 Wilson, *Bayeux Tapestry*, pls 25–6. I do not share the doubts of Parisse, *Bayeux Tapestry*, pp. 51–2 and 138 on the location (see also Cowdrey, 'Towards an Interpretation of the Bayeux Tapestry', p. 50 with n. 4 (p. 94 above)). True, it is not categorically stated that the oath is sworn at Bayeux, but this is surely the implication. We learn that William came to Bayeux, and immediately afterwards see the oath-swearing with the inscription, 'Ubi Harold sacramentum fecit Willelmo duci'. While it is just conceivable that this refers to a separate incident, the logical reading is that Bayeux, the aforementioned location, is *where* Harold swore the oath. No other place is specified. Moreover, the disposition of the words strongly favours this reading. The 'Bagias' at the end of the previous text is physically very close to the 'Ubi' of the next one, and the eye automatically takes them together: '... Bayeux where Harold swore an oath to William'. The two words flank the one town, their physical proximity underlining their common geographical point of reference. It may be added that the undulating groundline here does not indicate an outside setting (the same groundline is used inside William's hall: Wilson, *Bayeux Tapestry*, pls 34–5), any more than the smooth groundline below the knights who are assaulting Rennes (*ibid.*, pls 21–2) implies that that is an interior scene. Nor is the fact that the next scene is Harold embarking for England any argument against Bayeux being the setting for the oath: this simply reflects the fact that, after the oath, the next important event in this story is Harold's return to England.
123 For modern debate on the attitudes to violence that underlay the Crusade see F. H. Russell, *The Just War in the Middle Ages* (Cambridge, 1975), pp. 16–39; H. E. J. Cowdrey, 'The Genesis of the Crusades: the Springs of Western Ideas of the Holy War' and 'Cluny and the First Crusade' both repr. in his *Popes, Monks and Crusaders*, as nos XIII and XV; also the revisionist J. Gilchrist, 'The Erdmann Thesis and Canon Law 1083–1141', *Crusade and Settlement*, ed. P. W. Edbury (Cardiff, 1985).
124 They are conveniently assembled with a brief introduction by F. Wormald, 'The Inscriptions' in Stenton (ed.), *Bayeux Tapestry*, 189–92; and with facsimiles in Bertrand, *Tapisserie de Bayeux*, pp. 74–115.

as elsewhere,[125] and it would have been surprising, therefore, if they had *not* been used on the Bayeux Tapestry.

Palaeographically, the alphabet of the Bayeux Tapestry is characterised by the co-existence and alternation of Uncial-based letter forms and Square Capital ones. Thus sometimes Square Capital **H** is used, at other times the Uncial form; sometimes square **E**, other times rounded. Exceptions to such variation are the letters **A** and **V** which are always square, and **C**, **G**, and **S** which are always rounded. Overall the letters are characterised by their thin, spare style, their tendency to rectilinearity, and by the use of small, thin serifs to terminate most strokes. **O** is often smaller than the other letters. **W** is generally represented by two separate **vs** (**VV**: pls 1, 3–7, 10, 11), though occasionally a digraph of two intersecting **vs** is used (pls 15, 18). **Y** is invariably dotted. Up to the scene of the Normans feasting (pl. 18), the inscriptions are entirely in a very dark colour (dark green or black-brown). Thereafter different colours are used, changing from one word to another, and sometimes even from one letter to the next.[126] It is unlikely to be coincidence that the change from monochrome to polychrome happens exactly at the junction between two separate sections of the embroidery (the fourth and fifth).[127]

Words are sometimes split, contracted or suspended in response to the restrictions of the available space,[128] and from time to time individual letters or words shrink in size for the same reason.[129] Similarly, in the last third of the work, the final **NT**s of third person plural verbs are occasionally conflated into digraphs.[130] The great majority of the texts, however, are written out clearly in full. The end of some of the

125 The probably twelfth-century Gerona Creation embroidery, for example, bears both tituli and extended biblical quotations, which were clearly an integral part of the design: P. de Palol and M. Hirmer, *Early Medieval Art in Spain* (London, 1967), pls. XXXV–VI and 132–3. The written accounts of the hangings at Minden (presented in 1158) and Augsburg recorded their inscriptions: *Schriftquellen … Deutschland*, ed. Lehmann-Brockhaus, nos 2605 and 2580. The fictive hanging which depicted the Norman Conqeust that was described by Baudri de Bourgueil (d. 1130) in a poem addressed to Adèle, countess of Blois and daughter of William the Conqueror, included inscriptions: 'Littera signabat sic res et quasque figuras / ut quisquis uideat, si sapit, ipsa legit' (Baldricus Burgulianus, *Carmina*, ed. K. Hilbert (Heidelberg, 1979), p. 164 (vv. 565–6)). Further on the relationship of this poem to the Bayeux Tapestry itself see S. A. Brown and M. W. Herren, 'The *Adelae Comitissae* of Baudri of Bourgueil and the Bayeux Tapestry', *Anglo-Norman Studies* 16 (1994), 55–74 (repr. as Ch. 11 above). For a convenient overview of the extant textile material to *c.* 1200 see Dodwell, *Pictorial Arts of the West*, pp. 11–31.
126 Cf. Wilson, *Bayeux Tapestry*, pls 1–46; and 48 ff.
127 Clearly visible on *ibid.*, pl. 47. One wonders whether the red-brown 'ministri', at the very end of the fourth section and the only word in the entire Tapestry up to this point to be in colour, was embroidered after sections four and five were joined, the hypothetical motive being to smooth the transition from monochrome to polychrome lettering. The word is slightly smaller than the rest of the inscription, and the sentence could function without it: 'Hic coquitur caro et hic ministraverunt'.
128 See Wormald, 'Inscriptions'.
129 The scene of Harold's encounter with Edward the Confessor after the expedition to Normandy (Wilson, *Bayeux Tapestry*, pl. 28) provides a rare example where there was insufficient room for the whole inscription (though only just) and we read 'Edwardu regem' (not 'Edwardum' or even 'Edwardu-').
130 *Ministraverunt; fecerunt; prepararent; ceciderunt; pugnant; verterunt* (respectively Wilson, *Bayeux Tapestry*, pls 47, 47, 58, 65, 68, and 73).

individual texts is signalled by two points and a stroke; while a couple of the inscriptions are introduced by a cross – thus giving a subtle emphasis to William's first appearance in the Tapestry and to the launching of his invasion of England.[131] Sets of double and triple points frequently occur within individual phrases. Such pointing is the graphic vocabulary of contemporary inscriptions rather than that of books. The point to stress about its function in this context is that it is less punctuation in the modern sense than emphatic indication of word division. The language of the phrases is not sufficiently complicated to require subdivision into construable grammatical components via visual cues; however distinct word division is of crucial importance. Because they are interspersed among the imagery, individual words are sometimes broken up. In the inscription, 'Hic navis anglica venit in terram Willelmi ducis', for instance,[132] *angli / ca, ter / ram*, and *du / cis* are divided by a ship and a tree, as indicated. Similarly, in the next inscription, 'Hic Willelm dux iussit naves edi / ficare' (pl. 15), the final word is split, as shown, by the roof of his palace.[133] Nevertheless, the presence of strong pointing between individual words leaves no doubt as to where one word ends and the next one begins, ensuring maximum legibility and intelligibility. The examples I have just cited make the point very clearly for they are actually written as follows: 'Hic: navis: anglica: venit. interram //[134] Willelmi: ducis', and 'Hic: Willelm // dux: iussit // naves: edificare:'.

The thin form of the letters was probably determined at least in part by the exigencies of the medium of embroidery and the vast scale of the work. The use of more elaborate letter forms with undulating contours would have added appreciably to the production time. Making allowance for this, the contribution that analysis of the style of the lettering can make to the problem of localising the Tapestry is minimal. Letter forms of this basic type were fairly widely used in England, France, and Normandy from the mid-eleventh century. They can certainly be paralleled in general terms in manuscripts from St Augustine's, Canterbury, and Mont Saint-Michel; but so they can elsewhere, for instance at Jumièges and Christ Church.[135] They are also broadly (but not specifically) related to the alphabets of epigraphic capitals used in England and Normandy in the eleventh and earlier twelfth centuries.[136] They are clearly not related to the more elaborate forms of display script

131 '+ Hic venit nuntius ad Wilgelmum ducem'; and '+ Hic Willelm dux in magno navigio mare transivit' (*Ibid.*, pls 12–13 and 39–40).

132 *Ibid.*, pls 33–4.

133 *Ibid.*, pls 34–5.

134 This represents the end of a line.

135 Canterbury display script of the period is discussed in Gameson, 'Late Eleventh Century', esp. pp. 130–1. For Mont Saint-Michel see the plates in Alexander, *Mont Saint-Michel* and Dosdat, *L'enluminure roman au Mont Saint-Michel* (esp. pp. 39, 42, 47 and 62). Especially comparable lettering from Jumièges appears in Rouen, Bibliothèque municipale, A. 126 (s. xi^ex): Avril, *Manuscrits normands*, no. 40 with col. ill. on cover.

136 From Normandy cf. the Isembardus capital at Bernay: Baylé, *Sculpture romane en Normandie*, p. 63 with pl. 142. For English material see E. Okasha, *Handlist of Anglo-Saxon Non-Runic Inscriptions* (Cambridge, 1971), nos 12, 44, and 85; also her 'A supplement to *Handlist of Anglo-Saxon Non-Runic Inscriptions*', *Anglo-Saxon England* 11 (1983), 83–118, no. 161; and 'A second supplement to *Handlist of Anglo-Saxon Non-Runic Inscriptions*', *Anglo-Saxon England* 21 (1992), 37–85, no. 187.

that flourished in Normandy in the later eleventh century; nor do we see the delicate fluctuations in the thickness of strokes which characterises many Norman and Anglo-Norman alphabets;[137] but given the impracticality of translating such lettering into the medium of embroidery, this is hardly surprising. The difficulty of isolating telling parallels for the letter forms from one country as opposed to the other is perhaps significant: like the work as a whole, the script appears to be Anglo-Norman rather than *either* English *or* Norman.

The language presents a similar picture and supports this characterisation. Because of its brevity and simplicity, there are few diagnostically national features. It is all the more interesting, therefore, that the texts include a couple of words and spellings that definitely point to England, and one that distinctly implies contacts with France. The Anglo-Saxon usages were mentioned earlier; the word with French associations is *parabolant* (*parabolare*: pl. 4), from which modern French *parler* is derived.[138]

The point can be developed a little further. Multi-coloured display script, analogous to the lettering in the last four sections of the Tapestry, is a feature of the second half of the eleventh century, and is more pronounced in Norman than in English manuscripts.[139] On the other hand, England undoubtedly had a stronger tradition than Normandy of using inscriptions in association with pictorial matter. The Caligula Troper and the Tiberius Psalter provide examples dating from the mid and third quarter of the eleventh century.[140] A high percentage of the inscriptions in the latter book, it is worth noting, are introduced by 'Hic', like many of those in the Tapestry. The inscription above the depiction of the betrayal of Christ, for instance, reads: *Hic venit Iudas cum sociis suis cum gladiis et fustibus comprehendere Ihesum*; while that above the Ascension declares: *Hic ascendit Cristus ad caelos*.[141] There is, however, nothing more than a broad similarity of approach here, for the precise formula that was preferred differs from the one work to the other. In nine out of ten cases in the Psalter, the sentence begins: *Hic*, verb, subject. Although similar constructions do appear in the Tapestry (*Hic apprehendit Wido Haroldum*, for example: pl. 3), there we often meet the subject before the verb (*Hic milites Willelmi ducis pugnant contra dinantes*) or expressed via the verb (*Hic dederunt Haroldo coronam regis*: pl. 13).

In terms of their placement and spacing, the Bayeux Tapestry inscriptions were meant to be seen and read. This may sound paradoxical, but by no means all

137 E.g.: *Trésors des abbayes normandes*, no. 158; Gullick, 'Scribe of the Carilef Bible', figs 10–13; Mynors, *Durham Cathedral Manuscripts*, pl. 25; Kauffmann, *Romanesque Manuscripts*, ills 1, 7, 10, 30 and 32; de Hamel, *A History of Illuminated Manuscripts*, ill. 81.

138 *The Oxford Dictionary of English Etymology*, ed. C. T. Onions (Oxford, 1966), *vide* 'parlance' (p. 652).

139 Colour plates: Mynors, *Durham Cathedral Manuscripts*, pl. 28; Dosdat, *L'enluminure romane au Mont Saint-Michel*, pp. 28, 39, 54, 65, 66, 67, and 68.

140 The inscriptions in Cotton Tiberius C. vi are transcribed in Wormald, 'Eleventh-Century Psalter with Pictures', pp. 8–11; those in Cotton Caligula A. xiv in *The Winchester Troper: from manuscripts of the xth and xith centuries*, Henry Bradshaw Society 8 (London, 1894), pp. 110–20. Part of the explanation for this, of course, is that Normandy had a much slenderer tradition of full-page images, as we have seen.

141 Respectively fols 12r and 15r (Wormald, 'Eleventh-Century Psalter with Pictures', pls 12 and 18).

inscriptions on artefacts or associated with imagery in books were designed to be read easily.[142] Those that accompany the pictures in the Tiberius Psalter and the Caligula Troper, for instance, were written on a small scale and were arranged around the outer edge of the images – with the result that they can only be followed by turning the book on its side and then (in the case of the Troper) upside down. The role of such teasing lettering need not detain us here: all that matters in the present context is that the inscriptions in the Bayeux Tapestry are not like this. They, by contrast, are prominently positioned at the top of the picture area, often 'suspended' from the upper border. Occasionally when the action or pictorial subject require it, they occupy the border itself (e.g. pl. 12).[143] The letters are comparatively large (they are approximately the same size as the heads of the human figures) and are certainly unmissable.[144] Furthermore, the texts have word division. Many contemporary display texts and inscriptions lack, or have only minimal word division. Its consistent use in the Tapestry's inscriptions, therefore, (accentuated by heavy punctuation, as we have seen) is a further indication that these texts were meant to be read. The sole exceptions to the generally excellent word division are prepositions which, following the practices of many contemporary texts, are attached to the nouns to which they relate. A final yet fundamental point which underlines the fact that these inscriptions were meant to communicate as effectively as possible is the simplicity of their language. These are straightforward, short, direct statements; there are only three passives and one impersonal verb in the entire Tapestry. One can grasp their meaning with the most elementary command of Latin.

The inscriptions are carefully positioned so as best to interact with the imagery to which they relate. It is sometimes said that they have been squeezed around the pictorial matter and may have been an afterthought. This is an erroneous twentieth-century perception, presupposing the modern neat delineation between picture and caption. Its inappropriateness is underlined by the many early medieval book illuminations which include inscriptions within the picture space,[145] not to mention historiated initials which incorporate illustrations into the very fabric of the text.[146] The letters do, quite naturally, occupy areas which are vacant of imagery; and their arrangement was obviously subject to the exigencies of what had to be shown and what had to be said. But this hardly makes them afterthoughts. On the contrary, the way they co-exist with the imagery, occasionally being wrapped around it, is a

142 Cf. Gameson, *Role of Art*, pp. 74–6, 78–9 and 87–9.

143 Wilson, *Bayeux Tapestry*, pls 30, 32, 34–5, 68 and (arguably) 42. The majority of these (30, 32, 34–5) are in section three of the Tapestry.

144 It is difficult to understand how some commentators (e.g. Bachrach, 'Observations', p. 7) can maintain the reverse.

145 See, e.g., Temple, *Anglo-Saxon Manuscripts*, ills 30–3, 41, 48, 149, 181, 183–4, 241, 244, 245–6, 249, 277–80; L. Grodecki, F. Mütherich, J. Taralon, and F. Wormald, *Le Siècle de l'an mil* (Paris, 1973), ills 80, 83–5, 87, 96, 104–5, 109, 114, 116, 121, 134, 143–4, etc.

146 For a selection of examples see J. J. G. Alexander, *The Decorated Letter* (London, 1978), pls 5, 6, 13, 16, 18, 19, 21, 24–6.

strength not a weakness, enabling the two to interact more effectively, and forcing the literate beholder to consider them together. The point is underlined by the various figures depicted in the Tapestry who point at the inscriptions to draw the beholder's attention to them. The practice is established right at the beginning of the work: the fifth figure to appear points unmistakably to the inscription *Ubi Harold Dux Anglorum...* (pl. 1).[147] Such physical interweaving of words and imagery (with a minimum of disruption to the size of the former) would have been inconceivable if they had not been planned together at the design stage of the work.

Let us take a short extract and watch this interaction of word and image. The actual invasion of England comprises the following scenes. We see men hauling boats towards the water, and then carrying arms and other provisions to them (pl. 16). Embarkation follows, after which we watch the fleet sailing across the English Channel (pl. 17), then arriving at the coast. We are next shown the disembarkation of the horses; whereupon knights ride to Hastings to forage and seize provisions.[148] Interwoven with this, stage by stage, are the texts: 'Here the ships are hauled down to the sea'; 'These men carry arms to the ships'; 'And here they drag a cart laden with wine and arms'; 'Here Duke William in a great boat crossed the sea and came to Pevensey'; 'Here the horses leave the ships'; 'And here the knights hurried to Hastings to seize food'.[149] Written and visual messages move forward together, their physical intimacy underlining their semantic parity. The interspersal of *Hic willelm dux / in magno navigio / mare / tran / sivit / et venit / adpevene / sae* through the various elements of the very extended scene in question is particularly striking. Such close interrelationship of word and image can, incidentally, be paralleled in Anglo-Saxon, but not Norman, manuscripts from the tenth and eleventh centuries.[150]

Not only in arrangement, but also in content and message, imagery and inscription are parallel and complementary. The inscriptions fall into two distinct types, as do most such early medieval legends. A few are simple *tituli*, identifying a person or place. These generally appear where the visual imagery leaves this ambiguous. Instant recognition of identity is crucially important. Hence we need to be told that it is Harold who stands at the prow of the boat arriving in Normandy;[151] we have to be informed that this particular character is Turold (pl. 5);[152] it is important that we

147 Wilson, *Bayeux Tapestry*, pl. 2, Cf. also pls 6, 10, 25–6, 48, 50, and 57; with O. Pächt, *The Rise of Pictorial Narrative in Twelfth Century England* (Oxford, 1962), p. 10.
148 Wilson, *Bayeux Tapestry*, pls 34–45.
149 'Hic trahuntur naves ad mare.' 'Isti portant armas ad naves.' 'Et hic trahunt carrum cum vino et armis.' 'Hic Willelm dux in magno navigio mare transivit et venit ad pevenesae.'
150 Cf. Gameson, *Role of Art*, pp. 70–104.
151 Wilson, *Bayeux Tapestry*, pl. 6.
152 *Ibid.*, pl. 11. For the debates surrounding Turold – which figure is thus identified and who he might have been – see Fowke, *Bayeux Tapestry*, pp. 40–3; Prentout, 'Essai d'identification', pp. 21–3 (above pp. 21–30); Stenton (ed.), *Bayeux Tapestry*, pp. 10 with 24, n. 2 and 177 (section 12); R. Lejeune, 'Turold dans la Tapisserie de Bayeux', *Mélanges offerts à René Crozet*, ed. P. Gallias and Y.-J. Riou (Poitiers, 1966), 419–25; Brooks and Walker, 'Authority and Interpretation', pp. 8 and 22 (above pp. 68–9); P. Bennett, 'Encore Turold dans la Tapisserie de Bayeux', *Annales de Normandie* 30 (1980), 3–13; and Bachrach, 'Observations', pp. 12–14.

realise that the archbishop officiating at Harold's enthronement is Stigand (pl. 13);[153] and so on.[154]

Most of the inscriptions, by contrast, comprise short sentences. The scene of Harold enthroned, incidentally, provides a convenient opportunity to compare the two types of inscriptions (pl. 13).[155] The archbishop is identified by the titulus *Stigant archiep[iscopu]s* written directly around his head; whereas the scene as a whole is complemented by the general statement *Hic resident Harold rex anglorum*. The extended inscriptions almost invariably recount the action, and they, too, name the key characters as a matter of course: Here Harold did this; Where William does that. It is striking how very few words are wasted on description – there are in fact only four adjectival phrases in the entire Tapestry. But then the description is admirably supplied by the imagery. In point of fact, three of the four adjectival phrases are arguably of crucial importance for the story. When Harold crosses the Channel we are told that his sails are full of wind.[156] This may be simply to suggest his speed, but more probably it indicates that conditions are stormy and he is being blown off course, providing the explanation for why he fell into the hands of Guy of Ponthieu (as is spelled out by William of Poitiers).[157] When Edward the Confessor addresses his faithful followers, the inscription reports that he is in bed, thus underlining how impending is his demise (pl. 12).[158] And when Duke William sailed to England we are told he did so in a great ship, thereby distinguishing his flagship from the fleet as a whole, and making it seem portentious.[159] Is it coincidence, one wonders, that the fourth occasion – the one time that the adjectival phrase does not actually enhance the narrative – relates to Odo of Bayeux? In the Battle of Hastings we are told that he rallied the lads, carrying his staff (pl. 24).[160] The extra detail ensures that there can be no doubt as to which figure he is; and, equally important, it subtly stresses the scene and the figure in question.

153 Wilson, *Bayeux Tapestry*, pl. 31.
154 Attempts to 'restore' such tituli to a hypothetical, pre-existing, narrative form (e.g. Bachrach, 'Observations', esp. p. 14) are fundamentally misconceived. The representation of the seige of Dol has been regarded as evidence that the designer worked from a written text; however there are serious problems with this interpretation: see n. 233 below.
155 Wilson, *Bayeux Tapestry*, pl. 31.
156 *Ibid.*, pls 4–5. 'Hic Harold mare navigavit et velis vento plenis venit in terra Widonis comitis.' Bachrach, 'Observations', pp. 19–20, sees a possible Virgilian echo here (*Aeneid* V, 281).
157 William of Poitiers, *Gesta Guillelmi*, ed. Foreville, I, 41 (p. 100): 'Haraldus, dum ob id negotium venire contenderet, itineris marini periculo evaso littus arripuit Pontivi, ubi in manus comitis Guidonis incidit'.
158 Wilson, *Bayeux Tapestry*, pl. 30. 'Hic Eadvvardus Rex in lecto alloquit[ur] fideles'.
159 *Ibid.*, pls 39–41. '+ Hic Willelm dux in magno navigio mare transivit et venit ad pevenesae.' It is generally assumed that the prominent ship distinguished by a cross and a cruciform ?box atop the mast, and by a human figure blowing a horn and holding a penant on the stem is William's flagship (*Ibid.*, pl. 42). For comment see Fowke, *Bayeux Tapestry*, pp. 96–7; Stenton (ed.), *Bayeux Tapestry*, pp. 182–3; Bertrand, *Tapisserie de Bayeux*, p. 101; Gibbs-Smith, *Bayeux Tapestry*, pp. 12–13; and Wilson, *Bayeux Tapestry*, pp. 186–7.
160 Wilson, *Bayeux Tapestry*, pl. 67. 'Hic Odo episcopus, baculum tenens, confortat pueros'. Cf. n. 102 above.

Another case where the precise choice of words is arguably significant is the inscription above the three men, two holding axes, one upraising the crown, who stand between the death of Edward the Confessor and Harold enthroned, linking the two scenes. It says, 'Here they gave the crown of the king to Harold'.[161] This is by no means unfavourable to Harold, as it further implies that he did not simply seize the throne, but rather that it was offered to him. Nevertheless, it cannot simply be interpreted as a pro-English, anti-Norman touch.[162] On the contrary, the legend in question, as also the subsequent written declarations that Harold is *Rex Anglorum*, intimately associate the English as a whole with this fatal action. It is not just one man, but a whole nation which has sinned, and which will be judged accordingly.

In eleven places the inscription mentions an act of speech, thereby incorporating sound and specific verbal communication into the imagery.[163] Twice – 'Where Harold and Guy converse' (pl. 4), and 'Here King Edward on his [death]bed talks to his followers' (pl. 12) – it is a bald statement that verbal communication happened. On the other nine occasions, by contrast, the inscription provides a key to the content of the dialogue, thus further expanding on the information conveyed by the visual imagery. The degree to which the writing specifies the spoken words varies from a general indication of the matter in question to a précis of a particular speech. On the one hand, for example, we are told that 'Harold swore a sacred oath to Duke William' (pl. 10); on the other, we learn that 'a certain man ordered fortifications to be dug at Hastings' and that William, 'exhorted his soldiers to prepare themselves manfully and wisely for battle against the army of the English'. This last, incidentally, is the longest inscription in the Tapestry.[164] It is worth remarking that, with two exceptions (namely Harold swearing the oath, and William ordering ships to be built), the specified speeches all occur after the Normans have landed in England. This increase in sound and dialogue lends additional urgency and immediacy to the last phases of the story. It is also worthy of note that Odo of Bayeux is given verbal presence through inscriptions on two of his four appearances – he blesses the food (pl. 18), and he rallies the lads (pl. 24) – further enhancing his depicted persona.

In view of the simplicity of the language and the directness of the statements, the choice of the word *parabolant* to describe Guy and Harold's interchange at Beaurain deserves further comment (pl. 4).[165] As we have already noted, the verb *parabolare*

161 Wilson, *Bayeux Tapestry*, pls 30–1. 'Hic dederunt Haroldo coronam regis'.
162 Thus Bernstein, *Mystery of the Bayeux Tapestry*, pp. 122–3.
163 'Ubi Harold et Wido parabolant'; 'Ubi Harold sacramentum fecit Willelmo duci'; 'Hic Eadwardus rex in lecto alloquitur fideles'; 'Hic Willelm dux iussit naves edificare; 'Iste iussit ut foderetur castellum at Hestenga'; 'Et hic episcopus cibum et potum benedicit'; 'Hic nuntiatum est Willelmo de Harold'; 'Hic Willelm dux interrogat Vital si vidisset exercitum Haroldi'; 'Iste nuntiat Haroldum regem de exercitu Wilelmi ducis'; 'Hic Willelm dux alloquitur suis militibus ut prepararent se viriliter et sapienter ad prelium contra anglorum exercitum'; 'Hic Odo episcopus baculum tenens confortat pueros'. Dialogue is also implied (though not expressed) in, 'Ubi nuntii Willelmi ducis venerunt ad Widonem'; and an exclamation may be implicit in 'Hic est Wilel[mus] dux'.
164 Cowdrey, 'Interpretation', p. 61 (pp. 105–6 above).
165 Wilson, *Bayeux Tapestry*, pls 9–10. Comment: Fowke, *Bayeux Tapestry*, pp. 38–9; Stenton (ed.), *Bayeux Tapestry*, pp. 176–7; Bertrand, *Tapisserie de Bayeux*, p. 81.

attests to French connections; but what does it actually mean here? Of ultimate Greek origin, the corresponding noun, *parabola*, can be found in the straightforward sense of 'conversation', in the fuller sense of 'recounting' or 'story telling', and also with an antagonistic meaning approaching 'taunt'.[166] The precise nuance of the verb form in the present context is difficult to gauge. It may have been chosen to express nothing more than the fact that Harold and Guy talked. Alternatively, it might suggest a more expansive recounting of experiences; and it could imply a full and frank exchange of opinions! While one would not wish to place too much weight on the hypothesis, the context of the exchange, between a captive and his captor, suggests that an element of tension was indeed intended – and this seems particularly likely if, as William of Poitiers relates, it was the local habit not only to imprison noble captives, but also to torture them, and to sell them into slavery.[167] The imagery, with a dominant, enthroned Guy pointing with arm outstretched to a rather cowed-looking Harold, leaves little doubt that this was a strained encounter.

The terseness of the narrative inscriptions helps to keep the pace of the story brisk: events happen and are described in quick succession. The written messages are simple, clear and informative, and they invariably tell the literate beholder what he needs to know in order to understand the depicted events. Consequently, on the two occasions when the inscriptions do not provide the modern beholder with sufficient information – the mysterious scene 'Where one cleric and Ælfgyva' (pl. 7), and the problem of knowing which figure is 'King Harold was killed' (pl. 26) [168] – we can, I think, safely assume that this is because we lack information that was held to be common knowledge in the later eleventh century. The former case is of additional interest as the one extended inscription without a verb; if the reader were meant to supply one, it was most probably a bland *sunt* or *fuerunt*. In general, text and imagery are excellently complementary in arrangement, content and meaning.

In terms of their tense, the narrative inscriptions seem to be fairly evenly divided between the perfect and the present (or the historic present).[169] There is one single

166 Cf., e.g., Habacuc 2, 6.
167 William of Poitiers, *Gesta Guillelmi*, ed. Foreville, I, 41 (p. 100).
168 'Ubi unus clericus et Ælfgyva'; 'Harold rex interfectus est': Wilson, *Bayeux Tapestry*, pls 17 and 71. Considerable ink has been spilled over both points. For the latter see Brooks and Walker, 'Authority and Interpretation', pp. 23–34 (pp. 81–91 above); and S. A. Brown, 'The Bayeux Tapestry: Why Eustace, Odo and William?', *Anglo-Norman Studies* 12 (1990), 7–28 at 17–18. On the former see, *inter alios*, E. A. Freeman, 'The Ælfgyva of the Bayeux Tapestry' in his *The Norman Conquest* III, pp. 708–11 (repr. as Ch. 2 above); Fowke, *Bayeux Tapestry*, pp. 49–57 and 63; Prentout, 'Essai d'identification', pp. 15–18 (pp. 22–5 above); J. B. McNulty, 'The Lady Ælfgyva in the Bayeux Tapestry', *Speculum* 55 (1980), 659–68; M. W. Campbell, 'Ælfgyva: the mysterious lady of the Bayeux Tapestry', *Annales de Normandie* 34 (1984), 127–45; J. Gosling, 'The Identity of the Lady Ælfgyva in the Bayeux Tapestry and some speculations regarding the hagiographer Goscelin', *Analecta Bollandiana* 108 (1990), 71–9; E. F. Freeman, 'The Identity of the Aelfgyva in the Bayeux Tapestry', *Annales de Normandie* 41 (1991), 117–34; and Grape, *Bayeux Tapestry*, p. 40. The solutions proposed by McNulty and E. F. Freeman are particularly unlikely.
169 'Venit' and 'apprehendit' are ambiguous in this respect. I have taken them as preterites (a view defended by P. Clemoes, 'Language in Context: *Her* in the 890 *Anglo-Saxon Chronicle*', *Leeds Studies in English* n.s. 16 (1985), 27–36 at 33–4, n. 9). So too is the phrase 'Et hic defunctus est': 'And here he is dead' or 'And here he has died'.

imperfect – where Harold rescued some of William's men from quicksand when they were on campaign: 'And here Duke Harold was dragging them from the sand' (pl. 8).[170] This is surely to stress the fact that the Englishman performed this action for some time, or several times in succession, saving a number of men – a point conveyed more schematically in the imagery which shows him heroically rescuing two men simultaneously. There is no obvious rationale behind the use of the perfect as opposed to the present on a given occasion. All that can be said with any confidence is that the alternation from the one tense to the other repeatedly draws the reader's attention; and that the alternation is noticeably more frequent in relation to the events of 1066, as opposed to those of 1064 and 1065. The increasing fluctuation of the language subliminally suggests that things are hotting up.

On four occasions the individual 'sentences' are introduced by a demonstrative pronoun – *isti, iste* ('these men', 'this man'). Every other phrase is headed by *Hic* ('here') or, far less frequently, *Ubi* ('where'). All these words help to connect text and image, by underlining the fact that the words relate to the imagery which is right beside them.[171] In addition, through their demonstrative and locative force, they stress the immediacy of the event for the beholder. There was a venerable tradition for using *Hic* and *Ubi* in this way to introduce inscriptions that accompanied imagery.[172] On one occasion, right at the start, an *Ubi* is used disjunctively to indicate a new setting in contrast to the previous one (Edward's palace): *Ubi Harold Dux et sui milites equitant ad Bosham* (pls 1–2).[173] On the other four occasions, however, it is used conjunctively to indicate something that is happening at a place which has just been shown and mentioned.[174] *Hic* identifies distinct events, irrespective of their setting. The use of *Hic* in the Tapestry is reminiscent of the practice of introducing each year in the *Anglo-Saxon Chronicle* with *Her* ('here' or 'in this year'),[175] though it is doubtful that there is any direct connection between them. On the other hand, there is no doubt of its relationship to the *Hics* that introduce descriptive inscriptions accompanying images elsewhere, as for example in the Tiberius Psalter. Its wide use in such

170 'Hic Harold dux trahebat eos de arena': Wilson, *Bayeux Tapestry*, pls 19–20.
171 The suggestion (Bachrach, 'Observations', pp. 6–7) that these are 'instruction words' to the decorator (the fact that they were included suggesting careless supervision) can safely be disregarded, not least because of the explanatory inscriptions beginning *Hic* that occur as an integral part of the design in contemporary manuscript art.
172 As an example of *Ubi* it will suffice to cite the capitals in San Pedro de la Nave, Zamora, built *c.* 691, which show Daniel in the lions' den, and the sacrifice of Isaac, accompanied by the inscribed legends: '+Ubi Daniel missus est in laqum [lacum] leonum' and '+Ubi Habraam obtulit Isac filium suum olocaustum Dno' (de Palol and Hirmer, *Early Medieval Art in Spain*, ill. 7; J. Fontaine, *L'art préroman hispanique*, 2 vols (La Pierre-qui-vire, 1973), I, pp. 199–205; ills 70–1).
173 Wilson, *Bayeux Tapestry*, pls 1–2.
174 [Hic apprehendi Wido Haroldum, et duxit eum ad belrem et ibi eum tenuit] 'Ubi Harold et Wido parabolant'.
 And also 'Ubi nuntii Willelmi ducis venerunt ad Widonem'. (The need to show all this happening at one location probably explains why William's messengers appear from the right and move to the left.)
 [Hic dux Wilgelm cum Haroldo venit ad Palatium suum] 'Ubi unus clericus et Ælgyva'.
 [Hic Willelm venit bagias] 'Ubi Harold sacramentum fecit Willelmo duci'. (See n. 122 above).
175 See Clemoes, 'Language in Context'.

contexts reflects the circumstance that its demonstrative and locative force made it ideal for binding images and words together, as mentioned earlier. The regular repetition of *Hic* in the Tapestry establishes an internal rhythm; and the word punctuates the narrative as clearly as do the visual interruptions such as trees. The presence of the word underlines the fact that the extract to which it relates is a distinct scene within the spatial and narrative continuum. It has reasonably been suggested that these *Hic* and *Ubi* in general made the inscriptions highly suitable for functioning as cues for one person who was pointing out the imagery, performing the Tapestry, to others. 'So ladies and gentlemen here you see… And this was where…'.[176]

The literate beholder has little alternative but to read these inscriptions: it is very difficult to ignore clear, bold writing in simple language, immediately before your eyes, when you can read. But this was an age when reading was often a communal experience, even for those who were personally literate. People expected to hear texts. It is difficult to believe that, wherever the Tapestry was on show, there was not someone present who was ready to read and 'perform' it with the help of these inscriptions for beholders, literate and illiterate alike.

Furthermore, for all viewers the mere presence of such bold writing throughout the Tapestry, irrespective of what it said, will have contributed to the general impression of the work. Exactly what it contributed is difficult to gauge; however the Latin legends may have given the work a slightly ecclesiastical flavour; and we can be fairly confident that it imparted an official air, contributing to the credibility of this version of the events. Latin was the language of church and government; it was not the language of everyday speech.

Pictorial Narrative

My next theme is pictorial narrative. The skill of the designer in conveying the events of 1064–6 in visual form is superlative. To underline the magnitude of the task he achieved so well, one has merely to ask oneself: could I depict the main events of English history during the last three years equally well with the same resources? Many interesting and perceptive comments have been made over the years on the methods the designer used to recount his story.[177] There is, for example, the sensitive deployment of gesture to convey what characters are doing and how they are interacting, whilst simultaneously leading the eye on through the narrative. There is the way in which figures look in one direction but point or move in another, linking one event to the next, and tying a given moment to the one that succeeds it. And there is the use of trees or towers to create breaks in the sequence, signalling temporal or spatial disjunction. It is not my intention to reiterate or elaborate upon

176 Brilliant, 'Bayeux Tapestry', pp. 102–19 (pp. 119–34 above).
177 E.g. G. Henderson, *Early Medieval* (Harmondsworth, 1972), pp. 168–78; Parisse, *Bayeux Tapestry*, pp. 53–80; Bernstein, *Mystery of the Bayeux Tapestry*, *passim* but esp. pp. 89–104; Grape, *Bayeux Tapestry*, pp. 63–73. I have not seen J. B. McNulty's monographic work, *The Narrative Art of the Bayeux Tapestry Master* (New York, 1989).

these well known aspects, important though they are. The factors on which I wish to comment are more elementary and fundamental – so much so, indeed, that they are easily overlooked.

The first point is the shape of the object itself. The fact that the Tapestry is a long thin strip with a single continuous narrative (and not taller with the narrative arranged in registers, one above another, as, for instance in the ninth-century Touronian Bibles or the eleventh-century Codex Aureus Epternacensis)[178] ensures that the beholder moves ever onwards in a controlled progression. And as the eye moves along the strip, so it advances through time. The single exception to this is the death of Edward the Confessor, where two proximate moments appear one above the other (pl. 12).[179] We see the king addressing his faithful followers from his deathbed in an upstairs chamber, with the next event, the shrouding of his corpse, shown in the room below. This is one of two departures from the normal method of narrative presentation in this part of the Tapestry, the rationale for which will be discussed in a moment. The demerits of the Tapestry's long, thin shape for the nave of a church are sometimes noted (incorrectly in my opinion).[180] Be that as it may, this shape was ideally suited for telling a story and it contributes greatly to the work's narrative success. Moreover, as the Tapestry is an extended strip and not a coiled, rising one like the triumphal columns with which it is sometimes compared,[181] its sequence of images is easy and convenient to follow.

The second point relates to the basic design and contruction of the Tapestry: in particular to the fact that the entire background was left as blank linen. The fundamental contrast between the light ground and the richly coloured pictorial elements makes the latter stand out very clearly, particularly since, being 'laid and couch' work, they do in fact project slightly from its surface.[182] Considerations of time and cost no doubt contributed to the decision to leave the ground plain, but aesthetic reasons may also have played a part. And whatever the truth, the role of the plain ground in highlighting the subject matter and enhancing its legibility is undeniable. The extent of its contribution in this respect is underlined by other textiles whose

178 For which see respectively H. Kessler, *The Illustrated Bibles from Tours* (Princeton, 1977); and P. Metz, *The Golden Gospels of Echternach* (London, 1957).

179 Wilson, *Bayeux Tapestry*, pl. 30.

180 E.g. Dodwell, 'Bayeux Tapestry and French Secular Epic', p. 549 (p. 47 above); Bernstein, *Mystery of the Bayeux Tapestry*, pp. 104–5; Brown, *Bayeux Tapestry: history and bibliography*, pp. 34–5.

181 Namely Trajan's Column and Marcus Aurelius' Column (on which see R. Brilliant, *Visual Narratives: Storytelling in Etruscan and Roman Art* (Ithaca, 1984), pp. 90–123); and, much closer in time, that of Bernward of Hildesheim, for which see M. Brandt and A. Eggebrecht (eds), *Bernward von Hildesheim und das Zeitalter der Ottonen*, 2 vols (Hildesheim, 1993), II, 540–8. Though in the abstract, as strip narratives, these works are obviously comparable, in reality the way they can be read and their legibility is fundamentally different – a point that publication in book form tends to conceal. The spectator can easily follow the narrative strip of the Tapestry; he can with inconvenience and mild dizziness follow that of Bernward's column; he cannot follow that of the Roman columns at all.

182 Cf. S. Bertrand, 'Etude', esp. 202–3 (Ch. 5 above, p. 35), for the illusion of three-dimensionality that results from the relief created by the laid and couch work technique.

grounds are fully coloured. The figures on the Baldishol Tapestry, for example,[183] being absorbed into the overall decorative effect, are less prominent, and are less forcibly etched onto the mind's eye. In addition, the polarity between the blank ground and the coloured subject matter in the Bayeux Tapestry sends subliminal messages. When the action hots up and there are correspondingly more figures in less orderly arrangements, a larger amount of the ground is covered by the design: such moments are literally more colourful.

The third point is the story itself. The events in question are exciting and momentous: they are excellent material for an artist to work with. (To that extent my earlier challenge – to depict the events of English history during the last three years in similar form – was rather unfair: nothing comparably dramatic has happened.) Nevertheless, choosing the optimum series of scenes and moments that could flow smoothly from one to the next, telling the story clearly and interestingly, was of paramount importance. The thought this presupposed, and the artistry with which it was achieved can be most clearly appreciated in the sequence which extends from the swearing of the oath up to the order to build ships for the invasion (pls 10–15).[184] This section is particularly complicated, with a dense narrative; nevertheless, compressing real time, each scene interlocks with the next to emphasise cause and effect. The last event of Harold's sojourn in Normandy, as it is depicted, is his swearing of the oath, which thereby echoes through the following events. As soon as he has returned to England and confronted Edward the Confessor, the latter dies (though in reality several months elapsed between Harold's return and Edward's death); and immediately after Harold has accepted his crown, Halley's comet appears (again, events that were months apart). This is depicted as a portent, with the lower border alluding to the fleet which William orders to be built as soon as news of events in England reaches him.

Although the planning and design stages of the work are entirely lost to us, we can be confident that they absorbed considerable time and effort. The story the Tapestry recounts is broadly similar to that told by William of Jumièges and William of Poitiers,[185] and it sometimes seems to be assumed that the designer was presented with a comparable written account and simply got on with the task of illustrating it.[186] This, it seems to me, is altogether too simplistic a model. Whatever sources the designer worked from (and they would seem to have been generally well informed), and whatever the details of his brief, he had to ensure that the selected events led effectively from one to the next both in visual and in causal terms. We will never know how closely his task was mapped out for him; but the fact that the narrative flows so well suggests we should credit him with a pro-active and not

183 Reproduced in colour: P. Anker and I. Racz, *Medieval Norwegian Art* (Helsinki, 1970), pl. 127; E. Roesdahl and D. Wilson (eds), *From Viking to Crusader: Scandinavia and Europe 800–1200* (Council of Europe, 1992), p. 195.
184 Wilson, *Bayeux Tapestry*, pls 25–35.
185 For these authors see nn. 220–1 below.
186 Some scholars (e.g. Bertrand, 'Etude'; Bachrach, 'Observations') have hypothesised that the Tapestry follows a lost *Gesta* or *Chanson de geste*.

merely a passive role in the formation of this particular version of the story. No one doubts that a medieval author commissioned to write a chronicle or biography would have had a fair degree of freedom to select and mould the material according to the canons of his own style and art. Precisely the same is likely to have been true of the designer of the Bayeux Tapestry. One of the the most useful contributions that the *Carmen de Hastinga Proelio*[187] can make to our understanding of the Bayeux Tapestry is to underline this point.

Fourthly, there are the inscriptions. As I stressed in the previous section, they are intimately woven into the imagery, and are an important part of it. The interaction between text and image is underlined visually by their co-existence in one space, and by the occasional depicted figure who points at the words – to be seen, for instance, in the scenes where Harold swears the oath to William (pl. 10), and Odo blesses the food (pl. 18).[188] Some discussions of the Bayeux Tapestry's narrative techniques make one wonder if the author has even noticed there are words running right through the work. Yet the inscriptions provide clear, concise information about what is happening. As we have seen, they are themselves narrative – here such and such happens, where so and so was done – and they have their own fast pace. At the same time, the *Hic*s punctuate the story, clearly marking off distinct moments and events: the inscriptions play an important role in delineating the individual scenes within the continuous strip. Furthermore, the inclusion of inscriptions presupposed, and made it inevitable, that the visual narrative should run continuously (or nearly so) from left to right – the conventional direction for writing in a chauvinistically right-handed society.

So conforming to the requirement of the writing and using the strip shape to good effect, the story flows scene by scene from left to right. The beholder is carried effortlessly with the tide. As he moves along the course of the embroidery, so he travels through depicted time; and his own physical movement supplies a dimension of kinesis to the series of individually static but interlocking images in front of him.

There are, as is well known, a few exceptions to the left to right progression. The most famous and often discussed is the death and burial of Edward the Confessor, where the chronological narrative runs briefly from right to left (pls 11–12).[189] Following the scene of Harold, recently returned from Normandy, appearing in front of King Edward, we see the completion of Westminster Abbey, and then Edward's funeral cortège moving towards it. Next there is the 'double-decker' scene mentioned earlier, showing two prior moments in time: Edward's deathbed address to his followers, and the shrouding of his corpse. Then there appears a group of men who,

187 See n. 5 above.

188 Wilson, *Bayeux Tapestry*, pls 25–6 and 48. Cf. n. 147 above.

189 Wilson, *Bayeux Tapestry*, pls 28–31. For earlier comment see, *inter alios*, Fowke, *Bayeux Tapestry*, p. 75; Bertrand, *Tapisserie de Bayeux*, pp. 93–5; Brooks and Walker, 'Authority and Interpretation', p. 21 (pp. 80–1 above); Bernstein, *Mystery of the Bayeux Tapestry*, pp. 121 and 199, n. 16; Grape, *Bayeux Tapestry*, pp. 70–1; and, with an interesting but unprovable speculation, Cetto, *Bayeux Tapestry*, pp. 7–8. Another much discussed occasion is the arrival of William's messengers at Guy's palace (Wilson, *Bayeux Tapestry*, pls 10–12), for which see n. 174 above. (Bachrach, 'Observations', pp. 12–14, offers an alternative explanation.)

we are told, give the crown of the king to Harold; and this is followed by the image of Harold enthroned (pl. 13). Understanding this superficially puzzling section of the embroidery is of considerable importance for apprehending the way the designer worked, the difficulties he faced, and his general success in surmounting them.

The fact that the reversal of time occurs exactly at the join between two separate sections of the embroidery should be noted, though it is debatable whether this is particularly significant.[190] The funeral cortège and the left appendages of the building are at the end of section two, while the deathbed and shrouding appear at the start of section three. The inscription for the lower scene (*Et / hic: defunctus est*) straddles the join as indicated, as does the figure of the man on the left who is attending to Edward's corpse (pl. 12). It should also be borne in mind that the last four events in this cycle actually happened in fairly quick succession.[191] Westminster Abbey was consecrated on the 28th December 1065; Edward died on the 5th January 1066; and he was buried on the 6th, which was also the day on which Harold was crowned. If the enthronement occurred at Westminster, these events were close in space as well as time.

In point of fact, there is only one scene in the Tapestry's version that is out of order; and it seems likely that this circumstance (along with the 'double-decker' portrayal) reflects the conflicting demands of the individual elements of this complicated section. The fluidity and success of the narrative depended on the juxtaposition of key events which were sequential in time and/or causally related. Unfortunately at this very busy point of the story, the requirements of chronology and the demands of causality were incompatible. It was deemed desirable to show the completion of Westminster Abbey next to the living Edward in order to indicate the king's sponsorship of the foundation during his life; while it was necessary to have the deathbed scene juxtaposed with the acclamation of Harold as king of England because of the intimate causal relationship between the two events. The dead king was placed below the deathbed scene to minimise the contradiction; but the funeral cortège (an important event of the momentous day when Harold was crowned) still had to move from right to left.

The fact that such reversals are so rare further underlines the skill of the designer in marshalling his material. It is most interesting to note that causality was perceived to be more important than chronology here. This underlines the fact that action and reaction, and not simply orderly temporal progression, was a central principle of the designer's narrative art.

There are four less celebrated occasions when the left to right flow stops. These are not the product of conflicting requirements, but rather a deliberate negation of the normal progression for a perceived artistic effect. The beholder's attention is

190 The join is just visible in Wilson, *Bayeux Tapestry*, pl. 30, at the very right of the left hand page. Bachrach, 'Observations', pp. 7–8, sees this as the key factor; however neither of his reasons (carelessness, or the wish to conceal a pro-Anglo-Saxon detail from a Norman patron) seems very plausible.
191 See Freeman, *Norman Conquest* II, pp. 507–22 and III, pp. 4–31 for a full narrative account. More succinct and analytical is F. Barlow, *Edward the Confessor* (London, 1970), pp. 240–55.

involuntarily arrested by the sudden halt; and the device is used to convey tense and climactic encounters. The Tapestry sets off on its left to right course with Harold taking his leave of King Edward and then England.[192] The first case of right to left movement is the appearance of Guy of Ponthieu (pl. 3).[193] The fact that he appears from the other direction and is followed by a group of four knights also moving to the left, well expresses his checking of Harold's progress and arresting him. The technique is used with similar effectiveness to express the meeting of Harold, Guy, and William (where William and three companions ride from right to left: pl. 6);[194] and again for Harold's encounter with Edward when he finally returns to England. Here Edward is a monumental seated figure facing left with a left-facing retainer behind him (pl. 11).[195]

The last and most spectacular deployment of the device occurs towards the end of the Tapestry (in its present state) when battle is joined between the Normans and the Anglo-Saxons. We see the Normans riding forth to war, after being expansively exhorted by William (pl. 20).[196] They canter away to the right, gradually picking up speed, until finally we see them galloping in a full charge. Crash! They collide with the Anglo-Saxons who are all facing the other way (pl. 21).[197] This sudden unequivocal check to their progress excellently conveys the first impact of battle. Hereafter, left-facing and right-facing figures alternate, cross, and clash, the wholesale departure from the former order well expressing the confusion and conflict of war (pl. 22).[198]

It was important, if the narrative were to be effective, for the beholder to be able to identify the key characters without difficulty. As is well known, the Anglo-Saxons and Normans are distinguished visually from each other initially (though not throughout the work)[199] by the fact that the latter have shorn necks and are clean shaven, while the former have hair continuing on to the nape of their necks and some of them also sport moustaches.[200] Most of the figures who populate the scenes lack specific identity; but this really does not matter. They have definite roles to play and some are even given personalities, but more specific identity is irrelevant. Indeed it would be a distraction. They are not the focus of attention.

The five main characters, Edward, Harold, Guy, William and Odo, are carefully marked out visually. Edward and Odo both have a personal iconography, to the extent of being conspicuously old, and a cleric respectively. It is no accident that when Odo appears in the Battle of Hastings clad in helmet and armour (thus losing

192 Wilson, *Bayeux Tapestry*, pls 1–6.
193 *Ibid.*, pls 7–8.
194 *Ibid.*, pls 13–15.
195 *Ibid.*, pl. 28. Cf. the commentary of Brooks and Walker, 'Authority and Interpretation', pp. 10–11 (p. 72 above).
196 Wilson, *Bayeux Tapestry*, pls 57–60.
197 *Ibid.*, pl. 61.
198 The same contrast is found in the Old English Hexateuch: cf. Gameson, *Role of Art*, p. 165.
199 Fowke, *Bayeux Tapestry*, p. 71, accounted for Harold's lack of a moustache when he returned to England from Normandy on the grounds that, when in the Duchy, 'all the English temporarily submitted to the customs of Normandy'!
200 Cf. Bertrand, *Tapisserie de Bayeux*, p. 287; and Gibbs-Smith, *Bayeux Tapestry*, pp. 8–9.

the specific indicators of his identity), he is distinguished from all the other mounted figures by his *baculum* and by the overtunic which he alone wears (pl. 24). This is dark, fully coloured, and decorated with triangles, and it contrasts strongly with the light, uncoloured armour (evoked by circles) worn by all the knights.[201] Harold, Guy and William are often marked out from the figures around them by the wearing of a coloured cloak which functions as a symbol of rank. There is little attempt to use consistency of clothing, colouring or facial features to make them distinct.[202] If we examine the figure of Harold in Normandy, for example, we find that he travelled with a fairly extensive wardrobe of tunics and co-ordinating cloaks. It might seem that the designer 'dropped a catch' here (though whether he supervised the actual embroidering, and hence whether he could have standardised the colours is unknown). One might observe that, people, especially important ones, do change their clothes, and in a sense such variations are therefore naturalistic. More to the point, however, is the fact that they contribute to the continual, highly decorative colour contrasts that characterise the work as a whole, and help to make it so engaging. Context and posture generally make it quite clear who the key figures are; while Harold and, to a lesser extent, William, are further marked out by the hawks that often appear on their wrists – again a symbol of aristocracy (pl. 6).[203] In Harold's case, there may also be a personal allusion here, since the Duke seems to have possessed or composed a treatise on hunting.[204] But above all (literally as well as figuratively) the inscriptions indicate identity. They leave little doubt of who is who, and what they are doing at each moment of depicted time.

Space in the Tapestry is predominantly lateral – running along the surface of the linen – and it is intimately linked to time. There is little sense of recessive space (that is pictorial space), and this absence of depth contributes appreciably to the narrative flow. The beholder is encouraged to look ever onwards from left to right, rather than to stare 'into' a given area. Since time also progresses from left to right, he is thus encouraged to move continuously through time rather than lingering over one temporal moment. The only space in William's hall, for instance, is lateral not recessive (pl. 15).[205] We inevitably move through it, therefore, from the left side to the right. As we do so, we meet in quick, interlocking succession: a messenger giving William the news of Harold's occupation of the English throne; William and Odo discussing this development, with William ordering ships to be built (seemingly at Odo's instigation); and finally a carpenter ready to hurry away and carry out his command.

201 Wilson, *Bayeux Tapestry*, pl. 67. Comment: Stenton (ed.), *Bayeux Tapestry*, p. 187. William is likewise distinguished on the battlefield by his staff and mace: Wilson, *Bayeux Tapestry*, pls 54 and 68.
202 Odo remains closely similar in the juxtaposed scenes of him blessing the food and then sitting with his half-brothers (*ibid.*, pl. 48).
203 Fowke, *Bayeux Tapestry*, pp. 28–9. See further in general G. Owen-Crocker, 'Hawks and Horse-Trappings: the insignia of rank', Scragg (ed.), *Battle of Maldon*, 220–37.
204 C. H. Haskins, 'King Harold's Books' *English Historical Review* 37 (1922), 398–400.
205 Wilson, *Bayeux Tapestry*, pls 34–5.

It is significant that when some sense of depth is indicated for a given moment – generally by a second or third image higher up the picture space and hence in the background – its subject matter is identical to that in the foreground.[206] Thus in the next scene we see two sets of workmen building boats; and soon afterwards two files of men carrying armour to the completed vessels (pl. 16).[207] There is still only one narrative subject here: it is doubled up to indicate how much manpower and effort were involved. The temporary depth enriches the single image – it is not a multiple image – while our progress through time remains wholly lateral and is unabated.

The general lack of depth, the absence of a recessive plane, is consonant with eleventh-century canons of pictorial representation.[208] Its positive effect is to present the subject matter to the beholder in a very immediate way. We are not looking at a story unfolding at different depths into a space which recedes away from us: everything happens right in front of our eyes.

This leads on to the last point I wish to make on the subject of pictorial narrative, which concerns scale.[209] Scale fluctuates greatly from one scene to the next. Sometimes figures fill the entire picture area, other times a building or a ship does – at which point the figures have shrunk in size. Size and scale are flexible devices which the artist manipulates (as did some contemporary illuminators) to ensure that the principal subject of every moment occupies the maximum available space, subject to the need to include inscriptions. Thus when the principal theme is sailing, boats fill the space; when it is felling trees, trees fill the space; when it is riding, horse plus rider fills the space; and when it is the interaction of men, it is they that fill it. Fettered neither by the constraints of optical perspective, nor by the desire to make his images actually resemble the real world, the designer could symbolise it very effectively, and ensure that the true subject of each moment was impressed upon the beholder. From time to time he oversteps his self-imposed boundaries and details, buildings, or the action itself extend into the border, thereby expressing the special magnitude, excitement, or force of what is happening.[210] The grandeur of certain buildings, for example, is conveyed in this way (pls 9, 14, 15), as is the great size of ships (pl. 17). Above all, the technique is used to emphasise the violence of the Battle of Hastings. Here both borders are occupied, corpses filling the lower one, spearpoints projecting into the upper one (pl. 23). Such is the energy of what is happening that the linen can hardly contain it.

206 I am not wholly convinced by the suggestion (Brown and Herren, '*Adelae Comitissae*') that the little boats in the invasion scene are meant to be different types of craft – if so, why are none of them aligned with the other ships, and why are they set so high? The high set detail to suggest background or context had a venerable artistic tradition in, for instance, Ottonian manuscripts: cf. M. Bunim, *Space in Medieval Paintings and the Forerunners of Perspective* (New York, 1940), pp. 62–85, esp. 64–5.

207 Wilson, *Bayeux Tapestry*, pls 36–8.

208 See further Gameson, *Role of Art*, pp. 150–91.

209 Cf. *ibid.*, pp. 166–76.

210 The major examples occur on Wilson, *Bayeux Tapestry*, pls 5–6, 19, 23, 25, 28, 31, 32, 33, 34, 40–3, 61–73. Minor instances (a spear-point etc.) occur on *ibid.*, pls 21, 29, 39, 45, 50, 59–60. For the broader artistic context see Gameson, *Role of Art*, pp. 152–60.

Ultimately what makes the beholder follow the narrative is his interest in it. The excitement of the story, the skill with which it is told, the fast pace of what happens, and the general visual attractiveness of the work, all make the experience of viewing the Tapestry a fascinating one, and hence its story is compelling.

Historicity

Now that we have the Tapestry's nature as a carefully crafted work of art firmly before our eyes, we can profitably proceed to comment on the nature of the history depicted in it, and more generally on its historicity. The Bayeux Tapestry, unlike some works of art, is self-evidently an historical document. Its unique status in this respect is underlined by the fact that it is the only visual source in the massive *English Historical Documents* collection.[211] But what type of source is it; and what is the nature of the history it embodies?

To begin from a conventional starting point, the Tapestry is a problematic authority for the events of 1064–6 because its date and origin are uncertain, the traditions on which it depends (its own sources) are unknown, and its relationship – if any – to the surviving written accounts is obscure. The Tapestry may well be nearly contemporary with the events it depicts (as I believe most probable), however we cannot wholly rule out the possibility that it postdates them by up to a quarter of a century. In the view of some historians, it must be treated with additional caution because it is patently art; this, however, is simply anachronistic, iconophobic chauvinism. There is absolutely no reason to believe that a textual account *per se* is any more reliable than a visual one. Writer and designer alike had agendas to follow; and a text could, in its way, be as enigmatic or as formulaic as an image. William of Jumièges' version of events, for instance, is singularly lacking in depth; while some of William of Poitiers' details were shaped by literary artifice and classical models[212] rather than historical reality.

This is not to deny that a pictorial source presents its own problems. On the one hand, it is sometimes unclear what exactly is depicted in the Bayeux Tapestry; while on the other hand, the work includes a plethora of descriptive detail which, although unambiguous, is nevertheless potentially misleading. Let us consider these two points in turn.

The exact content and implication of key scenes such as the oath swearing, the death of Edward the Confessor (pl. 12), and the death of Harold (pl. 26) have long been debated and opinions still differ; the interpretation of certain other figures and scenes is equally varied – as perusal of any selection of commentaries will reveal. The imagery in question is not fully explicit and self-explanatory, and consequently its interpretation depends on the beholder's suppositions, or on external information.

211 Ed. Douglas and Greenaway, pp. 247–301, where its value as a historical source is rated very highly (p. 247).

212 As set out in the notes of Foreville's edition.

This will always have been the case: whereas modern scholars rely on the surviving range of written sources to form their opinions (and these have generally varied according to which source – or hypothesis – is favoured), the eleventh-century viewer was, doubtless, influenced by what he knew personally or by a human guide, as noted earlier. The only way to cut this Gordian knot, it seems to me, is to remember that the designer can hardly have been unaware of the limitations of his art in this respect. Consequently, whilst he no doubt added subtleties and embellishments as he saw fit, he is likely to have stressed the key points he wanted to convey as forcibly as he was able.[213] I will explore this theme more fully in due course.

Turning to the second point, the crucial difference between the Bayeux Tapestry and the other sources is that, being a visual rather than a textual account, it does not merely state what came to pass, it also depicts the events in question. The Tapestry by its very nature includes a mass of descriptive pictorial detail: that is how it tells its story. The beholder, in consequence, not only learns what happened, but simultaneously *how* it happened, and what it looked like. The mass of descriptive pictorial detail renders this version of the story highly credible – seeing is believing – and makes the experience of viewing it enthralling. This is ultimately why, although few individuals today read William of Jumièges, William of Poitiers, or the *Anglo-Saxon Chronicle*, countless people make the pilgrimage to Bayeux. For those modern historians who remain shy of artistic evidence, it is a forcible advertisement of the great importance of visual representations in eleventh-century culture, and one which simultaneously provides a potent demonstration of why this was the case.

The Tapestry has long been studied for its invaluable record of eleventh-century material culture; and in general, making allowance for pictorial convention and schematisation and for the fact that the designer is highly unlikely to have seen every place and object he had to depict, its witness seems to be fairly reliable.[214] This is as one would expect. Nevertheless, we should be very careful to distinguish between the credibility of the individual details in their own right on the one hand, and their authority in a particular scene on the other. The fact that the depicted clothes are, insofar as we can judge, reliable representations of eleventh-century garments, for example, does not mean they record what a particular historical character actually wore on a specific occasion. This may seem obvious. In reality, however, it is all too easy to forget that the portrayal of countless details, from feasting to sailing, is equally fictitious. The art of the Tapestry is not only highly attractive, it is also very seductive. The deathbed of Edward the Confessor is a helpful case to bear in mind here

213 *Pace* Wissolik and Bernstein, who seem to believe precisely the reverse.

214 See *inter alios* J. Mann, 'Arms and Armour'; J. Nevinson, 'The Costumes'; and R. A. Brown, 'The Architecture', all in Stenton (ed.), *Bayeux Tapestry*, respectively 56–69, 70–5, and 76–87; also Bertrand, *Tapisserie de Bayeux*, pp. 261–309; Parisse, *Bayeux Tapestry*, pp. 81–123; G. R. Owen-Crocker, *Dress in Anglo-Saxon England* (Manchester, 1986), pp. 131–73; Wilson, *Bayeux Tapestry*, pp. 213–27; and R. A. Brown, 'The Castles of the Conquest' in *Domesday Book Studies*, ed. A. Williams and R. Erskine (London, 1987), 69–74.

(pl. 12).[215] It is a very striking image; yet it can hardly be regarded as evidence that the King died in an upstairs chamber when, as we have seen, the 'double-decker' portrayal was motivated by complex narrative and artistic factors. Similarly, the Tapestry depicts the various military operations in Normandy and Brittany in stylised and generalised forms rather than in specific, historically accurate ones (pl. 9).[216] There is no reason to believe that the designer of the Tapestry was an eye-witness to any of the events he depicted; and we can be confident that it was artistic no less than factual considerations that determined how he portrayed them. The Tapestry is an eleventh-century evocation of history, not a visual record of the events in question, and we must resist the temptation to consider it as such.

Furthermore, the designer had to convey the concept of what was being done – and its thematic relevance – in the clearest and most intelligible way possible, and this could often be at odds with 'reality'. An obvious example of the phenomenon is the exaggerated depiction of Anglo-Saxons watching for Harold's return from Normandy.[217] One figure looks out to sea, his action accentuated by a magnificently rubbery arm, and the message is underlined by the fact that every window of the structure behind him is filled with a head peering in the same direction (pl. 11). No one would seriously consider this as a factual representation. Yet every inch of the oath-swearing scene down to the minute details of the two reliquaries has been scoured for its 'historical' implications (pl. 10).[218] Are we, however, really entitled to see in this powerful image anything more than a heavily accentuated way of show-ing that Harold swore a sacred oath to William, as the inscription declares?

Thus while we may regard the depictions as a dependable impression of eleventh-century material culture, and while we can view the story as, in outline, a fairly reliable version of events, we should be very wary of accepting the imagery as an accurate portrayal of how the events in question happened, and we should avoid placing too much weight on the interpretation of details. Accordingly, the following discussion will focus on the broad outlines of the story rather than on the minutiae of individual scenes.

In point of fact, most of the early sources for the events leading up to the Norman Conquest are in broad agreement, subject to their different origins and perspectives; and in outline at least there is little doubt that the Bayeux Tapestry offers a reason-

215 Wilson, *Bayeux Tapestry*, pl. 30.
216 Cf. Bachrach, 'Observations', pp. 8–12, who, however, takes a very literal view of how an early medieval artist should have depicted a town. No contemporary, surely, would have expected more verisimilitude. One should, however, be cautious here. While Fowke, *Bayeux Tapestry*, p. 99 regarded the horses clambering out of the ships as a reflection of true, albeit primitive practices, Bachrach, 'Observations', pp. 11–12, pointed out that it was impossible; however practical trials with a reconstructed Viking ship proved that it was indeed possible – at least on a small scale (cf. Grape, *Bayeux Tapestry*, p. 38).
217 Wilson, *Bayeux Tapestry*, pl. 27.
218 *Ibid.*, pls 25–6. For a selection of comment cf. Fowke, *Bayeux Tapestry*, pp. 67–9; Bertrand, *Tapisserie de Bayeux*, pp. 91–3; Stenton (ed.), *Bayeux Tapestry*, p. 179; and Bernstein, *Mystery of the Bayeux Tapestry*, pp. 116–17 and 196–7; also D. Rollason, *Saints and Relics in Anglo-Saxon England* (Oxford, 1989), pp. 191–2.

able rendering of what happened.[219] The degree of historical accuracy in its general narrative underlines the care that was lavished on it, and it might also be held to favour an earlier rather than a later date.

Assessing all the early sources together, we find that in overall balance, pace and story the Bayeux Tapestry is most closely comparable to the pithy pro-Norman account of the monk William of Jumièges, the earliest Norman writer. He completed his *Gesta normannorum ducum* before 1060, and later, probably at William's behest, appended an account of the Conquest which was completed in 1070.[220] In the detail of its tale the Tapestry has many correspondences with the slightly later, much fuller, and more literary version of William of Poitiers, who probably wrote between 1071 and *c.* 1077 – though his adulation of Duke William is conspicuously lacking in the visual narrative.[221] Scrutinising the various accounts more carefully and looking for discrepancies, the overall Norman perspective of the Tapestry remains striking. It recounts events in Normandy in considerable detail, as does William of Poitiers (though the two accounts disagree at certain points);[222] while it omits Stamford Bridge, a key part of the Anglo-Saxon story and an important contributory factor to their defeat at Hastings (which is mentioned by William of Poitiers, but not William of Jumièges).[223] It lingers over the Normans building and equipping their ships (arms and wine being the commodities specified: pl. 16), and it allots a generous amount of space to depicting an impressive invasion fleet (pl. 17). We also see, as has long been noted, that Odo of Bayeux and Bayeux itself play a more prominent part than in any other source.

Yet the Tapestry is not relentlessly, jingoistically pro-Norman, and it is certainly not a panegyric of Duke William like the *Carmen de Hastingae Proelio* and William of Poitiers' *Gesta Guillelmi*. Harold dominates the story, occurring more frequently than any other character including William,[224] and care and attention is lavished on his

219 Numerous writers over the years have compared the Tapestry with the written accounts. F. M. Stenton, 'The Historical Background' in Stenton (ed.), *Bayeux Tapestry*, pp. 9–24, and Barlow, '*Carmen de Hastingae Proelio*' remain immensely valuable. For more recent treatments from different perspectives see R. H. C. Davis, 'William of Poitiers and his *History* of William the Conqueror' in *The Writing of History in the Middle Ages: essays presented to Richard William Southern*, ed. R. H. C. Davis and J. M. Wallace-Hadrill (Oxford, 1981), 71–100, repr. with postscript in his *From Alfred the Great to Stephen* (London, 1991), 101–30, esp. 104–14; and S. A. Brown, 'The Bayeux Tapestry: history or propaganda?' in *The Anglo-Saxons: synthesis and achievement*, ed. J. D. Woods and D. A. Pelteret (Waterloo, 1985), 11–25; also her, 'Why Eustace, Odo and William?', esp. pp. 13–18.

220 The standard new edition is *The Gesta Normannorum Ducum of William of Jumièges, Orderic Vitalis and Robert of Torigni*, ed. E. M. C. van Houts 2 vols (Oxford, 1992–5), replacing *Guillaume de Jumièges, Gesta Normannorum Ducum*, ed. J. Marx (Rouen and Paris, 1914). van Houts discusses the date of the work on pp. xxxii–v of vol. I.

221 William of Poitiers, *Gesta Guillelmi*, ed. Foreville, with discussion of the date of composition at pp. xvii–xx. See also Davis, 'William of Poitiers and his History', with discussion of the date at p. 104.

222 Conveniently summarised by Grape, *Bayeux Tapestry*, pp. 57–8. But cf. n. 232 below.

223 *Anglo-Saxon Chronicle* 1066 (C, D, E): *English Historical Documents* II, ed. Douglas and Greenaway, pp. 144–7. William of Poitiers, *Gesta Guillelmi*, ed. Foreville, II, 8 (p. 166). Symeon of Durham includes Stamford Bridge in the very brief account of 1066 included in his *Historia Dunelmensis ecclesiae*: Durham University Library, Cosin V. ii. 6, fols 63v–4r.

224 Cf. Cowdrey, 'Interpretation', n. 11.

activities well beyond the requirements of the Norman version of events. We see him going to Bosham church and feasting in England (pl. 2), for example, and heroically saving some of William's men in Normandy (pl. 8).[225] After he returns to England, we are apparently shown him being rebuked by King Edward (pl. 11), a scene which invites comparison with Eadmer's later, pro-English account of the event.[226] Subsequently Edward's deathbed commission of England to him seems to be represented (pl. 12) – something merely alluded to by William of Poitiers, but spelled out by the *Anglo-Saxon Chronicle* (C and D)[227] and by Florence of Worcester, and fully recounted, albeit in studiedly discreet terms, in the *Vita Edwardi*, a work sympathetic to the Godwin family which was probably composed between 1065–7 and certainly before 1075.[228] Thereafter, in the inscriptions of the Tapestry, Harold is unambiguously styled 'king' or 'king of the English' (*Rex anglorum*). Whatever nuances and innuendos a Norman viewer may have seen in all this, and whatever sardonic comments some beholders may have perceived in the borders,[229] Harold is depicted (like Oedipus) as a good man who did a bad deed and paid the price. We can empathise with him, and this is surely another indication of the English connections of the work. Yet the point should not be pressed too far. The actual sequence of events required a fair amount of space to be given to Harold; focusing on him was an expedient for giving continuity to the visual narrative; the overarching theme of the events in Normandy was the power of Duke William and Harold's relationship to him; and there is no doubt that from the moment news reaches William that Harold has been crowned (pl. 15), it is the Normans who dominate the work. The moral dimension of the story likewise demanded that attention be paid to Harold's deeds; and if their rights and wrongs are slightly ambiguous at this stage, they were to be judged unequivocally in due course.

Discrepancies between the imagery of the Tapestry and an early written version raise interesting questions, and scholarly attention has, quite naturally, focused on these 'cruces'. What really happened? Which account is the most reliable? Why has the other version departed from the 'truth'? When the first question is insoluble, the answers to the second and the third depend on the judge. Only when both the first and second questions can be answered with some confidence can the third be approached; and it still requires sensitive handling. Was the cause ignorance, artistic convention, or a deliberate wish to re-present the events in question for a perceived result?

225 Wilson, *Bayeux Tapestry*, pls 3–4, 19–20.

226 *Ibid.*, pl. 28. Eadmer, *Historia Novorum in Anglia*, ed. M. Rule, Rolls Series (London, 1884), 6–8. Cf. Brooks and Walker, 'Authority and Interpretation', pp. 10–11 (p. 72 above).

227 *English Historical Documents II*, ed. Douglas and Greenaway, p. 143.

228 *The Life of King Edward the Confessor*, ed. F. Barlow (London, 1962), pp. 79–80. See pp. xv–xviii for comments on the author's treatment of Godwin and his family; and pp. xxv–xxx for the date of writing. R. R. Darlington argued in his review (*English Historical Review* 79 (1964), 147–8) that the death of Edith in 1075 was the only secure *terminus ante quem*. Cf. also Barlow, *Edward the Confessor*, pp. 247–53. *Florentii Wigornensis Monachi Chronicon ex Chronicis*, ed. B. Thorpe 2 vols (London, 1848–9), I, 224; to be read in the light of R. R. Darlington and P. McGurk, 'The *Chronicon ex Chronicis* of 'Florence' of Worcester and its use of sources for English History before 1066', *Anglo-Norman Studies* 5 (1983), 185–96.

229 Cf. Cowdrey, 'Interpretation', pp. 53–6 (pp. 99–100 above), for the suggestion that the main story at this point is potentially subverted by elements in the borders.

The place where the Tapestry is most obviously (or seemingly) at odds with the corresponding written source, namely William of Poitiers, is the Breton campaign, and the location and timing of Harold's oath. Few would disagree that by presenting the oath-swearing (pl. 10) as the culmination of Harold's sojourn in Normandy, it is accentuated and made all the more relevant to the events that follow it (seemingly in quick succession) on his return to England.[230] Similarly, assuming Odo of Bayeux was indeed the patron of the work, the relevance of (re)locating the oath at Bayeux is equally apparent.[231] But why is the Breton campaign depicted in so different a way? Here, however, we must be cautious. The seige of Dinon is shown only in the Tapestry,[232] the route thereto via Rennes seems bizarre, and there is no immediately obvious explanation for either point. This could, however, be the sum total of the discrepancy. The scenes around Dol are not necessarily at variance with the written account in the way that modern commentators have assumed. The belief that the Tapestry depicts Conan and his force inside Dol and escaping therefrom (as opposed to besieging it, as William of Poitiers relates) rests solely on the interpretation of a single figure on a rope which extends from the town.[233] But there is no reason to assume that he is Conan. Earlier commentators did not interpret him as such,[234] and indeed this seems a most improbable way of representing an alien force in possession of a town. On the contrary, it is far more likely that Conan and his troops are represented by the figures to the right of the town, who are raising the siege and fleeing at the approach of William's party – as the written account says. Whatever the truth of the matter, it is clear that before we can ascribe any general significance to such a 'discrepancy' – and this one has been interpreted as evidence for the existence of a written text underlying the Tapestry[235] – we must be wholly certain that we are reading the image correctly.

Needless to say, correspondences of detail between the Tapestry and a written version of the events do not demonstrate that the designer of the Tapestry knew the text in question. At the most they suggest that the writer and the designer were drawing on common traditions.[236] Such correspondences likewise fall short of proving that *that* is what actually happened. The available body of material is too small and too partisan for such alignments to be decisive. Moreover, there is no '*Ur*

230 William of Malmesbury's short account has the events in the same order: *Gesta Regum Anglorum*, ed. W. Stubbs 2 vols RS (London, 1887–9), I, 279.

231 But cf. Bates, *William the Conqueror*, p. 61.

232 Wilson, *Bayeux Tapestry*, pl. 23.

233 *Ibid.*, pl. 21, with comment at p. 180. Cf. William of Poitiers, *Gesta Guillelmi*, ed. Foreville, I, 45 (p. 110). The figure in the Tapestry is identified as Conan in, for example, Stenton (ed.), *Bayeux Tapestry*, p. 180; and Grape, *Bayeux Tapestry*, p. 111.

234 Freeman, *Norman Conquest* III, pp. 711–12, followed by Fowke, *Bayeux Tapestry*, interpret the scene (and hence the figure) in an entirely different way. Bertrand, *Tapisserie*, p. 89, however, is non-committal.

235 Brooks and Walker, 'Authority and Interpretation', p. 3 (pp. 65–6 above).

236 See Barlow, '*Carmen de Hastingae Proelio*', esp. p. 202. Brown and Herren, '*Adelae Comitissae*', argue methodically for the view that Baudri had seen and been influenced by the Bayeux Tapestry.

text' to recover.[237] Nor, incidentally, do minor agreements and disagreements with the written accounts provide satisfactory grounds for dating the Tapestry.[238] The concerns and priorities of the patron and designer are unlikely to have been altered by a mere text even if they knew it.

The key point, of course, is that, irrespective of the insoluble problems of obtaining wholly reliable information themselves, these accounts were not compiled to record objective fact and to preserve history, but rather to make it. What actually happened was relevant source material for this process; but even if this were known, it was not binding, nor was it an end in itself. What *should* have happened was sometimes more important than the accident of what did happen; and what it signified was invariably more important than what it was. The best historian was the one who told his tale most compellingly and convincingly, preferably to the most influential audience. Judging by manuscript survival, William of Jumièges' version was the most popular and widely disseminated.[239] However, in terms of compelling and convincing, there can be no doubt that the designer of the Bayeux Tapestry was much the best historian of the Conquest, and that his medium was potentially the most powerful.

The Bayeux Tapestry can be scrutinised and plundered alongside the other sources in the cause of a modern craving for factual accuracy; but that was not what it was made to record. It was designed to enshrine a highly selective interpretation of what happened, and to make that interpretation normative. To do so effectively it had to portray the broad sweep of events correctly, and it had also to be credible in visual detail.[240] (And let us remember that very few, if any, contemporary viewers will have looked at it with an alternative written version in their hand; and none will have had the opportunity to compare it with the range of texts that modern scholars have at their disposal.) Such was its success that we can be fairly confident that most people who saw the Tapestry in the eleventh century will have received the story exactly as the designer presented it. The Bayeux Tapestry is an objective record of how some people wanted to conceive the events in question, and correspondingly of how certain others came to perceive them. Whoever heard or read the *Carmen de Hastingae proelio* or William of Poitiers' *Gesta Guillelmi* would have known that Duke William was a hero of epic stature worthy of comparison with the ancients,[241] upholding his case against an evil tyrant. Anyone who read or heard the *Anglo-Saxon Chronicle* would have been aware that King Harold was hardy and

237 Grape (*Bayeux Tapestry*, p. 57) apparently believes that one can discount English sources (because they are either hagiography or date from the twelfth century: p. 51) and apply stemmatics to the surviving Norman writings to deduce that the Tapestry relies on a lost Norman source. For the parallels between William of Jumièges and William of Poitiers and their possible implications see William of Poitiers, *Gesta Guillelmi*, ed. Foreville, pp. xxv–xxxv; and Davis, 'William of Poitiers', pp. 104–10.
238 *Pace*, e.g., Cowdrey, 'Interpretation', pp. 62–3 (pp. 107–8 above).
239 See *Gesta Normannorum*, ed. van Houts, I, esp. pp. xcv–cxxviii.
240 See n. 214 above.
241 See Davis, 'William of Poitiers', pp. 102–3.

energetic, but beleaguered and had faced overwhelming odds. Whoever saw and heard the Tapestry would know that Harold was brave; that he was bound to William by the gift of arms and an oath sworn at Bayeux (pl. 10); that his kingship was associated with the disreputable Stigand (pl. 13); that Odo of Bayeux played an important role in his come-uppance (pls 15, 24); and so on. The historicity of the Bayeux Tapestry in an eleventh-century context is the history that it makes. The principal question we should, therefore, ask is: what is the history that it creates?

Meaning and Message

This leads directly on to my conclusion which concerns the overarching message of the Tapestry. The Bayeux Tapestry provides a rich account of the events of 1064–6, full of countless subtleties. Within this framework, as we have seen, some aspects receive particular emphasis, certain others less so, while yet others are ignored. The more you look, the more you see; and the work was undoubtedly designed to support and engage detailed scrutiny. For some people, notably Wadard, Vital, and Turold, not to mention Odo, the imagery is likely to have had deep personal resonances. It is certainly not my intention to minimise the wealth of meaning and messages that this rich work conveys and could have conveyed, but rather to enquire whether there is a dominant or overarching theme here. Or, to state the matter more bluntly and return to the observations I made at the outset: what above all did the hypothetical eleventh-century 'general' beholder take away from the experience of seeing the Tapestry?

Over the years many writers have, with great skill and ingenuity, expounded the possible meaning and relevance of puzzling motifs and details.[242] Some have gone on to deduce that the motif or section in question provides a key to the work as a whole. I see no value in engaging in detailed discussion (or, in some cases, refutation) of the various views that have been put forward. It seems fairly self-evident that any methodology which bases a general interpretation of a vast work on a couple of details within it, is fundamentally flawed. An overarching message that every beholder was meant to grasp is not likely to have relied on absorbing the significance of a single figure. As we have seen, the designer was adept at underlining the things he wanted to stress.

The story of the Tapestry focuses above all on Harold. We meet him at the very beginning (pl. 1), and follow his adventures in Normandy and Brittany. Subsequently, we see him swearing an oath before William (pl. 10). He eventually reneges on his putative obligations to William, accepting the crown of England (pl. 13), and it is immediately made clear – via the appearance of the comet, by the boats in the lower border, and by the unease with which he sits on the throne (pl. 14)[243] – that nemesis is coming by sea. As numerous commentators starting with William of

242 Two recent examples: D. J. Bernstein, 'The Blinding of Harold and the Meaning of the Bayeux Tapestry', *Anglo-Norman Studies* 5 (1983), 40–64; and Brown, 'Why Eustace, Odo and William?'.
243 Wilson, *Bayeux Tapestry*, pls 32–3.

Jumièges have stated, Harold and the English fell through their own treachery.[244] The later sections of the Tapestry, as it survives, show the working out of this process.

But what in this is stressed above all? What is it that that first-time viewer cannot miss? What is it that overwhelms us if we step back from inspection of details and look at the Tapestry as a whole? What truly dominates the work? The answer is simple and obvious: war, war, war – and in particular the Battle of Hastings (pls 20–6). The section that narrates the conflict comes at the very end of the work as it now survives, and was probably near to the end in its original form. (Speculation about what has irrevocably vanished is clearly of little value, but if the final section of the Tapestry was of a similar length to its five predecessors, only about 2 metres have been lost.[245] It is possible that the work ended at Hastings showing the Normans as masters of the battle field. And even if more events have gone – including the much hypothesised coronation of William – we can be confident that they were for the most part military ones.) The Battle of Hastings is, through the superlative skill of the designer, engrossing and unforgettable; its energy is underlined by its being one of the areas where the action spills into the border; and it is a very lengthy section – far longer than any other event depicted, comprising just over a quarter of the surviving artefact. We can perceive distinct phases in the conflict: the joining of battle (pl. 21), the deaths of Harold's brothers (pl. 22), the tumultuous cavalry attack on a hillock (pl. 23), the Norman rout and its reversal (pls 24–5), the Norman counter-offensive leading to the death of Harold (pl. 26), and the English turning to flight.[246] And an attempt is made to show the different tactics that were used.[247] The imagery is carefully orchestrated; it shows that it was a hard fight, and it demonstrates how it was won.

The Tapestry's focus on war has been commented on before. It has been likened to the slightly later French *chansons de gestes*, as also to the rather earlier Old English *Battle of Maldon*, and has been interpreted as a 'secular' feature.[248] The Battle of Hastings itself receives a similarly extended treatment from William of Poitiers, who does his best to evoke its ebb and flow, and to heroicise the Normans, especially, needless to say, Duke William. There is no doubt that martial endeavour did appeal to a contemporary audience, not least a secular one. But is this all that is at stake here? I suggest not. To see this focus as the counterpart of contemporary literary tastes and interest in martial excitement is at best a partial and rather modern

244 *Gesta Normannorum Ducum*, ed. van Houts, VII, 13 with (35) (vol. II, pp. 160 and 166–8). Cf. W. R. Letheby, 'The Perjury at Bayeux', *The Archaeological Journal* 14 (1917), 136–8 (repr. as Ch. 3 above).

245 The lengths are conveniently illustrated in tabular form in Bertrand, *Tapisserie de Bayeux*, p. 24.

246 Wilson, *Bayeux Tapestry*, pls 51–73. For comment see Brown, 'Why Eustace, Odo and William?', pp. 11–20. For a modern account see R. Allen Brown, 'The Battle of Hastings', *Anglo-Norman Studies* 3 (1981), 1–21; repr. in *Anglo-Norman Warfare*, ed. M. Strickland (Woodbridge, 1992), pp. 161–81, citing earlier literature in n. 2.

247 Fowke, *Bayeux Tapestry*, pp. 120–36; Cowdrey, 'Interpretation', pp. 61–2 (pp. 105–7 above).

248 Dodwell, 'Bayeux Tapestry and French Secular Epic'; Wilson, *Bayeux Tapestry*, p. 203. Further on the analogies between the Tapestry and *Roland* see S. A. Brown, 'The Bayeux Tapestry and *The Song of Roland*', *Olifant* 6 (1979), 339–50.

answer. We still see the battle as exciting, as no doubt did our eleventh-century predecessors. We can distinguish the various stages in the struggle, and they will have done so with greater knowledge and interest than us. But the key point is that they, unlike us, appreciated what it all signified.

William of Poitiers provides clear guidance here in his (no doubt fanciful) account of the preliminaries to the Battle of Hastings. According to him, William suggested that the rival claims be submitted to legal judgement; if Harold refused, he challenged him to single combat, declaring, 'Behold, I am ready to wage my head against his that it is to me rather than to him that the English kingdom falls by right'. Harold did not accede to either request. He continued to move his forces forward, and then, asserts William of Poitiers, he 'lifted up his face to heaven and said, "May God today judge what is just between me and William"'.[249]

Trial by battle was fairly widespread in the early middle ages, not least in the eleventh century.[250] Three sources even report that a dual was fought in 1077 to decide whether or not the Roman liturgy should replace the Mozarabic one in Spain.[251] Charges of treason in particular seem to have been resolved in this way. The *Anglo-Saxon Chronicle* (E), for example, recounts that in 1095 at William Rufus' court 'Geoffrey Bainard accused William of Eu, the king's kinsman, of having been party to the treason against the king; and he fought it out with him, and overcame him in trial by battle. And when he was overcome the King ordered his eyes to be put out and that he should afterwards be castrated.'[252] The fate of the fictitious traitor Ganelon in the *Chanson de Roland* was likewise decided via trial by combat. As the fight intensified, we are told that Charlemagne cried, 'O God, make clear the rights of the matter'.[253] Trial by battle seems to have been formally introduced to England after 1066, first appearing in the Laws of William I.[254] However, the philosophy that underlay such specific, judicial combat had been a fundamental tenet of belief for centuries, in England as much as elsewhere. No one doubted that ultimately God decided the outcome of war. The good Christian king would win his battles, as Constantine had done, because God was on his side. Conversely as Charlemagne and Alfred the Great believed, if a Christian kingdom was beleaguered and losing its wars, it was because something had gone fundamentally wrong with its observance of the faith.[255] Thus both these monarchs, like many

249 William of Poitiers, *Gesta Guillelmi*, ed. Foreville, II, 12–13 (pp. 176–80).

250 Cf. in general C. Morris, '*Judicium Dei*: the social and political significance of the ordeal in the eleventh century', *Studies in Church History* 12 (1975), 95–111; and R. Bartlett, *Trial by Fire and Water: the medieval judicial ordeal* (Oxford, 1986), pp. 103–26.

251 Namely the *Chronicon Burgense* (ed. H. Flórez, *España Sagrada* (Madrid, 1749–1879) XXIII, p. 309); the *Annales Compostellani* (*ibid.*, p. 320); and the *Chronicon Nájera* (ed. J. Cirot, *Bulletin hispanique*, XI (1909), p. 277). I am very grateful to Rose Walker for these references.

252 *Sub anno* 1096: *Two Saxon Chronicles Parallel*, ed. Earle and Plummer, I, p. 232; *English Historical Documents* II, ed. Douglas and Greenaway, p. 181.

253 Line 3890. *La Chanson de Roland*, ed. Whitehead, p. 114: 'E Deus, dist Carles, le dreit en esclargiez'.

254 *Die Gesetze der Angelsächsishen*, ed. F. Liebermann, 3 vols (Halle, 1903–16), I, p. 483.

255 Cf. *King Alfred's West Saxon Version of Gregory's Pastoral Care*, ed. H. Sweet, 2 vols Early English Text Society 45 and 50 (Oxford, 1871), I, pp. 2–9.

others, tried to strengthen their military performance by enhancing the spirituality of their kingdoms. The point is articulated throughout the *Chanson de Roland*, where we are shown God's repeated intervention to fortify the good Christians. God, we are told, guards Oliver for example; while the Angel Gabriel watches over Charlemagne and provides decisive support enabling him to defeat the pagan emir Baligant.[256] Spirituality is integral to the Franks' martial endeavours: their bishop fights with them; they prepare for combat by receiving mass and being shriven; and their key weapons incorporate relics. When the pagans are defeated, we are told that this is because it is God's will.[257]

The Norman written sources for the Norman Conquest make the same points quite clearly in their different ways by stressing the spirituality of Duke William. William of Jumièges juxtaposes Duke William's coronation with his intimate involvement in the dedication of the abbey church at Jumièges.[258] William of Poitiers stresses Duke William's love for, and sponsorship of, the church in Normandy before his expedition; his seeking and gaining of papal approval for the venture (underlining the sanctity and learning of Pope Alexander II in order to emphasise its significance); his use of relics to smooth his path; and his substantial gifts to the church in Normandy after the Conquest.[259] Whatever of all this we are inclined to accept as 'true', it underlines the central role of the philosophy that ultimately it was divine intervention and not human prowess that won battles.

Now the message that the Bayeux Tapestry conveyed to the contemporary beholder was the exact counterpart of this. It stresses the importance of the battle, and shows how the Normans eventually won; thereby demonstrating beyond a shadow of doubt that God was with them and supported their cause. Looking with modern eyes, we see a tense, exciting battle; eleventh-century eyes would, we can be quite sure, perceive a closely fought battle betokening divine judgement. The earlier sections of the Tapestry illustrate the extent to which this case was a difficult one for man to understand: Harold's predicament is made intelligible in human terms; the dying Edward the Confessor appears to be shown entrusting the kingdom to him (pl. 12).[260] This is acceptable because Hastings ultimately reveals the unequivocal, divinely ordained truth of the matter.

Thus, despite arguments to the contrary, the subject matter of the Bayeux Tapestry makes it eminently well suited for display in a church, and to be the property of a swashbuckling cleric. Indeed it is wholly in keeping with the Romanesque

256 E.g. ll. 1316, 2448–57, 2525–8, 2847, and 3602–19.
257 E.g. l. 3623. The formalised struggle between good and evil has been likened to the conflict between Virtues and Vices in Prudentius' *Psychomachia*: E. J. Mickel, 'Parallels in Prudentius' *Psychomachia* and *La Chanson de Roland*', *Studies in Philology* 67 (1970), 439–52.
258 *Gesta Normannorum Ducum*, ed. van Houts, VII, 16–17 (vol. II, pp. 170–2).
259 William of Poitiers, *Gesta Guillelmi*, ed. Foreville, I, 52; II, 3; II, 8; and II, 31–2. The point was developed above all, needless to say, in the Battle Abbey Chronicle: *The Chronicle of Battle Abbey*, ed. E. Searle (Oxford, 1980), pp. 36 and 66, and cf. her comments at 18–23.
260 Wilson, *Bayeux Tapestry*, pl. 30; cf. Barlow, *Edward the Confessor*, pp. 249–53. Edward's actions and his attitude towards the succession are plausibly reconstructed by Barlow, 'Edward the Confessor and the Norman Conquest', repr. in his *Norman Conquest and Beyond*, 99–111.

taste for depictions of combat in the decoration of churches, not to mention the politicised commemoration of historic or local heroes.[261] Some of the martial scenes that adorn eleventh- and twelfth-century ecclesiastical structures advertise quite clearly the role of warfare in defending the faith and, more generally, proclaim its spiritual dimensions. The image of St Michael slaying the dragon on the tympanum of St Michel d'Entraigues, Charente,[262] the portrayal of St George helping the crusaders slay the infidel at Antioch above the south door of St George's, Fordington,[263] and the ?Roland cycle on the lintel of the west façade of Angoulême Cathedral[264] are some of the many cases in point. One thinks also of the painted knights who fight their way along the north nave arcade of All Saints, Claverley in Shropshire, which, as a strip measuring *c.* 50′ by 4′ 8″ flanked above and below by a decorative border, invites formal as well as thematic comparison with the Tapestry.[265] The Bayeux Tapestry uses similar language to show that the interactive relationship between man and the divine, expressed through war lay at the heart of the Norman success. The Normans won because their case was just, because of their spirituality (which is advertised by their cross-adorned banners (pl. 19)[266] and by the cross atop the mast of their flagship (pl. 17)[267]); and, no doubt, because of the presence of great Bishop Odo in their midst. The overarching message conveyed by the Tapestry is that the Normans hold England by divine judgement.

Contemporary English and later Anglo-Norman writers conceded precisely this. Eadmer reported that 'the French who were in it still bear witness about this battle that, although fickle fortune veered from one side to the other, nevertheless so great was the slaughter and rout that the victory they gained is truly and without doubt to be ascribed solely to the miraculous intervention of God, who by punishing the evil crime of Harold's perjury in this way showed that he is not a God that countenances iniquity'.[268] William of Malmesbury likewise ascribed the Norman victory, 'not to the art of war but [to] the occult and wondrous determination of God'; it was 'as if the whole strength of England had failed with Harold, who could and should have paid the price of his perfidy'.[269] The earliest of the pro-English accounts, the

261 E.g. the Charlemagne cycle at S. Maria in Cosmedin, Rome: R. Lejeune and J. Stiennon, *The Legend of Roland in the Middle Ages* 2 vols (London, 1971), I, 43–50.
262 E. Mâle, *Religious Art in France: the twelfth century*, ed. H. Bober (Princeton, 1978), ill. 200.
263 S. Alford, 'Romanesque Architectural Sculpture in Dorset: a selective catalogue and commentary', *Dorset Natural History and Archaeological Society Proceedings* 106 (1984), 1–22 at 1–5. It is probable that the depiction of St George fighting the infidel at Hardham, Sussex, of *c.* 1100, reflects the same event: Park: '"Lewes Group"', pp. 217–22.
264 Lejeune and Stiennon, *Legend of Roland*, I, pp. 29–42; II, ills 14–19.
265 Tristram, *English Medieval Wall Painting*, pp. 111–13 with pls 72–3.
266 Cf. Wilson, *Bayeux Tapestry*, pls 49, 50, 53, and 68.
267 *Ibid.*, pl. 42.
268 'De quo proelio testantur adhuc Franci qui interfuerunt, quoniam, licet varius casus hinc inde exstiterit, tamen tanta strages ac fuga Normannorum fuit, ut victoria quo potiti sunt vere et absque dubio soli miraculo Dei abscribenda sit, qui puniendo per hanc iniquum perjurii scelus Haroldi, ostendi se non Deum esse volentem iniquitatem.': Eadmer, *Historia Novorum*, ed. Rule, 9.
269 William of Malmesbury, *De Gestis Regum Anglorum*, ed. W. Stubbs, 2 vols (London, 1887–9), I, 281–2.

Anglo-Saxon Chronicle (D), blames the English nation as a whole. And it will be re-membered that the Bayeux Tapestry implicates all the English in Harold's kingship and fate: *they* gave him the crown (he did not seize it), and he is their king (*Rex Anglorum*). The Chronicle's terse pronouncement on the subject, probably written shortly after the event, well articulates the predominant message of the Tapestry: 'There King Harold was killed, and Earl Leofwine his brother, and Earl Gyrth his brother, and many good men. And the French remained masters of the field even as God granted it to them because of the sins of the people.'[270]

Amidst its many subtleties and complexities, the Bayeux Tapestry projects this same clear and awesome message: that the Normans now hold England because God in his infinite wisdom and just judgement gave it to them. The Tapestry was designed to answer the question, 'Why was the Norman Conquest successful?' We may disagree with its answer, but this is indubitably the answer that it gives.

270 *English Historical Documents* II, ed. Douglas and Greenaway, p. 147. Cf. Edward the Confessor's famous deathbed vision of two monks who predicted, 'Since those who have climbed to the highest offices in the kingdom of England, the earls, bishops, abbots and all those in holy orders, are not what they seem to be, but on the contrary are servants of the devil, on a year and one day after the day of your death, God has delivered all this kingdom, cursed by him, into the hands of the enemy, and devils shall come through all this land with fire and sword and the havoc of war.' (*Vita Edwardi*, ed. Barlow, pp. 74–5).

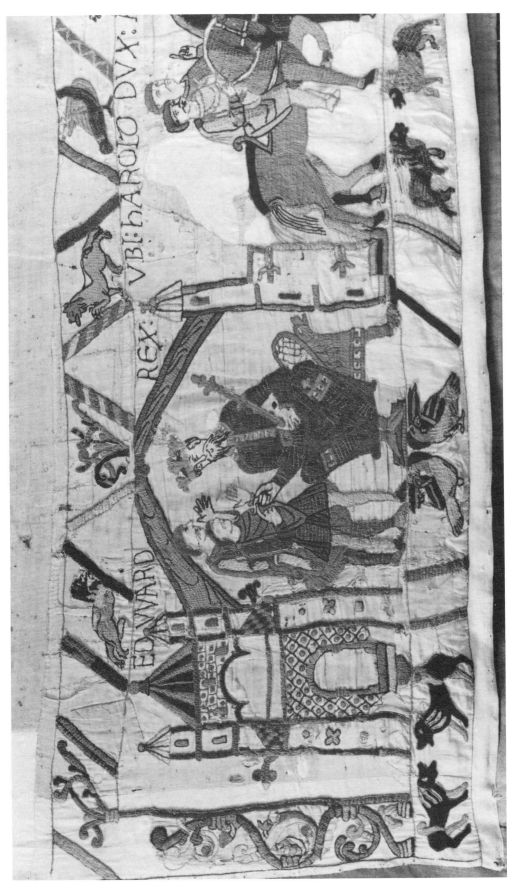

Plate 1

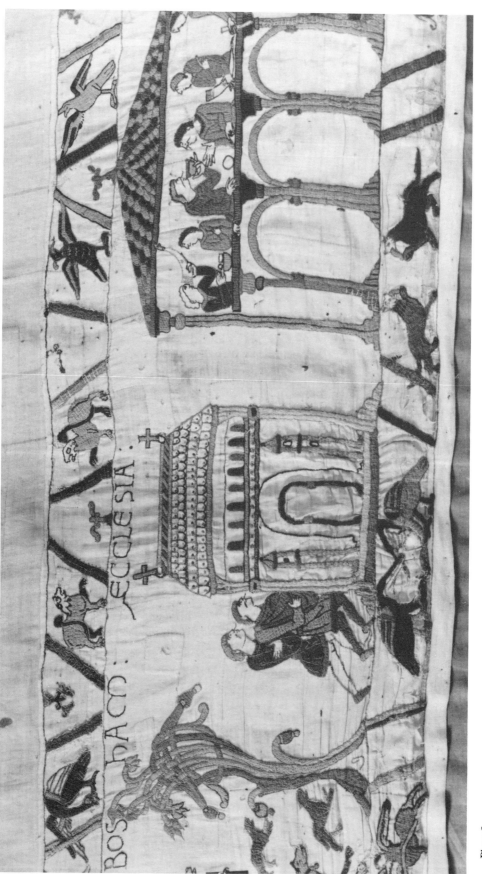

Plate 2

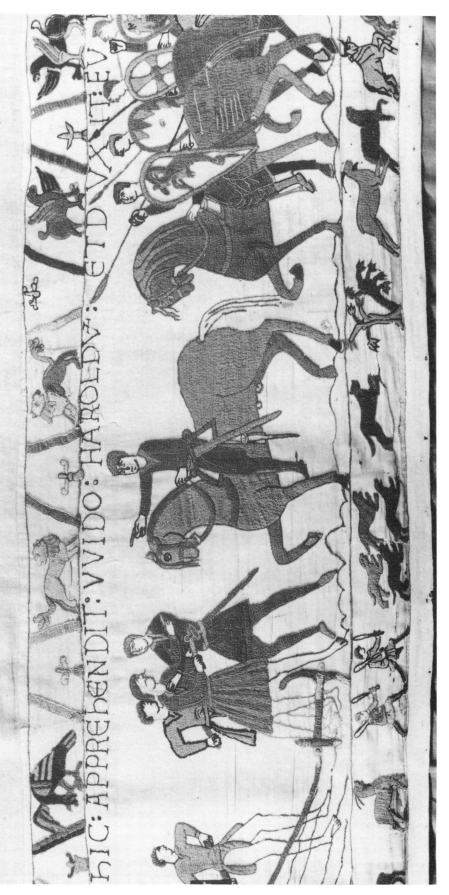

Plate 3

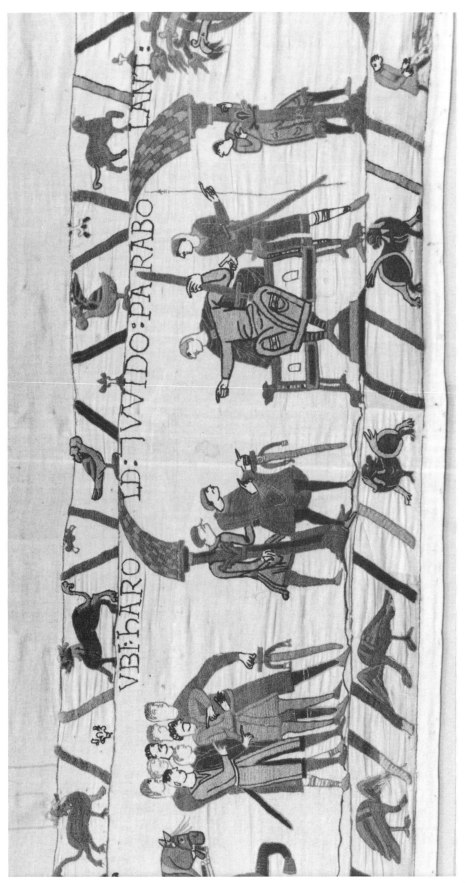

Plate 4

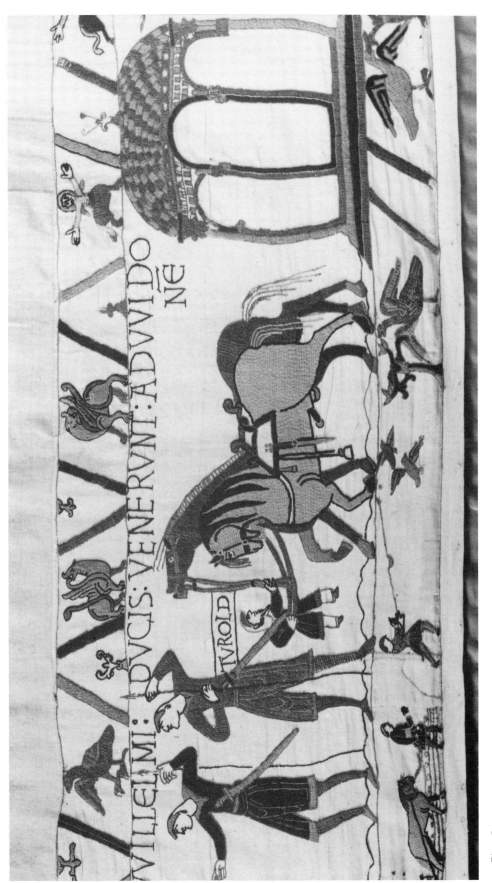

Plate 5

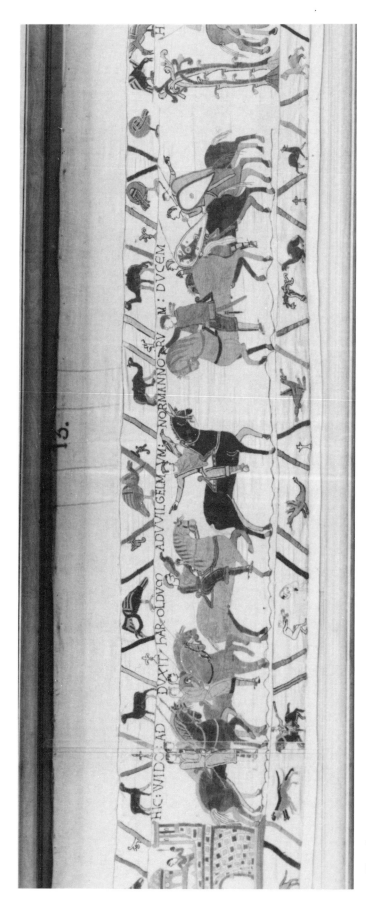

Plate 6

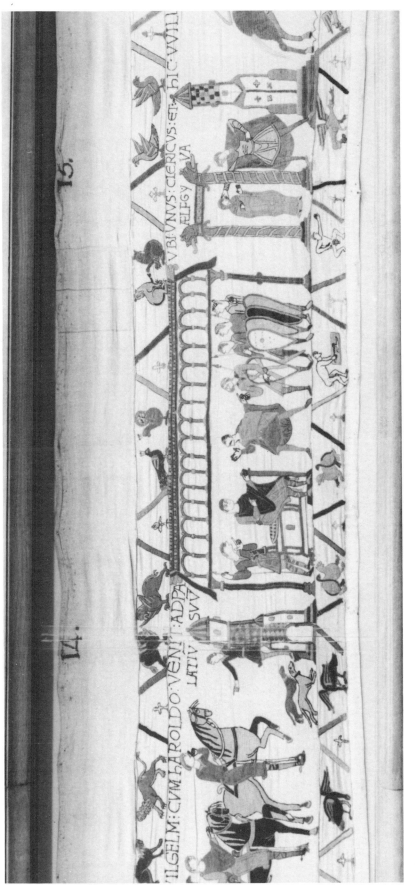

Plate 7

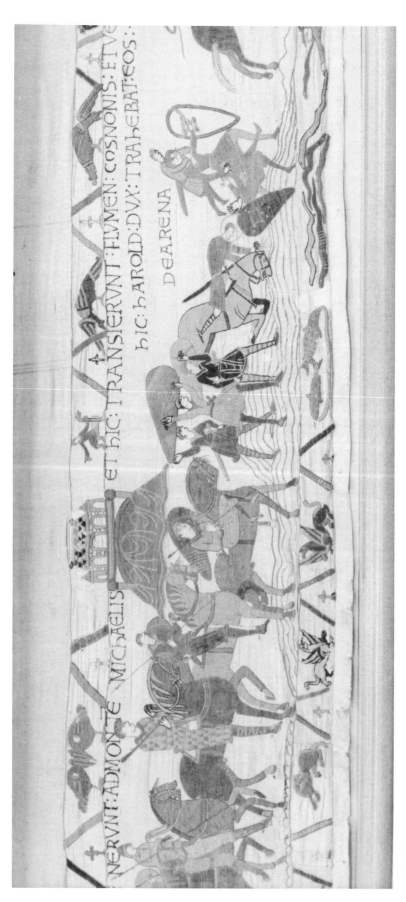

Plate 8

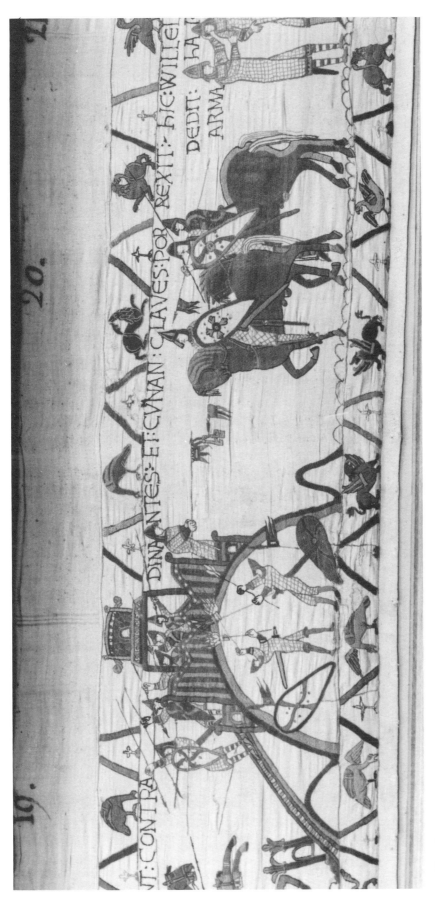

Plate 9

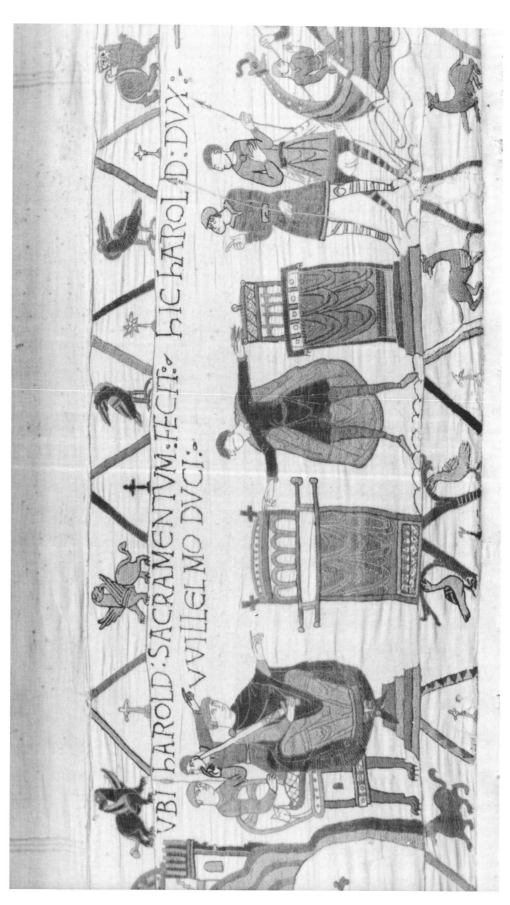

Plate 10

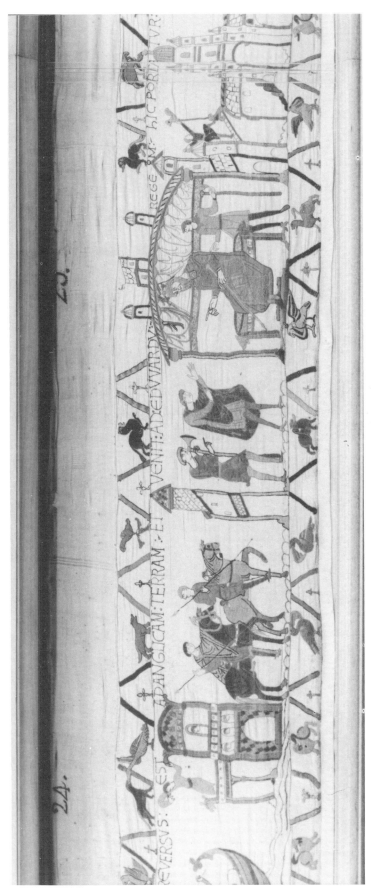

Plate 11

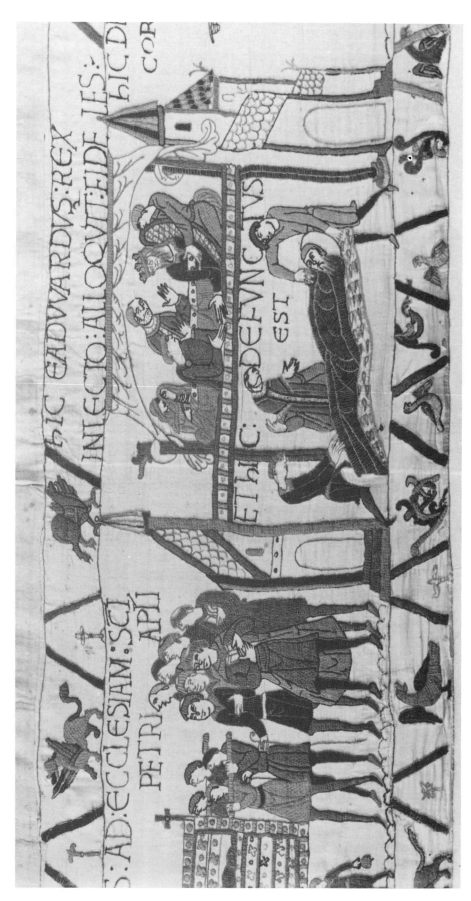

Plate 12

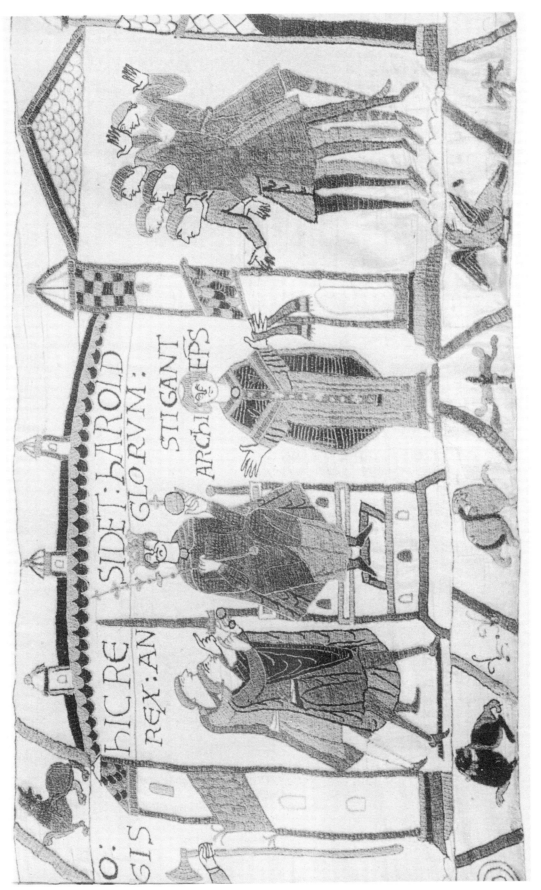

Plate 13

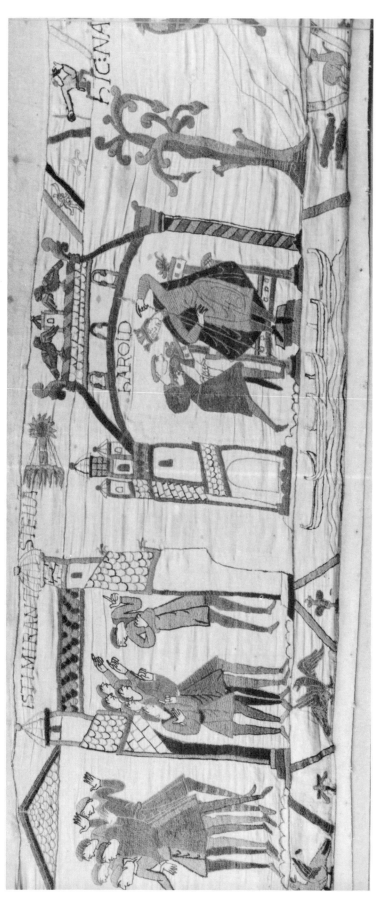

Plate 14

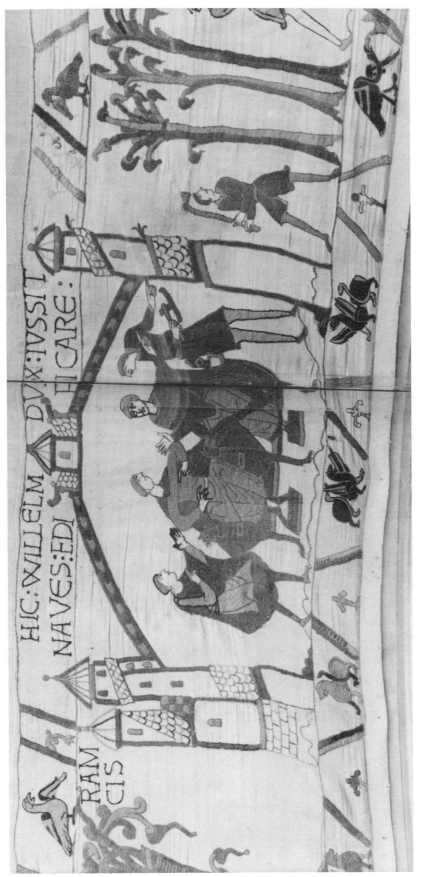

HIC:WILLELM DUX:IVSSIT NAVES:EDI FICARE:

RAM CIS

Plate 15

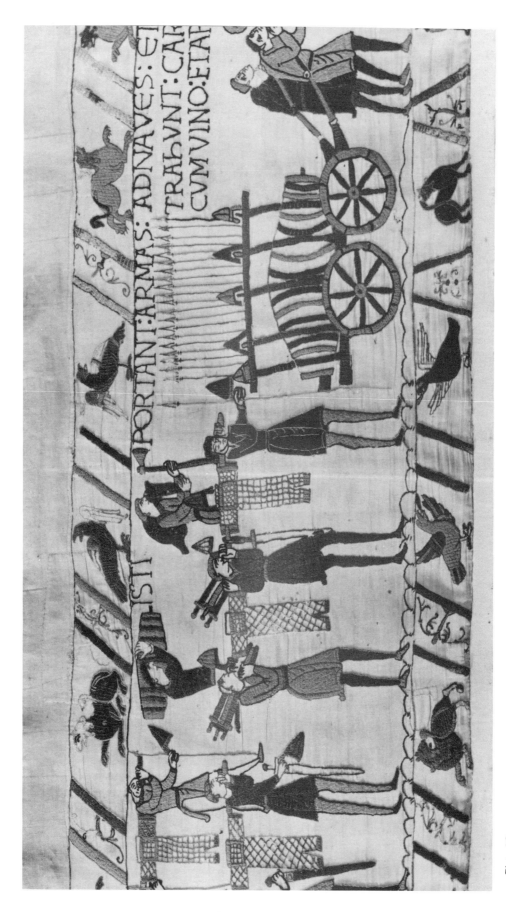

Plate 16

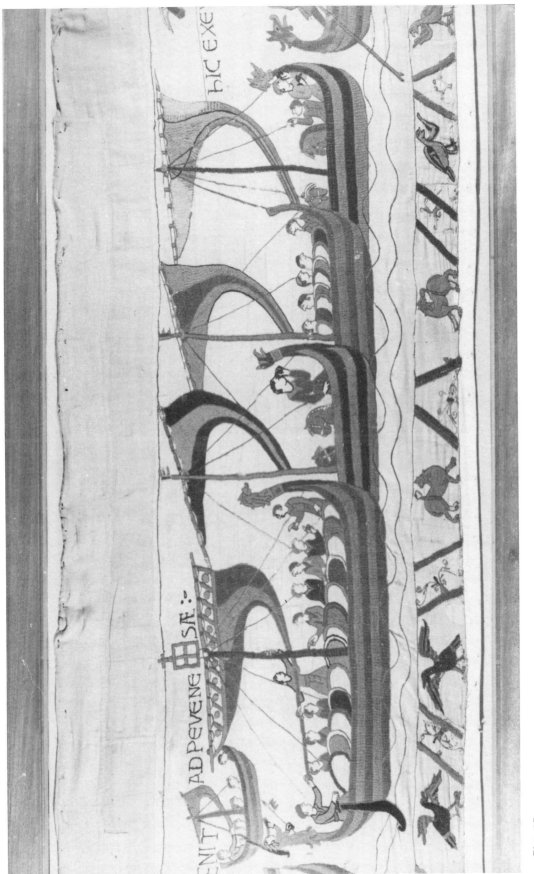

ENIT AD PEVENE SÆ:

HIC EXE

Plate 17

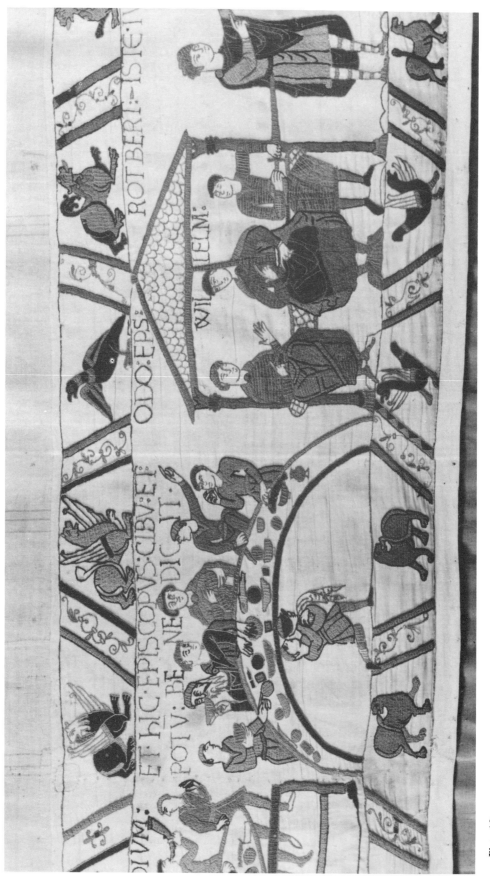

Plate 18

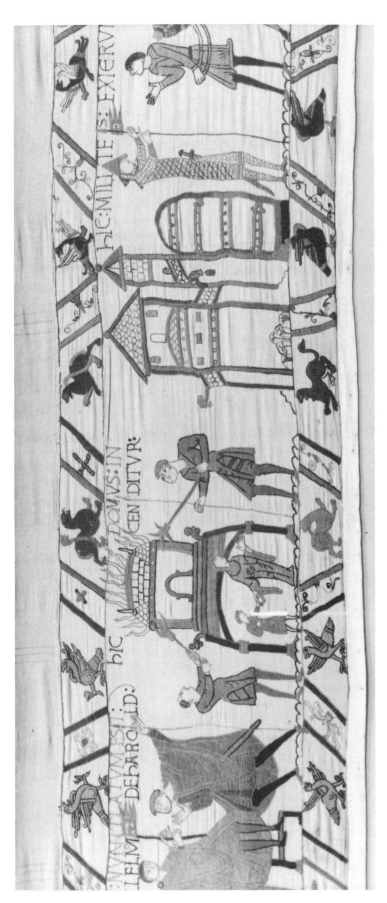

Plate 19

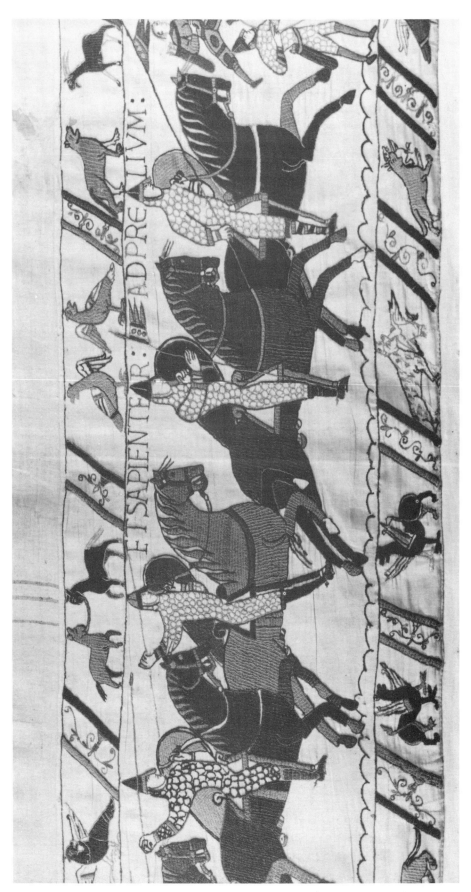

ET SAPIENTER: ADPRE:LIVM:

Plate 20

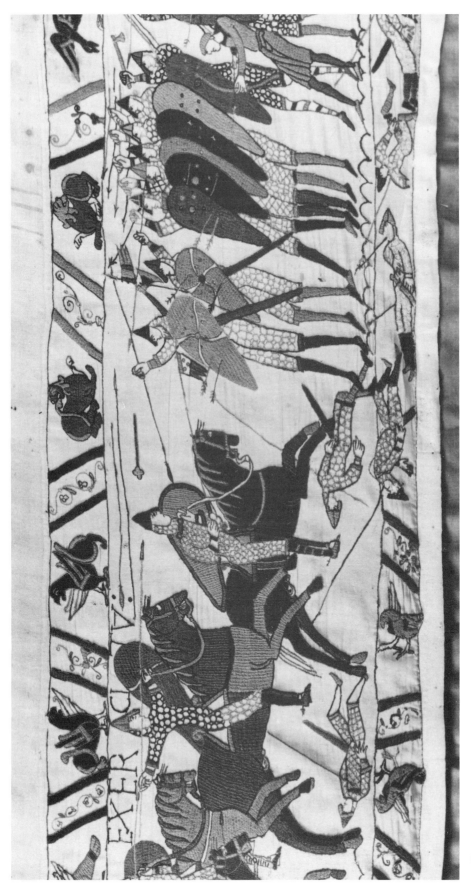

Plate 21

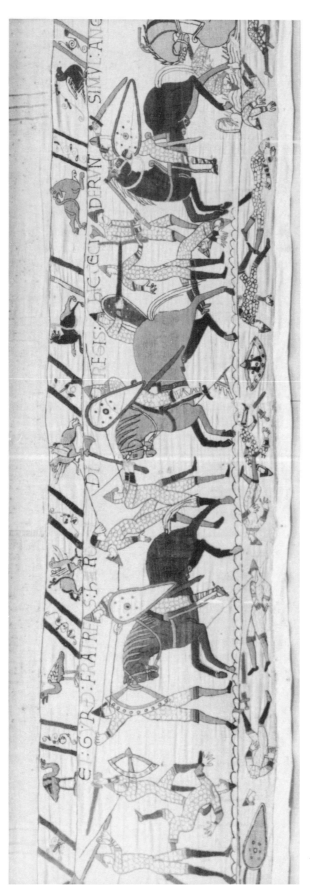

Plate 22

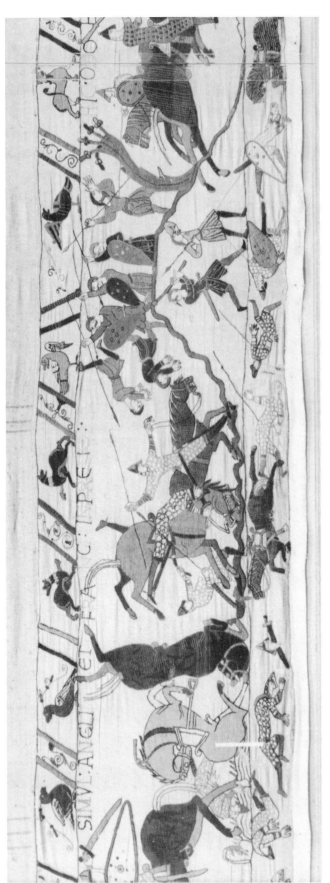

SIM:ANCLI ET FA CITEP[...]

Plate 23

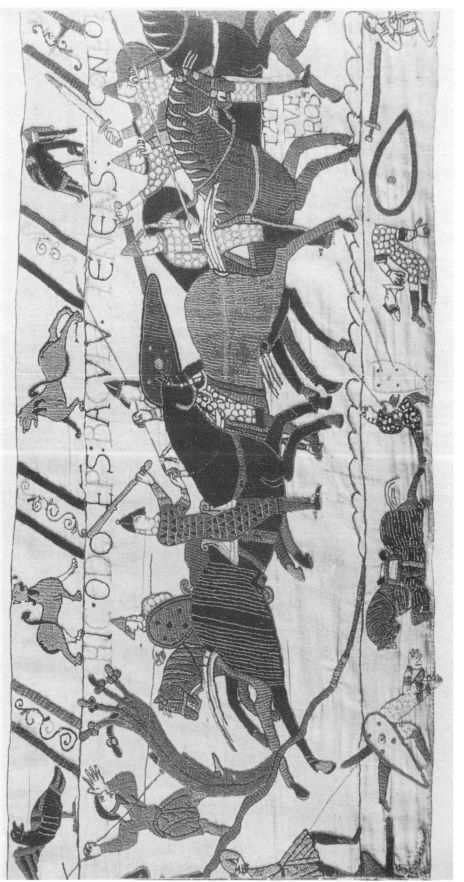

Plate 24

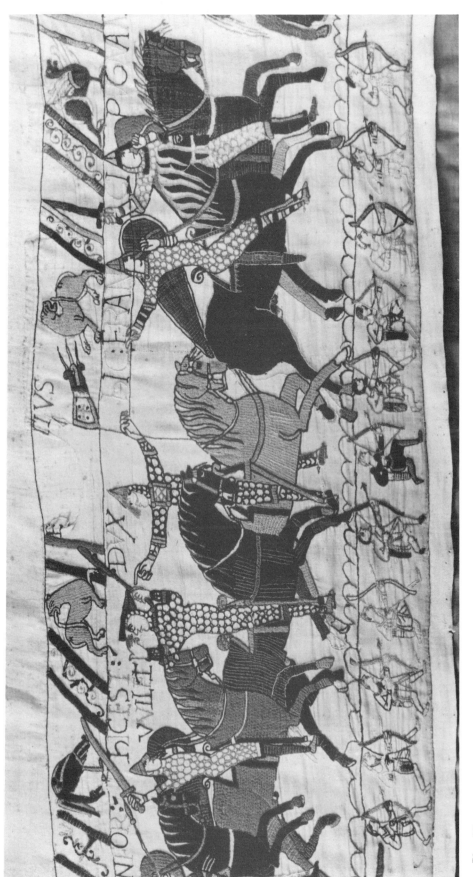

Plate 25